On the Camera Arts and
Consecutive Matters

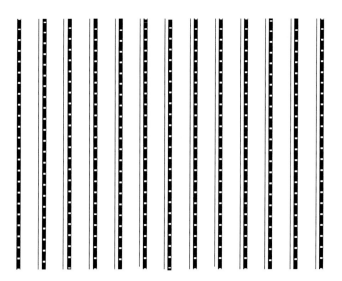

**The MIT Press Writing Art series, edited by Roger Conover**

# On the Camera Arts and Consecutive Matters

## THE WRITINGS OF HOLLIS FRAMPTON

EDITED WITH AN INTRODUCTION BY
**BRUCE JENKINS**

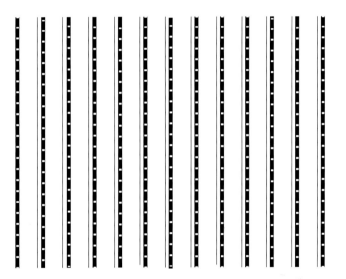

WRITING**ART** SERIES

THE MIT PRESS
CAMBRIDGE, MASSACHUSETTS
LONDON, ENGLAND

MIT Press books may be purchased at special quantity
discounts for business or sales promotional use.
For information, please e-mail special_sales@
mitpress.mit.edu or write to Special Sales Department,
The MIT Press, 55 Hayward Street, Cambridge,
MA 02142.

This book was set in Filosofia and Solex by Graphic
Composition. Printed and bound in Spain.

Library of Congress Cataloging-in-Publication Data
Frampton, Hollis, 1936–1984.
On the camera arts and consecutive matters :
the writings of Hollis Frampton /edited with an introduction
by Bruce Jenkins.
     p. cm. —— (Writing art)
Includes bibliographical references and index.
ISBN 978-0-262-06276-3 (hardcover : alk. paper)
1. Motion pictures. 2. Cinematography. 3. Photography.
4. Arts. I. Jenkins, Bruce, 195– II. Title.
PN1995.F69——2009
791.43—dc22

                    2008029245

10  9  8  7  6  5  4  3  2  1

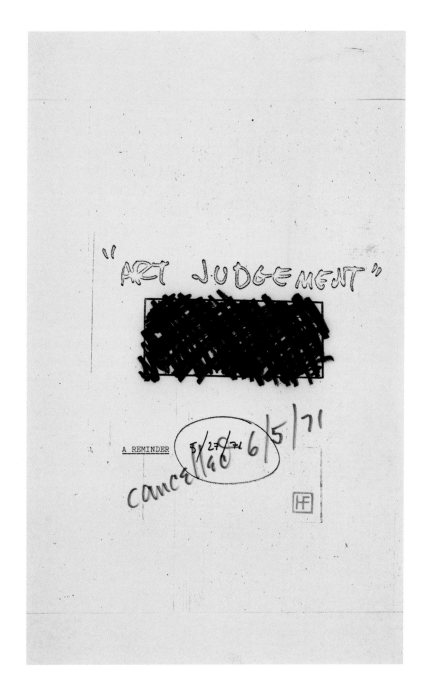

*A Reminder* from *Reasonable Facsimiles,* 1971
Collage on color xerograph. Collection Walker Art Center,
Minneapolis, Clinton and Della Walker Acquisition Fund, 1993
Courtesy Walker Art Center

# CONTENTS

## COLLECTING HIS THOUGHTS: REMARKS ON THE WRITINGS OF HOLLIS FRAMPTON

Bruce Jenkins

A quarter-century ago, a selection of Hollis Frampton's major writings was published under the title *Circles of Confusion*.[1] That book, now long out of print, capped a significant period in Frampton's work as both an artist and what he came to call a "metahistorian" of the camera arts. The dozen essays contained in the book, written over as many years, chronicled his concerted efforts to develop an engaged, intellectually resonant, and distinctly modernist form of critical discourse for the fields of photography, film, and video—a discourse for which he sought equivalence not only with critical thinking in literature and the visual arts but, audaciously, in the philosophies of history and science as well. And yet as Frampton acknowledged in the Preface to the book, there was much more work to be done regarding what he termed "new options and responsibilities for speculative writing." His untimely death in 1984, a year after the book's publication, ended his own direct role in completing such tasks. Nonetheless, and despite difficulties in accessing them over the years, these critical interventions and metahistorical inquiries have proved exceedingly resonant and enduring, gradually leveraging just such a critical enterprise among a small but influential contingent of contemporary artists and scholars.

The republication of these twelve essays, together with a range of additional writings, including introductory remarks and lectures, production notes and proposals, correspondence and interviews, is intended to broaden that continuing enterprise and introduce the work to new audiences. They have been gathered together here, along with their lesser-known but no less provocative siblings, in a format that focuses thematically on Frampton's explorations in several related areas of inquiry. An attempt was made to compare the essays as they were published in 1983 in *Circles of Confusion* with their original publications and, where possible, with the author's manuscripts, restoring when necessary (meaning, when channeling the distinctive timbre of Hollis's voice) phrases, passages, or emphases that had been excised, correcting minor errors, and applying a consistent stylistic and grammatical schema to the whole. On occasion, editorial notes (marked B.J.) have been added where further explanation seems useful.

The impetus for Hollis Frampton's writing stemmed in part from what he deemed the paucity and poverty of then-contemporary critical discourse on the camera arts. These theoretical undertakings were an enterprise he could further deploy to anchor his own work as an artist: first in photography, a practice

he largely abandoned by the late 1960s, and then in his body of films, for which he gained international recognition. In many senses, the writing and the practice were inseparable: two aspects of the same aesthetic aspiration, each of which informed the other. He was, from the first, a writer, and he continually sought in his art a system as responsive in its cognitive and perceptual reach as that of natural language.

The model may have been established with one of his first pieces of published critical writing, in which he attempted to fend off the misguided appraisals of a newspaper critic reviewing an early exhibition of his colleague Frank Stella's paintings. Composed as a letter to the editor of the *New York Herald Tribune* in 1959 and ghostwritten under Stella's name, the brief manifesto addressed a significant misreading at the material level of the work.[2] Rarely were the intentions of Stella's painting misinterpreted in this way again, and the artist's career was launched. In many ways, this impulse by an artist to critically intervene can be traced back to the French painter Eugène Delacroix, who in 1857 challenged the critical judgments of the "many semi-erudite men [who] have treated the philosophy of art." In a passage that served as an epigraph to Soviet director Sergei Eisenstein's first book of writings on film, Delacroix captured the fundamental absurdity of a critical system that seemed to value a "profound ignorance of technical matters," effectively "render[ing] professional artists rather unfit to rise to the heights which are forbidden to the people outside aesthetics and pure speculation."[3]

Frampton himself would frequently take refuge in the confines of the art review, where his critical assignments could become the springboard for more substantive reflections. Writing in the pages of *Artforum* and *October,* he was able to work through issues that impinged on the reception of his own work and that of colleagues. These reviews served collectively as a corrective lens through which to view critical lapses of the past—still photography's continued reverence for the f/64 school (Edward Weston, Ansel Adams, Minor White), the myopic reception of the post-Brakhagean generation of experimental filmmakers (including, of course, himself)—and as a guide to a more rigorous theoretical basis for addressing the emerging arena of the media arts. Within the context of reviews and historical analyses, Frampton embedded his own manifestos: deft rereadings that provide a coherent analytical framework for photographic theory and practice; and, for film, the missing link that connects advanced theories that emerged in the late 1920s and 1930s with the discontinuous advances in radical cinematic aspirations of the late 1960s and 1970s and, rather presciently, with the arena he began to glimpse in the late 1970s that we now call digital media.

In this respect, one can sense these writings were destined for a future—the future, in fact, in which we now reside. There is a time-release aspect to the discourse that, while attempting to historically ground the paradigm-shifting practices of his own times, in many ways prefigures those of our current era. Writing well in advance of the moment when such practice would demand its own ontology and taxonomy, Frampton could only sense, but not name, the art for which his writings would have the greatest impact. "Find a word or phrase for 'photo-media' imagery," he writes in a set of lecture notes, and can offer only the hyphenated term *photo-film-video-computer*. Frampton was an early adopter of the new media sensibility in an era when there was no notion of convergence and barely a sense of the myriad forms the digital arts would generate. All he knew (but he knew it with full surety) was that this unnamed form of media would have enormous impact ("at least as far-reaching as . . . broadcast television") and that it would be based on the ubiquity of fast and cheap computing power.

All of this is not to suggest for a moment that the reading of these essays and lectures, reviews and introductions, artist statements and working notes will feel as if they are of our times. They are figuratively and literally *out of time*, and as such they represent a multivalent dialogue with spirits past and present, figures arcane and familiar, specialists engaged in the hard sciences and those laboring in arenas more abstract and abstruse. Frampton may strike contemporary readers as being a bit like the protagonist of the Dali and Buñuel film *Un chien Andalou:* a figure whose quest is freighted with cultural baggage from the past, symbolized in his arduous attempts to drag a pair of grand pianos, laden with dead donkeys, and two bound Catholic priests across the parlor that separates him from the object of his desire.

Part of the calculus for Frampton's theorizing of the camera arts was situated in the past: Aristotle and Dante, Descartes and Darwin, Herodotus and Hermann von Helmholtz all make appearances, but so do Joyce and Beckett (especially Joyce and Beckett). It is situated in particular in the poetics of Ezra Pound, who advocated for a "hard poetry," in the ideologically engaged cinematic practices of Eisenstein and Dziga Vertov, and even in the twelve-tone compositions of Schoenberg, to say nothing of the growing discourse that accumulated around the work of his peers, the minimalist, conceptual, and performance artists, a portion of which he helped to formulate.

No less a factor was the need to be taken seriously, which led Frampton at times to cloak his writing with a certain density of allusion and breadth of reference that oscillated between the arcana of the classics (Greek drama, Roman allegory, Sanskrit poetry) and the argot of scientific discovery, with occasional

doses of continental philosophy, visual anthropology, and structural linguistics thrown in for good measure.[4] The result is writing marked with a sense of high seriousness and rigorous literateness—aided, at times, by a pungent humor that could turn slapstick—that plays seemingly all at once to the mind, the eye, and the ear.

Frampton's voice—a resonant basso—is a factor as well, especially for readers who may be fortunate enough to recall it from encountering the author on one of his frequent lecture-screening tours ("medicine shows," as he called them). Having come of age within a generation that still aspired to the vocation of the poet (the next, as we now know, yearned to be filmmakers) and having as a young man sat literally at Pound's feet, Frampton mastered a continental manner of verbal felicity and the necessary wit and erudition that the mode demanded. Behind the workman's attire that was his uniform of choice throughout his adult life, there resonated locutions worthy of an Oxbridge don.[5]

Despite his remarkable speaking abilities, Frampton acknowledged on at least one occasion the challenges posed for him by writing. In the course of an interview with the cultural affairs director of the university at which he taught, he was complimented on his extraordinary verbal and literary skills. Frampton countered by comparing the former to cutting with a knife through butter, and the latter, for him, to using that same knife on marble.[6] He labored over his writings much as he labored over his films. Both were integral parts of his artistic practice; in fact, the two were inextricably bound.

This was the case in practical matters, where, for instance, his travel to review photographic exhibitions in England for *Artforum* provided him the chance to develop important contacts for screenings and for the critical reception of his films. More significant was the enduring nature of his polysemic engagement with language, which would continue most directly in his writings but remain a dominant motif in his visual art as well. At least two of his most celebrated films, *Zorns Lemma* and *(nostalgia)*, allegorize his journey from young man of letters to practitioner of the camera arts. And one of the striking features of the short film *Gloria!* that marked the conclusion of his massive film cycle *Magellan* was its emulation of a computer-based flow of language. Frampton sought in the moving image a system of communication as precise and agile as language. And he sought that system in his theoretical musings as much as in his artistic practice. Writing was Frampton's lifelong métier, and this book is in large measure as significant an act of preservation as the parallel work being undertaken to conserve and restore his cinematic oeuvre.

[ ]

This expanded version of Frampton's collected writings embraces the diverse forms of his discursive efforts while attempting to situate them in a manner consonant with the set of registers conceived for the title (but not the organization) of his earlier book: film, photography, and video. Making use of his overall characterization of these writings as "texts," a fourth category has been added to capture what emerged as his more distinctly literary efforts. And because his writings often crossed the discrete boundaries between the arts to comment on sculpture, painting, and various intermedial forms, it was useful to situate a selection of his critical remarks on "The Other Arts."

The earliest body of sustained critical commentary appears in the Photography section of this book and includes essays that chart not only the direction of Frampton's critical thought but the development of his own photographic practice. It is chockablock with musings on big ideas like Time and History, the relation of images to their referents in the real world, and the impact of the medium on consciousness itself; it also embraces anecdote and storytelling, and poetic musings on fellow practitioners of the medium.

The previously unpublished "Some Propositions on Photography" offers an intervention into the field—a manifesto—by insisting on opening up the frame of inquiry to embrace the other arts. Several of the longer essays take the form of exhibition reviews and reflect Frampton's complicated relationship to the medium, which, as the critic Christopher Phillips defined it, involved his being "simultaneously drawn to and repelled by his subject."[7] The key text in this regard is "Impromptus on Edward Weston: Everything in Its Place," an extended essay in which Frampton carried out what he would call in an interview with Adele Friedman "the ritual murder of the father." The other significant patriarch who emerges here is Eadweard Muybridge, a key figure in the development of the moving picture, a factor Frampton brilliantly reads back onto the artist's no less seminal landscape photography.[8] In his deliberations on the work of Paul Strand, he posits one of his most resonant analogies for describing the critical quandary facing the photographic image, which is denied "the very richness of implication that for the accultured intellect is the only way at all we have left us to understand (for instance) paintings." Frampton the fabulist makes an appearance in a tale about the photograph-obsessed lost continent of Atlantis that launches his review of two early photography exhibitions in "Digressions on the Photographic Agony." The section concludes with a series of more contemporary appraisals of artists with both aesthetic and personal ties to Frampton and the text and images from his own remarkable photographic series *ADSVMVS ABSVMVS*.

The script for Frampton's sole performance piece, "A Lecture," a work for projector and audio recorder, opens the Film section. No theoretical exegesis could more succinctly (or deliciously) embody the precision of his thoughts on the cinematic apparatus. Frampton's most widely cited critical essay, "For a Metahistory of Film: Commonplace Notes and Hypotheses," was his first major treatise on the medium, and it amassed an impressive battalion of scientific, artistic, and philosophical registers in order to announce the emergence of cinema as "the Last Machine" and to usher in its cultural caretaker, "the metahistorian," who was charged with inventing for it a coherent tradition. More than three and a half decades after its writing, the essay remains a potent challenge to artists engaged with the moving image and a valuable cipher for the direction that Frampton's own expanding practice would take, including the articulation of a conceptual framework for what would become his *Magellan* cycle, a "Tour of Tours."

But Frampton was not merely engaged in the realm of history and theory; he was very much focused on the issues of his times. His letter to Donald Richie, then the director of the film program at the Museum of Modern Art, documents, in arch Framptonian form, his participation in the broader assertion of artists' rights that was taking place in New York in the late 1960s and early 1970s. Frampton employs a logician's scalpel—and the worker's political passion—in dissecting the particular dilemmas faced by a film artist being "honored" by such an institution. (This theme is taken up again seven years later in his dialogue with Bill Simon, where we learn about the prohibitive costs of his prints for *Magellan*.) Another aspect of Frampton's contemporary focus is evidenced in the selection of his writings on the work of peers. These range from his impassioned reading of a major new work by Stan Brakhage (in a letter to the artist) to his lucid, singular assessment of the films of Michael Snow, the cumulative historical impact of which is "like knowing the name and address of the man who carved the Sphinx."

The remaining components of this section comprise an array of scripts, textual material, and scores, as well as production notes for a pair of Frampton's most critically acclaimed films, *Zorns Lemma* and *(nostalgia)*, and an unpublished proposal for *Magellan*. Putting that final leviathan work into perspective is Bill Simon's substantive interview with Frampton. The concluding essay, "Mental Notes," originally authored for a film conference on autobiography, suggests that even in films that bear few overt marks of the personal, "everything in a filmmaker's life forces its way into his work." Proving this point, the figure of Frampton's maternal grandmother makes a brief appearance in the essay,

as she does so memorably in the stirring autobiographical closure to *Magellan* that is *Gloria!*

The prehistory of the digital arts emerges with both technical specificity and critical ambition in the three pieces of the Video and the Digital Arts section. His major essay on the subject is "The Withering Away of the State of the Art," written when the medium of video was still very much in its infancy. Frampton, the metahistorian of film, emerges to assist this new form, unique in having virtually no past, in envisioning its future. Parallel to such tasks are Frampton's own artistic ambitions in this new arena, which set him on a collaborative journey working with colleagues and a talented group of students to create both the machines and methods that would allow him to turn the computational power of the personal computer into a sophisticated tool for artistic production.

In addition to his commentary on the camera arts—from the earliest forms of still photography to the cutting edges of the new media of his era—peculiarities of space and time frequently conspired to bring him into the company of artists engaged in more traditional media, and consequently led to a body of critical writing on The Other Arts. Among his earliest compatriots were two other scholarship students at Phillips Academy in Andover, Massachusetts, Carl Andre and Frank Stella, who would play defining roles in the shifts in sculpture and painting that took place in the 1960s. Frampton participated in their journey, documenting his friends' work, challenging their ideas, and shaping the critical context in which their art would gain recognition. Ample evidence of this emerges in the chronicle that Frampton provides the Dutch curator Enno Develing for the catalogue to an important early exhibition of Carl Andre's work. His year-long set of dialogues with Andre revealed the shrewdness of his analytical style, and in the piece reproduced here, he specifies what he feels is the proper link between theory and practice: "I believe that there are no ideas except in execution." Evidence of such a belief can be found in his scores for such idea-driven objects as *Comic Relief* and *Two Left Feet*. This section concludes with writings devoted to the work of two other artists within his circle and a brief gloss on his own early experiments with an adjacent camera art: xerography.

Finally one encounters Frampton the fabulist, as a tendency one feels coursing through much of his ostensibly critical discourse emerges full blown in a pair of writings in the Texts section. Originally included in *Circles of Confusion* as a critical essay, "A Stipulation of Terms from Maternal Hopi" is a striking piece of pseudo-anthropology predicated on a vividly imagined

find of "caches of proto-American artifacts." It presents Frampton the enticing opportunity to construct a culture in which the projected image functioned as a primary conveyor of beliefs, knowledge, myth, and history. "Mind over Matter" was described in its original publication in *October* as Frampton's "first work of fiction." A sprawling set of allegories, it by turns delights and perplexes, conjoining as it does a complex system of mathematical formulas to a set of Borgesian tales that turn on arcane allusions and surrealist wordplay—and not infrequently, acid commentary on the cultural condition: a corpse is discovered to contain thousands of precious objects hidden in its body, leading to the conclusion that the "nameless deceased was, in a word, a walking museum."

[ ]

While Frampton wrote for a decidedly post-Barthesian reader—a condition that necessitates active (indeed, rigorous) participation—these are nonetheless thoroughly writerly texts, artfully crafted, often elegant, and occasionally acerbic disquisitions crammed with historical reference, scientific taxonomies, classical allusion, and wellsprings of recondite knowledge: literary, artistic, and cultural. This complex weave of citation in turn gives voice to the multiple narrators of Frampton's texts: the raconteur, the philologist, the cultural historian, the critic, the poet, and even the prophet. As a member of the younger generation of scholars of Frampton's critical work has noted, "His highly playful approach, which embraces wit and irony, as well as indirect allusion and intertextual intricacy, seems designed to address an impossibly learned reader."[9] And yet, as with his films, the rewards of the effort are great for the diligent or impassioned reader, and repeated immersion yields surprising clarity.

Frampton viewed these writings not only as the fruits of his own knowledge and labor, and a theoretical template for his personal artistic practice, but equally as a call to action for the next generation of artists, theorists, and writers, believing that such a challenge might be a "not wholly unrewarded expectation." He has not been here to witness the continuation of these efforts. One can hope, however, that he is indeed enjoying that dreamed afterlife he envisioned awaiting him in some version of Dante's limbo: "I should hope to spend the balance of eternity in the company of virtuous pagans . . . engaged in million-year afternoon conversations with Aristotle or the Emperor Ch'in Shih Huang Ti, builder of the Great Wall of China, or with Hegel." He even deigned to devote a portion of his time in these precincts to continuing his interrogation of the camera arts: "One such afternoon I would propose to spend with Edward Weston, seeking satisfaction in the matter of the facts in this case." Undoubtedly, by now, he has gotten the better of them all.

## Notes

1. *Circles of Confusion: Film, Photography, Video; Texts 1968–1980*, foreword by Annette Michelson (Rochester, N.Y.: Visual Studies Workshop Press, 1983).

2. "An Artist Writes to Correct and Explain," *New York Herald Tribune*, December 27, 1959, sec. 4, p. 7. The incident is recounted in Harry Cooper and Megan R. Luke, *Frank Stella: 1958*, exhibition catalogue (New Haven, Conn.: Yale University Press, 2006), p. 27.

3. From *The Journal of Eugène Delacroix*, trans. Walter Pach (New York: Covici-Friede, 1937), quoted in Sergei Eisenstein, *The Film Sense*, ed. and trans. Jay Leyda (New York: Harcourt, Brace and World, 1947), p. xi.

4. An *Oxford English Dictionary* and a set of the *Encylopaedia Britannica* are often handy when sleuthing for the sometimes arcane references in Frampton's writing. The meaning of the title of his original preface to *Circles of Confusion* in 1983—"Ox House Camel Rivermouth"—eluded me for decades, until an accidental foray through an old encyclopedia revealed these to be the set of real-world correlative symbols for the first four letters of the Phoenician alphabet (A, B, C, D). The curious reader will no doubt unearth many more such games, puzzles, and allusions in the course of reading.

5. As the artist Michael Snow noted for a memorial program following Frampton's death in the spring of 1984, "He was the most extraordinary conversational and public speaker I've ever known." See "On Hollis Frampton," in *The Collected Writings of Michael Snow* (Waterloo, Ontario: Wilfrid Laurier University Press, 1994), p. 241.

6. "Conversations in the Arts: Hollis Frampton Interviewed by Esther Harriott," State University of New York at Buffalo, 1979.

7. Christopher Phillips, "Word Pictures: Frampton and Photography," *October* 32 (Spring 1985): 63.

8. In her book-length study of the pioneering photographer, the writer and critic Rebecca Solnit hails this article by Frampton as "the best essay ever written on Muybridge." See Rebecca Solnit, *Rivers of Shadows: Eadweard Muybridge and the Technological Wild West* (New York: Penguin, 2004), p. 84.

9. Federico Windhausen, "Words into Film: Toward a Genealogical Understanding of Hollis Frampton's Theory and Practice," *October* 109 (Summer 2004): 95.

## ACKNOWLEDGMENTS

Many of the same people who supported Hollis Frampton in his lifetime were instrumental in the preparation and completion of this book. First and foremost in both regards is the photographer and educator Marion Faller, who has supervised the organization and conservation of his work and provided rights to the entirety of the artist's writings. Faller's generosity and commitment are matched only by her meticulousness and compassion. The regular parcels she sent containing writings and documentation, her frequent conversations and correspondence, and her sage counsel and advice were invaluable. Without her goodwill and active engagement at every stage of conception and execution, this book would not exist.

Anthology Film Archives, where Frampton deposited many of his production notes, materials, and records (a practice Faller has continued), generously provided access to its collection of files, audiotapes, and records. Thanks are due to Jonas Mekas and Robert Haller, who have diligently overseen this material for many years, and to the current team of Andrew Lampert, John Mhiripiri, and Wendy Dorsett.

Several scholars have been of long-standing support to those of us who have been engaged in the study of Frampton's work. Annette Michelson, a former editor at *Artforum* and a cofounder of *October*, supported the publication of much of Frampton's most important writings, and herself wrote the deeply provocative Foreword to *Circles of Confusion*. She was Frampton's close friend and a longtime champion of his films and writing. Gerald O'Grady, who brought Frampton to teach in the 1970s at his visionary Center for Media Study at the State University of New York at Buffalo, has been a diligent chronicler of the entire corpus of Frampton's work and has generously provided access to this growing archive. Scott MacDonald conducted a series of substantive interviews with the artist and graciously shared material from those sessions.

The pioneering work of other scholars, including Michael Zryd, Bill Simon, and Ken Eisenstein, has served as an important resource; as colleagues, they have graciously shared their notes, recollections, and advice. Acknowledgment is due as well to the collections at the Harvard Film Archive, Cambridge, and Walker Art Center, Minneapolis; the Video Data Bank, Chicago; and Robert Gardner, who made available to me his illuminating dialogue with Frampton that was part of the long-running *Screening Room* television series.

An important moment in refocusing critical attention on the work of Hollis Frampton (including my own) took place at Princeton University in November 2004. The symposium "*Gloria!* The Legacy of Hollis Frampton," organized by Su Friedrich, Keith Sanborn, and P. Adams Sitney, brought together a number of artists and scholars across diverse disciplines; the liveliness of their discussion contributed greatly to the vision of this project.

Thanks are due to the artist Robert Huot, a close friend and colleague of Frampton, for his swift response to my queries of historical fact. The video artists Woody and Steina Vasulka, who worked closely with Frampton at the State University of New York at Buffalo, were similarly gracious in providing information and recollections. I am also indebted to Keith Sanborn, Robert Coggeshall, and John Minkowsky for their assistance in tracking critical information.

For the illustrations, thanks are due to Marion Faller, Walker Art Center assistant registrar Pamela Caserta, and Anthology Film Archives archivist Andrew Lampert as well as to Bill Brand, whose meticulous care of Frampton's moving-image oeuvre these past twenty-five years has been a gift to the field at large.

At the MIT Press, Roger Conover, who initiated the idea for the publication of this book, and Marc Lowenthal provided ample doses of sage advice and gentle patience in good measure. They ably guided the book through all stages of production. Sandra Minkkinen and Beverly H. Miller provided thoughtful editorial input, and Margarita Encomienda created the elegant design.

Final thanks are due to a friend of Frampton and my own professional and personal partner of many years, Janet Jenkins, who not only helped to prepare the manuscript but provided steadfast research and illuminating insights on the writing.

Bruce Jenkins

## ILLUSTRATIONS

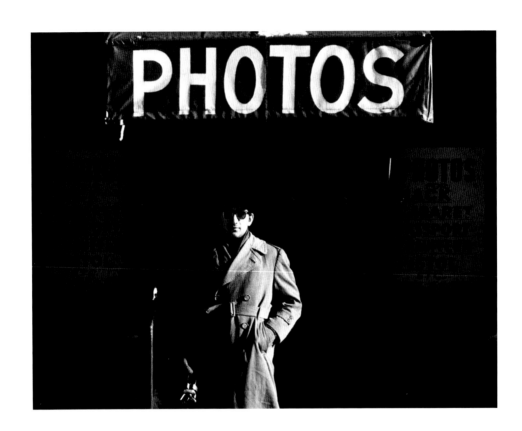

Untitled from *The Secret World of Frank Stella,*
1958–1962. Black-and-white photograph. Collection Walker
Art Center, Minneapolis. © Estate of Hollis Frampton
Courtesy Walker Art Center

# PHOTOGRAPHY

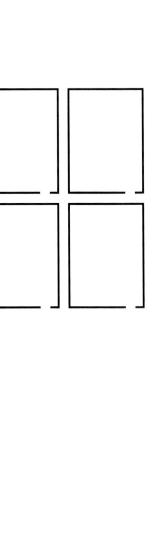

# Some Propositions on Photography

*Photography*, a word that could get along handsomely with two or three fewer syllables, entered the English language in the year 1839, perhaps the coinage of William Henry Fox Talbot, the inventor of a process he at first called "photogenic drawing." By the time Picasso left Barcelona, the Oxford lexicographers had called photography "the *process or art* of producing pictures by means of the chemical action of light on a sensitized film on a basis of paper, glass, metal, etc.; the *business* of producing and printing such pictures." The emphases are my own.

The first panchromatic emulsions were still a generation away, a few octogenarians could remember the presidency of Andrew Jackson, and what was then called the civilized world had already become the First Photographic Culture of the Disposable Epoch. The photograph was doing to nonverbal thought what movable type had done for verbal thought ... and just as unexpectedly.

At the present time, *photography* is a term that brackets a number of activities:

An INDUSTRY: the manufacture of sensitized goods, and the machinery for using them, is the sixth largest in the Occident—small change compared with ferrous metals or petroleum distillation but thoroughly competitive with chicken raising.

A CRAFT, empirical, superstitious, and copious as any in history, the unchallenged bailiwick of professional technicians, who spend long years and appalling amounts of material consolidating journeymanship, or occasional mastery, of a constellation of procedures second only to medicine in regard to sheer crabbed density.

A TECHNOLOGY as precise, delicate, and diverse as you please, whose masterpieces to date are the multilayered color materials. It produces, through frenzied diligence, rough-sawn log butts, not even timbers; and it is up to the customer to determine the lie of their grain.

A TOOL, versatile and misunderstood, from which depend dozens of hybrid technologies. At its worst, it enables us to fuse uncomprehended data inextricably with our errors in acquiring them.

A SCIENCE, comprehending such diverse bedfellows as protein chemists and quantum mechanics.

A flock, or pack, or if you will a *pride* of TRADES, ranging from weddings-and-babies to the astronomer's prime focus, via photojournalism, the X-ray room, the six-color offset plant.

A RACKET, comprising most of the rubbish that goes under such diverse names as fashion photography, commercial photography, executive portraiture, etc.

A HOBBY: the most dismal, most unnerving, most expensive imaginable. The present commentator recommends three-cushion billiards or long-distance telephony as gratifying alternatives.

A NATIONAL PASTIME: the snapshot, which is presumably more popular than writing personal letters.

Last of all, there is an ART of photography. It consumes the least material and funds, is the least noticeable. Few persons have ever seen a photographic print resulting from the intent to produce a work of art; a few more have seen gravure or halftone reproductions of such prints, which represent a mapping of photographs on the graphic arts' means, for cheapness' sake.

Nevertheless, it moves. Edward Weston left sixty thousand negatives from a lifetime in which nothing short of absolute accuracy was at stake every time he went to his ground glass.

Photography was indeed conceived in the belly of the Muse, but later plucked from her ashes and nurtured in the thigh of Commerce. The art of photography is in a healthier state than the art of painting because any man may make photographs, art or otherwise, to suit himself.

The artist in photography is responsible, at least to his own Demon, for the *whole* field of photographic activity, its merits *and* defects, its entire possible manifestation.

Halide crystals of the metal silver are sensitive to light, the more so if they are suspended in gelatin made from the cheeks and ears of Argentine beef cattle that have fed on mustard greens. Certain salts of iron, chromium, and the platinum metals, a few rigid polymer plastics, a number of tars, some gums, and zinc oxide in one crystalline state are sensitive to light. Some dyes are destroyed by light. All exhibit forms of what is called the photographic effect. All find, or have found, application within the total photographic field. *All* fall within the precincts of the photographer's responsibility.

Photographers are themselves, in a limited way, sensitive to light. It is their responsibility to extend the range and power of their sensibilities.

Gamma rays, X rays, and ultraviolet radiation affect all these sensitive materials. Visible light affects silver emulsions sensitized in various ways, as does infrared radiation within rather wide limits. Some other kinds of energy may be photographed second hand: I refer, for instance, to thin-film thermography and the schlieren techniques. To the photographer, *any* energy whose

force and distribution may be registered on sensitive material is *light*, de facto, and a matter of absolute concern.

The trace made by light on sensitive material is an *image*. A camera may have been involved, or it may not. The light may or may not have been focused by a lens. The image may very well not look at all like a cow, or like Simonetta Vespucci; but because it is a *photographic* image, it is subject to the same procedures. Most important: *it is accessible to our sensibilities on precisely the same basis*.

PHOTOGRAPHY IS FUNDAMENTALLY UNRELATED TO THE PLASTIC AND GRAPHIC ARTS. To see painter and photographer as siblings, simply because the work of both is apprehended via the eye, is as absurd as confusing the humane disciplines of cooking and dentistry because the results of both are appreciated by the mouth.

"Plastic" means soft, susceptible of being modeled, tractable. The plastic artist controls the soft stuff of his art by inchmeal procedures; his energy follows a path as wide as his brush, or precipitates in hollows made by the ball of his thumb.

Photographic materials are, in the thumbprint sense, intractable. Modification of a range of response, adjustment of a parameter, affects the whole photographic image. Photographic control is total control. The photographer's energy is distributed equally throughout the field of his lens and along the sequence, often attenuated, of his process.

Fujiyama and a photograph by W. Eugene Smith: both belong to a world that seems, to our unaided senses, a perfect continuum; as we come closer, the fine structure of photograph or mountain resolves at the same rate.

George Washington's face on the dollar bill is made up of dots and dashes. The engraver and printmaker map their intentions and pretexts on a traditional vocabulary and syntax independent of faces, just as the sentence "Jack threw the ball and I caught it" carries on its business in the arena of language, far removed from the actualities of an afternoon's game.

PHOTOGRAPHY IS THE PARAGON OF THE PLASTIC AND GRAPHIC ARTS. The visible arts are engaged in a common enterprise: the grasping and holding for contemplation of perceptual space (with its contents), both directly and through its attributes: mass, volume, color, gradation, tone. For the painter, the material itself is plastic; but the photographer's consistent procedures provide axes upon which to map and against which to measure the plasticity of space itself, and the supreme plasticity of our human perceptions.

The graphic artist catches space a drop at a time, but always in the same cup. The mesh of the silk screen is narrow as the needle's eye. But the whole space of the electromagnetic spectrum, by one ruse and another, forms its characteristic display on the light-sensitive surface.

We may yet come to see as much of Fate in the X-ray crystallograph of human hemoglobin as in Hokusai's breaking wave.

THE PHOTOGRAPHER CUTS DIRECT. Constantin Brancusi, in the teeth of the Renaissance habit, Rodin's habit, of modeling soft to cast hard, insisted that direct cutting was the true road to sculpture. Cut art has gained ground since Brancusi, the direct cutter, made such excellent photographs of his own work. Much sculpture is now cut in the mind before it occupies public space. At least one poet I know has cut dictions from the dictionary and proclaimed them his poems. Serial music is an attempt, surely, to put composition on a cutting rather than a modeling basis. The fundamental operation of filmmaking is called cutting.

The photographer's whole art may be seen as a cutting process. The frame is a fourfold cut in projective space. The selection of a contrast curve of a given slope and shape, and the mapping of bright and dark zones on that curve, are clearly operations that cut the intended from the possible. If I am making a color print and, at a certain point, decide that it must be lighter, more green, higher in contrast, then I am making a threefold cut in an unmodified field of fifty-five possibilities.

[ ]

All this may seem to you a dry way to look at a preeminently wet art. I offer neither apology nor defense: it has helped *me*, at least, to go a little way toward discovering the necessities of the art I practice. If others find that starved women or frozen orange juice do the same for them, they are welcome; I desire only sovereignty over my sheet of printing paper ... and myself.

Any art hopes to provide intimations of perfection; to speak with some cogency of our condition as human beings; to nourish our affections. Art can accomplish such ends only through accuracy, through exact definition, what Confucius referred to as "calling things by their right names." I can recommend no higher ambition to anyone.

H.F.
New York
November 1965

Unpublished manuscript, 1965

8

# Digressions on the Photographic Agony

This is the end of art. I am glad I have had my day.
—J. M. W. Turner, 1839/40

I begin with a fantastic case: the recent discovery of an imaginary relic.

A tanker returning to Arabia, running blind in a fog at night, collides with an uncharted object. The morning light reveals, instead of the expected crag, an enormous sphere floating in the sea, covered in barnacles and corrosion: it is nearly one thousand feet in diameter. Investigators at the scene determine that the thing is metallic and hollow, a colossal bubble, within which the most sensitive devices fail to detect any activity whatsoever.

A tabloid columnist hints that the menace to navigation may be a product of intelligence. His speculation prospers, and the sphere is towed ponderously up the Thames to the Isle of Dogs to be beached where, more than a century before, I. K. Brunel built and launched the *Great Eastern*. In a fury of sandblasters and jackhammers, workmen swarm over the riveted hulk. The first square yard scraped clean reveals, in indubitable relief, the single word: *Atlantis*. Screaming headlines proclaim the Lost Continent found.

A small contingent of heavily armed commandos escorting three specialists—a mountaineer, a photographer, and a psychiatrist—descends through a manhole found at the zenith of the sphere. Hours later, the whole party emerges unharmed. Dazed, grimy, their faces frozen in the hornswoggled look of men lost in a perfect ecstasy of boredom, they explain that they have found . . . nothing. Or rather, *less* than nothing: they have found only *photographs*.

Of a hundred decks within the structure, the bottom dozen or so are awash in bilge; the remainder are piled high with photographs of every sort and condition. Some are immaculately preserved, others eroded and dog-eared and faded nearly past recognition. They are boxed, or tipped into albums, or rolled into cylinders that crack at a touch, or strewn in loose stacks on shelves or underfoot. Some few bear signatures, or captions, or dates. Most are on paper, but a few images adhere to metal or glass; very occasionally, a picture adorns an otherwise undistinguished mug or platter. Interspersed throughout the mass are verbal oddments: manuscript pages, pamphlets, articles torn bodily from magazines, a few books. And that's all. The most pitiless search turns up nothing of value.

Once the find is established as utterly worthless, there remains the problem of disposal. Respectable institutions flatly refuse to have anything to do

with the dusty mess; finally, a few indigent archives of technological incunabula are persuaded to trundle away a portion of the stuff. The rest is given out to the middle class, as a sort of perverse ballast for their attics, or else it just disappears.

Time intercedes with its familiar mercies. A generation passes. And then an obscure doctoral candidate stumbles upon a hypothesis that electrifies the scholarly world. Kneeling in the gloom of a subcellar in Rochester, New York, leafing through a crate of Atlantis's leavings, the young man glimpses a pattern of coherence in its contents and leaps to an insight that startles him half out of his wits.

Reasoning from an imperfect analogy with the mysterious culture of porpoises and whales, who abandoned the encumbrance of physical objects when they returned to the sea and embraced instead a bodiless oral tradition of music, literature, and argumentation, our scholar postulates an Atlantic civilization that expended its entire energy in the making of photographs. During its palmiest days, the whole citizenry united in the execution of a great project, much as the medieval towns had built their cathedrals or the men of Ch'in their Great Wall. But the Supreme Artifact of Atlantis was vaster than either ... and incomparably more sophisticated.

Briefly described, it consisted in nothing less than the synthesis, through photographic representation, of an entire imaginary civilization, together with its every inhabitant, edifice, custom, utensil, animal. Great cities were built, in full scale and complete to the minutest detail, by generations of craftsmen who dedicated their skills to the perfection of verisimilitude: these cities existed only to be photographed. But the ambitions of Atlantis went far beyond this concern for *mise en scène*. Patient research establishes a deliberate fourfold complication in the plan.

In the first place, the imaginary culture is depicted as passing through time ... the total apparent span amounting to about eighty years. This necessitated endless further effort: walls had to be gradually dirtied and effaced; buildings demolished or burned, repaired, rebuilt. Illusory machines were gradually refined. Celebrities were made to age. A sprinkling of wars, natural disasters, and social upheavals were staged with the utmost care.

Secondly—and this was a masterstroke—the people of the fictitious culture itself were represented as the makers of the Artifact. It is remarkable that, in the whole work, no faintest trace of Atlantis proper is visible anywhere, nor has any Atlantic technician left a shred of evidence from which his own existence might be inferred. It is the creatures of illusion who are avid photographers.

An unexpected corollary provides that these illusions have, on the whole, no uniform concern for their photographs. Some few are treasured in museums, their delicacy guarded in unseen vaults; far more are treated as expendable and survive according to chance, there being no apparent qualitative difference between what is saved and what is discarded.

And finally, as a crowning touch, the Atlantic masters fabricated a critical tradition to accompany the images: a puzzling collection of writings that is gathered into the so-called Atlantic Codex. It is precisely the opposite of its subject: the photographs are everywhere copious, exact, assured; the Codex is unrelievedly sparse, vague, and defensive.

Following immediately upon the revelation in the Rochester basement, scholars undertake an Inventory (of uncertain completeness), which is succeeded by a somewhat shaky *Grundriss*. Monographs, synopses, and *Festschriften* proliferate; at this writing, in fact, they still continue to multiply.

Every researcher finds himself first hypnotized and then exasperated by the Artifact's most striking quality: through some freak of clairvoyance, the illusion that emerges from the endless photographs bears an uncanny resemblance to our own nineteenth century, or, more precisely, the years 1835 to 1917. By further miraculous coincidence, the Codex is written largely in what appears to be semiliterate dialects of English and French—although the text often lapses into nonsense.

What is the meaning of the Artifact? And why did the people of Atlantis go to such lengths in making it? Hope seems to be waning that the riddle will be solved. The answer rests, finally, upon the decipherment of two words, both hopelessly ambiguous, that appear on nearly every page of the Codex. Barring the chance discovery of a Rosetta Stone, we may never understand them, since they defy contextual analysis.

The first of these is *science*. And the second is *art*.

[ ]

Whoever once notices early photography soon finds it bulking large as a continent ... what in *this* world that continent recalls is hard to say. Viewed as a body of innocent document, only our reflex acquiescence to the plausibility of the photographic image contradicts what that same image so poignantly enforces: a sense of times and places altogether lost, and thus irretrievably alien—an Atlantis. Analytic criticism finds it an Antarctica: clearly marked boundaries mostly filled with the white that cartographers use to designate unexplored wilderness. Excavating for the remains of the responsible parties—the photographers themselves—yields us a gallery of hybrid monsters long extinct: half

astronomer, half painter, half mathematician, half showman, and so on . . . a kind of aesthetic Gondwanaland.

It is a continent bounded in time. Landfall occurs in August of 1835, at Lacock Abbey, Chippenham, where William Henry Fox Talbot made the first paper negative; the farther coast is reached in June 1907, aboard the liner *Kaiser Wilhelm II*, where Alfred Stieglitz made *The Steerage* . . . through shoals and reefs extended through the days of "291" and on into the First World War.[1]

Whatever sort of place early photography is, there have been repeated attempts to map it. Two such attempts are the occasion of this text. Both partake a little of the quaintness of old maps of America, which are as likely to show local fauna or minerals as they are major landmarks.

The first is called *Masterpiece* and is subtitled "Treasures from the Collection of The Royal Photographic Society." (This map shows us where the gold is.) The second is called '*From Today Painting Is Dead*,' subtitled "The Beginnings of Photography." (This map shows us where the animals are, along with a great deal else.) Both exhibitions appeared under the auspices of the Arts Council of Great Britain. Both proceed from very different assumptions, and it is these assumptions that I shall have to examine at some length.

*Masterpiece* allotted its small space with scrupulous fairness. Six or seven prints apiece represented thirteen photographers. Since they are masters (Q.E.D.), it matters what their names are. They are, in order of their dates of birth: David Octavius Hill, 1802–1870 (with Robert Adamson, 1821–1848); Oscar Gustav Rejlander, 1813–1875; Julia Margaret Cameron, 1815–1879; Roger Fenton, 1819–1869; Henry Peach Robinson, 1830–1901; Frank Meadow Sutcliffe, 1853–1941; Frederick Henry Evans, 1853–1943; Peter Henry Emerson, 1856–1936; Alfred Stieglitz, 1864–1946; Richard Polak, 1870–1956; Clarence White, 1871–1925; Edward Steichen, 1879–1973; Alvin Langdon Coburn, 1882–1966. (The history of photography is compressed: I am obliged to notice that fully half these names belong to men still alive during my own lifetime.)

The list reads like a roll of honor, openly courting the customary blasts and blesses of the reviewer. One is ritually grateful for Rejlander's *The Two Ways of Life*; one questions, ritually, the inclusion of Evans, whose oeuvre is small and specialized (cathedrals, plus Aubrey Beardsley), in a notably copious and variegated company; one ritually grits one's teeth at the ritual inclusion of Steichen, whose work certainly has been blessed sufficiently, by this time. One is ritually astonished at Polak's Old Dutch interiors, made between 1913 and 1917 (presumably in obeisance to Burlington House) in the very teeth of Vorticism, not to mention the Armory Show and God knows what else. But one is *not* invited to question the assumption implicit in the title of the show.

If the roster of contributors is unimpeachable, it nevertheless strongly suggests a *Little Golden Book of Photography*. We have all seen the same thing done to painting: the sort of kid stuff that begins with Raphael (adroitly side-stepping Giotto), gumshoes its way through Leonardo *and* Bosch *and* Velasquez *and* Gainsborough, omits Turner, coyly assents to Gauguin, captures Juan Gris *en passant*, and ends with a haughty nod at Klee. Our objections to such crude anthologies are twofold: they avoid "difficult" artists, certainly; and, disingenuously, they avoid "difficult" works by their chosen exemplars. Pedagogy alone protects such nonchoices, with arguments as unanswerable as Jehovah's.

And pedagogy is the tacit pretext for *Masterpiece*. The show was designed to tour England (where photography is a national pastime second only to gardening); in other words, it was packaged for the provinces ... ever so neatly packaged, in modular panels, behind wavy Plexiglas that drowned the images in ambient reflections. When I saw it (at Portsmouth) the provinces seemed to be receiving the package with customary thanks: five days after the scheduled opening, the panels were still propped at random around the walls.

I had been lured to England by a catalogue that implied (without ever promising it) great amplitude; the disappointing impression was instead one of paucity—and, moreover, of downright preciousness, as of ambrosia being dispensed a drop at a time. In the midst of gratitude for much of what *was* shown was a titillating sense of seeing "samples" rather than fully representative segments from thirteen bodies of work. In a word, photography, which has been the unacknowledged staple protein of Western visual sensibility for more than a century, was finally being served up in the eggshell teacups of Art. The very title, *Masterpiece*, had been lifted bodily from the assumptions surrounding painting.

Now I do not deny the existence of masterpieces, so long as that word is understood to connote seminal force rather than mere luster. But the term brings to mind an image of discrete monuments, arrayed with perpetual care in the cemetery of Culture, evaluated by a boom-or-bust criticism that would prefer every candidate to be named Gutzon Borglum, the sculptor of Mount Rushmore. What engrosses us more readily, I believe, is the patterned perceptual energy displayed in the work of a lifetime; for a photographer that work nearly always amounts to many hundreds of images, and may run much higher (Edward Weston left sixty thousand negatives). Comparatively slow and expensive procedures like painting *fragment* sensibility into the massive precipitates called masterpieces. Cheapness and rapidity of execution are fundamental conditions of photography; they facilitate *continuous* entrainment of sensibility, so that it is probably more precise to say that in photography there are

13

Masters who are likely at any instant to make an image that will teach, or move, or delight us.

But behind this flooding of the photographic continent to produce from its peaks an archipelago of masterpieces, there lies more than mere aesthetic confusion, or a good-natured attempt to put photographs over as High Art by pretending that they're paintings. An official of the Royal Photographic Society contributed a catalogue preface in which she points out (in the midst of a mouth-watering enumeration of the Society's holdings) that *rare, old* photographs (*aliter*, "masterpieces") are now worth *money*. In fact, the sum of sixty-eight thousand quid is mentioned, and deprecated as "too low a figure." The vexing old question of archival permanence is deftly tied to money (right where it belongs). It is intimated that before the collection may be made available to scholars, the Society must get more money. Such indeed, folks, are the facts of life. I question whether the front pages of an exhibition catalogue are the most appropriate place to have one's nose rubbed in them. The space might better have been given over to an introductory essay by Aaron Scharf, who wrote the very serviceable notes.

[ ]

Far from the opalescent hush of *Masterpiece*, another sort of show entirely, 'From Today Painting Is Dead,' closed at the Victoria and Albert Museum a few days before I arrived in London; I was privileged to see the photographs (but none of the apparatus that made up a substantial part of the more than nine hundred items exhibited) after they had been taken down for return to scores of public and private lenders in England and France. I must stress the word *privileged*, for I don't expect ever to see most of them again. It is unfortunate that some museum—*any* museum, no matter what kind—did not bring this exhibition to the United States, since we haven't the resources, on this side of the Atlantic, to put together anything even remotely like it. All that is left is a catalogue that should become a model of its kind.

'From Today Painting Is Dead' troubles itself not at all about the dignity of art (though its contributors do, often enough) but assumes instead that photography is a *technology*, designed for making whatever image the user pleases, without excessive fuss: the motive is presumed to differ from one photographer to the next.

The show details, at lucid length, the invention of the magical contraption of optics and chemistry, and then sails cheerfully into the ebullient free-for-all that photography has been since its first moments. And yet every image seems directly linked to every other, like a neuron in the racial memory that is the chief social function of photography.

The most astounding things, it seems, have been photographed: the great and famous, of course, by others who somehow became great and famous in the act of photographing them. But here too are anonymous images of the descendants of the *Bounty* mutineers; and archaeological excavations undertaken by Isaac Newton; and men on the barricades in the rue de Flandre, during the Paris Commune; and tiny I. K. Brunel in top hat, standing beside the surrealistically enormous anchor-chains of the *Great Eastern*; and . . . the list is endless.

Literally everything has been photographed . . . that is, *since* 1835. In case this observation seems drearily obvious, I would point out simply that we know (whether we want to or not) what Ulysses Grant looked like, and the Crystal Palace; the same thing cannot be said, with any conviction, for Aristotle, or the Alexandrian library. In the course of a few generations, the past has taken on much of the substantiality of the present, most of which we only experience indirectly—that is, through photographs—anyway.

The instantaneous mnemonic process works with perfect precision, no matter *who* presses the button. In every early discussion of photography as an art, it is that single fact that seems to cause the most trouble.

[ ]

Points define a periphery. Three points define a triangle; but it is well to remember that the same three points may also determine a unique circle. A collection of points, if sufficiently large, delimits the boundary of a continent—provided only that we know where each point stands in relation to every other one. Call each point a work of art: the task of criticism may be understood as the location of points in relation to others. Normally, that task is facilitated by the emergence of axes that gradually crystallize from a saturated solution in which the ingredients are expectedly tedescan—inventory, *Grundriss*, synopsis, monograph, *Festschrift*—and the solvent, long contemplation.

There is no substitute for critical tradition: a continuum of understanding, early commenced. Rémy de Gourmont surmised that the *Iliad* discovered today in the ruins of Herculaneum "would produce only some archaeological sensations" . . . illustrative of some vanished civilization. Precisely because William Blake's contemporaries did not know what to make of him, we do not know either, though critic after critic appeases our sense of obligation to his genius by reinventing him. . . . In the 1920's, on the other hand, *something* was immediately made of *Ulysses* and *The Waste Land*, and our comfort with both works after 50 years, including our ease at allowing for their age, seems derivable from the fact that they have never been ignored.[2]

Thus the critic Hugh Kenner, on a problem in contemporary literature. He might as well be writing about photography during the embryonic period under discussion; only the least shift in conjectural emphasis is required. For a kind of mute *Iliad* has been dug up, from the ruins of one and another collection, that fairly vibrates with the urge to produce more than "archaeological sensations." And neither *Masterpiece* nor *'From Today Painting Is Dead'* makes of the photographs anything more than their contemporaries did: on the one hand, photography is uncomfortably treated as an Art (that is, a branch of painting, seen strictly as an image-making craft); on the other, it is viewed as a Science (or technology—the two were scarcely dissociated during the extended *annus mirabilis* that begat photography), a way to ordered knowledge.

And around the 1920s, *something* was immediately made of work by the generation of Strand and Weston. In fact, they were themselves finally able to make something coherent of it, to found a "continuum of understanding." The question of whether photography was a Science had evaporated by then, since photographic technology had already assimilated the hard sciences: astronomer, radiologist, high-energy physicist, physical chemist, molecular biologist were (and remain, in the operational sense) photographers; handfuls of hybrid technologies had sprung up as well. But the hoary question remained to bedevil the men of "291": is photography an art?

Polemically, they annihilated it. Paul Strand exhorted young photographers to "forget about art" (recommending "honesty" as a more useful *mantram*); Weston flatly refused to be called an artist in print. The posture solidified, and it is characteristic of most photographers today that they couldn't care less.

But the question dogged the photographer's every step for six or seven decades, splintering into a one-sided catechism: is photography an art? if the answer is "yes," what sort of art is it? is it like painting? how is it unlike painting? if the answer is "no," then what *is* it anyway? and so on, *ad nauseam*. An agonized confusion came of the effort to cover every imaginable bet; the effort to resolve that confusion has engendered transvaluations that have yet to run their full course in the visual arts (although, admittedly, still photography itself has not occupied the main arena for a long time).

For the photographer willing to adopt a fixed perceptual distance from his pretext (to become a "stylist"), Art offered a workable recourse and rationale: and the century gestated a phalanx of memorable stylists. Of these, Julia Margaret Cameron can serve as the perfect type; sitters recall in their diaries Procrustean ordeals in the back garden of an obsessive, dumpy woman exhaling hypo. The results were images of oneiric force: but one cannot help asking

whether the eyes of Herschel, Tennyson, and Darwin could all have been haunted in precisely the same way.

But for more restless spirits, the pattern became intricate to the point of disjunction or of self-interference. The portraitist Nadar began as a newspaper caricaturist: his portraits hint, rather than betray, such beginnings. And then he ascended in a hot-air balloon and became the first aerial photographer of Paris. And *then* he made a blandly ironic self-portrait, posed in a balloon's basket, inside his studio, against a painted backdrop derived from one of his own aerial photographs.

Roger Fenton's reputation is based upon his photographs of the Crimean War: a subset within his body of work that is strictly comparable to that of the corporate fiction we call "Matthew Brady." In Fenton's time the painterly categories were fairly rigid. Ontologically handcuffed as he was to the prior existence of a "subject," he should have waited for the next war. But no; a catalogue note tells us: "[his] activities extended to . . . a striking set of informal photographs of the Royal family, with landscape and architectural views, still lifes, city and river views and exotic 'orientalist' costume pieces."

In 1857, O. G. Rejlander composed (the verb is deliberate) *The Two Ways of Life*, a monumentally campy and insipid moral tableau, "inspired" by a currently influential treatise on painting. Amid murmurs of indecency, the work was certified as Art when Prince Albert bought a print. What is remarkable about it is that it was synthesized from more than thirty separate negatives: a dimensionless stasis fabricated from an armload of negatives shot during long months. The same invention generated a series of "composite photographs" that prefigure images we associate, eidetically, with the 1920s and 1930s. In 1860, Rejlander publicly repudiated art, but continued his experiments on the sly. What did he do for a living all this time? Seemingly at the other end of the spectrum, he made candid, pathetic views of street life. His photographs of children interested Charles Darwin, who used them in preference to drawings to illustrate (with the required accuracy) his book *The Expression of the Emotions in Man and Animals* (1872).

At thirty years of age, Peter Henry Emerson abandoned a medical career for photography. Three years later, in 1889, he published *Naturalistic Photography [for Students of the Art]*, a defense of photography as an art, basing his arguments firmly (and rather grotesquely) upon Helmholtz's *Treatise on Physiological Optics*, a book that also interested painters of Emerson's generation, just as Goethe's treatise on optics had polarized Turner's thought nearly a century earlier. The book aroused controversy, in the midst of which, only one year later (following upon an interview with "a famous painter"), he published *The*

*Death of Naturalistic Photography* and proceeded to buy up and destroy copies of the earlier work, denouncing photography as an art. In 1899, Emerson published an "expurgated and expanded" third edition of *Naturalistic Photography*. And during the whole time, his style suffered little change beyond a gradual refinement.

Clearly, we are in the presence of minds experiencing a serious confusion. The speed and ease and economy of their process traps that confusion, as if in amber ... without explicating it.

Consider the preposterous case of a contemporary painter who invents, within a period of five years, the mature styles of, say, Willem de Kooning, Frank Stella, and James Rosenquist ... and then denounces painting. We should be obliged to consider such a person a little crazy, or else a naive opportunist; alternately, we might think of him as a critic.

But the latter evaluation would necessarily rest upon our reflex tendency to examine axioms rather than corollaries, to seek the energy of thought among the deliberately held assumptions of a work ... seen *alongside* that work's denumerable traits, in a kind of stereoscopy.

And the nineteenth century was not noticeably given to examining its assumptions. In most disciplines, the more pressing game of consolidating holdings was afoot. They scarcely seemed to imagine that there *is* such a thing as an assumption: Locke and Newton had bequeathed them Laws, instead. Hence our perpetual temptation to suspect that they couldn't think their way out of a paper bag.

And because they couldn't, it quite often happens that we can't either.

[ ]

'*From Today Painting Is Dead,*' we are told, in a moment of bravado dating to the early 1840s. The remark (It is apocryphal. Of course.) is attributed to one Paul Delaroche, himself a reformed painter, who ran a prosperous school and studio in Paris.

Behind the assertion lies an explicit assumption about painting that painters themselves had already begun to question: that the inescapable condition of painting was representation, spatial and tactile illusion—"imitation," in the narrowest possible sense. And the invention of photography made it forcibly obvious that representation was a task to which painting had never been very well suited. For those with *a need to make images*, painting had simply sufficed, as a "technology" ... there being none other available.

William Henry Fox Talbot, who invented the negative-positive process that has become synonymous with photography, is the first person in whom we find, fully dissociated from the painter's legendary object-making and

surface-marking needs, *the need to make images*. Talbot was an amateur scientist. His first published paper was called "On the properties of a certain curve derived from the equilateral hyperbola": a curve is the *image* of an equation. He writes of tracing images on the camera obscura:

> This led me to reflect on the inimitable beauty of the pictures of nature's painting which the glass lens of the Camera throws upon the paper in its focus ... creatures of a moment, and destined as rapidly to fade away ... how charming it would be if it were possible to cause these natural images to imprint themselves durably, and remain fixed upon the paper.[3]

Nature itself is seen as a succession of fugitive *images* ("paintings!"); Talbot explicitly withdraws the artist's hand from the making process (though it is hidden there anyway, since opticians *assume* Renaissance perspective when they grind their lenses). The images are to fix themselves, durably outside time. The notion of the apparently self-generated work, sufficient in its own immanence and only nominally connected to an invisible or anonymous maker, has haunted art ever since.

But along with the obvious representational assumptions about painting, early photographers unconsciously adopted others less obvious, and it is here that they confounded themselves.

Painting "assumes" architecture: walls, floors, ceilings. The illusionist painting itself may be seen as a window or doorway. And painting in the Occident, like architecture, is "built" from the ground up and a brick or gesture at a time. Indeed the metaphor of "building," of composition, has underpinned our choice of what is *respectable* in art for a long time. But of course there have always been works of art that are simply "made," emerging from nowhere in particular, through the mediumship of the artist, like Pallas from the brow of Zeus, in seeming defiance of ordinary gestation.

"Built" art and "made" art have never inhabited watertight compartments; rather, each has glanced wistfully over its shoulder at the advantages of the other ... has, on occasion, worn the mask of the other. But those who build have tended to scorn those who make, for the air of naked *utterance* in which the made work so often wraps itself. Gertrude Stein, the most obvious aspect of whose work is its appearance of having been built up from small pieces, quotes herself scolding a protégé: "Hemmingway, remarks are not literature."

Early photographers accepted the axiom that True Art must be *built*, and mimed it faithfully. But their image-making process, instantaneous and indivisible, did not lend itself to analysis into successive painterly gestures, so photographers adopted a different strategy: they made "arrangements,"

substituting persons and things for the painter's brushstrokes and washes. And the results were, as often as not, ludicrous. A hilarious case in point is the oldest surviving specimen of photographic pornography, a "mythological subject" dating from 1842. At his obscenity trial, the photographer proposed to justify the picture as art by pointing out the careful inclusion of Doric columns and a potted palm.

By the mid-1850s, Rejlander and H. P. Robinson had made this process of construction, from literal image-pieces seamlessly joined, absolutely synonymous with photographic Art: for they had not merely pressed the button ... demonstrably, they had performed skilled labor, had Done Something. Where most photographs seemed to exist by suspicionable fiat, they had manufactured an Object. And object-making is a second assumption, brought over from painting, that has confounded photography.

Paintings are traditionally built by a process we might call *dubitative*—in other words, the painter fiddles around with the picture till it looks right. At its least coherent, the painting process recalls Anton Webern's description of modulation in tonal music: "I go out into the hall to hammer in a nail. On my way there I decide that I'd rather go out. I act on impulse, get into a tram, come to a railroad station, go on travelling, and finally end up—in America! That's modulation!"[4] Such objects respond well to a critical approach that derives from Cartesian doubt: criticism has typically made discoveries about painting, representational or otherwise, by pretending that it does not know what it is looking at.

But photographs do not respond at all gratefully to this sort of examination: their illusions are too carnally potent to remain submerged for long in matter. Considered as objects, photographic images are quite unprepossessing—flat, anonymous sheets of paper, sensually unrewarding aside from their modulation of light—and often completely insubstantial: the projected photograph (which subsumes the whole of the cinema) simply has no physical existence at all.

Nor does the survival of the photographic work of art seem to depend very firmly upon its casual materiality: photographs withstand the grossest attrition, remaining plausible illusions so long as the least shred of an image lasts. (*The Last Supper*, or the papyrus fragments of Sappho, are objects of veneration from which we *infer* works of art; but they ceased to be a painting and some poems a long time ago.) Attempts on the part of photographers themselves to treat the image as an object have ultimately degenerated into an insistent shibboleth called "printed quality," the sole pursuit of which virtually assures slow death in that same Sahara where every art ends up that identifies itself with its own

mechanics. The photographic process is *normative*. Perfect adequacy is always good enough.

I seem to be saying of photographers that they toil not, and neither do they spin. But in fact the photographer does make something; and what that is is easy enough to say, if I may be permitted a homely simile. A butcher, using only a knife, reduces a raw carcass to edible meat. He does not *make* the meat, of course, because that was always in the carcass; he makes "cuts" (dimensionless entities) that section flesh and separate it from bone.

The photographic act is a complex "cut" in space and time, dimensionless, in itself, as the intersections and figures in Euclid's *Elements* . . . and, in the mind, precisely as real.

Certain photographs, through the justice of their cutting, even seem to share a privileged identity with their subjects. Every visitor to Mount Rushmore, the Grand Canyon, the Pyramids, the Parthenon, hastens to bring home precisely the image he has already seen, hundreds of times—in photographs; he thereby makes his own clichés that were at one time vistas newly decreed, imaginary lines laid out in projective space by the first photographers who saw them, acts of making more durable than stone, and nearer to geomancy than bricklaying.

Through such acts, endlessly renewed, we have learned to recognize all the appearances of the world; through such acts, from its very beginnings, photography reasserts art's most ancient and permanent function: the didactic.

### Notes

1. The reference is to Alfred Stieglitz's groundbreaking Gallery 291 (originally called the Little Galleries of the Photo-Secession), which opened in New York City in 1905 at 291 Fifth Avenue and closed in 1917. The gallery introduced work by contemporary American photographers as well as that of many significant Modernist painters and sculptors. (B.J.)
2. Hugh Kenner, *The Pound Era* (Berkeley: University of California Press, 1971).
3. William Henry Fox Talbot, *The Pencil of Nature* (London: Longman, Brown, Green, and Longmans, 1844; reprint, New York: Da Capo Press, 1969).
4. Anton Webern, *The Path to the New Music*, ed. Willi Reich, trans. Leo Black (Bryn Mawr, Penn.: T. Presser, 1963; reprint, London: Universal Edition, 1975). The remark is from the lecture dated February 4, 1933.

*Artforum* 11, no. 3 (November 1972): 43–51. Reprinted in *Circles of Confusion* (Rochester, N.Y.: Visual Studies Workshop Press, 1983), pp. 177–191.

# Eadweard Muybridge: Fragments of a Tesseract

It is the artist who is truthful and it is photography which lies,
for in reality time does not stop.
—Auguste Rodin, 1911

Here is an irksome paradox of public consciousness: to be accorded the status of a legend is to be whittled down to a microscopic point, a nonentity at the intersection of a random handful of idiosyncrasies, tidbits of gossip, shreds of advertising copy.

To the nonspecialist, René Descartes was the philosopher of a single motto (just three little words ... and in Latin, no less). He didn't like to get out of bed in the morning (rhymes with Belacqua, Oblomov, Beckett). His taste in eggs was, to put it mildly, revolting. That Descartes presides over a truly exquisite adventure of the mind, the marriage of geometry with algebra, is mere impedimenta for scholars to attend to.

Beatrix Potter, a savante of mycology whose theories of symbiosis have recently found vindication, is known to some of us, at least, as the authoress of *Peter Rabbit*, illustrated; ignorant of her circumstances, we miss the satire in the little books.

The Reverend C. L. Dodgson, a crucial figure in the development of mathematical logic, inventor of a device for recording dreams, photographic portraitist of Victorian celebrities and young girls, is survived in public memory by his literary persona, Lewis Carroll.

And of the extraordinary man who chose to call himself Eadweard Muybridge, we learn in school only that he was hired as a technician, by a California nabob, to settle a colossal wager over whether a galloping horse, at any instant in its stride, has all four feet off the ground.

The story is almost certainly a fabrication: Leland Stanford was keen enough on horseflesh and took a vast interest in the "scientific training" of trotters, but he was neither essentially frivolous nor a gambler. Nor could the single incident explain the ensuing decade of personal friendship between Stanford and Muybridge, during which Stanford gave his full support to projects having precious little to do with horses, opening to the photographer the engineering facilities of the Central Pacific Railroad and even providing legal defense when Muybridge stood trial for his life.

Eadweard Muybridge was forty-two years old when the association began, with the first "inconclusive" photographs of the champion trotter Occident, so

we can hardly assume that he sprang, fully armed, from the brow of his personal Maecenas. How, then, are we to account for his extending the commission into a lifework? The eleven folio volumes of *Animal Locomotion*, comprising many hundreds of photographic sequences, show men, women, children, domestic and wild animals, and birds—and even amputees and persons suffering from nervous disorders—engaged in hundreds of different activities: they constitute a unique monument that is clearly the work of a man obsessed. And his zoopraxiscope, a machine for resynthesizing the illusion of motion from the analytic images provided by his batteries of sequential still cameras, established Muybridge as the inventor of the photographic cinema.

Four generations of artists, of the most diverse persuasions, have acknowledged the fascination of his work, and it is obvious that many have learned from it, if only at second or third hand: that alone justifies our curiosity about the genesis of his sensibility.[1]

[ ]

Enter Edward James Muggeridge, on April 9, 1830. He is supposed to have received a good education. Local tradition held Kingston on Thames to have been an ancient seat of Saxon royalty. In 1850, the Coronation Stone (I'm told that half the towns in England boast one) was set up in the Market Square, upon a hexagonal plinth engraved with the names of the kings crowned there. Two of the six were Eadweard the Elder (900 A.D.) and Eadweard the Martyr (975 A.D.). Muggeridge, an East Anglian version of Mod-Rydd, an Old Norse name with magical associations, was less pliable. But a *muy* had once been a dry measure of grain; the elder Muggeridge, who died when the boy was thirteen, had been a corn chandler. Exit then, at about the age of twenty, Eadweard Muybridge, young Romantic, already considered an eccentric. (Thousands of miles away, and twenty-five years later, a man who had been his intimate friend was to tell a jury, in support of a plea of insanity: "I have known Muybridge to sit up all night reading, generally some classical work.")

His destination was California, a simply fabulous land, like Szechuan or the West of England, where gold, shipping, and the whalefish had kept some men rich enough long enough to make them hungry for culture. He set up shop as a genial bookseller in San Francisco, got to know the bohemian crowd, and prospered by outfitting the local gentry with entire libraries.

In 1860 he returned to England, convalescent from a serious stagecoach accident, for a visit that lasted nearly seven years; while he was there he learned the cumbersome, delicate craft of the collodion wet plate, and discovered his vocation as a photographer. When he returned to California it was to work under

the pseudonym "Helios," affecting the broad-brimmed hat and velvet cape of continental poets and painters and calling himself a "photographic artist."

During the next five years he systematically photographed the Far West, producing some two thousand images in several series catalogued by Bradley & Rulofson, a photographic gallery that distributed his work; these series included views of San Francisco, lighthouses of the Pacific Coast, Vancouver Island, Alaska (as director of photographic surveys for the United States government), Farallone Island, railroads, Geyser Springs, Woodward's Gardens, Yosemite, Mariposa Grove. "Helios' Flying Studio" offered not only albums of contact prints made from very large plates but also innumerable slides for the stereopticon that had already become indispensable in every American household.

In fact, it does not seem that Muybridge ever quite stopped making conventional still photographs with the large view camera; material in the Kingston Library includes images made in places as diverse as Alberta, Louisiana and Georgia, Maine, Chicago (at the World's Columbian Exhibition of 1893, where he operated his Zoopraxographical Hall among the sideshows on the Midway), and the beaches at Atlantic City (New York holiday crowds romping in the surf, dressed as if for an Arctic blizzard); many were made long after he had completed and published his work in Philadelphia, in the midst of repeated American and European tours with his zoopraxiscope, lecturing on "The Science of Animal Locomotion in its Relation to Design in Art."

Sometime in 1870 or 1871 Muybridge married Flora Shallcross Stone, a woman much younger than himself, who had been (gasps from the jury) divorced. The work at Leland Stanford's Palo Alto farm began in the spring of 1872; the earliest instantaneous photographs of horses, exposed with a high-speed shutter Muybridge built from a cigar box, have been lost, along with those made the following year under improved conditions. The work was at first only sporadically pursued, with crude equipment. Muybridge pronounced himself dissatisfied with the results, which nonetheless attracted a good deal of attention as curiosities and augmented his considerable international reputation. In 1873 he photographed the progress of the Modoc Indian War, making images of considerable intimacy on both sides of the conflict, apparently acting as a free agent, much as Roger Fenton had done in the Crimea. When he returned home, Flora Muybridge presented him with a baby boy that she had conceived in his absence by one Harry Larkyns, ne'er-do-well. On October 17, 1874, Muybridge traveled by boat and wagon to Calistoga, where Larkyns was staying, and killed his wife's lover with a single pistol shot. After a sensational

trial, the jury found the homicide justifiable. During four months of imprisonment, Muybridge's hair and beard had turned entirely white.

He left immediately for a yearlong photographic expedition in Central America. While he was gone, Flora sued him for divorce on the grounds of extreme cruelty (in support of which she deposed only that Muybridge had looked through their bedroom window, seen her sleeping, and then left; the case was dismissed, and we are left to imagine the ferocity of the man's stare). Shortly thereafter, she died. Returning to California, Muybridge issued an immense portfolio of photographs from Panama, Guatemala, and Mexico, including a study of the cultivation of coffee.

1877 brought his last major work in still photography proper: an immense 360-degree panorama of San Francisco, in thirteen panels, taken from the roof of the Mark Hopkins house on Nob Hill. He had already resumed his studies of locomotion, at Palo Alto, and this time it was in absolute earnest. He was forty-seven years old.

[ ]

Had Muybridge left us none of his celebrated sequences, his place as an innovative master in the history of photographic art would nevertheless be assured. The huge body of work from his years of greatest creative expansion, the decade 1867–77, sustains from the very outset, with almost voluptuous intensity, a markedly personal vision. Among early photographers of the American West, there is scarcely anyone (with the possible exception of Timothy O'Sullivan) to put alongside him: he is the Grand Progenitor of a West Coast school of view-camera photography that has included Edward Weston, Imogen Cunningham, Wynn Bullock, and others in our own time. He was, moreover, an indefatigable stereoscopist; his stereo images, committing him by definition to the most thoroughgoing photographic illusionism this side of full color, function as a curious palimpsest to the mature sequences, from which very many of the illusionist strategies available to photography have been rigorously evacuated.

In his advertising cards for Pacific Rolling Mills and for Bradley & Rulofson (neither are isolated instances) he seems to anticipate much later developments elsewhere in the visual arts. "Studies" of trees and clouds (the latter emphatically including the sun) predate by fifty and eighty years, respectively, the tree photographs of Atget and Alfred Stieglitz's late work, the Equivalents.

If any other photographer in the nineteenth century foreshadows the twentieth as massively, that man must be Oscar Gustav Rejlander (1813–1875); and it is curious that Muybridge's method for making the serial photographs was a practical elaboration of a theoretical scheme published by Rejlander.[2]

One wonders whether Muybridge ever met the man who began with *The Two Ways of Life* and ended as Charles Darwin's illustrator, making *The Artist's Dream* along the way.

But what interests me most in all this work of Muybridge's first career is something that seems to anticipate, almost subliminally, the sequences of *Animal Locomotion* ... a preoccupation that is restless, never quite consistently present, seldom sharply focused: I refer to Muybridge's apparent absorption in problems that have to do with what we call *time*.

[  ]

Philosophical questions about the nature of time, originating in the ascendancy of Newtonian mechanics, variously energized and vexed much of nineteenth-century thought. Einstein's relativistic mechanics eventually established that time is simply a function of the observer's frame of reference; twentieth-century cinema discovered, quite early on, that temporality is precisely as plastic as the filmic substance itself. It is remarkable that cinema depends from a philosophical fiction that we have from the paradoxes of Zeno, and that informs the infinitesimal calculus of Newton: namely, that it is possible to view the indivisible flow of time as if it were composed of an infinite succession of discrete and perfectly static instants.

But, during the long interval that concerns us, the question brought forth a profusion of views, each of which met its scientific apology and its specific implementation in art. The heathen opinion had been that time was some sort of personifiable substance, *Chronos*, a corrosive universal solvent into which all things were dumped at the moment of their creation and then slowly sank, suffering gradual attrition. From some such simile, speculations proliferated. Time was duration, or was rate of change, or it was the sum of all conceivable rates. It was seen, always, as linear and isotropic. Time, it was said, passed ... which looks, nowadays, like an excessively euphemistic way of saying that we pass.

Art historians invented a variation, "influence," in which the fluid metaphor becomes a hydraulic system for transmitting energy: the frog Virgil, jumping into the old pond, makes waves whose widening rings eventually joggle the cork Tennyson. The flow is still seen as unidirectional. T. S. Eliot's crucial insight, that the temporal system of a tradition permits, and even requires, movement of energy in all directions, could not have taken place within the metaphoric continuum of "classical" temporality.

The underlying assumption was that time "exists," just as fictions like ether and phlogiston were once supposed to exist, on a basis of parity with the paper on which these words are printed. Whereas a conjectural summary of our

own view might read: *Time* is our name for an irreducible condition of our perception of phenomena; therefore, statements that would separate the notion of time from some object of direct perception are meaningless.

Much of the early history of still photography may be looked upon as the struggle of the art to purge itself of temporality. The normative still photograph, the snapshot, purports to be an ideal, infinitely thin, wholly static cross section through a four-dimensional solid, or tesseract, of unimaginable intricacy. W. H. Fox Talbot, inventor of photography and also a mathematician who was certainly acquainted with the incremental model of time, writes of his longing to "capture ... creatures of a single instant": the creatures in question are landscape images projected on the ground glass of his camera obscura. He would escape time and fix his instantaneous pictures, immutable and incorruptible, outside the influence of entropy, the destroyer. But it was not long before still photographers began toying with the temporal: the first known narrative sequence (illustrating the Lord's Prayer) dates to 1841, and that opened the field to the likes of *Little Red Riding Hood* (high seriousness in four panels, by Henry Peach Robinson, originator of new sins). That even the single image, in epitomizing an entire narrative, may thereby imply a temporality was knowledge learned from the still photograph, of which the Surrealists were to make much.

The work of Étienne-Jules Marey, a scientist who switched from graphic to photographic notations of animal movement under Muybridge's direct tutelage, summarizes the point of disjunction between the still photograph and cinema; his studies consist of serial exposures made on a single plate. The photograph could no longer contain the contradictory pressures to affirm time and to deny it. It split sharply into an illusionistic cinema of incessant motion and a static photographic art that remained frozen solid for decades. So complete and immediate was the separation that by 1917 the photographer Alvin Langdon Coburn (an ex-painter, who is rumored to have collaborated on a Vorticist film, long since lost, with Ezra Pound) could speculate in print—and in ignorance— on the "interesting patterns" that might be produced if one were but to do what Marey had in fact done, mountainously, thirty-odd years before.

On first inspection, Muybridge's early work seems to affirm the antitemporality of the still photograph as he had inherited it. He may have meant to do so; an imperfection of his material ran counter to such intentions. The collodion plate was slow, exposures long, the image of anything moving blurred. Yet Muybridge, in some of his earliest landscape work, seems positively to seek, of all things, waterfalls, long exposures of which produce images of a strange, ghostly substance that is in fact the *tesseract* of water: what is to be seen is not water itself but the virtual volume it occupies during the whole time-interval

of the exposure. It is certain that Muybridge was not the first photographer to make such pictures; my point is that he seems to have been the first to accept the "error" and then, systematically, to cherish it.

In the photographs concerned with Point Bonita Lighthouse there is a kind of randomization, or reshuffling, of the sequence of approach to the lighthouse, seen from several different viewpoints in space, which destroys the linearity of an implied molecule of narrative time, reducing the experience to a jagged simultaneity that was to be more fully explored in film montage fifty years later.

Generically allied to this series is the tactic adopted in an advertising photograph made for Bradley & Rulofson (and their center-ring attraction, Muybridge himself). The resemblance to later collage and accumulation pieces long familiar to us is striking (the year is 1873), but it is, I think, superficial. Because the elements of the image are themselves illusionistic fragments of photographs, of varying implied depth, the space is propelled backward and forward on an inchmeal basis as we contemplate the contents of the frame; only the edges of the individual elements and the graphic lines of type, which make us conscious of seeing marks on a surface, tend to compress the image into the shallow inferential space proper to Cubism. But the arrangement of photographs within the image is deliberate, and what we do infer is the sequence in which the pieces of this still life were laid down: in compounding a paradoxical illusionist space, Muybridge has also generated a "shallow" inferential temporality.

Muybridge continued this same investigation in at least one other work: the title page for the Central American album issued in 1875, the largest number of images from which remain breathlessly immobile. But in one subset, of a hunting party in Panama (the photographs are in Kingston), Muybridge transgresses against one of the great commandments of view-camera photography, permitting what was at that time the most violent smearing and blurring of moving figures (again, he acknowledged the images and assumed responsibility for them by allowing them to be publicly distributed); the jungle background against which they are seen is rendered with canonical sharpness.

Finally, in the great San Francisco panorama of 1877 he condenses an entire rotation of the seeing eye around the horizon (an action that must take place in time) into a simultaneity that is at once completely plausible and perfectly impossible; it is as if a work of sculpture were to be seen turned inside out, by some prodigy of topology.

[ ]

Muybridge returned, then, to Palo Alto and his sequences. The new attempts were immediately successful, and the work continued, for nearly two decades, in a delirium of inexorable logic and with little modification, synthesis following analysis; the results, at least in excerpt, are known to everyone who associates anything at all with the name of Eadweard Muybridge.

Having once consciously fastened upon time as his grand subject, Muybridge quickly emptied his images as nearly as he could of everything else. His animals, athletes, and subverted painters' models are nameless and mostly naked, performing their banalities, purged of drama if not of occasional horseplay, before a uniform grid of Cartesian coordinates—a kind of universal "frame of reference," ostensibly intended as an aid in reconciling the successive images with chronometry—that also destroys all sense of scale (the figures could be pagan constellations in the sky) and utterly obliterates the tactile particularity that is one of the photograph's paramount traits, thereby annihilating any possible feeling of place. About all that is left, in each case, is an archetypal fragment of living action, potentially subject to the incessant reiteration that is one of the most familiar and intolerable features of our dreams.

Beyond that, there is a little that Muybridge, looking from close up, could not have seen. I am always aware, looking at the sequences, that the bodies of Muybridge's actors are somehow strangely unlike our own, as if slightly obsolescent: the men seem to be heavy-duty models; and all but the stoutest women are round-hipped, with small high breasts that remind me of Cranach's *Judgment of Paris*. Their postures, gestures, gaits are not quite ours either, and seem to mean something a little different.[3] The children, birds, dogs haven't changed much. The horse is notable chiefly for appearing with what at first seems uncalled-for frequency—until one recalls that there was once a time (geologically remote in feeling from our own) when the horse represented very much more than the rather mannered recreation we know today.

And it was over Muybridge's photographs of the horse, of all things, that a great storm of controversy broke in his own time. Painters, it seems, were absorbed in rendering, with perfect verisimilitude . . . the horse! Emotions ran high, and so forth, and so on. I have neither space nor inclination to pursue the argument here. Paul Valéry, in the midst of a discussion of Degas, gets to the heart of what was serious in the matter; I reproduce his discussion as definitive:

Muybridge's photographs laid bare all the mistakes that sculptors and painters had made in their renderings of the various postures of the horse.

They showed how inventive the eye is, or rather how much the sight elaborates on the data it gives us as the positive and impersonal result of observation. Between the state of vision as mere *patches of color* and as *things* or *objects*, a whole series of mysterious operations takes place, reducing to order as best it can the incoherence of raw perceptions, resolving contradictions, bringing to bear judgments formed since early infancy, imposing continuity, connection, and the systems of change which we group under the labels of *space*, *time*, *matter*, and *movement*. This was why the horse was imagined to move in the way the eye seemed to see it; and it might be that, if these old-style representations were examined with sufficient subtlety, the *law* of unconscious falsification might be discovered by which it seemed possible to picture the positions of a bird in flight, or a horse galloping, as if they could be studied at leisure; but these interpolated pauses are imaginary. Only *probable* positions could be assigned to movement so rapid, and it might be worthwhile to try to define, by means of documentary comparisons, this kind of *creative* seeing by which the understanding filled the gaps in sense perception.[4]

[ ]

A question remains to haunt, and I will offer a bare intuition of my own by way of attempted answer.

Quite simply, what occasioned Muybridge's obsession? What need drove him beyond a reasonable limit of dozens or even hundreds of sequences to make them by thousands? For the "demonstration," if such a thing was intended, must have been quite adequate by the time he left California. Instead, with Thomas Eakins's help, he went to Pennsylvania and pursued it into encyclopedic enormity.

I will simply invert Rodin's remark (he was, in fact, speaking of Muybridge's work) to read thus: "It is the photograph which is truthful, and the artist who lies, for in reality time *does* stop." Time seems, sometimes, to stop, to be suspended in tableaux disjunct from change and flux. Most human beings experience, at one time or another, moments of intense passion during which perception seems vividly arrested: erotic rapture, or the extremes of rage and terror come to mind. Eadweard Muybridge may be certified as having experienced at least one such moment of extraordinary passion. I refer, of course, to the act of committing murder. I submit that that brief and banal action, outside time, was the theme upon which he was forced to devise variations in such numbers that he finally exhausted, for himself, its significance. To bring back to equilibrium the energy generated in that instant required the work of half a lifetime. So that we might add, in our imagination, just one more sequence to Muybridge's multitude, and call it: *Man raising a pistol and firing*.

[ ]

When the work was done, Muybridge retired to Kingston on Thames. With-drawing from all contention, he serenely took up the British national pastime of gardening. The old man imported sago palms and a ginkgo tree from California and planted them in his backyard. I am told that they still thrive. When he died, in 1904, he was constructing a little pond, in the shape of the Great Lakes of North America.

I am tempted to call it a perfect life.

[ ]

The steps a man takes, from the day of his birth to the day of his death,
trace an inconceivable figure in time. The Divine Intelligence
perceives that figure at once, as man's intelligence perceives a triangle.
That figure, perhaps, has its determined function in the economy
of the universe.
—Jorge Luis Borges, "The Mirror of the Enigmas"

**Notes**

1. In its original publication in *Artforum*, in 1973, the essay contained at this point brief remarks on a then-recent exhibition at Stanford University of Muybridge's work. Those paragraphs, excised in 1983 for the revised version of the essay in *Circles of Confusion*, are as follow (B.J.):

> And now, finally, we are given, if not answers, then at least rich substance for contemplation. Anita Mozley, curator of photography at the Stanford University Museum of Art, who has spent nearly twenty years in the pursuit and study of Muybridge's work, prepared the exhibition *Eadweard Muybridge: The Stanford Years, 1872–1882*, together with its accompanying catalogue.
>
> The catalogue is one of the most thorough (and seductive) I have ever seen. If the sheer quantity and energy of work done are astonishing, the magnitude of the aesthetic terrain Muybridge had staked out, decades before commencing his magnum opus in Philadelphia, is more so; page after page tempts hyperbole. Mozley has contributed an introduction and extensive notes on the photographs, and there is also an extended biographical essay by Robert Bartlett Haas; a brief monograph by Françoise Forster-Hahn details the commerce among Muybridge, the painter Meissonier, and the physiologist Marey. An attempt has been made to approximate the tonality of the original prints (nineteenth-century photographs are properly spoken of as monochrome, within a range of sumptuous reds, browns, sepias; they were almost never black and white). And the book is otherwise chock full of scholarly apparatus, patent diagrams, technical and historical documents.
>
> The exhibition proper nevertheless includes some surprises. To begin with, it is precisely the right size, neither inundating nor settling for mere titillation. A number of the protocine-matic devices (phenakistiscope, zoetrope, praxinoscope ... "Philosophical Toys," they were called) that were kept in the Stanford home, presumably for the edification of Leland, Jr., are there. All are in good working order and may be played with by the spectator, along with a

precise working replica of the zoopraxiscope that became part of Muybridge's bequest to the Public Library at Kingston on Thames, where he was born and died; this latter machine, an elegant hand-cranked projector, demonstrates forcefully how tenuous the illusion of the earliest cinema must have been: the ghost of an illusion, so to speak, demanding much of [what Valéry called] the "kind of *creative* seeing by which the understanding filled the gaps in sense perception."

Finally, I must remark on the insight that arranged for essential images, otherwise unavailable, to be reprinted from the original negatives and permitted copy prints to be shown wherever an album might not be dismembered for exhibition: these re-executions are, in every case, immaculate. A photographic print is not, after all, a unique object but only a member of a potentially infinite class of "related" interpretations of a negative.

2. *British Journal Photographic Almanac* (London, 1872–1874): 115.
3. It seems quite appropriate that Ray Birdwhistell should be pursuing his studies of kinesics at the same university where, ninety years before, Muybridge had stared the vocabulary of body language into such voluminous existence, whether or not he understood anything of its syntax.
4. Paul Valéry, *Degas, Manet, Morisot*, trans. David Paul, Bollingen Series XLV, vol. 12, *The Collected Works of Paul Valéry* (Princeton, N.J.: Princeton University Press, 1960), p. 41.

*Artforum* 11, no. 7 (March 1973): 43–52. Reprinted in *Circles of Confusion* (Rochester, N.Y.: Visual Studies Workshop Press, 1983), pp. 69–80.

# Incisions in History / Segments of Eternity

**Time cuts down All,**
**Both Great and Small.**
—*The Bay State Primer*, c. 1800

**Time is not, Time is the evil, beloved**
—Ezra Pound, Canto LXXIV

Here are some hand-tinted snapshots of myself talking with a tall young woman at an imaginary party:

Time out of mind I find myself seized, at one and the same moment, by a fit of obstreperousness and a female historian. Reasoning, more from circumstance than tradition, that all men, by their nature, desire to know, I desire of her to know just what history is, anyhow.

"Near as I can make out," she allows, "it's just one goddamned thing after another."

I put on a reasonable face. "Come now," I venture, "what about cause and effect?"

"Take your choice," she says.

"Come again?" I choke.

"Cause *or* effect: take your choice. Right now, during the Historical Period, causes seem to be inbreeding among themselves, engendering more of their own kind. Later on, perhaps, when life has fled matter, there may remain some residual effects. But don't worry, it won't happen in our lifetime."

"Absence of evidence is not evidence of absence," I quote, clutching vaguely at the sort of aphorism by which astronomy once managed to ally itself with biology.

"Don't be scientific," she replies tartly.

I paw and snort. "Change!" I bellow. "Flux!"

She sniffs. "We historians are divided among ourselves," she recites primly. "Some reason that history began with a Big Bang ... the appearance of mankind ... and interpolate occasional Lesser Bangs thereafter. This school proceeds from solipsism to academic territorialism with no intervening period of maturity. Certain others imagine history to be an oscillatory machine that maintains itself in a Steady State: they leave themselves open to political cynicism, on the one hand, and aesthetic inertia on the other."

"But what do you believe?" I ask.

She stiffens. "Listen," she replies, "the trouble with the Universe, seen from a rigorously historical point of view, is just this: no one was there to photograph the beginning of it—and presumably, at the end, no one will bother. After all, history, like pornography, couldn't really begin until photography was invented. Before that, every account of events is merely somebody's panting prose fiction. Have you ever read Herodotus' description of a crocodile? It is the *Fanny Hill* of zoology. Nothing is presented to the senses, and so nothing can enter the mind that wasn't there in the first place."

She pauses to inhale deeply, and continues: "But assuming a beginning and an end to the Universe, all evidence indicates that the whole contraption is winding down like the spring in a cheap movie camera."

"Now I hope you won't think me vulgar," she confides, "but it seems to me that nowadays both the ash heap and the file of photographs are constantly expanding. I suspect, even, that there is some secret principle of occult balance, of internal agreement, between the two masses of stuff. The photographs are splendidly organized according to date, location, author, and subject; the ash heap is perfectly degenerate. Both are mute, and refuse to illuminate each other. Rather, pictures and rubbish seem to conspire toward mutual maintenance; they even increase, in spite of every human effort. Just between you and me, it won't be long before they gobble up everything else."

"Isn't there anything we can do?" I gasp.

"We might try praying," she suggests.

"Good Lord, are you kidding?" I gag.

"No," she muses, "that particular prayer doesn't sound quite appropriate; it's much too general. I tend to favor The Modernist's Prayer."

"And what might that be?" I beg to know.

"We'll begin with something traditional," she says, "like a Pater Noster, or Now I Lay Me ..., and then add to it the words: And please, God, can't you do something about Entropy?"

That was not the end of our *tableau vivant* ... but the rest of the album seems to be empty. Wait: here is a picture of my former wife and a friend, walking with a dog in the snow ... but you wouldn't be interested in that.[1]

Please remember that these snapshots are, in the first place, only in your mind. After all, I may have told you no more than I want you to know. I may even have forgotten some of the important parts. On the other hand, perhaps I've forgotten all of them.

[ ]

Let us pretend that the compound activity of making and experiencing photographs may be examined simply as a form of human behavior. Beginning, during the presidential incumbency of Andrew Jackson, as a novel aberration, it had assumed the proportions of a pandemic when our grandfathers were infants. By now, we recognize that the photographic syndrome is congenital in our culture. While it is most often to be encountered in its chronic phase, acute cases are by no means rare; and occasional individuals exhibit the disorder in a degree that we are obliged to regard as terminal.

So we are entitled to ask, with the neo-Darwinists, what there may be in all this photographic behavior that is "adaptive"; that is, in what way does it promote, actively or passively, the survival of the organism and of the species. And, given that it *does* perform such a function, we may also ask how its ways of so doing differ from those of the venerable arts of painting, or of literature.

How, indeed, does any work of art help us to survive?

I admit that my own convictions in the matter are neither complex nor original. I believe that we make art—and every deliberate human activity known to me seems to aspire, however obliquely, to the estate of art—as a defense against the humiliating, insistent pathos of our one utter certainty: that we are going to die. Of all animals, we seem alone in our stewardship of this intolerable secret—and alone, as well, in our propensity for making art. William Butler Yeats is succinct:

> Nor dread nor hope attend
> A dying animal;
> A man awaits his end
> Dreading and hoping all;
> Many times he died,
> Many times rose again.
> A great man in his pride
> Confronting murderous men
> Casts derision upon
> Supersession of breath;
> He knows death to the bone—
> Man has created death.

The ways we have found out to live in equipoise with this "creation" of ours are, I suspect, encoded upon our very genetic spiral, so that we have no choice in the matter: we do not define our art (although, consciousness interposing the gift

of fallibility, we believe we do) but rather it somehow defines us, as hexagonal labyrinths of wax both circumscribe and detail the honeybee.

Toward that cessation of consciousness that is to be our death, as toward a vanishing point in convergent rectilinear space, an instrument within the mind, which we might call conjecture, maintains incessant attention. Along the same axis, the instrument of memory addresses itself to a complementary vanishing point: the incipience of consciousness that first stirred, as some reason, at the instant of our conception. The confused plane of the Absolute Present, where we live, or have just seemed to live, brings to irreconcilable focus these two divergent images of our experience of time.

The impossibility of resolving, simultaneously, two incompatible systems of perspective upon a single plane may tolerate or favor our perennial uneasiness at living in the moment, as if we were forever being disposed from the few certitudes of our own knowledge.

Between birth and death, leaving aside the automatic transactions of metabolism, most animals engage in only one pursuit: the more or less intricate and constant exercise of sexuality . . . which I understand to be a remarkably elegant and economical method for assuring the physical species of virtual immortality by offering immediate rewards to the mortal participants.

Between consciousness' uncertain beginning and its equally certain end, man superimposes upon animal sexuality the pursuit of art. Seen as a recent adaptive mutation aimed at assuring mental continuity, through historic time, to a species whose individual experiences constitute a testament to the notion of disjunction, art making appears, thus far, to be moderately successful . . . amazingly economical (as compared with its perverse imitations, like experimental science, or its unsuccessful vulgarizations, like religion) . . . although it is of vacillating elegance, and offers uncertain rewards to its participants.

This is not the time for an extended investigation of the ways in which art, or the creation of immaterial mind, and sexuality, or the recreation of carnal substance, interresonate, seeming always about to fuse in a perception that remains, inseparably, immanent in the moment of experience itself. But it is inevitable that every impassioned act or discourse must, somehow, become a part of that investigation, sharing with it an expectation of imminent revelation which is itself both the ubiquitous center and the invisible periphery of all our thought.

For whatever wisdom language holds, I would point out that our verb *to create* and our technical term for the strictly human part of the brain, *cerebrum*, both derive from the Latin verb *creo*, which means: "I beget." And Aristotle, who excused himself some time ago, says of the gonads and the brain that they

bear a functional resemblance to each other, in that both are capable of exteriorizing a form without reference to anything else. He goes on to call *spermatikotatos*, "most spermatic," the optic chiasm, which is that intersection within the physical mind where our two eyes compare notes before writing home to their respective parents, the twin hemispheres of the brain.

[ ]

The trouble with practically everything, seen from a rigorously inquisitive point of view, is just this: no one was there at the beginning to take notes on the proceedings. Cro-Magnon man, for all his obvious charm and cunning, seems not to have had the forethought to bring with him into the world a camera, a tape recorder, or even (delight of scholars!) a Xerox machine. Of the arts, only photography, along with its prodigious sibling, the cinema, has appeared during historic time; and, viewing them from outside, we seem curiously unwilling to trust the discoveries made, in all the arts, on the "inside," where their substance and implications are recreated, *ab ovo*, in every really new work.

For whatever wisdom language holds, it is common knowledge among philologists that languages spring, as it were, full-blown into life and proceed, as time passes, from complex to simple. The most primitive languages we know are, quite uniformly, the most complicated grammatically. The utopian artifices once put forth as "universal languages" are a case in point: the oddity called Volapük, a predecessor of Dr. Zamenhof's Esperanto, boasted more cases, tenses, moods than Sanskrit (itself a priestly invention based on Vedic). Sir Thomas Urquhart, Rabelais's first English translator, is said to have brought forth a "tongue" of even daffier proportions.

So we might reasonably expect to find, in the very first scrawls and babblings of an infant art, a map of its later typical attitudes and preoccupations, and even a concise definition of the art's specific given task, somewhat as we discover, densely folded into a few chromosomes, all the instructions (could we but decipher them) for building a rhinoceros.

In his prefatory essay to the first photographically illustrated book, *The Pencil of Nature* (1844)—the title itself is a stew of significations—William Henry Fox Talbot speaks of a vision that had come to him nine years earlier, at Lake Como, where he was trying to make landscape drawings with the aid of a camera lucida:

> This led me to reflect on the inimitable beauty of the pictures of nature's painting which the glass lens of the Camera throws upon the paper in its focus ... how charming it would be if it were possible to cause these natural images to imprint themselves durably, and remain fixed upon the paper.

He goes on to call his paradoxical "natural" images "creatures of a moment, and destined as soon to fade away."

The accent is familiar enough; if we substitute the elevated diction of Madison Avenue for Talbot's emaciated echo of Keats, we get something like the opening benediction that accompanies every new Kodak Brownie:

> Your camera is a magic black box for capturing precious moments that you will treasure for many years to come ... so always take your pictures carefully, and they will come out nice.

The latter text is imaginary, and disastrously typical; it shares with Talbot's account concerns that make up, as I shall contend, the (largely unconscious) preoccupations of still photography to the present day.

There is nothing in the world less "natural" than an image ... with the possible exception of silence: both are supreme artifices. To the undifferentiated consciousness, all the sensible world must be continuously, and infinitely, replete. The act of distinguishing an image, that is, of partitioning a "figure" from its proper "ground," is, if we are to believe Jean Piaget, one of the first heroic feats of emergent consciousness. Another, and contiguous, appalling accomplishment of developing sentience is the discovery that such figures are, or at least may be, continuously stable ... that they may persist, independently of our noticing them, even when we shut our eyes, or shift our gaze, or displace our perceptions in space and time. Upon the substrate of those two insights the infant mind erects a structure that is as intricate as the world, because, for the purposes of the animal within, it *is* the world.

The principles by which the sages and wizards of geomancy decree sites and vistas (and we all do that), or the reasons why the Japanese venerate a seemingly random tree, refuse to rise to the surface of the mind for inspection precisely because they are part of its endoskeleton, to which language has access only when it is, as it were, cut to the bone, and another mind, which is never precisely either present or absent, may speak through the wound as through an accidental mouth.

Disregarding minor statistical variations, the landscape at Lake Como does not change either, any more than it is handily dissected into images. What, then, is Talbot, who has got to use words when he speaks to us, talking about? Let us examine his circumstances for a moment.

First of all, he is far from his home at Lacock Abbey, in a delectable and strange place where vicissitude may prevent his ever returning. And then he is immersed (incompetently, or he wouldn't be tracing his picture on an optical cheating device) in the fashionable activity of pretending

to draw—indispensable, for Englishmen in Italy, as the piano in Flaubert's receiving parlor—when, with no warning at all, he sees, for its own qualities and for the first time, the very thing that has been before him all along, and that has been his secret fascination: he realizes, in one piercing instant, that the "image" that he had sought to make is already there. But more: the emergence of that image somehow sufficiently mimes that extraordinary moment when, time out of mind, the unspeakable, primal Image became the first gift Talbot's mind gave itself. And then: after the merest interruption, thready and insistent as the drone of the brain's theta wave, faintly overheard in an anechoic chamber, comes the accustomed reminder of mortality.

But for one instant, attenuated to the limits of his energy, Talbot has escaped Time, the Evil. For an ecstatic moment, time is not. We may presume that Lake Como, along with everything else, persists in dropping "natural images," like ripe fruit, into the lapses of the beholder. So that it was not the banal landscape Talbot thought he saw but the radiant sight of his own insight that transfixed the artist in a realization too rude for language: that the "creature of a moment, and destined as soon to fade away," was himself.

He had been to a far place, after all, and wonders had befallen him, and he wanted to bring home some intelligible account ... some disposition of sensible matter ... that might remain as a static sign of what had been a fugitive motion. In a life doomed, by the structure of language, as the lives of most Occidentals are, to supine acceptance of history as a linear narrative, that moment on the lake must have seemed a boulder in a rapids, which diminishes neither the force of a stream nor its volume but rather, by virtue of the local turbulence it generates, serves to measure and demonstrate both.

I imagine, then, that Talbot believed he was somehow augmenting history by implanting, into brief incisions, new values as stable, as endlessly recurrent and irrational, as the decimal *pi*. Instead, his discovery ... and its consequences ... seem to establish clearly that there are two different sorts of perceptual time. I propose to call one of them historic, and the other ecstatic.

But there is something that I cannot account for in any way. In 1835, Wordsworth's *dicta* must have hung pungent in the air. Perhaps Talbot was protected from literature by his inherited wealth, or by his other interests (he was a mathematician of sorts, and a Fellow of the Royal Society), as he was certainly protected from Beethoven or Büchner by that widest of oceans, the English Channel ... but we find here, in its purest form, the novel impulse to generate a work of art in the very heat of the moment of conception, and to hell with recollecting emotion, of all things, in tranquility.

Finally, rather chillingly, he suggests that it would be "charming." Indeed. Sometimes it's difficult to stay cheerful about the human mind. Anyway, with nascent Romanticism constrained to a vocabulary of that sort, it's no wonder the poets went abroad.

Your camera is a magic black box for capturing precious moments that you will cherish for many years to come . . .

We shall have to return, presently, to those precious moments.

[ ]

Historic time consists only of a past, whose chief claim to superiority is that we're not part of it. Science proposes to lay hold upon the future by an inversion of perspective, an adequation of vanishing points, invidiously treating the future as if it were a department of the past . . . and the deception works for as long as the systems of memory and conjecture remain cramped into relative congruence. But the intellect (which is, as Descartes reminds us, one of the passions) is a perfectly elastic medium, which can only accumulate stress, in disequilibrium, for a limited time before rebounding with a force that has repeatedly shattered cosmologies. We find ourselves battered by the passing shock waves of several such explosions at the present moment.

Historic time is the time of mechanistic ritual, of routine, automatic as metabolism. It is composed of sequential, artificial, isometric modules that are related to one another, in language, by the connective phrase: "and then." This sort of connection, like that between links in a chain, is capable of transmitting energy only under the tension of implied causality. The sentence "Jack threw the ball and I caught it" does not establish a trajectory but only marks its limits, in unyielding postures carved by Praxiteles.

In short, historic time retains its credibility only so long as we each abstain from testing its assertions against our personal experience. I can believe in my own quotidian history, so long as it passes unchallenged, because the ordained tale of hours and days offers me a vague comfort; if the clock ticks, and convinces me that time is passing, then something is happening, and I am reassured in the midst of my sad suspicion that most of life is remarkably unmemorable. But the prosecutor's opening question to the accused, "Where were you on the night of September 17th?" is one that, ordinarily, only a murderer could answer with certainty.

And when it comes to your history, I confess to utter skepticism. I can recall vivid encounters, and even whole ecstatic afternoons, that I've spent in your company, because they make up the warp of my own days . . . but as I watched you through my window, crossing into the park and vanishing among the beech trees, you ceased to breathe, you disintegrated . . . hastily

reconstructing yourself, from a random shower of atoms, only seconds before we met, as design would have it, in the Museum, in front of Delvaux's painting *The Echo*. The same thing happened to me.

Nevertheless, this fiction of historic time, which we have just refuted, at once brightens us and wears us away, like the centuries of kisses bestowed upon the Fisherman's Ring. It even contaminates a present that we are left to embody, since, like Yeats's Truth, we may never know it.

"I am told," Borges writes in his essay "A New Refutation of Time," that "the present, the 'specious present' of the psychologists, lasts between several seconds and a tiny fraction of a second; that is how long the history of the universe lasts. . . . The universe, the sum of all events, is a collection that is no less ideal than that of all the horses Shakespeare dreamed of between 1592 and 1594."

Even James Joyce, that most ardent of newsreel devotees, said that history was a nightmare from which he was trying to awake. It is obvious that historic time, though quite well suited to the needs of matter, is a terrain too sparse to afford the mind any lasting amusement or sustenance. So we must clear out, stand aside, and enter, if we can, the alternate and authentic temporality of ecstasy. I assume that everybody knows what that is.

[ ]

Questions concerning temporality have haunted photographers of every generation since Talbot; oddly enough—for they have always been a notoriously unlettered bunch—a number of photographers have even written on the matter. Not surprisingly, most of the writing is pseudo-scientific mystification, synesthetic gobbledygook, or plain evasion. In a 1911 note, all of three pages long, called "The Relation of Time to Art,"[2] the painter-photographer Alvin Langdon Coburn achieves something of a tour de force by mentioning his subject not at all, and then closes with an intriguing submerged metaphor that aborts just as it shows promise of being as fancy as any of my own.

Well, I may be getting nowhere also; what is important is the redundance of an urgent pressure to say something, as if to obviate any possible misunderstanding concerning the aesthetic thrust of the new art . . . as if to repudiate, in the spasmodic single gesture of a revulsion only half-sensed, the wavering concerns of painting, purifying and reclaiming for itself those perfected illusions, spatial and tactile, that alone could arrest consciousness and suspend its objects of contemplation, outside the ravages of entropy.

We must remember that the most serious painter of Talbot's day was J. M. W. Turner, in whose centerless late works painting methodically abolishes perspective both geometric and atmospheric and, turning upon its own materi-

ality with something like a vengeance, abandons all but the most tenuous claims to illusion.

On the other hand, photographers inherited, at the very outset, and hardly unawares, some centuries of hard-won knowledge of just the sort that painters were losing interest in—much like what the Renaissance, North and South, had learned of perspective, *chiaroscuro*, and surface rendering was simply incorporated by the lens grinders into their optics—so that photographers were able to plunge straightaway into the maze of time. Only color was lacking, and even that problem yielded, theoretically at least, in little more than a generation: the earliest color photograph dates to 1865. Which is not to say, at all, that painting has ever ceased to bedevil photography: no man who refuses to clean his house can remain long untroubled by vermin.

From the beginning, then, we shall find photographers employing a variety of strategies for confronting, and then eluding, historic time; and all of them are, as we shall see, operational in the present day. But before examining these strategies, I think, after all, that I should offer an example of consciousness at work in ecstatic time.

[ ]

Under certain conditions we feel the measured passage of historic time to be altered, or to stop entirely. In the extremes of terror or rage, in erotic rapture and its analogues, in suicidal despair, in sleep, and under the influence of certain drugs, consciousness seems to enter a separate temporal domain, one of whose chief characteristics is its apparent imperviousness to language.

As I sit writing this text, on one of the days of the only life I shall live, a fine April afternoon is passing outside my window. Like a novelist, or a painter, I have walled myself into a room, away from the passage of time. Photography, uniquely among the visual arts, allows us to have our cake and eat it too: if I were making images today, I could be outside, within that day, converting its appearances to the requirements of ecstasy. Instead, I am enmeshed in these very words. But I can't find words to tell you what it is like to be writing them.

Saints, the berserk and the possessed, speak in tongues (there is even something called *erotolalia*), and sleeptalkers speak our own language, but with impatient terseness and an alien inflection; so it is seldom that we have extended verbal reports from the domain of ecstatic time. From any point outside the general locus of art, I can recall only one.

Several years ago, a man by the astonishing name of Breedlove became, for the second time in his life, the holder of the world land-speed record. He did this thing at Bonneville Salt Flats, in Utah, in a rocket-powered car called the Spirit of America. For two runs over a marked course one mile long, with

a five-mile running start, this Breedlove averaged a little over 600 miles per hour … slightly faster than the legally established speed of a transoceanic passenger jet. Had the ride been uneventful, we may expect that he would have had nothing at all to say about it; the efficient driving of an automobile at any speed neither requires nor permits much in the way of conscious deliberation.

But, as it turned out, something did happen. At the end of his second run, at a speed of about 620 miles per hour, as he was attempting to slow down, a brake mechanism exploded, and in the space of about one-and-one-half miles both drogue chutes failed to operate, and the car went entirely out of control, sheared off a number of handy telephone poles, topped a small rise, turned upside down, flew through the air, and landed in a salt pond. Incredibly, Breedlove was unhurt.

He was interviewed immediately after the wreck. I have heard the tape. It lasts an hour and thirty-five minutes, during which time Breedlove delivers a connected account of what he thought and did during a period of some 8.7 seconds. His narrative amounts to about 9,500 words, which is about as long as this text will be when I have finished writing, and it has taken me all my life.

In the course of the interview Breedlove everywhere gives evidence of condensing, of curtailing; not wishing to bore anyone, he is doing his polite best to make a long story short. Compared to the historic interval he refers to, his ecstatic utterance represents, according to my calculation, a temporal expansion in the ratio of some 655 to 1. Proust, Joyce, Beckett seem occasionally to achieve such explicatory plenitude.

But perhaps Breedlove's most amazing remark came before all that. Rescuers, expecting to find him mangled as by a tiger, discovered him instead intact, prone at the pool's edge, still half in the water. He looked up and said to them, very distinctly: "For my next act, I'll set myself on fire."

[ ]

Art is the human disposition of sensible or intelligible matter for an aesthetic end.
Question: Can a photograph be a work of art?
Answer: A photograph is a disposition of sensible matter and may be so disposed
for an aesthetic end but it is not a human disposition of sensible matter.
Therefore it is not a work of art.
—James Joyce, *Paris Notebook*, March 28, 1903

I excerpt. We may judge the level of Joyce's perennial exasperation by an earlier question in his catechism: "Are children, excrements and lice works of art?" Perhaps I do no more than reveal the extent of my own exasperation in remarking that the camera is an instrument neither less nor more "human" than the

typewriter upon which I now dispose intelligible matter to no aesthetic end: Joyce, sensibly, preferred to ruin his eyes proofreading his own handwritten works of art.

But if human deliberation is a criterion for art, then Talbot failed his dream . . . and perhaps, in that failure, became an artist after all. The reason is simple enough, and enough, in another time, to drive anyone gifted with a shaman's vision to hack in fury at everything around him.

The photographic machine, simply put, is a device for accumulating energy. Talbot's machine was inefficient, his lenses narrow as eyes slitted against antarctic glare, his materials unreceptive to light. It took long minutes, rather than instants, to make his images. His means had betrayed him; Omar Khayyám's bird had flown even as he had it in hand. And he succumbed politely, tormented as he was, to that heartbreak known to every artist since Plato: the slow fabrication of an equivalent for his singular vision.

His household servants must have been models of patience, for he trained them to pose, motionless as children playing the game called Statues. We may imagine that he prayed, in a rapture of chagrin, for windless days. Where he had imagined a process of angelic velocity, he was constrained to work in a manner almost vegetative: his process resembled nothing so much as photo-synthesis. Remarkably, his very first image was of the mullioned windows in his scholar's study . . . which he escaped, through that other window, the camera, into a tense world of *tableaux vivants* whose inhabitants, wavering ever so slightly under false arrest, seemed perpetually about to break into a smile.

[ ]

Question: If a man hacking in fury at a block of wood make there an image of a cow (say) has he made a work of art?
Answer: The image of a cow made by a man hacking in fury at a block of wood is a human disposition of sensible matter but it is not a human disposition of sensible matter for an aesthetic end. Therefore, it is not a work of art.
—James Joyce, *Paris Notebook*, March 28, 1903

As I write this text I am, if you will, carving in that pathless matrix of all tropes, language . . . somewhat as a photographer, against or along the grain, follows the edge of his vision, in whatever mood he must, through the penetrable body of a world that is, or has just seemed to be, alive in every inquisition. Pretending, then, that what I now make is a fiction, I shall dissect from the dictionary the word *window* and write a window into my scholar's study, and escape through it into the sunshine of an abrupt summary.

That other art that uses the camera, the cinema, of which we may not, for the moment, speak, has discerned and enunciated for itself a task: namely, the founding of an art that is to be fully and radically isomorphic with the kineses and stases—in short, with the dynamic "structure" (if one may still dare to use that word)—of consciousness. Film art has, perhaps, been able to predicate for itself an ambition so appalling precisely because it is "about" consciousness.

On the other hand, if still photography has seemed, since its beginnings, vastly pregnant with the imminence of a revelation that never quite transpires, and if it has never coherently defined a task for itself, we might make free to infer that it mimes, as does cinema, its own condition: we might imagine, in a word, that photography is "about" precisely those recognitions, formations, percipiences, suspensions, persistences, hesitations within the mind that precede, if they do not utterly foreshadow, that discovery and *peripeteia* and springing-into-motion and inspiration that is articulate consciousness.

Now since I have professed that photography, from its first moment, never quite consciously addressed itself to that intuition we once called "time," I shall offer a brief inventory of the ways in which I think that happened.

First of all: photographers attempted a direct, frontal assault on narrative time. Photographs were jammed into sequences that told stories. Henry Peach Robinson's *Little Red Riding Hood*, in four installments, tells us as much more than we want to know as any of them. The poor dog, clotheslined, sandbagged, and trussed into the role of Grandma, speaks as well for the plight of the image under the lash of the word as any dog I know.

Secondly: with an improvement of means, and because the notion that had begun to struggle into the world in Talbot's initiating vision continued to press for admission, still photographers sought for that memorialization of the emergence of a figure from its ground that we still celebrate. The grand protagonist of this impulse was, and remains, Edward Weston.

Weston began, alongside his only contemporaries, Paul Strand and Alfred Stieglitz, with an interest in that mysterious antique thing, composition. Decades passing, as Strand repudiated the erotic possibilities of photography for its indexical functions, and Stieglitz came to posit the whole field of the photograph as an energetic equivalent for emergent steady states of consciousness whose only names were his own images, Weston, more and more often, simply centered his figure, outside time and within the nominal spatial ground of the photographic artifact, celebrating, with unexcelled carnality, the differentiation of the moment of perception from all those moments of impercipience during

which the resting brain processes only two billion binary bits of information per second.

Thirdly: a doctrine arose, purporting to exonerate photography as an art, that raised the specter of what I might call the Quintessential Sample. Henri Cartier-Bresson speaks of decisive moments, in tones that seem to suggest that the making of art is a process of tasteful selection. I have been privileged to see one of Cartier-Bresson's contact sheets: thirty-six images of a dying horse were as alike as intelligence could make them, and I am constrained to believe that the "decisive moment," if such a thing occurred, happened when the photographer decided which of the three dozen pictures he would print and publish.

Finally: the strategy of mapping time back upon space led a legion of explorers to astonishments hiding in the reaches of historic temporality. Eakins, Muybridge, Coburn, Marey, Morgan, Edgerton—a restless crew of refugees from painting, physiology, and physics—have found lurking, in the compressed or expanded reaches of clock-time, entities of superlative beauty and terror: along with much that is pedestrian or equestrian, Edgerton's *Swirls and Eddies of a Tennis Stroke*, for instance, offers photographic proof that William Blake wasn't as crazy as he thought he was, and instructs us with its suggestion that artists may be least inventive where they are most visionary. These photographers, voyageurs in the continent of time, bring back records that recall the precisions of the diarist Scott, dying in Antarctica, or W. H. Hudson's curious Argentine dissolution of the membrane that had separated himself from his pretexts.

[ ]

Does our mind sometimes leave our body?

If written language is the shelter Recollection found, after her expulsion from the Garden of the Mind … and if Charles Babbage and the computer boys have banished Calculation from the human brain and locked her up in a brass machine … then I suppose a trap can be sprung for Memory as well. Is Memory more than the elastic set of all photographs, or is she less?

Before Alexander Graham Bell extracted my voice from my body, I used to bump into my friends once in a while. Now I only talk with them on the telephone. How grateful should I feel for that?

Returning, once, to a palace of my childhood, I found its rooms small and shabby, admitting a caustic sunshine through dusty panes that looked out on shimmering prospects of nothing in particular. If I had only had a photograph of that house, I should have remembered it as it really was, whatever way that is, and then I would never have needed to see it again. If I ever return, I'll remember to bring along my camera.

I seem to remember ... it was before I took note of such things ... the picture of a former American president on the cover of the *New York Times Magazine*. Photojournalists had just then begun to use motorized still cameras that make serial exposures, in the manner of a semiautomatic rifle, at the rate of three per second. The *Times*, instead of extracting from the roll of film a single epiphany, simply reproduced all thirty-six consecutive images.

About two-thirds of them exhibited the president's face as a familiar icon of benignant, immobile blandness. But the remaining dozen, more or less uniformly distributed, were pictures of a face that was not quite the same nor yet entirely different, whose expression suggested, during instants newly visible, the extremes of terror and of rage, suicidal despair, the forgetfulness of sleep, or the vacuity of utter confusion. It seems to me, almost, that another mind grasped and manipulated the features, reaching out with a kind of berserk certitude through temporal fissures whose durations could be measured in thousandths of a second.

Ray Birdwhistell, the pioneer explorer in what has come to be known, vulgarly, as "body language," offers us, in his remarkable essay "The Age of a Baby," a scene from nature that suggests similar dark speculations.[3]

Investigating the kinesics of a household that had already brought forth two schizophrenic children, Birdwhistell filmed the mother in the banal and repetitive act of diapering the third child, a baby girl a few months old. Careful frame-by-frame analysis of the cinema strip revealed that, during one moment in the process, the mother appeared to give the child simultaneous and contradictory signals, putting her in a confusing double-bind.

Birdwhistell states that rigorous examination of such films requires, on the average, about one hundred hours per running second of real time. He also points out that, within a family, many thousands of such brief, wordless exchanges take place every day.

If there is a monster in hiding here, it has cunningly concealed itself within time, emerging, in Birdwhistell's film, on four frames ... that is, for only one-sixth of a second.

If it is dragons we seek, or if it is angels, then we might reconsider our desperate searches through space and hunt them, with our cameras, where they seem to live: in the reaches of temporality.

During two decades after Edward Weston's death, photographic art remained unhappily frozen in the stasis he had bequeathed it. A thaw, in the past few years, has unblocked a flow of energy in two distinct directions. On the one hand, we

find a strong resurgence of the manipulated pictorialism that Stieglitz and his generation, for the polemical needs of their own work, ruthlessly purged.

And on the other hand, a number of photographers have taken to making sequences of images that seem to derive from the history of still photography at large, taking their formal bearings from the journalist's "picture-story" and the ubiquitous illustrated instruction manual. Resembling a motionless cinema of indeterminate duration, they seem to rest upon the implicit (and extremely novel) assumption that the photographic cinema has never existed.

Two photographers have been especially persistent in finding out what revelations inhere in the sequential mode: they are Duane Michals and Leslie Krims. Both began with, and continue to make as well, single images that implicate us in mysterious or terrific narratives. Both have proliferated iconographies that test the limits of obsession. Otherwise, they resemble one another not at all. Most recently, Michals's sequences have tended toward a paradoxical circularity that subverts the linearity of historic time into static, eternal loops and labyrinths. Krims's work, which appeals as often to inventory as to succession, achieves similar precarious satisfactions in that region where image and word perpetually contaminate each other, in a Mexican standoff between poisonous wit and jocular compassion.

[ ]

When it comes to practically everything, we seem to be of two minds.

The discovery that we have, each of us, two independent hemispheric brains may yet prove an aesthetic Krakatoa, the dust of which will never settle in our lifetime. For they seem, these two, caught in the act of going their separate ways, and at once forced into a cooperation that mixes uncertain affection with expedience.

We might imagine them as a couple of seasoned, quarrelsome lovers, whose affinities for one another are never quite comprehensible even to their closest friends. They inhabit one of those untidy households where the doors are never quite precisely open, nor yet completely closed.

We might imagine her as a bustling, quiet Hungarian whose last name sounds oddly like a French pun ... and him as a punctilious, loquacious small shopkeeper in some commodity for which there is a steady, if unspectacular, demand. He thinks of her as an awesome pool of fecundity, a sexual abyss from whose precipice he longs to fling himself. She finds him erotically uninventive, for all his dirty-minded innuendoes, but consoles herself that her lover has the biggest cock on the block, and the finest mind of its kind. He admires himself for always knowing what day of the week it is, and for keeping his ledger ever

ready for the tax collector; she has everything she needs, doesn't look back, and feels at once amused and bored by his incorrigible filing and cataloguing.

But what he really likes best to do is talk, talk, talk. Every so often, she shyly gets a word in edgewise, deliberately contradicting or mispronouncing something he has just said, and embarrassing him in company. But most of the time she prefers simply to sit and look out the window, expressionless.

Once, in a sentimental moment, he joined her at the window. "Beautiful, isn't it?" he boomed, and slapped her on the back. "You son of a bitch," she hissed, so quietly that no one else could ever hear, "why do you have to murder everything by talking about it?" And then in a fit of venomous rage, she broke a chair over his head.

Things have never been quite the same between them since.

[ ]

Diane Arbus has left us images that affirm, in ways as various as themselves, this doubling, and duality, and duplicity of our every experience. She made them, as she once found words to say, "because they will have been so beautiful."

She shows us identical twins, for instance, who might personify our twin minds, nine years old and already at war; or a brawny, tattooed circus performer, obviously a tough customer, whose paramount trait is a surface filigreed in elegance; or a standing naked man, his genitals tucked away between his thighs, "being" a woman as if the verb *to be* were somehow made transitive; or a lonely Victorian mansion that is nothing but a facade. Freaks, nudists, transvestites, masked imbeciles, twins and triplets inhabit an encyclopedia of ambiguities buried so far beneath language that we feel a familiar vague terror at the very suggestion of being asked to speak of them ... an irrational suspicion that, should we ever find and utter a name for what these images mean to us, we would so profane them that they might vanish like Eurydice, or fall to dust.

Now, in this moment, as I see, once again, the photographs of Diane Arbus, these words that I drop behind me consume themselves as if by fire, evacuating the pathway of my thought as it is drawn to what is before it: namely, the images themselves. So that the phrase "in this moment" dissolves, in an obliteration of all moments, into my accustomed unspeakable fascination by images that seem to possess the vertiginous stability of dream, of *déjà vu* ... or of those artifacts of the seeing mind, glimpsed before light broke upon the eyes, that coinhabit with palpable matter the whole space of the world. And after that dissolution of a phrase, the adverb *once again* is annihilated, in my seeming surprise, as these images, time and again, suggest that only a vicissitude of words segments their eternity into a mensurable time—invented, once, to resemble articulate space—that now no longer seems to matter.

These images, then, which offer me everything but words, enclose or apostrophize the exquisite stasis of a *tableau vivant* . . . tinted, to my disturbance and satisfaction, by my own lenses . . . divided by an impenetrable membrane that is neither quite gauze nor caul nor screen nor window nor yet mirror, within which, or through which, or upon which, two personifications fix each other in endless regard. In a posture of easy attention, image and word, *Eros* and *Thanatos*, eternity and time, multitudes of partnerships at once open and secret, stare each other and themselves into existence. Diane Arbus and I, more or less in focus, may even be among them: because she is gone, but never, to my pleasure, quite entirely absent . . . and I am here, but never, to my pain, quite entirely present.

Within our tableau, now, all these personages bear toward one another an archaic expression that we cannot quite comprehend. Sometimes it looks to us like a smirk of angry conceit . . . or again, as briefly, a vacuous grin of confusion. But sometimes, for an instant that will outlast us, we animate upon these ancient faces, suddenly as a veil of an aurora, a smile of triumphant happiness.

[ ]

Time is the substance of which I am made. Time is a river that bears me away,

but I am the river; it is a tiger that mangles me, but I am the tiger;

it is a fire that consumes me, but I am the fire. The world, alas, is real;

I, alas, am Borges.

—Jorge Luis Borges, "A New Refutation of Time"

**Notes**

1. The image to which Frampton alludes is a reference to the final sequence of his 1970 film *Zorns Lemma*. (B.J.)

2. Alvin Langdon Coburn, "The Relation of Time to Art," *Camera Work* 36 (October 1911): 72–73.

3. Ray L. Birdwhistell, "The Age of a Baby," in *Kinesics and Context: Essays on Body Motion Communication* (Philadelphia: University of Pennsylvania Press, 1970), pp. 11–23.

*Artforum* 13, no. 2 (October 1974): 39–50. Reprinted in *Circles of Confusion* (Rochester, N.Y.: Visual Studies Workshop Press, 1983), pp. 87–106.

# A Talk on Photography and History: Time, Space, and Causality

I thought I might start by introducing not a clarification but an example, a precious example of why our topic—which I believe has something to do with the new, as distinct perhaps from the Hellenic or Babylonian histories of photography—gets to be so confusing.

About a week ago a preadolescent of my acquaintance gave me a comic book. It was a Disney-family comic book. One of the little stories or tableaux in it was called "A Photography Contest." In this tableau, Clarabelle Cow purchases something that looks very much like a Nikon and enters a contest in the photography, mind you, of animals. And there are various misadventures, needless to say, connected with this. She enlists the help of her boyfriend. I forget his name; he's a bull in any case. And the encounters with animals that she photographs obviously become more and more horrendous until, in one frame, a lion that has escaped from the zoo is pursuing her boyfriend, the bull; and with a big bovine grin she snaps the picture of the lion. As she does so, she says to herself, "Great shot."

The fact that we have the image of a cow using a camera engaged in a contest to photograph animals reminds me of a moment of vertigo I experienced the first time I ever watched German television. There was an ancient American movie that had Anthony Quinn as Chief Thundercloud, or whoever, and someone else as his young white friend. It's the plot where the Indian boy and the white boy have been raised together as children, fall out, and are reunited at the end, and so forth. And of course the whole thing is dubbed in German. At the very end of the film, the red and white man are riding along together once more, side by side on their horses. In the original Quinn had turned to whomever it was and spoken to him in English for the first time, not in Ogala, or something like that; but since this was dubbed in the version I saw, the white man turned back to Anthony Quinn and said, "In all these years I never knew you spoke German."

Graft then, if you will, onto that ironic vertigo the fact that the comic book I told you about was in fact in Spanish: the name of the tableau was "Concurso de fotografía." And what Clarabelle Cow said when she snapped the picture of the lion was, "precioso ejemplar," a great shot.

In that scientific, Latinate diction of a Disney cow taking a picture of a lion, with a Nikon, in the kind of exploded and arrested pseudocinema of a comic book—the pictorial vulgate of Western capitalist childhood, if you will—we have, I think, the rack upon which the not-yet-very-well-formed backbone

of photographic theory has been broken before it ever grew straight and strong: namely, that photographs, in their immense number (it's like overkill, like nerve gas; there's enough doses of still photography to kill every one of us a hundred times over) have never been seen in any way systematically; they are a virtually infinite collection of *preciosos ejemplares*, great shots, every one of which of course tends to make all the others temporarily invisible—to arrest the attention so completely that it becomes, as it were, paralyzed.

Watch out for comic books, they're excessively instructive.

[ ]

I'm going to begin with two epigraphs or quotations. The first is attributed (I attribute it, I heard him say it) to Gene Youngblood, in a lecture in March 1977. It wasn't all the lecture mind you, but he said: "I used to spend a great deal of time predicting the future. I am trying to cure myself of that habit; prophecy is a supremely undignified activity."

The second, and even briefer, quotation is from *The Savage Mind*, by Lévi-Strauss: "History has always struck me as a method without any clearly defined object corresponding to it."

So then I will read this as a text because the first part of this is continuous, and you will know when the continuous text is finished because you will observe that my personality begins to deteriorate.

[ ]

If the West may be said to harbor a single problem as venerable as that of our cultural obsession with those things—severally troublesome to our understandings of causality, time, and space—that we call "images" and "words," then that preoccupation must be the interminable projection of every possible future from any discernible cause that we call "history." A notion that occupies no imaginable space of its own, history symbiotically annexes for its representational arena the whole intellectual space of every other activity. No thought or act that has not somehow "entered" history, and thereby been brought into ghostly superimposition with everything else in the world, seems quite properly to exist; until its territory is thus preempted, it can claim none of its own. Thus, in an historical culture, in a culture as preoccupied with history as ours is, nothing can be perceived as new until it is already ancient and pervasive.

History—alone among the sciences in its failure to free itself, even in its most theoretical reaches, from the minutely specific and ephemeral, without ever having invented a satisfactory general procedure for including or describing its cherished specificities— has never founded a humane discipline of time. But whatever would assert its novelty on the grounds that it is its own novelty, on the grounds that history cannot predict with accuracy, attempts a precarious

defense, since history, nonetheless dreaming forever of supreme rationality, rejects mechanism (unlike prophecy) in favor of what we may call, in the broadest sense, psychological causation: human effects proliferate from the set of all possible interpretations of events so that, in deriving every conceivable development from every discernible latency, an ultimate history of thought and practice will appear to have been right at every moment.

For the present, though, whatever moment that was, history claims only the past (a terrain that intimidates us through its superiority, which derives from the fact that, for the most part, we are not in it) and treats the present instant as a clanking factory for processing the future, equally privileged, which offers us, as its only assurance, that we will certainly corrupt it in the name of every sacred principle history has extrapolated from the past.

And at this moment, as well, we set ourselves the task of examining, of all things, the history of a practice new to history, a social and intellectual phenomenon so common and old that it seems to share, with written language, a fundamental identity with the method and matter of history itself: the diffuse general practice, I mean, of photography. Not even the illiterate can imagine a world without written language, and a world without photographic imagery is, for us, unthinkable. If it often seems to us, as we think about thinking, that we think in words, it seems as often, when we are not thinking about thinking, that we think not merely in "pictures" but in photographs.

Habituated to language, we may no longer think of it as a machine—or as the manifestation of a high technology for manipulating and accounting for a universe whose boundaries it obscures in a profusion of centers occupied by ourselves, who speak, understand, write, read—an unspeakably complex automaton that claims every mind as a subassembly, or an interlocking set of algorithms, self-defining and self-extending, that so determines the substance and limits of thought that every proposal to think anew automatically, relentlessly, imposes upon the one who would think the task of extending and redefining language itself. But to attempt to speak or write with conscious exactitude is to find oneself painfully vulnerable to the realization that language, whatever more it may be, is all those things.

But accustomed as we grow to the photographic image, nevertheless its origins seem less past than language's perfect past, and less "transparent"; in symmetry with the visibility of its artifact, the photographic mode of production and the mechanism of photographic thought retain a certain "opacity." If this is a sign of its immaturity as countermachine and complement of language, it is contradicted by history's present readiness to unite, by a process of mutual ingestion, with the photographic image, incorporating it into its method as

well as its object. The photographic machine embodies and exercises with effortless precision much of what has ever been discovered about the description and recollection of spaces, their enclosing or imbedded volumes, the surfaces that delimit those volumes, the colors that qualify those surfaces. What was once, and for long, a subject of the most intense experimentation is now simply knowledge, parameterized, quantified, seamlessly indistinguishable from the rest of inherited mother's-milk culture and thereby all but inaccessible to individual practice within that culture, save through the mediation of photography.

In that indistinct moment when photographic representations, scarcely less abstract than the graphic signs of written language, became for the naive or unreflective citizen (and we are all that person a good part of the time) associated with things as intimately and automatically as their names, our culture had passed an epistemological point of no return. In an age that has characteristically, in science as in art, preferred retinal to cortical vision, photography has provided an infallibly retentive super-retina, more persuasive than a mirror, allegedly value- and language-free (or at least independent of the linguistic and social processes of discourse and evaluation). Darwin, Mill, Galileo, Democritus are photographers now, and the frontier of the knowable has become, often enough, the limit of what may be photographed; the photographic antilogos would have us collect the autographs of all things rather than read their signatures.

We shall never again imagine such ordinary things even as the cave of the heart, the weather of Jupiter, the faces of the living unborn, because we have seen these things in photographs, much as, in the nineteenth century, Bombay and the Andes vanished from the country of the imagination.

Suppose this conversation:
"What are you drawing, Johnny?"
"God."
"But nobody knows what he looks like!"
"They will when I get through!"
In a photographic epoch, the foregoing conversation becomes increasingly unlikely.

I submit that the avalanche of photographic evidence was crucially implicated in the evacuation from the sciences of all but trailing vestiges, now disguised or atavistic, of the impulse to what was once called philosophical speculation. How one hesitates to use that word, *speculation*, twice in the same day has now become, by a default that we are slow to understand, the peculiar province and indispensable commitment of art. And we are so accustomed to

this problematical state of affairs that we tend at once to decategorize or demote purported works of art that ignore their speculative duties, or fail in them, and to forget that such delightful inventions as Alfred Jarry's "pataphysics," or the Dadaists' summary forced hybridizations among mediative and perceptual genera of mixed or dubious ancestry, apostrophize serious defections in physics and psychology, respectively. The incontrovertible photographic image, which was to have rescued the sciences from the most irksome of immemorial doubts about the reproducibility of observation and at the same time confirmed their academic curricula in enviable economy, enclosed them all within an impenetrable fortress-prison of image, a panopticon of visibilities—condemned them, in a word, to a long sentence on the basis of no more subtle argument than that of the decrepit legal principle (shared with some of the apologetics of Modernist art) *res ipsa loquitur*, the thing speaks for itself.

If the visual arts have assumed, by now, many of the customary tasks and prerogatives once allotted to the sciences, is it reasonable to suggest that they may have assumed, as well, their practical axiomatics and methods, their concrete kit of tools? Let me put the question differently (tacitly implying that it is the same question): can we imagine such supine manifestations as painting, sculpture, drawing, graphic design, as we now find them, transpiring anywhere else than in the climate of unassimilated photographic experience that everywhere confronts us? And then, and more: will the photographic theorem—namely, that the material, and thus the psychological, universe may be perfectly described and accounted for in a concatenation of fragmentary and codified illusions of its own presence—eventually banish speculative energy from its last sanctuary in the disorderly house of art? Once, when nothing more was at issue—socially, aesthetically, mathematically, sexually—than the definition and conquest of space, we might have attempted compact answers. Now, we cannot even feel sure that time will tell. She is too much taken up with her own problems these days.

We now have a synthetic conversation. Do not go looking for it in the library.

[ ]

"Excuse me!" interjected Alice. She was always polite, but she had waited long enough for the White Knight to catch his breath. "But what is this history you keep bringing up? I thought history was full of knights, but you're a knight and you're right here, so you can't be part of history."

"Quite so, my dear!" the knight replied, "unless your friend, the Reverend Dodgson, puts me in one of those books he writes when he's pretending to be an author. In that case,

I shall have to be content. It's better to be in a silly history than in none at all. But you must but know by now, young lady, that what history *is* depends remarkably upon whom you're talking with. For instance, should a physician ask you for your 'history,' he only wants to know about the times and ways in which you have been ill."

"But I've never been ill at all!" Alice cried.

"No history there, then!" the White Knight answered, unperturbed. "There are other kinds, though. Your member of Parliament for Oxford will tell you that they make the stuff every day, up in London, like grinding out forcemeat."

"How long does it last?" ventured Alice, feeling that she was starting to get the hang of the conversation.

"Forever!" shouted the knight. "I mean, as long as anyone remembers it; and it's a mercy that's not long at all, or else by now the world would be so full of history that there would be no room left in which to do anything."

"Well then," Alice said pettishly, and stamped her foot, "I suppose I'll never be in history because I never do anything much besides thinking and talking."

"But that's the very best kind of history, my dear Alice!" the White Knight answered, "because if you keep yourself to thinking and talking you can never make a mistake! Standing here talking with you, I feel much more certain of my place in history than I should if I were out looking for dragons to slay!" Encouraged by his own speech, he tipped his visor and blinked.

"Do you mean," inquired Alice, "that history is like a game: one bad toss and you're out of it? That doesn't seem fair to me!"

"Nor to me, sweet child," sighed the knight. "And indeed some have kept their place in history by making nothing but mistakes, which shows what an odd sort of game it is."

"At least it seems easier than being right all the time!" Alice pouted.

"Now, now!" the White Knight remonstrated. "I said it was an odd game. The rules change with every turn!"

Alice bridled with annoyance. "What sort of game is that, I ask you!" she wanted to know. "It sounds more like a nightmare to me! One can't either win or lose, nor tell if one plays it alone or with another person . . . nor even know if one is playing it or not!"

The White Knight lowered his visor and drew himself, for the first time, to his full height. Impressed by the extent of his glittering panoply, Alice fell silent. "There is another name for this game of history," he boomed, finally. "It is also called being grown up. It is the only game I know, because I have forgotten how to play all the others. So don't speak badly of it, or else I'll stop explaining things to you. Now if you'll excuse me for a moment . . . ?" and he receded, clattering in his rusty armor.

"Good riddance," Alice thought. Then, after a while, she reflected that the White Knight was, at least, more polite than the Red Queen had been. After another while, she noticed that the room in which she sat was without windows or doors, and wondered mildly if that had anything to do with its lacking walls.

I assure you that after his trip to the bathroom, the White Knight returns and proceeds to question Alice rather carefully about the photograph that Mr. Lewis Carroll has made of her and some of her young friends. Unfortunately for our purposes, he's not able to get too much more out of her on that score than the Gernsheims did.

Lecture delivered for the symposium "Toward the New Histories of Photography," School of the Art Institute of Chicago, 1979. Published in *exposure* (*Journal of the Society for Photographic Education*) 21, no. 4 (1983): 32–34.

# Meditations around Paul Strand

They say that we Photographers are a blind race at best;
that we learn to look at even the prettiest faces as so much
light and shade; that we seldom admire, and never love.
This is a delusion I long to break through.
—Lewis Carroll, 1860

Is still photography fated to wrestle forever with its immemorial troubles?

A year ago, a student of mine explained, with great agitation, why she was giving it all up: there was "no history of thought" in photography, but only a "history of things." During 130 years of copious activity, photographers had produced no tradition, that is, no body of work that deliberately extends its perceptual resonance beyond the boundaries of individual sensibility. Instead, there was a series of monuments, mutually isolated accumulations of "precious objects," personal styles more or less indistinctly differentiated from the general mass of photographic images generated "by our culture, not by artists," from motives merely illustrative or journalistic.

Furthermore, every single photographer had somehow, for himself, to exorcise the twin devils of painting and the graphic arts: there was, seemingly, no way for photography to cleanse its house. Master and journeyman alike had to face down, in a kind of frozen Gethsemane, the specter of the plastic arts. She had wearied of it.

Twelve years before, less than certain of an alternative, I had wearied too. So I baited her, and listened. What would she do? Why not embrace the monster, and paint? "Good God, no," she answered, "that would be even worse!"

There was only one thing to do: she would make films. And then: "What I mean is, films are made for the mind; photographs seem to be only for the eye."

And again: "Anyway, all photographs are beginning to look alike to me, like pages of prose in a book." Did I know what she meant?

She meant that they all "looked as if they had been made by the same person."

[ ]

If twentieth-century American photography has given us as many as three grand masters, undisputed by virtue of their energy, seniority, and bulk of coherent oeuvre, then their names must be Alfred Stieglitz, Paul Strand, and Edward Weston. The first and last are gone; Strand alone, Homerically, survives.[1]

Stieglitz, a volcanic figure whose precise mass has never been rigorously assayed, was born in Hoboken, New Jersey, in 1864; he was Paul Strand's mentor (so says Strand) and died in 1946. The transplanted Californian Weston, born in 1886 (between Pound and Eliot), was confirmed in his true vocation during a 1920 visit to New York, in the heyday of *Camera Work* and "291," where he saw photographs by Stieglitz and Strand, and met both. Weston died on New Year's Day, 1958.

It is scarcely necessary to point out that exhaustive examination is decades overdue for all three of these men. Mercifully, we are given, for the first time since his 1945 retrospective at the Museum of Modern Art, a view of the whole work of Paul Strand in a massive exhibition originating at the Philadelphia Museum of Art. There are nearly five hundred prints, together with the films for which Strand must bear crucial aesthetic responsibility.[2] The show is accompanied by the publication of *Paul Strand/A Retrospective Monograph/The Years 1915–1968*, a large quarto volume that contains, along with the biographical and bibliographical material and a systematic nuggeting of texts by and about Strand, acceptable reproductions of more than half the photographs in the show.

[ ]

Paul Strand himself supervised in detail the installation of the show and the design of the book. The results of both efforts vary from ordinary expectation in ways that illuminate Strand's convictions on the nature and cultural meaning of photographic images. So I shall have to examine their suggestions at some length, and also take up, along the way, some fundamental problems implied by photographs at large.

To begin with: the word *retrospective* is sufficiently misleading, in this case, to suggest important dissociations. Nearly all the prints in the show are new, made and matched especially for the occasion. (Consider, for a moment, the unimaginable parallel case in painting!)

What Strand has actually made, during fifty-three years, is a large number of *negatives*.

The negative has somewhat the same relation to the photographic print as the block has to the woodcut, with the important difference that the curatorial notion of "states" does not apply to photographs. That is, the graphic artist's plate suffers gradual attrition during the pulling process, whereas a virtually infinite number of prints may be generated from the information stabilized in a single negative.

But the photographic result is no more fixed or automatic than the graphic. In the hands of a gifted and able printer (and Strand is supremely

both), a single negative may be made to yield prints of the most extraordinary variety. I would compare the process to that of deciphering the figured basses in baroque keyboard works: given a sufficiently wide rhetorical field to work in, there must finally obtain the possibility of shifting a whole work from one to another mutually contradictory emotional locus by the variation of a single element.

I seem to be speaking, of course, of what has been derogated as *nuance*; and there is a strain in the temper of modern art that has found suspect any tendency to locate the qualities of art works outside the direct conceptual responsibility of the artist, in "performance" or "interpretive" values. But for Strand (himself the craftsman-performer of his stock of negatives) such concerns amount, as we shall see, to very much of his art.

Nuance is a superficial matter. But photographs are, in the precise sense, perfectly superficial: they have as yet no insides, it would seem, either in themselves or inside us, for we are accustomed to deny them, in their exfoliation of illusion, the very richness of implication that for the accultured intellect is the only way at all we have left us to understand (for instance) paintings.

To put it quite simply, a painting, which may be, after all, nothing but some paint splashed on canvas, is comprehended within an enormity that includes not only all the paintings that have ever been made but also all that has ever been attributed to the painterly act, seen as abundant metaphor for one sort of relationship between the making intelligence and its sensed exterior reality. The "art of painting" seems larger than any of its subgestures ("paintings"), protecting, justifying, and itself protected and justified as a grand gesture within the humane category "making."

Contrariwise, photography seems to begin and end with its every photograph. The image and its pretext (the "portrait" and the "face," which bear to one another the relationship called "likeness") are ontologically manacled together. Every discrete phenomenon has its corresponding photograph, every photograph its peculiar subject; and after little more than a century, the whole visible cosmos seems about to transform itself into a gigantic whirling rebus within which all things cast off scores of approximate apparitions, which turn again to devour and, finally, replace them.

We are so accustomed to the dialectics of twentieth-century painting and sculpture that we are led to suppose this condition is a sorrow from which photographers hope for surcease. But this simply is not true, on balance; and most certainly not in Strand's càse. Rather, a stratagem by no means peculiar to Strand, but detectable in the work and published remarks of photographers in every generation since Stieglitz, has consisted in insisting (with considerable

energy) upon the primacy of photography's illusions and, simultaneously, upon the autonomy of the photographic artifact itself.

The larger aesthetic thrust of photography has concentrated not upon annihilating this contradiction, as painting seems always to verge upon doing, but instead upon containing it: since the West is still largely populated by closet Aristotelians, we are far from inheriting all the wealth that may be born to the mind in entertaining, equidistant from a plane of contemplative fusion, two such evidently antagonistic propositions. However, in photography the paradox lies at the very core of the art, refusing to be purged.

For Paul Strand, both theses interlace and are succinctly bracketed in a single notion: Craft. For it is by craft that illusion reaches its most intense conviction, and by craft also that the photograph is disintricated from other visible made things, through regard for the inherent qualities of photographic materials and processes. Craft is, moreover, a complex gesture, which begins with a formal conception and precipitates in the print.

So we return to the exhibition: hundreds of such precipitate.

Yet I should like to pursue this matter of photographic prints into still further distinctions, since they are, after all, the only evidence we have.

Let us suppose, for a moment, that every work of art consists of two parts: a deliberative structure, and an axiomatic substructure. The structure is what is apparent, that is, the denumerable field of elements and operations that constitute the permanent artifact of record. Barring corruption by moth and rust, it is immutable—and of course it is here that art, curiously, used to spend so much of its energy, in consolidating physical stability.

The substructure consists of everything the artist considered too obvious to bother himself about—or, often enough, did not consider at all but had handed him by his culture or tradition. Axioms are eternal verities—subject, as we have begun to see, to change on very short notice.

There was a time when art concerned itself with its structure merely: what art itself *was* seemed clear enough. That every single work of art assumes an entire cosmology and implies an entire epistemology (I take it this is the Goldbach's Theorem of analytic criticism) had occurred to no one. And they called it the Golden Age.

We are accustomed to examine the axiomatic assumptions of any work of art (or of anything else)—to examine its substructure, in short—in stereoscopic focus with its structure. The tendency to do so is what makes us (for serious lack of a better term) "modern." The concentration of attention upon what is assumed, upon the root necessity of an art, is called radicalism.

Photography came in 1839 into an axiomatic climate of utmost certainty. What art was, and what it was for, were known. The photograph simply inherited the current axioms of painting. It became a quick and easy method for meeting most of the conditions prescribed for the art object: it "imitated," according to the strangulated contemporary understanding of that verb. By the 1890s, painting had begun to examine its own assumptions and bequeath those it discarded to the photograph, which had long since bifurcated: there was the photographic "record," and then there was photographic Art. The former went its own way; the latter imitated currently fashionable (not radical) painting.

Enter Stieglitz, who came, in time, to sense that the photograph merited at least a generic substructure of its own—whose reflex sympathies (he had been trained as a photoengraver) moved him eventually to choose an alternate pathway: the photograph that, if it had not repudiated the assumptions of art, was, at least, indifferent to them. At this remove, many of Stieglitz's prints still look suspiciously like art, but his *Steerage* remains a talisman as acute as any in photography. He was an able polemicist, and "291" was a sure and defensible critical act—but he was not a particularly nimble or fervid theorist.

Enter Paul Strand, a man very much younger, of drastically different temper. It must be admitted that some of his earliest work also looks like art, and moreover like modern art. But it is quite clear from his photographs and from his early writing[3] that he saw, instantly:

1. Photography must separate itself immediately from painting and the graphic arts.
2. The separation must be based upon sensible axiomatic differences directly related to illusion.
3. Photography must insist upon the special materiality of its own process.

It is easy enough to assent to all this, although the arguments were certainly fresher in those days, and their paragraphs more open to the mysterious options of self-cancellation. But then—indistinctly (and three generations later, they still are not wholly focused)—come intimations of a novel insight.

If I read Strand correctly, his reasoning (in my own terms) runs thus:

A. The structure of the photographic image is wedded absolutely to illusion. As photographers, we are committed to the utmost fidelity to spatial and tactile illusion.

B. *Mais d'abord, il faut être poète*. No two men, however perfect their illusionary craft, make commensurable photographs from the same pretext.

C. These differences must somehow be accounted for. So they must lie within the substructure of the work, that is, among its cosmological and epistemological assumptions.

D. Therefore, every parameter of the photographic process (". . . form, texture, line, and even print color . . . ") directly implies, and defines, a view of reality and of knowledge.

In so conceiving the structure of a work as entirely "given," and locating all control in its axiomatic substructure, Strand originates an inversion of Romantic values that is still in the process of assimilation. To the sensibility oriented toward painting, quite extreme parametric variations on a single photographic image must seem no more than pointlessly variant "treatments" of an icon. But to a mind committed to the paradoxical illusions of the photographic image, the least discernible modification (from a conventionalized norm) of contrast or tonality must be violently charged with significance, for it implies a changed view of the universe, and a suitably adjusted theory of knowledge.

In cleaving thus to sensory *données*, the photographer suggests a drastically altered view of the artist's role. The received postures of Spirit Medium and Maker nearly disappear. On the deliberative level, the artist becomes a researcher, a gatherer of facts, like Confucius' ancients, who, desiring Wisdom, "sought first to extend their knowledge of particularities to the uttermost." And on the axiomatic level, where the real work is now to be done, the artist is an epistemologist.

[ ]

The quest for nominally perfect fidelity to spatial and tactile illusion excludes the very concept of style as irrelevant; and "development," within the lifework of one man, yields to increasingly exhaustive rigor of Archimedean approximation. (In portraiture, for example, expression is to be avoided, for it must necessarily interfere with the study of physiognomy.) Ideally, the fully disciplined artist should be able to visit the same site on two occasions decades apart and return with identical images.

Carried to its logical outcome, the ambition of this activity can amount to nothing less than the systematic recording of the whole visible world, with a view to its entire comprehension. And that is a sober enterprise indeed.

Thus the importance for Strand of what he calls "craftsmanship," and thus also the importance of the print. In reprinting nearly every photograph for the present exhibition, Strand is conforming the investigations of a lifetime to his current (presumably mature and perfected) view of the world. So that this

retrospective view of his work is not for us, the spectators, alone; it is not even primarily ours, for we have never seen the prints he made in 1916 from the negatives of that year. Nevertheless, he holds them in his own mind: this retrospective is for Strand himself.

[ ]

The photographs are hung, in single or double rows, at eye level. They are presented with the most severe uniformity, in wide white mats, behind glass, in narrow white frames. The gallery walls are white. There are no captions or dates, but only the most unobtrusive small numbers, and these do not run serially. The prints are not arranged chronologically. The treatment is reminiscent of microscope slides—somewhat disordered cross sections from the tesseract of Strand's sensibility—or criminological photographs from old Bertillon files.

Most of the prints fall within the bounds of 8-by-10-inch paper, although a very few go to 11-by-14 and a few more are smaller. Strand seems indifferent, but hardly insensible, to classic prohibitions against cropping. A small number of prints are toned: I assume these are the oldest in the show. Occasional prints are extremely grainy: that the superimposed syntax of grain is "admissible" is surprising.

With a single exception, Strand appears to accept the standard painterly categories of portrait, landscape, still life, abstraction (the latter remains strictly referential, and is achieved through extreme close-up and adroit cropping: a familiar device of which Strand is co-originator). Each category is dealt with from a few carefully standardized points of view. Landscapes, seldom peopled, are of two sorts: a wide panorama, on the one hand, and on the other—where there are man-made structures—a near middle distance characterized by flattened, geometric frontality and extremely delicate attention to the boundaries of the image-rectangle. Portraits are frontal, posed. They are Roman busts. (But there are a few full-lengths, and an extensive subset of heads.) There are few interior architectural spaces but a relative abundance of exterior architectural detail, often carved wood or stonework related to Christian iconography. Images of animals are rare, and then most often parenthetical: friends who have spent time (and have themselves photographed) in Mexico, Mediterranean Europe, and Africa, Strand's own sites, have commented upon this with amazement.

Finally, there is one category entirely missing: the nude. There simply are not any images of the nude human figure at all. And then, as if to underscore deliberately the omission, one is obliged to reckon with the presence, on loan from Strand's private collection, of a quarter-scale bronze-sculptured nude by Gaston Lachaise, long a close personal friend of the photographer. I

am constrained to consider what Strand has in fact done—and not what he has omitted or avoided doing—but I cannot help but record my absolute astonishment at this; it is a *lacuna* that contradicts much that I had divined of Strand's aesthetic, for there is nothing elsewhere, in either his work or his writing, which suggests that anything under the sun might be exempt from the scrutiny of his lens.

[ ]

I have said that the ordering of photographs, in both the show and its strictly parallel monograph, pointedly avoids both chronology and titling. Nonetheless, there *is* a principle of organization.

The small numbers on the mats refer us to placards posted occasionally throughout the exhibition space, which describe each image by title (when there is one)—and always by date and locale. And it is by locale, in fact, that the prints are sorted. Strand has returned often to his accustomed sites, and two adjacent photographs from Vermont, for example, may be dated thirty or forty years apart. (Predictably, they differ from one another no more than they might if made on consecutive days.) The photographer, if he could go on working for a few more millennia, might photograph the whole terrain of the world; the local human fauna seem almost excrescences of the landscape and local architecture.

The barest attempt to reconstruct a diachrony meets with the photographer's implicit reproof: information is never withheld, but it is made effectively inaccessible, since its pursuit necessitates endless trips from photograph to identifying legend and back again. The meaning is quite clear. Still photography has, through one and another stratagem, learned to suspend or encode all but one of our incessant intuitions: I refer to what we call *time*. Paul Strand seems consciously intent, in his presentation of his work as in the work itself, on refuting time. It seems distinctly forbidden that the problem shall ever arise.

[ ]

Paul Strand's work has been praised by everyone who has ever written about it, and I will not presume to praise it further. It has been called everything. Stieglitz called it "pure," and thereby perhaps founded our abuse of that adjective; others have called it "brutal" and "elegant" (though it is curious that no one person has thought it both). But I should like to say something about the residue of feeling I am left with, at the brief remove of three weeks: the entire exhibition rhymes perfectly twice with every photograph in it—once in its unbearably sumptuous appearance, and again, in the exquisite chastity of its assumptions.

[ ]

Through the years, a man peoples a space with images of provinces, kingdoms, mountains, bays, ships, islands, fishes, rooms, tools, stars, horses, and people. Shortly before his death, he discovers that the patient labyrinth of lines traces the image of his own face.

—Jorge Luis Borges

New York City, 1972

**Notes**

1. Strand's work ended a year after this writing.

2. Strand was a professional cameraman for a large part of his adult life, and so probably shot scores of films. I refer only to *Manahatta*, 1921 (with Charles Sheeler); *Redes*, 1933; *The Plow That Broke the Plains*, 1935 (directed by Pare Lorentz); *Native Land*, 1942.

3. Three early essays contain, as it were, the Analects of Paul Strand; later items in his bibliography do not modify appreciably the views expressed in: "Photography," *Seven Arts* (August 1917): 524–526; "Photography and the New God," *Broom* 3, no. 4 (1922): 252–258; and "The Art Motive in Photography," *British Journal of Photography* 70 (1923): 612–615.

*Artforum* 10, no. 6 (February 1972): 52–57. Reprinted in *Circles of Confusion* (Rochester, N.Y.: Visual Studies Workshop Press, 1983), pp. 127–136.

# Impromptus on Edward Weston: Everything in Its Place

The greatest potential source of photographic imagery is the human mind.
—Leslie Krims

By all means tell your Board [of Trustees] that pubic hair has been definitely
a part of my development as an artist, tell them it has been the most important part,
that I like it brown, black, red or golden, curly or straight, all sizes and shapes.
—Edward Weston, in a letter to Beaumont Newhall, 1946

In 1960, a few days before Christmas, a Midwestern museum mounted, for the first time since 1946, and three years after the artist's death, a major retrospective of the photographs of Edward Weston. I had been sojourning in Ohio for some months and decided to see that exhibition before returning to New York. I arrived in the early afternoon of the only day I had allotted myself to discover that over four hundred prints were on view. Finding those few hours too short a time to spend with the work, I hastily changed my plans and stayed in town for another day.

The flight that I would otherwise have taken, inbound from Minneapolis, collided in midair over Staten Island with another aircraft. The sole survivor, a ten-year-old boy, fell two miles into the streets of Brooklyn. I well remember a newspaper photograph from that day: the broken child, surrounded by ambulance attendants and police, lay on the pavement in front of an *iglesia pentecostal* called Pillar of Fire.

Since then, I have never been able to decide whether Weston tried to kill me, or saved my life. For reasons more abstract, I suspect that many photographers, over the past thirty or forty years, have felt the same way.

[ ]

If the recording process is instantaneous and the nature of the image such that it cannot
survive corrective handwork then it is clear that the artist must be able to visualize his final
result in advance. His finished print must be created in full before he makes his exposure,
and the controlling powers . . . must be used, not as correctives, but as predetermined
means of carrying out that visualization.[1]

Out of the Ages we seem to have retained no more than a few hundred saints. But modernism in the sciences and in the arts seems to bring forth secular saints at the drop of a hat. Sainthood for artists seems to derive from a terse refusal to address oneself to questions about one's work, disguised as a moral aphorism.

Among major sculptors, Auguste Rodin and David Smith will never achieve sainthood; but Constantin Brancusi, who is on record with no more than ten prose sentences, achieves a sanctity that tends to make his work invisible, tacitly admonishing against critical examination. Somewhere in the firmament, at this very moment, the cunning Romanian soul announces once more that Direct Cutting Is the True Path to Sculpture, and choiring angels sing hosannas around him.

The roster definitely includes such mortifiers of the flesh as Jackson Pollock, Mark Rothko, and Alban Berg, who qualifies as a kind of crazy saint, like Mechtild von Magdeburg. Those not yet fully canonized, but definitely among the beatified, include Martha Graham, Diane Arbus, Georgia O'Keeffe, and a number of other candidates to whom no miracles have yet been attributed (not even the minor one of resuscitating otherwise stagnant academic careers). Wherever there are saints, there must also be heresiarchs like Marcel Duchamp and John Cage, and heretics. For this last category I would like to recommend the filmmaker Michael Snow and the photographer Leslie Krims.

Heresiarchs are chiefly of interest to other heresiarchs; whereas saints are of interest to everyone who, aspiring to sainthood, recoils before the heretical suggestion that any work of art that can be killed by critical scrutiny is better off dead. As for the rest of us who toil upon the sands and seas of art, we are just Workers, and our myth is still "under construction," though it dates at least to J. S. Bach, who once answered a question with the words: *Ich musste fleissig arbeiten.*"

If still photography has produced a single saint, then that one is indisputably Edward Weston. St. Edward is one of your manly, businesslike saints, like Ignatius Loyola, who received his vocation only in maturity, after a time of roistering and soldiering. In Weston's case, the two halves of that career seem constantly to be superimposed. The assertion perpetually quoted, that The Photograph Must Be Visualized in Full Before the Exposure Is Made, is scarcely an example of the complex wit of a grand aphorist. Rather, it comes to us as a commandment, brooking no reply or discussion. The Weston Codex abounds in such utterances, any of them a match for Brancusi.

The tone is invariably resounding, reassuring, and, above all, utterly proscriptive. We recognize it in the advice of a Japanese master of *sumi* painting, who tells us that the ink is best ground by the left hand of a fourteen-year-old virgin (presumably she must be right-handed!), as in Ad Reinhardt's animadversions on pure spirits of turpentine and the preparation of canvases: it always proposes an amelioration in its proper art—and always gives rise, eventually, to a mean and frigid academicism.

As we cut direct in wood or stone or metal, we are told, we must surely be on the True Path to Sculpture. If we can but learn to Previsualize the Photograph in Its Entirety, then we can be certain that we have mastered the first prerequisite to ascending the photographic Parnassus. To so much as hear the words of the commandment magically curses the hearer: he can neither obey nor disobey; for to disobey is to forfeit Art; and to obey is to declare oneself, at best, a disciple of the Master. The very possibility for work, for the construction of a *praxis*, has been preempted. Perhaps the photographer would be better advised to shoulder a tripod and walk inland until someone asks if it is a prosthetic device. It was in some such fashion that sculptors, for a time, transformed their chisels into tools to dig in the earth.

[ ]

Since the nature of the photographic process determines the artist's approach, we must have some knowledge of the inherent characteristics of the medium in order to understand what constitutesthe aesthetic basis of photographic art. . . . The photographer . . . can depart from literal recording to whatever extent he chooses without resorting to any method of control that is not of a photographic (i.e., optical or chemical) nature.

There is this to say about the possession of a thinking apparatus (what we call a mind, in this case): one cannot *not* think; even to attempt to do so is painful. But it is also difficult to think; and it is the more difficult because one has got to think about something in particular.

In the act of listening to music, of hearing, apprehending it, one thinks, vigorously, without thinking about anything in particular; so that one is given the pleasure of exercising the instrument of thought without the pain of having to direct that exercise toward anything that is not, as it were, already taken into thought, that is outside the instrument itself. Whence, then, the "universality" of music. We might pause to ask what we mean when we say we understand a piece of music. Presumably we mean something different from what we mean when we say we understand a spoken utterance or written text in a natural language.

There is one sort of understanding that we can attribute to both: a grammatical and syntactic understanding which we have from real-time analysis of the harmonic structure, the rhythmic structure, of a piece: the retrieval, let us say, of a generating dodecaphonic row, and the manner in which that row is manipulated in order to produce what we hear ... which seems to resemble the process of understanding a sentence by parsing its grammatical structure. In order to understand a natural-language artifact in this way, we must strip it of all specific reference: for "Jack ran," we might write, "proper noun/verb intransitive." Thus far, our understanding of language is like our understanding of

music: or this is the largest part of what we mean when we say we understand music—whereafter, the musical work is immediately transparent to its mediating culture. Music is a code stripped of everything but its own specifications.

But that is not all that we mean when we say we understand a natural-language artifact. In that moment when one suddenly comprehends, encloses within one's own thought, a work in music ... or a mathematical theorem ... the sensation is not that of having determined the referent of a word (an immediate, but minor, gratification that language offers). Rather, one experiences the sensation of being struck by thought itself.

It has been possible to say that pictorial spaces, the spaces generated and inhabited by the visual arts, may be parsed—that it is possible to recover from these artifacts a "grammar," a "syntax," and indeed more: a "diction." Images are socially comparable to music, in that an uncertain understanding of them can and does cross psycholinguistic boundaries. It is possible to strip painting of everything but its own specification. After we have got rid of the *putti*, bananas, tigers, naked women, it is nevertheless still possible to have painting: a code stripped of all but a description, a "metapainterly" specification of grammar, syntax; what was called Style has often amounted to no more than statistics on the potential size of a "diction."

It would seem impossible to strip the photograph in the same way, because the photograph, in affirming the existence of its pretext, would appear to be ontologically bound to it: Nature (that is, everything on the other end of the lens) is all of grammar, all of syntax, Diction of dictions, alpha and omega, Oversign of Signs. If we attempt to strip the photographic image to its own specifications, we are left, in the case of the projected image, with a blank screen, with a Euclidean surface; if we strip the photographic print, we run aground upon an emptied specification that is no longer a photograph. It is only, and exclusively, a piece of paper.

Why undertake to strip the photographic code? To determine the absolute, irreducible set of specifications for a code is a typically modernist enterprise in the arts. Expunging item after item from the roster of cultural imperatives, we come, eventually, to a moment when the work at hand is no longer recognizably picture or poem; in this moment, we know that we have mapped at least a single point on the intellectual boundary of what must constitute an image or a linguistic artifact. During this century, music, painting and sculpture, dance and performance have entered into this process of self-definition ... a process, moreover, into which film has recently invested new and massive energies. We find, for instance, an entire body of work that has been seen as a critique

of cinematic illusionism, testing whether illusionist space itself is properly part of the grammar of film, or only part of its diction: I refer to the work of Paul Sharits.

This enterprise has not, however, been systematically pursued with seriousness, or anything approaching rigor, in still photography, which has therefore tended to remain isolated, an enclave within modernism, a practice atavistic in its unselfconsciousness, a magnificent but headless *corpus*, an aesthetic brute whose behavior is infallible, perfectly predictable, and doomed by its own inflexibility. At this extremity, then, it is only fair to point out that Edward Weston was virtually the first photographer to make an effort to define the bare set of specifications for a still-photographic art.

Weston adopted a strategy that is perfectly familiar to us, proposing to identify the work of art with its own material rather than with its pretext. This reduced his problem to that of determining the nature of the material, and in turn suggested a second common strategy, that of circumscribing as drastically as possible the list of attributes of the photographic material. If we are not always convinced that Weston thought through his posture with utter clarity, nonetheless we must take care to note the severity with which he applied his chosen set of axioms in his artistic practice.

Still, to identify the photograph wholly with its own material could not completely satisfy Weston, and indeed it cannot satisfy us, because the photograph is, in fact, like language, doubly identified: once with itself, and once again with its referent; thus, modernism has had to set for itself a second grand problem, namely, to strip the *pretext* of the visual image or the referent of the linguistic artifact to its own proper set of specifications as well.

The very presence of a natural-language utterance in the world already asserts two things: that something is being said, and also that some Thing is being said. It is not difficult for us to perceive in the mature writing of Samuel Beckett, of Jorge Luis Borges, of Alain Robbe-Grillet, a determination to strip the Thing that is being said, the referent of the discourse, to its own set of specifications by making the very substance of the text refer to the materiality of language. We may trace the origins of this latter process of definition, within literature, through Joyce and Valéry to Mallarmé and Flaubert. It goes without saying that the work of specifying not only the possibility of saying but also what may be said at all is long and arduous, so that we never received from his own hand the delicious project that Flaubert had hoped to begin after the completion of *Bouvard et Pécuchet*, that is, the writing of a novel about Nothing. But how is an artist who would attempt to recover both the bare specifications for

a photographic image and the bare specifications for the photographic pretext to proceed with the second task? We cannot make a photographic image that is a picture of nothing.

But perhaps there is a way out, after all. Literary modernism in its latter development adopts a strategy that we might call displacement, whereby temporal and causal connections within the text are systematically forced out, made virtually irrelevant, their claims annihilated by "equating" the literary text with an illusionist pictorial image. Again and again, we find texts that amount to nothing other than minute descriptions, in flat, declarative sentences, of spaces, of objects disposed within those spaces, of the surface and volumetric attributes of those objects. In Beckett, in Robbe-Grillet, in Borges, we are accustomed to notice, at first, that nothing appears to be happening. Causality and temporality having been dispossessed from the text, we are left free to enjoy the gradual construction of the space within our consciousness that the text will occupy, as we experience the process of reading in a time—that of the spectator—which is explicitly and entirely disjunct from the atemporality of the text itself.

I would suggest that we might detect in Weston's photographs the nascence of a similar strategy of displacement. The possible set of pretexts for a photograph is reduced to a set of abstract categories deliberately taken wholesale from illusionist painting—Portrait, Landscape, Nude, *Nature Morte*—that, taken together, make up a rigid spatial typology. Weston repeatedly abjures the "snapshot," with a vehemence that enlarges that term to encompass most of the photographs that have ever been made. In the midst of a century and a half of photographic activity, during which the frame has been populated by an overwhelming profusion of spaces as its rectangle has become that indivisible point, that Borgesian *aleph* within which we see all the universe, that blank arena wherein converge at once the hundred spaces that Paul Klee longed for, this is extraordinary. The incessant reiteration of such a decision throughout a vast body of work finally transcends the polemical.

We must also remember that there may be strategies more elegant and powerful for accomplishing the same end that are simply and permanently rendered inaccessible by Weston's a priori refusal to manipulate, to lay a hand on his photographs, confining his bodily intervention to their subjects, his objects. Such strategies, however, are not to be discovered, like smooth, round stones on a beach, and dropped into an overcoat pocket. They must be invented. Some have reasoned that they are all of invention.

[ ]

In the time the eye takes to report an impression of houses and a street the camera can record them completely, from their structure, spacing and relative sizes, to the grain of the wood, the mortar between the bricks, the dents in the pavement. . . . In its ability to register fine detail and in its ability to render an unbroken sequence of infinitely subtle gradations the photograph cannot be equalled by any work of the human hand.

To the sparse list of spatial caricatures annexed from representational painting, Weston appends one further item: he photographs *surfaces*; and, as well, he sometimes so deprives deep spaces of their perspectival indicators that they appear to us as surfaces during the appreciable interval required by our effort to reinstate, from scanty evidence, the lost pretextual space. Arguing from a narrow experience of painting (which includes, as we know, the Mexican muralists Rivera and Orozco) he presupposes that he can permanently evade the troublesome paradoxes of illusionist painting, with its perpetual oscillation between inferred depth and aggressive materiality, by suppressing its recognizable marks of craft, of manual labor; by mechanizing the act of making, he would evacuate the maker, put him resolutely out of the picture. The photographed surface—and it is always an insistently "interesting" one, replete with entropic incident—at once corroborates and is ennobled by the condescendingly lapidary surface of the photographic print, which stoops to conquer everything under the sun.

Twenty years ago, one heard it boasted in New York that some painters had achieved work that "looked like" nothing else except painting. If we are willing to set aside such concerns as scale, chromaticity, and thumbprint evidence of human intervention (and the Abstract Expressionists must have been willing to do so, else they would not have admired Aaron Siskind's contemporaneous photographs of surfaces) then we confront a double irony: that Weston, exclusively equating painting with its procedures, and disregarding its appearance, had made photographs that proleptically were to resemble paintings to be made a generation later; and painters had finally achieved, in that future, work that looked like photographs that had been made twenty years before. If Abstract Expressionism echoes and amplifies the expectations of Symbolist poetry, aspiring to prove that the materials of the art could be depended upon to bring forth paintings as surely as language itself secretes the poem, then these antique photographs must charm by virtue of their authenticity, suggesting that the broad side of a barn is at least as likely to produce the appearance of art (which is nothing if not appearance) as all our strivings and conundrums. The photographic act, furthermore, gathers to itself a certain prizeworthy power: with a swiftness and parsimony that makes the utterance of a single word seem

cumbersome, it accomplishes its ends in an instantaneous, annunciatory gesture. Finally, Edward Weston meets an aphoristic requirement: he does not stop photographing when the dinner bell rings, but only when he reaches the edge of the frame.

For all that the photographer's frame derives from the painter's, regurgitating it whole, and shares with it a fundamental rectilinearity, differences between the two remain to be accounted for. The painter's frame marks the limits of a surface that is to be filled with the evidence of labor; the photographer's frame, sharing the accustomed rectangle with the standardized opportunities of painting and, also, with those of the printed page, resuscitates its own distant origins in post-and-lintel fenestration: it purports to be not a barrier we look *at* but an aperture we look *through.* Most bodies of work in still photography may readily be seen as picaresques whose denuded protagonist is none other than the abstract delimiter of the frame, bounded in a nutshell but traveling through infinite spaces howsoever fate, or desire, or vicissitude may command; while, from the very first, Daguerre's dioramas entertain the notion of a photographic imagery as big as life, photographs have largely remained small, contenting themselves in matters of proportion (or what is called aspect ratio) and ignoring those of scale.

The frame presents itself to the painter as a set of options and to the photographer as a constellation of severe constraints. Photographic materials "come" in sizes and proportions dictated by industrial conveniences disguised as cultural givens, and limit the secondary ratio between the absolute size of an image and what can reside within our field of vision at normal reading distance ... much as the arbitrary width of the canvasmaker's weft and the nominal dimensions of urban architectural spaces have, within recent memory, set a limit upon the scalar ambitions of painting.

And yet, it is not quite correct to say that Weston's photographs of surfaces "look like" Abstract Expressionist paintings, not even at those relative viewing distances from which both subtend a visual angle small enough to transform them into unitary signs centered on the retina. Rather, they resemble monochrome *reproductions* of such paintings, or, better still, reproductions of meticulous renderings, by a trompe l'oeil painter, of Abstract Expressionist canvases, done in miniature, with the sensuous delicacy of line and minute attention to the suppression of painterly surface of an Ingres.

And yet Ingres, although he is an illusionist of volumes and of a strict subset of the properties of surfaces (color, and yieldingness or hardness), effaces most of the tactile indicators that we ordinarily associate with his cherished pretexts, the nude female body and such other caressables as blossoms, pelts,

fabrics: an irreducible iconography of eroticism. But it is a detactilized eroticism. Our pleasure in the work derives not at all from any suggestion that we might enter the space of the painting (we are blandly excluded from it) and touch its pretext; what Roland Barthes would call the *jouissance* that we may have from an Ingres painting arrives when, with a certain indrawing of the breath, we suddenly comprehend that there are ecstasies of restraint as well as ecstasies of abandon.

Ingres's line, in his drawings, is nominalized, standardized, and displayed upon a surface of industrial featurelessness, as if produced by a machine of extreme precision designed to do something else entirely, which generates the drawing that we see to document a proof that that other thing is being, indeed has been, accomplished. Were such drawings to be made by human beings it would be necessary to train away the stubbornness of the drawing hand, replacing it with the patient, infinite exactitude of the tip of the tongue.

Weston repeatedly asserts that the qualities of the photographic print are dependent upon, derive from, qualities of the artist's perception at the moment of making, of exposing a member of that unique class of objects, the photographic negative. This must imply, in what Weston likes to call "lay language," that the photograph can never be fully intelligible without reference to the photographer; and it presents us, as spectators, with a dilemma: we can neither discard these precious scraps of paper whose immanence, whose copious presence, enters a strong claim on our attention ... nor can we ever hope to understand them fully. Do Weston's photographs somehow look different now that he is gone? We can never know. But it seems clear that in the hour of his passing they did not, for instance, turn crimson and explode. What, then, is it that the artist may be supposed to share with his photographs?

The photographic image, for Weston, affirms the existence and enforces the persistence of its immediate pretextual object and thereby of its grand pretext, namely, the space in which that object subsists. The artist reaffirms his own existence through gradually replacing the space of the given world with the inventory of spaces of all the photographs he has made. It may be that Weston's refusal to emancipate his images from the patriarchal house of his own perceptions amounts to nothing more than the simple declaration of a territorial claim.

The artist is fugitive; the photographs aspire to the monumental permanence of empty signs; the rectangle of the frame is made a stage upon which the photographer mounts a high drama of contingency, disputing with his chorus of things the absolute ground of existence. The photographs mutually affirm the claim of the artist and the existence of his object. Neither lobe of this simultaneous affirmation is impaired by the absence, or exalted by the presence,

of the other. Through the mediating power of illusion Weston may coinhabit, with a host of strangers, dumb things, lovers, Space Itself. The photographer, Event that he must know himself to be, can join in the easy commerce of spatial intercourse with his pretexts because he has conferred upon them the status of Eternal Objects, drastically redefining their claim, as aggressive as his own, upon the crucial territory. It is remarkable that Weston never quite gets around to making an honest woman of his own aesthetic doctrine, forever insisting upon his right to deny it, and yet united with it in that special, inextricable bond reserved for longstanding common-law relationships.

Eroticism, in all its implicit and explicit forms, is a particular mode of knowing; more than that, it is a school of thought that insists not only upon the physical body of the object of desire but also upon what we might call its temporal body. Gesture, habit, modulation establish, in time, within the mind of the knower, a *virtual* space whose contours are those of the temporal body of the known; and, if all goes well, it is this creature of time that becomes the true object of desire. What are called things, which behave not and are susceptible only of corruption, are without such temporal bodies, and so we habitually confer them, endlessly manufacturing brief experimental fetishes out of doorknobs and paperweights. The dish ran away with the spoon.

If it so happens that nothing, including ourselves, can fully be known until it is somehow made the object of desire, and if our knowledge must forever be mediated by codes and by illusions, then the still photograph, as expounded by Weston, in perpetuating a single instant in time, must remain, for all its repletion of knowables, a defective way to know, leaving something to be desired. Savages naked in the dawn of mechanized illusion though they may have been, the aborigines of that continent we call the nineteenth century must have sensed this, else they would not have struggled so to bring into the world a cluster of artistic means that we still call cinema, a compound way to know the temporal body of the world. Film was born into that silence bequeathed it by the still photograph, saving its first cries for the end of its adolescence. Is Eros mute?

[ ]

The photograph isolates and perpetuates a moment of time: an important and revealing moment, or an unimportant and meaningless one, depending upon the photographer's understanding of his subject and mastery of his process. The lens does not reveal a subject significantly of its own accord.

In a celebrated passage in the *Critique of Pure Reason*, Immanuel Kant concludes that the three categories available to human reason are Space, Time, and

Causality. Weston is everywhere concerned, as are so many other still photographers, with the annihilation of time. The image is to subsist not in a time but in all of time, taking for its duration the supreme temporal unity of eternity. In reclaiming the noun from the depredations of the verb, Weston snatches his beloved things from the teeth of causality, orphically rescuing them from the hell of entropy; and, orphically again, at the snap of the shutter, as if at the utterance of a word or the incantation of a song, causing these opacities to compose themselves into durable and serene hieratic geometries, Euclidean rather than Pythagorean, worthy of Eduard Tisse.

In so detaching these apparitions from causality and from time, Weston binds them to his own purposes, immobilizes them, transfixes them in an airless Space, rendered aseptic as if by a burst of lethal radiation. At the moment of their eternalization, Weston delivers his things to himself and to us, much as William Carlos Williams once said that he wanted his words "scrubbed, rinsed in acid, and laid right side up in the sun to dry."

That generic space, so prepared, is one with which we have been familiar for some time. It is composed only of visibilities embedded in their own vicinities, uniformly and brilliantly illuminated. The factual surface upon which they are to be made available to us, by the processes of projective geometry, is featureless but nonetheless distinctly present, firm but slightly yielding, either perfectly black or perfectly white, according to the needs of the moment. It is, in short, the surface of a dissecting table upon which all the most intimate secrets of the object are to be laid bare. It is a space within which, or surface upon which, we have long since come to expect to find beauty in chance encounters. Weston's self-confessed and notorious tendency to serendipity inflects the quality of these encounters, by extending their range: if there are neither umbrellas nor sewing machines, there are egg slicers and bedpans, and their strangeness repunctuates the prose of rocks, trees, animals, and the human body into a syntax that argues at once for the intolerably familiar and the gratifyingly alien.

[ ]

Photography must always deal with things—it can not record abstract ideas—but far from being restricted to copying nature . . . the photographer has ample facilities for presenting his subject in any manner he chooses. . . . The photographer is restricted to representing objects of the real world, but in the manner of portraying those objects he has vast discretionary powers.

What is there, by now, to be said of that grand category, Space Itself, a careful invention that comes to us from two thousand years of occidental diligence in science and art, within whose awful dominion reasonable facsimiles of all things that are may be disposed and arrayed?

Stripped to its specifications, this Space may be described in the following ways: it is infinite, but it may be bounded; the position of any point within it may be perfectly described with reference to only three mutually perpendicular axes; it is structureless, perfectly uniform throughout its extent, and may be regularly subdivided; it is inert, colorless, odorless, tasteless; and it is absolutely empty. It was created for a single purpose: to recertify the existence of things released from, purified of, the contingencies of our other two splendid fictions, Causality and Time. When we bother to perceive it, we do so chiefly through only two senses: those of sight and hearing.

Finally, it may contain, enclose, define only one thing: Matter. Stripped to its specifications, matter has two qualities. First of all, you guessed it, it occupies space. Furthermore, it does something else: it has mass; but that is no concern of ours, any more than causality and time are concerns of Weston's. Things are that they are.

Matter is what we cannot avoid, because, out of sight and earshot, it is never out of mind, self-verifying to the deaf and blind; because, for us, a thing is real or it is not, in measure as it is palpable. Whatever is "out of touch" cannot ever be fully present to consciousness, because things must be verifiable by all our senses. Failing even a single sensory test, we are obliged to assume that we are in the presence of an illusion; or else that something has gone badly wrong, and we are "seeing things," or "hearing things." Thus the voiceless visual illusion, colorlessly volumetric, can never, for Weston, sufficiently testify to, perfectly enunciate, that irradiated vacuum within which alone things may be definitely measured off against Cartesian coordinates, and thereby proved to exist. It is as though the artist were obliged to discard his convictions about the prior existence of the things of the world, to rebuild them upon a rigorous philosophical foundation before he may permit himself the luxury of assuming them as pretextual objects. Otherwise, there is always the danger that the illusion of volume may break down, defaulting to the material paper surface upon which the illusion transpires.

Hence, then, the overwhelming importance for Weston of the rendering of tactile surface detail. Not even the commonplace set of visual marks that we decode, by reflex, into tactile sensations . . . accessories, so to speak, that are invisibly packed in the box with every new camera . . . are enough to content Weston. He must have more than the smooth and rough, the wet and dry, hard and soft, the dense and the friable; he must contrive, if he can, to bring to his images the hot and the cold, the hirsute and the glabrous, the rigid and the limp, the unreceptive and the lubricious.

Then, in order to preserve the purity of Space against the premature conclusions of desire, to maintain some equipoise in this torrent of retinal concupiscence, Weston falls back upon ancient strategies: like sculpture, like painting, like drawing, the photographs decontextualize (metonymically truncating, but seldom amputating); they typify; they render anonymous, faceless.

Only the utmost conviction of the authenticity of the illusory context of a space guarantees the continuation of that space, sustains it, at once holds open its portals and maintains its elastic limits; so that it may be entered, may be possessed, without endangering the requirement that the one who enters, possesses, shall always be able to find his (yes, *his)* way out again.

Thus we discover, in these images, a certain cryptic symmetry among ends and means. If the pursuit of an illusion of space suggests a heightened rendering of the tactile, and its capture necessitates a pervasive, generalized eroticism, the artist finally has forced upon him a monumental paradox: driven to the utter mastery and possession of an abstraction as extreme as Space Itself, Weston is invincibly propelled toward the sexualization, the genitalization even, of everything in sight.

Finally we can begin to say what it is in Weston's photographs that at once attracts and repels us as our attention slowly oscillates, repeatedly penetrating the space of illusion and withdrawing to the visibility of the projective surface. The photographs, as physical objects, are of a voluptuousness that rarely falls short of the exquisite. At the same time, they are only scraps of paper, held in the hand: typical nameless merchandise of the industrial age. That is the distance the photographer sets between himself and us.

[ ]

An intuitive knowledge of composition in terms of the capacities of his process enables the photographer to record his subject at the moment of deepest perception; to capture the fleeting instant when the light on a landscape, the form of a cloud, the gesture of a hand, or the expression of a face momentarily presents a profound revelation of life.

Somewhere in a book whose name I have forgotten, Alfred North Whitehead proposes to correct two items of vulgar terminology. What we call *things*, he says, we should in fact refer to as Events. A little more or less evanescent than ourselves, things are temporary, chance encounters and collocations between and among particles of matter or quanta of energy, each of which, engaged in a journey through absolute space and relative time, has compiled a history that is not yet finished.

Contrariwise, what we call *ideas* should, according to Whitehead, be renamed Eternal Objects, since their perpetuation, while owing something

to such events in the universal history of matter as this present mind which thinks or deciphers, and this absent hand which writes, are, once formulated, independent of the local frailties of matter, standing at once within and without it. An Eternal Object, furthermore, is more than what is to be inferred from the static description of an Event; it is a behavior conducted by an Event, or, perhaps, it is an Event's notion of how to get other Events. I do not remember whether or not the recurrent patterns we call myths qualify as Eternal Objects, contingent as they are upon such momentary proclivities of matter as sexuality, curiosity, or irony. But what we call Language, understood as the maximal set of language-like codes that includes music, the natural languages, mathematics, kinesics, and pheromones, qualifies as a prime candidate for the status of Eternal Object.

Current neurophysiology and sociobiology regard the pheromone (a hormone-like medium that travels outside the body and is decoded by the olfactory apparatus without being consciously perceived as an odor) as a protolinguistic sign operating in a single verbal mode: the jussive. Who receives the pheromonal message simply acts upon it, instantly, with the enthusiasm of a crocodile. Kinesic signals, purely neuromuscular in their expression and thus independent of glandular fallibility, represent, in this cartoon, a more intricate and parsimonious concatenation. Birds do it, laughing all the way. We might speculate, extrapolating from such principles, that the modes of the verb evolve in the order: jussive, imperative, optative, hortatory, conditional, subjunctive, declarative. The last named suspends, in a shared intellectual space between a message's sender and receiver, a representation of a mutually imagined object, unqualified with regard to what the sender expects the receiver to do about it.

Since every natural language known to us comprehends some equivalent of every one of these modes, but some cultures are without mathematics, or figuration, we may further speculate that a certain maturity of the declarative mode is prerequisite to language-like objects more ambiguous than natural language itself. Mathematicians, for instance, may be understood to assess the beauty and elegance of a proof according to whether or not it achieves full declarativeness, suspending itself within the space of the mind in a posture that requires of us nothing less than perfect recognition.

Like the pages of mathematical journals, Edward Weston's photographs present themselves to us bristling with indecipherable meanings, exhaling the certitude that somebody, somewhere, made this thing that is before us and understands it. To the uninitiate, the mathematician's whole page amounts

to a single, indecipherable *numen*; to the initiate that opacity blossoms into discourse.

Weston's photographs entice us to discourse as well, promising, can we but learn to read their entrails, to deliver us, in their own voices, those absolute names of things that are identical with things themselves. Once so seduced, we can never fully withdraw; but neither can we fully enter, because the space of the discourse is not our own. The mysteries are offered, but the rites of passage are withheld.

[ ]

The appeal to our emotions manifest . . . is largely due to the quality of authenticity in the photograph. The spectator accepts its authority and, in viewing it, perforce believes he would have seen that scene or object exactly so if he had been there. . . . It is this belief in the reality of the photograph that calls up a strong response in the spectator and enables him to participate directly in the artist's experience.

Whatever our apparent situation among the imaginary lines within their pro-jective geometry, all of Weston's photographs present themselves to us at the same psychological distance, that is, in extreme close-up. Apostrophizing the significance of every last particle of matter, these images characteristically tell us more than we want to know; and yet, at the same time, they remain hope-lessly distant, their glazed surfaces interposing, between spectator and spectacle, a barrier as impassable as language. As often as not, peering at or through or into these photographs, I have felt like a curmudgeon with my nose pressed to the window of a candy store whose goodies are offered at the single price of unconditional surrender. Take it or leave it. It remains to be seen, however, whether this violent polarization of distances inheres unconditionally in the materials and processes of photography as a universal constant, like the speed of light, or is to be understood as a benchmark and limit of Weston's art.

While they share with such other banalities of our culture as the printed page and the architectural facade a commonplace rectilinear planarity, painting, film, and photography differ among themselves with regard to the distances that they invoke and enforce for both maker and spectator, and it might be worth our while to examine this family of distances from a strictly material point of view, as Weston would exhort us to do.

The most elementary of these distances is that remove, normally subject to severe anatomical limitations, between the painter and his canvas, which once tended to limit the absolute size of the painted surface to that which could be seen whole, at arm's length, while standing foursquare in front of it. Thus we might imagine that the brief ascendancy of the roughly isotropic painting of

mammoth dimensions proceeded from an impulse to exceed anatomical scale without making the painter walk too far or overstrain his imagination, and that such seeming tactics of physical distancing as Jackson Pollock's paint-slinging and Yves Klein's use of a flame thrower amounted to temporary strategies, transforming the vast surface of the work plane into a miniature and extending across the interval of an enlarged studio the long arm of painting itself.

The spectator's distance from painting is of an elasticity normally limited only by the size of the architecture, except in such rare cases as James Rosenquist's *F–111*, whose panoramic format turns inside out the normal perceptual situation of monolithic sculpture and offers the spectator the odd sensation of being scrutinized, from every side at once, by a reptilian gaze. Should we step within the confines of the velvet rope, the physical surface reassures us spectators that it is made up of nothing more alarming than kindly, benevolent old paint, which, as we already know, covers a multitude of sins.

The spectator's distance from film is more difficult to discern with clarity, because he stares at once at two surfaces: a physical one, which he had better not see, upon which is mapped, at high magnification, the virtual image of a barely intelligible little shred of picture-bearing stuff, the film frame … and a temporal surface, which does not exist but whose construction defines and circumscribes his work as a spectator. A fundamental illusion of cinema is that the image itself, carrier of illusions, is "there," before us. It is not. Both physically and temporally, it is behind us. In film, the spectator's future is the artist's past. Within extremely wide limits, film images engage the spectator in a mutable dialogue on the nature and meaning of scale; but they are inherently sizeless. Thus the very notion of the spectator's distance from them must remain problematical.

Held in hand or hung on a wall, the photographic print is normally examined at a distance that is defined culturally rather than metrically. I refer to what is called "reading distance." A photograph takes up about as much *Lebensraum* as a quarto page; in particular, Weston's prints, and those of his epigoni, hang on for dear life to that great gift of Eastman Kodak, the industrial 8-by-10 format, as though it were their pants, or derived from the Golden Section, or Mosaically prescribed, like the chubby but sacred 1.33:1 aspect ratio of the cinema frame. Thus the photograph forever recollects, collides with, shares the space of another generalized and grossly meaningful mediator: the printed word. In fact, most of the photographic images we see are not photographs at all but halftone reproductions accompanying text, indentured servants in the house of the word, usurping that white space of the page that Mallarmé was at such terrible pains to establish as an equivalent

to the emptiness of blue air occasionally traversed by the projectiles of spoken utterance.

Now the printed page is not something that is to be examined every which way, but yields its meaning as we scan its serial collocation of signs in a carefully fixed order. In neither sense of the word is written language to be taken literally, for in pausing to examine typographic figures we lose the "sense," withdraw our culture, and become aware of seeing the page for what it really is: inherently meaningless marks inscribed upon a flat surface. These marks are, moreover, quite small, and the reading of them requires of us a blindness, achieved through long training, to everything that lies outside the fovea of the eye. To read is to constrict physical vision to a microscopic point.

If we were to attempt to examine an image in this same way, we would find ourselves traversing that image, in darkness, with a flying spot of light, reading it out, as it were, a line at a time; it is interesting to note that the video image analyzes and resynthesizes its pretext in precisely this way, literally equating real spaces with the pages of a book. Clearly, though, looking at photographs in this way gets us nowhere fast. Photographs are small enough to be taken in whole, and yet large enough to afford the eye meandering and peripatetic opportunities that extend, like those offered by painting, over the entire area of the image.

Most of Weston's photographs, however, like most photographs that have ever been made, do not even try to account for the entirety of their rectangle. Typically they simply center a recognizable, bounded, and nameable icon within that rectangle and let the rest of it trail off into pictorial indeterminacy. It is as though the photographer were, and insisted that the spectator be as well, blind to everything outside the center of the eye ... as though the hypertrophied single sign had invaded the space of the text, like an isolated symbol ballooning to occupy a whole page. In the historically recent superimposition of the space of the photograph upon the space of the page, a polluted, hybrid space has arisen that offers, on the one hand, to return the printed book to the illegible magnificence of the Lindisfarne Gospels, and, on the other hand, reduces pictorial space to a membrane in whose neighborhood we are increasingly likely to find something neither more nor less complex than a written word or a letter of the alphabet.

(The Greco-Roman form of the capital letter "A" recalls, in profile, the elevation of a pyramid, that is, the tomb of a Pharaoh, whose central chamber, when finally penetrated, is invariably found to be empty.)

In photography and film, the artist's physical distance from his work can never be satisfactorily quantified, because the actual surface upon which the

work transpires cannot be located, or even identified, with certainty. Aside from the vague sense in which a film emulsion may be understood to be defaced, optically deformed (and even that by remote control), the still photographer's negative or the filmmaker's row of sequential images cannot properly be regarded as the "actual" work; both are, rather, complex tools uniquely constructed for the job at hand, the negative amounting to something like a found-ryman's mold, and the filmstrip to an intricately specific notation to be performed automatically by a canonical machine. Neither negative nor filmstrip is normally seen by the spectator, who is unlikely, in most cases, to find them comprehensible, or their qualities crucially relevant to his experience of the work. What the spectator looks at, whether it be paper print or projection screen, is a standardized, nominally flat blankness, whose vicissitudes are immaterial to an understanding of the work, since they can never uniquely determine its appearance.

Weston, finding in the physical world no surface that he can point to with certainty as his workpiece, is at pains to construct one: a doubled imaginary plane, one face of which lies within the artist's consciousness and the other within the spectator's, upon his own side of which he projects, "previsualizes," a print that is to be finished in more ways than one. Weston's acute concern for the print, the grave libidinal importance he attaches to it, comes from this: it is no mere expendable sheet of paper that he marks but an entity within the mind of another, which he delineates and authorizes.

In so relocating the site of the photographer's work, Weston effects a divorce between photography and painting more consequential than the separation announced in his refusal to "manipulate" the print. The painter's artifact is a unique material object which, once impaired in the slightest, is permanently destroyed, and lost forever to consciousness. The photographer's print, prodigy of craft though it may be, is a potentially indestructible *scenario* whose paramount quality is its legibility. Thus the photograph is made to resemble the word, whose perpetuation is guaranteed by the mind of a whole culture, safe from moth and rust; and the photographer's art becomes the exercise of a *logos*, bringing into the world, by fiat, things that can never escape. Is this what Weston means when he uses the adjective "eternal"?

[ ]

Conception and execution so nearly coincide in this direct medium that an artist with great vision can produce a tremendous volume of work without sacrifice of quality.

A photographer as prolific as Weston enjoys a peculiar and appalling opportunity: that is, to reduplicate the world in a throng of likenesses and possess it

entirely. It is true, of course, that one cannot photograph all cabbages, but one can photograph one and generate from the negative a potentially infinite supply of prints, happy in the certainty that one will never run out of cabbages. No levity, no mere question of connoisseurship, can be involved in the selection of the precise cabbage to be photographed. It must be undefiled, incorrupt; no verb may intrude to pollute, delete in the slightest from, the fulsome purity of the noun. Into the workshop of the photographer who would remanufacture the world, only one or the other of two verbs may come, and it is obliged to wipe its feet at the door: *take* or *make.* Take your choice.

The new universe, furthermore, must be, to put it mildly, more manageable than the old one. The noun must be modularized, made compact. By the operation of an algorithm that would seem to derive more from Lewis Carroll than from Procrustes, every noun must be shrunk or stretched to fit within the 8-by-10 rectangle. Were it a question of preserving the physical bodies of things, one might imagine them hollowed, bleached, pickled, and put up in endless rows of little glass jars, limp and folded like one of Salvador Dali's "cuticles." But the taking and storing of likenesses is ever so much more compact.

There is, in the spectacle of Weston's accumulation of some sixty thousand 8-by-10 negatives, something oddly funerary. It is as if one had entered the tomb of a Pharaoh. The regal corpse, immured in dignity and gilt, is surrounded on every side by icons of all that he will need to take with him into eternity: there must be food to eat, girls to fuck, friends to talk to, toys to play with; trivia and oddities to lend homely verisimilitude to that empty place; earth to walk upon and water to give the eye a place to rest; skies to put a lid on it all; other corpses to remind one that things have, indeed, changed; junk and garbage and rubbish to supply a sense of history; animals living and dead to admire, gawk at, or avoid; vistas to wander through when the spirit is weary.

Certain comical perils attend the assemblage of this riot of nouns. Failing the accomplishment of the sorcerer, one is in danger of being inundated like his apprentice. Is Weston, a typical modernist of the generation of the '80s, like T. S. Eliot, "shoring fragments against his ruin"?

[ ]

[The discriminating photographer] can reveal the essence of what lies before his lens in a close-up with such clear insight that the beholder will find the recreated image more real and comprehensible than the actual object.

*Ipse dixit!*

[ ]

It is now more than thirty years since Weston made his last photograph, and twenty since he escaped permanently from the domain of Time, joining the illustrious dead, and becoming an ancestor. But many of us cannot own him as an ancestor of ours. His splendors as a carnal parent are beyond contention; but as an intellectual parent he amounted, finally, to one of those frowning, humorless fathers who teaches his progeny his trade and then prevents them from practicing it by blackballing them in the union. We are under no obligation to put up with this sort of thing.

But since some sort of choice must be made, I would state a personal preference for a chimera—a hybrid of Venus Genetrix, who broods over the mountains and the waters, indifferently donating pleasure and pain to everything that lives, and Tim Finnegan, who enjoyed everything, and most of all his own confusion, and ended with the good humor to preside happily over his own departure—whose picture in the family album is no photograph at all but an unfinished painting on glass, at once apparent within and transparent to this very space in which we live and work and must try to understand.

[ ]

He especially liked to find the coded messages, the surfaces behind surfaces, the depths below depths, that gave ambiguous accounts of the nature of things. He loved the Atget photographs that looked into store windows in Paris and combined the world within with confusing reflections of the world without. It was the kind of conundrum he found irresistible.

—Charis Wilson

Order is, at one and the same time, that which is given in things as their inner law, the hidden network that determines the way they confront one another, and also that which has no existence except in the grid created by a glance, an examination, a language; and it is only in the blank spaces of this grid that order manifests itself in depth as though already there, waiting in silence for the moment of its expression.

—Michel Foucault, *The Order of Things*

[ ]

Possibly straining fairness, these notes tend to insist upon the typical photographs and manifestoes of Weston's maturity, largely disregarding the maverick work in which he transgresses against his own doctrine. This latter category, while it is not as copious as Weston says it is, does include a considerable part of his last work, which proposes to supersede everything that had gone before.

If it is so that the spectator or reader may understand more from a work than the artist understands, it is also true that he may understand other. For

the consequences, in this writing, of exercising that last kind of understanding, I offer no apology.

Houston/San Juan/Buffalo, 1977–1978

## Note

1. The quotations interspersed throughout are taken from an article, "Techniques of Photographic Art," by "E. Wn.," written in 1941 and published in the *Encyclopaedia Britannica* of that vintage.

*October* 5 (Summer 1978): 48–69. Reprinted in *Circles of Confusion* (Rochester, N.Y.: Visual Studies Workshop Press, 1983), pp. 137–160.

## Lecture Notes on Edward Weston

*Symposium* means "a drinking party." We seem not to have been spared the ecstatic leisure of such an occasion. In Plato's *Symposium*, Aristophanes' longest speech itself requires more than fifteen minutes to read aloud, and it's not all of the dialogue by a long shot. What we do here today resembles a fifteen-second TV spot advertising a consumer item of rather perverse generality ... and thereby takes on the aspect of cooperating exclusively in a process of distribution indifferent, in the typical terms of late capitalism, to what is distributed. In short, this is no critical occasion if we are to align, as I hope we are, critical discourse with the social and psychic mode of production, of making—which can never be, in any but the shallowest sense, a mode of velocity, a quick thing.

"INTERESTING"

"EXCITING"

"NEW"

But I would rather assume, for the moment—which is all I have—that we are here to cartoon, briefly, serious [things] that will come later: [things that] invoke, and celebrate, a privileged future. That future, which is at once past, present, and still before us, with the invention of photography.

[Emergence of a new art
photo/film/video/computer/laser technology//
and now monochrome and color xerography]

[ ]

end with this:

[The] most attractive territory within the schema of the world of the spirit that Dante presents in *The Divine Comedy* is *limbo*. If I believed in such things, in such a place, I should hope to spend the balance of eternity in the company of virtuous pagans (surrounded, presumably, by squalling unbaptized babies), engaged in million-year afternoon conversations with Aristotle or the Emperor Ch'in Shih Huang Ti, builder of the Great Wall of China, or with Hegel.... One such afternoon I would propose to spend with Edward Weston, seeking satisfaction in the matter of the facts in this case.

Handwritten notes of opening and closing statements for a lecture on Edward Weston delivered in Houston, Texas, 1977.

# Erotic Predicaments for Camera

It has been widely alleged that a picture is worth some reasonably large but finite number of words. It has been widely believed that a photograph is as plausible as—or approximates to the plausibility of—that swarm of events that we are accustomed to call the real world. And indeed the entire photographic literature of eroticism depends very heavily on exactly that supposed plausibility. I have chosen, therefore, to attempt to believe what is believed, to attempt to generate those words that the photograph is supposed to be worth, in four instances of erotic predicaments for camera, using my possibly defective understanding of the method of Robert Browning.

[ ]

The year is, or is about to be, or has recently been, 1855. I am in France. This part of France is delicately colorless, and faintly metallic in texture; if I adjust my position slightly, I may find my own fragmentary image reflected in the darker parts of the scene before me. Light here is diffuse, shadows transparent. Either the time is approximately local apparent noon, or I am indoors; the locale is indeterminate. In what may be the distance, I find only a vague, uniform mist—but that distance may amount to no more than a blank wall whose junction with the floor is elided. Nearer, and to my right, I find a semisolid entity the size of a large boulder, but a little more complex in shape.

About half the space before me is occupied by two anonymous strangers. They are quite clearly a woman, who faces me, and a man, who presents to me his left profile. Both are mesomorphs, both sustain their weight on the left foot, both are quite naked. The man's right leg is extended behind the woman's left leg, as if encountering her in mid-stride. They embrace. The woman's left arm encircles the man's upper torso: the fingertips are visible below his left shoulder blade. Her right arm crosses her body horizontally; the extended fingers nearly touch, or touch lightly, near the lower insertion of the left pectoralis major muscle. The man's right arm encircles her and emerges below her right arm; the splayed fingers partially enclose her right breast. His left hand is pressed against her abdomen, the thumb fourteen centimeters below her navel, the palm guarding the vulnerable passage of the femoral artery into the thigh, the fingers reaching the pubic symphysis. The woman flexes her right knee, resting her foot on a barely visible thing as thick as a plump pillow; her left hip inclines toward the man, her head away. He closes his eyes and kisses her cheek. She lowers her eyelids and averts her gaze from me, looking above me and to my left. I make a quarter plate daguerreotype of this scene,

trusting that neither person will move during the long interval required by the exposure, and that the man will sustain, unwavering, his very enthusiastic erection. The couple vanishes, or I vanish. Was their encounter arranged for my benefit, their postures rehearsed, the space evacuated to enhance their visibility? Or did I merely chance to witness an occasion that would have transpired in any case? Did my intervention inject uncertainties into the event? Would they have behaved differently had I not been present, or if I had brought no camera? Did I leave too soon, or arrive too late? Am I entitled to suspect that I failed to record something of interest? To suspend and memorialize all these irresolutions, I shall mount the little picture in an elegant frame of tortoise shell, lined with gold, and leave it, for more than a century, in a bureau drawer. About myself, I know only that I am a mature adult, whose name is F. J. Moulin.

[ ]

The year is 1878, and it is high summer. I am in England, probably in Oxford, where the University has not closed its doors since the time of Dante Alighieri; the light here is typical of our fine English days. Hazy, but permeant, it illuminates a hand-painted tropic world nearing twilight. In a distant seascape, the black skeleton of a derelict ship is half-submerged. A slight foamy chop in the water suggests a breeze I cannot feel. Nearby, to my right, the tip of a rocky promontory slopes into the water, lightly overgrown with a sketchy greenery that looks like mimosa. Two perfectly real children, nicely tinted, are entwined within the brushwork, which mainly surrounds their outlines, appearing behind them in atmospheric perspective, but somehow encroaches before them, as well, to conceal their respective loins with a ragged cloth and a bit of foliage. Nearer still, painted wavelets splash without wetting the children's feet.

It is as though this fragment of the universe had been created using two different methods, or sets of rules, each foreign to the other but mutually inextricable, like that landscape, at once nonsensical and plausible, through which I have walked, in dreams recorded with a special instrument of my own invention.

That the children are girls I infer from their fine features, long tresses, pensive demeanor. One, on the left, sits on the rock and rests her right hand on it. Her right leg is drawn up and crossed so that the ankle rests on her left knee; her left hand, then, rests on the ankle. The other stands, the width of a body apart from her, leaning against the same rock, hands on hips.

Both girls look to the left, at right angles to my own sightline, but they direct their attention to two different things, neither of which is known to me. The seated child seems melancholy, the standing, expectant. Neither appears

to notice the wreck behind them, or to require from it any of those comforts that Defoe's Crusoe salvaged and patched together into a threadbare cartoon of civilization. Indeed, they seem unaware that they are castaways in a menacing island of artifice; one might more easily suppose them at rest after hours of playing naked in the sunshine among our lawns and hedgerows.

To record my own puzzlement at finding them in such contradictory surroundings, I photograph the scene before me with a collodion wet plate I have freshly prepared, whereupon the environs disappear, but the children remain. And now I recall the circumstances that brought me this fanciful vision. My colleague, Patrick Henderson, a Fellow of Wadham College, had left with me his daughters Annie, aged eight, and Frances, younger by a year, for an afternoon chat and tea. To my delight, these innocent little creatures thought nothing of showing themselves to me, and to my camera, in their natural state. I delight especially in the company of little girls, whose boundless, prankish curiosity to satisfy I am always ready to invent a new puzzle, rebus, word game, or nonsense story. Indeed two stories that I made up to amuse Alice Liddell, the daughter of the Greek lexicographer in Christ's Church, have been published here and abroad. What momentary aberration, then, could have caused me to imagine, so vividly, Annie and Frances in such wild surroundings? I must make an albumen print of this picture, and give it to Mrs. Hatch to paint over in oils according to that fancy, so that I may contemplate it at length. Convinced of my artistry, she might then allow me to photograph her daughter Evelyn Maud, of whom I would like to do an infantile version of Goya's *Maja desnuda*.

In fact I am, by profession, neither storyteller nor photographer, but a logician. Personally, I so much hate the idea of strangers being able to know me by sight that I refuse to give my photograph, even for the albums of relations and friends, who know that my name is Rev. Charles Lutwidge Dodgson, and that I am called Lewis Carroll.

[ ]

The year is 1885, on an afternoon in early November. I am in London, in Whitechapel, a teeming slum just north of the city, where the circumstances of life are so vile that even the fearless Jack London, come to study, left, sickened, after a few months. I am in room 13, off a foul alleyway in Miller's Court. I am told that the whole space is no more than twelve feet square and contains only two chairs, a table, and a bed, but I can see only the last named item and a corner of the table beside it, and behind it, very near, the lower part of a closed door. The rent, which is four shillings a week, is three months in arrears.

The light is dim and will need to be augmented with magnesium. Today, mercifully, the world is colorless, odorless, tasteless as distilled water. On the

bed, still wearing portions of a linen undergarment, lies what remains of a woman. The throat has been cut straight across with a knife, nearly severing the head from the body. The left arm, like the head, is attached to the body by skin only. The nose has been cut off, the forehead flayed, and the thighs stripped of flesh. The abdomen has been slashed with a knife both across and downward, and the viscera wrenched away. Both of the breasts have been cut from the body. The flesh from the thighs, together with the kidneys, nose, and breasts, has been placed on the table, and the liver placed between the feet. An amputated hand has been pushed into the stomach. The eyes are intact. Blood, from the severing of the carotid artery, is everywhere, but the bedclothes, which have been rolled aside, are surprisingly unstained.

Because it is my duty to do so, as it is my duty to be here in this place at all, I make a single photograph of this shambles. The scene vanishes.

This is my fifth such encounter in recent months, and it is destined to be my last. After the first, it was given out to the papers that, through the photograph's power of minutely detailed observation, Scotland Yard expected to determine the murderer's identity with all speed. Formerly, known miscreants were routinely photographed as part of an immense project that was to delimit the criminal type of physiognomy for good and all. Here and in France, vast libraries of these photographs have accumulated, but not one man has been remanded to Dr. Bentham's famous Panopticon in Newgate Prison on the strength of their information. It would seem that what such photographs will teach us, if, in time, they teach us anything, is the precise location of the boundary between knowledge and understanding—assuming that those two principalities of the mind border on one another.

Thus my work has not, in fact, illuminated our pursuit of the murderer, of whom it is known only that he is right-handed . . . and that from medical evidence alone. But it has not been, I fear, without its miserable effect, because, knowing that the result of his own work is to be photographed, he has come to perform for my camera. In each successive instance he has become more thorough, painstaking, ingenious in his ghastly craft. In the first case, he probably accomplished his business in a minute or two, but the coroner has estimated that he spent three hours arranging this final and most spectacular masterpiece, like an artist who would rearrange anatomy to his whim, in whom all affection for that grand edifice, the human body, has soured and rotted. But may there still be hope that the camera will come to our aid? It is rumored that a new technique has been invented, in Germany, to develop the retina of the eye, like a photographic negative, and retrieve the ultimate image perceived by the dying. To that end, the body of this piteous victim will be desecrated

yet once more, and this time in the name of science. Will we understand that photograph any better than we have any of the others we have made, of everything under the sun? Not long ago, the man we seek sent a letter to the Chief Inspector, dated, with perfect correctness, "from Hell." Our incomprehension of these pictures, which we so desperately need to comprehend, has made for us a Hell of our own. At least, out of our need to know the murderer's name, we have conferred one upon him: he is called Jack the Ripper. My own name is unknown, even to myself; my photographs will be hidden away for three generations, and when they come to light again the meaning that we seek in them will be no plainer than it is at this moment. Perhaps they mean something else entirely.

[ ]

The year is 1980, and the season indeterminate except that an abbreviated patch of sky, visible through a far window, seems bleakly overcast. I am in something like Boston, where there are still turn-of-the-century houses of a spacious cut, in a white room in such a house. The floor is of polished hardwood; there is a handsome fireplace, and a rug before it that looks like fur; brass electric sconces and chandelier are extinguished. The space is otherwise as replete as a Victorian parlor. On the left, an open grand piano displays albums of Chopin and Mozart. Its bench is ornate. On the right, a magnificent big cabinet of Far Eastern design supports a much smaller one, from beneath which dangles a silk stocking. Three modern chrome-and-leather chairs are disposed as if for conversation, with a matching chrome-and-glass coffee table. Two large embroidered cushions, numerous exotic plants, African and Asiatic objets d'art, and a few things that I cannot identify fill the scene, throughout which, arrayed on floor, walls, and furniture, with rectilinear, geometric precision, I see scores of minor oral mollifiers in the shape of bars of Hershey's Milk Chocolate (with Almonds) and sticks of Juicy Fruit chewing gum, and twice I distinguish, on small plastic signs a trifle larger than the gum, and of the sort posted on office doors, the name G. I. FREUD.

In the middle of this plethora, a young oriental woman kneels, naked, on one of the cushions. Her left hand rests on her left thigh, and her right hand encircles, just above the knee, the left leg of a standing naked man in his mid-thirties. The man's left arm is behind his back, his right foot advanced, his right arm raised so that the forearm is level at the latitude of his navel. He is clean-shaven and holds an open straight razor in his right hand. Both of these personages face me in aggressively direct eye contact. I choose to regard the woman's expression as mildly surprised, and the man's as mildly annoyed.

Although their postures occasion a minor difficulty for such an act, the woman is fellating the man.

There is an instantaneous, blinding burst of light, as if from an electronic flash, and I realize that a photograph has been made. Now I find myself elsewhere, at my worktable, examining a print of this photograph, and trying to decide who made it. There are two possibilities. I may be a genial professor of art in an upstate–New York university, the photographer Leslie Krims; but if, as I suspect, the man who has just been photographed is himself Leslie Krims, then my pretense that I have been other than a nameless spectator is invalidated, and the maker of the piece, synonymous with its prime watcher, is watching himself and his friend performing the act of making the photograph. But if that is true, what rationale can obtain for annoyance or surprise on the part of the performers? On the other hand, if I am the photographer, then my intrusion at this private amorous moment justifies both those emotions; but I cannot fail to question their stances, which suit the necessities of the camera far better than the convenience of erotic enjoyment.

Therefore, I will keep this photograph, taking pleasure in the ways it criticizes my every attempt to include my own contemplation in a system of which it is, itself, both center and limit, knowing that its intellectual economy partakes of a class of problems that may never be resolved, because it is congruent with an instance in which we touch the limit of our reasoning powers. That limit may be best generalized in a letter of 1885, written by Lewis Carroll to a mathematician:

> Let a geometrical point move from A to B. In so doing, it passes through intermediate positions. Now, of these positions, either (1) there is a position through which it passes first after leaving A, or (2) there is not such a position. These propositions are contradictories, so one of them must be true. But neither is conceivable.

Buffalo, New York
April 1982

Text presented at the symposium "The Pornographic and Erotic Image—Toward Definition and Implication," International Center of Photography, New York, April 17–18, 1982. Published in *October* 32 (Spring 1985): 56–61.

# Fictcryptokrimsographology

This year brings us two prodigious constellations of still photographs. One is the new work (we sense in it the constitution of a new *body* of work) of Leslie Krims: his *Fictcryptokrimsographs*. The other is the contextual publication, eighty-seven years after it was gathered, of a body of "evidence": photographic relics from the brief career of Jack the Ripper. Each is doubly inscribed, and it is to a proportion among inscriptions that we attend: this emotion is naturally opposed to sensational analogy.

The anonymous photographer from Scotland Yard, trying to see in the strongest way, has left us immaculately normal silver prints. His magnesium flares were carefully disposed only to reveal: Act V over, and the stage all blood, every dramatic option lay exhausted. It remained only to close the shutter and yearn for the oblivion of a dreamless sleep. Why, then, were these images made?

*Language* decreed that they be made. Some person unseen and unknown had caused to die five (named) creatures inhabiting London, all human beings; had committed (repeatedly, with abominable trimmings) murder, an unlawful act; had, that is, seriously trespassed in the zone (the only one, in our culture) where language actively engages with social fact: The Law ... which is a subset within language that quintessentializes its tendency, persistent at the inflectional level, to seek or designate instantiations of Causality, and prohibit some of them.

The axiomatics of the situation seemed simple enough. They affirmed that every act, every ephemeral Cause, implodes and imprints itself upon static Reality as a residue: an Effect. For those skilled to read the Signs—detectives, for example—the process was reversible. Deciphering such glyphs might take long, long; in an age without refrigeration, the photograph was a kind of formaldehyde, superior even to words, serving to immobilize Reality until Culture should inexorably metabolize it into Knowledge. Our own psycholinguistic community still persists in behaving as though the prior assumption of our object amounted to thought ... and we are not even ashamed. In 1888, the name of the game was phenomenological Innocence.

But it is not only through their alleged "transparency," an ontogeny shared between photographic text and pretext, that these particular images must horrify us. Like the good citizens of every imperium since the Aztec, we have acquired a certain taste for ritualized or mediated horror—a debased appeal to catharsis serves as armature for our apologetics—and we have even superimposed upon that taste a kind of tremulous patience with the most appalling sexual atrocities. Rather, we come to read within the sequence of photographs, within their bland record of a geometrically escalating ferocity, that these are radically other than the leavings of passion … that Jack the Ripper was no mere invisible tiger or angelic machine. We recognize at last, in the methodical precision with which he mutilated and disemboweled Mary Jane Kelly, that this killer *composed* … not for himself alone, but for that most generalized of spectators: the camera; that he might as well have called himself, in his cruelty and madness, the Master of Whitechapel. We realize, with a thrill of misery and loathing, that we confront, in these images, the embodiment of an infinitely displaced, attenuated, and soured *aestheticism*.

Now to aestheticize the world, and one's experience of it, is to embrace, as if unknowingly, a peculiarly insipid and perverse notion of that dynamic mode of conscious activity that we call, generically, art: it is to hold that art refines (that is, simplifies and adorns) and seeks to render beautiful. In a fully aestheticized universe, the artist can do no more than "select," representing from among a welter of appearances, recording endless variations upon that failed moment when, in an access of monstrous Innocence, thought and its object commingle into mutually inextricable opacity. Aestheticism distances experience, objectifies it, simplifies it (even murder is, after all, a kind of ultimate simplification) in the furtherance of a passivity that we understand to be symptomatic of alienation . . . and alienation, like freedom, is indivisible, occupying the mind from horizon to horizon. We recall Ciano, Mussolini's son-in-law, aestheticizing in his diaries the bombing of the blameless Ethiopians: the lovely great fire bursts, he writes, bloomed in the desert like incandescent roses. This is the sort of thing that has given art a bad name.

The history of still photography (and that history, we remember, must include all the photographs that were ever made, for whatever purpose) has been a history of aestheticism. The photographic sign, in the instant of its apparation, snatches its referent from the fires of time. Mutability, process, context: all are annihilated when sign and referent collapse together to form a unique single object, self-establishing, self-sustaining, self-perpetuating—a

confusion wherein imagination shares a precise boundary with all that beck-
ons to it across the immeasurable distance of resemblance. All such objects
("photographs") resemble one another, because a photograph really *is* nothing
more than a disposition of tonalities (the standard epithet—and it is accurate—
is "exquisite"); and every such photograph, because it aspires to show no trace
of facture, *resembles* our universe ... to any stronger interaction with which it
remains *absolutely impervious*.

Because all photographs look alike (but are, nevertheless, believed), they
set all experience at an equal distance from consciousness, submerging every
distinction in a microscopically inflected rhetoric of—*miserere nobis*—"shades
of gray"; even the sort of simple binary syntax that might divide sense from
nonsense, what is recognizable from what is not, is bizarrely contaminated,
and somehow confounded, by the fluctuation of our own perceptions. Curtis's
truly beautiful and terribly embattled Kwakiutl or Hopi ... Hine's little boys
and girls, destroyed alongside power looms ... the breasts and flanks and cunts
and eyes that Weston refused to exclude from his monumentally concupiscent
lifework: all these images, made to teach or move or delight, are as remote from
us as the Great Wall of China, which casts its intricate system of shadows (how
closely we have studied the pictures!) over lands I shall never see. All photo-
graphs converge, whatever the motive that first prompted their making, in an
aestheticism that ought to be, by now, notorious. Why, then, do we tolerate
their presence among us? They are, surely, better than nothing; but so is every-
thing else ... and the answer is simpler than that anyhow: they are, or are about
to be, *all that we have*.

But they are, in an exact sense, all that we have ever had: there can be
no mourning, because nothing has been lost. What we have called Innocence,
and identified in that sad moment when the mind abandons its encounter
with a world that includes itself, clearly belongs among the humiliating inven-
tions of senescence; that childhood from which we all recede is brightened by
Experience, which we take to be an enterprise of discovery that defines, and
creates anew, consciousness itself: the supreme mediator.

[ ]

[At this point, I seem to find a lacuna in my manuscript. I do not pretend to
understand what became of the rest of it; at the very moment when my reader
must have urged that I get around, finally, to writing about Leslie Krims's
photographs, I found myself obliged to consider the needs of those who
might have come to do other than scan marks upon a surface. I had hoped, as I
recall, to introduce strangers already favorably disposed toward one another

... and to relinquish the opportunities of the essayist. Some such paradoxical ambition (to write oneself speechless) I seem to have achieved by default. What remains is a prolegomenon; it is, as it should be, entirely contingent upon the rewarding density of Krims's work. I have known that work longer than I have known the artist, and feel for both something larger than respect: the contours of affection are, in every case, what we find out for ourselves.

The problematics of a possible art of photography are those of a text under extreme pressure, both from without (that is, from language, on the one hand, and from the respectable visual arts on the other) and from within: only weariness can condone forgiving as philosophic naiveté the incomparable levity of most photographers, who have traditionally dismissed art in favor of a polemical nonesuch suspended somewhere or other between the anecdotal and the retinal. To seek to extricate, from the accumulated images, a photographic discourse, is to confront an historic surface replete with digressions, qualifications, variant readings, alternative formulations, contradictions—all set off in the visual equivalents of quotation marks, inverted commas, parentheses, brackets, vincula, braces . . . or else in footnotes and marginalia that far outbulk, and long ago submerged, the codex itself. So that I may, for all I know, have written at some length about the strategies by which Krims castigates this problematics of photography and, through it, much that is radiant and terrible in our life. In any case, a puzzling fragment is all that is left to add:]

[ ]

... who can only find pleasure in classification might derive an inventory, a litany, a crescendo of dereliction. Let's hear it.

"I've lost my Innocence!"

"I've lost my Rubber Duck!"

"I've lost my place in the book!"

"I've lost my virginity!"

"I've lost my appetite!"

"I've lost my self-esteem!"

"I've lost the affection of my lover!"

"I've lost my self-control!"

"I've lost my way!"

"I've lost my mind!"

After Ives (to name yet another) such hierarchic modulations offer nothing beyond satisfaction. Leslie Krims, virtually alone, succinct as a firecracker, summarizes in his work the predicament of Experience: "I find myself at a loss!"

Hollis Frampton
Eaton, New York
September 1975

Introduction to *Fictcryptokrimsographs: A Book-Work by Les Krims* (Buffalo, N.Y.: Humpy Press, 1975).

## Pictures, Krims's Pictures, *PLEASE!*

For the reason that it preexists any living spectator, photography is as ancient as any other mode of artistic production, and our ways of knowing photographs are as riddled with unexamined assumptions as our ways of knowing music, poetry, or dance. Moments of radical change in artistic practice typically challenge those assumptions at unrecognized levels: made newly visible, they momentarily opacify the intellectual surface of a work. It is a task of criticism to facilitate an historical process that eventually restores transparency to such work, familiarizes its principles … and, in normalizing it, forcing its embedding culture to metabolize it, ages it and makes the newly old work newly available to the cataclysmic analyses of the truly new.

Examples abound. Ezra Pound's *Cantos* were, for a time, illegible in proportion as they ignored customary bardic subvocalization, expanding the options of a poetics of the printed page invented by Mallarmé. It is a crucial insight of Samuel Beckett's that the theater is a bounded public space into which a number of people are staring in the expectation that something will happen, as well as (or instead of) a written text to be examined at private leisure. Above all, the advent of photography initiated, and its persistence has sustained, a crisis in the Western notion of representation that has spread beyond the visual and saturates our culture with undigested opportunities and hyperbolic irresolutions. We have only begun to invent tools that will help us to imagine and say what the presence of photography is to mean to us: this effort of imagination and pressure of speech, eventual progenitor of understanding, leaves us quite at sea, because where we once thought in language we now find that we think, more often than we know, in photographs. The world without the image is, literally, as unthinkable as the world without the word.

We assume, then, that there are certainties in our knowledge of, and through, photographs. An extended generation of photographers dominated the propagation of the photographic code (and the distribution of photographs) by enforcing their belief that the legibility of photographs is directly dependent upon a credibility guaranteed by ontological association with a pretext. But a photograph is, above all, a sign of the radical *absence* of its pretext. To validate the prior existence of another object from a photograph is to commit a novel sin, whose consequent improbability is an assertion that document (whatever that is) and fiction (whatever that is) may be rigorously distinguished from each other by an automatic process.

All of Leslie Krims's work proceeds from a crucial recognition that this is simply not so, and thus participates in an enterprise of dissolution of the fictitious boundary between the sciences and the arts. Like a theorem of mathematics or a triumph of cuisine, a viable work of art, for Krims, must first be constructed in the mind before it can be made present to the senses: art is not to be found, like oxygen or libido, free in nature, but rather, like some radioactive substance, augments nature over a period determined by its social half-life, and must be renewed, remanufactured. Ideas reside in things, and complex ideas in concatenations of things, precisely because the work of consciousness put them there in the first place.

This stubborn contemplation of the limits of fiction does not, of course, originate with Krims: we detect its first occasion in some of Talbot's salt prints ... and nostalgia for the codes of hunting and mining cultures (idealist atavisms that classified the photograph as blood-trace spoor or outcropping of a more privileged and other reality) traverses the spectacle of systematic neglect accorded a Rejlander or a Mortensen. Rather, we honor in Krims's work the prodigious, strategic energy with which he has encapsulated that perception, and derived its corollaries. His first published images represented fortuitous samples of empirical events as incredible; his mature photographs invent intricate fictions that present themselves to us as articles of unconditional surrender. Leslie Krims's workroom is a factory of facts.

In *PLEASE!* we are given, apparently, a record of a series of events that should never have transpired.[1] By the skill of the photographer, we are vouchsafed night vision. A blind woman well into middle life, turned out in a way that invites anything but charity, attempts to beg in the empty nocturnal streets of a devastated modern industrial city. She is isolated and centered, as well, within a circular pool of illumination, whose separation from the shadowy remainder of the surface at which we are actually looking is at least four times inscribed. This circle is a spotlight directed into a performative arena, the hypostatic center of a theater of undivided attention; it is that constricted place within which all ecstatic or disastrous encounters take place (our own impending sudden collision with a derelict in the streets, her own longstanding perfect distance from what surrounds her); it is an abrupt circumscription of the foveal mode of scanning encouraged by long habituation to written text ... and categorically inappropriate to image and word alike; it proposes a contravention of a decorum of rectilinearity hallowed by the engines of Euclidean convenience and commercial profit.

The tableaux that we seem to see are typical; they are transformed into exoticisms through a standardized prodigy of craft. What is unexpected here

is the enunciation of a fictive blindness, which violently aborts our axiomatic spectatorial voyeurism by denaturing the implicit returned gaze of our counterpart, the assumed exhibitionist whom we watch. To know is to see: in many natural languages, the verbs are cognate. By a drastic convention worthy of Gertrude Stein, those who see not know nothing of their own appearance: the surface of oneself is as distant as the eye of the beholder. The surfaces of these mute and eloquent sheets of paper (and to examine them is *our* only verifiable act) know nothing of how they appear, and are unaware of our gaze. We are in the presence of an allegory on the defects of knowledge acquired through the eye alone, for the retinal mind sees what its culture would have it see. We who look must sustain entire responsibility for the act of seeing.

It has never been otherwise. All those instants of pity and terror that transfix us in these photographs never passed. The only event that recommends itself to us began when *PLEASE!* came into our hands; its precipitate is a comedy that resolves at once in favor of the photographer, his model, and ourselves: spectators whose welcome duty is to build an understanding of this work and whose hard privilege is to determine its future. Leslie Krims, as always, offers to that duty, this privilege, another beginning.

HF, Buffalo, January 17, 1982

**Note**

1. *PLEASE!* was the title of a solo exhibition of Leslie Krims's photographs, held at the Phototheque of Thessaloniki, Greece, in 1980. (B.J.)

Unpublished text.

# Notes on Marion Faller's Photographs

The photograph is a chimera: two beasts, pretext and text, occupy the fragile body of the image, contending for space in the spectator's consciousness. The photographer is a similar monster: carnivorous perpetrator, slicing raw artifacts from the optical continuum ... and agrarian witness, domesticating the exotic, hybridizing the familiar. Photographic act and machine intersect in a paradoxical automaton whose motive is everywhere; photographs are propagated by the whole culture, requiring no intervention by those special effigies called Artists. Thus, the generic photograph is as permeant as language, without which thought itself was once unthinkable. It has preempted description, the indispensable precursor of discourse, permanently inflecting literary and visual poesis. During the past decade, as a proscriptive consensus that doomed the photograph to merely seminal status has revealed its own poverty, we have come to understand that photography may be thought's instrument and substance as well as its occasion.

That same decade encloses Marion Faller's artistic maturation, and the public emergence of her work. Ms. Faller is one of a sparse generation whose practice has forced a radical transvaluation within photography and elevated its level of discourse ... and whose shared predicament has consisted most of all in the luxury of alienation from the normative art world and its valorizing apparatus. The body of her work (the present exhibition only suggests its magnitude) presents her as typical of this generation, and as a considerable master within it.

The customary place of the photograph as commemoration, illustration, and mediator to the twin impulses of voyeurism and exhibitionism is acknowledged and ironically anatomized into a psychosocial typology. The claims of painting and its allies, and of paraliterary language, are confronted and abruptly engulfed, in a gesture that invites an expanded definition of the art and of its role in the economy of the intellect. An affinity for series produces both an inventory of photographic rhetoric and the beginning of a new, atemporal montage. That this photographer is a woman is inscribed in these images with rich candor, and with a grand intimation of the utopian humor that the accident of physical gender may one day come to elicit—a humor not lacking in compassion for whatever sex happens to be the other.

Marion Faller's enterprise is, in the most welcome sense, ambitious: aesthetically, philosophically, politically. Better, the scope of that enterprise is

still under construction. Best of all, the wit and grace with which it is joined make her work entirely unique.

Hollis Frampton, January 1981

Brochure text for the exhibition *Marion Faller/Photographs*, Edith Barrett Gallery, Utica College of Syracuse University, Utica, New York, March 22–April 17, 1981.

# Proposal for *ADSVMVS ABSVMVS*

Funding is requested for a photographic project that falls within the general category of Artists' Books.

One general, public assumption about photographs is that the process of photographic representation amounts to a preservation or embalming process. The lost presence of the photographed thing, person, situation is invoked through a mummified echo, reduced to a husk of the light that once revealed it. The photographic likeness bears a distant, partial, decolorized, or muted resemblance to its "subject"; at the same time, it has unique qualities of its own, which are entirely independent of what it depicts. Every photograph is potentially a keepsake, like a lock of hair, and a *memento mori*.

For some years I have been interested in this abstract process of preservation, and its symmetry with natural processes of mummification where the contour of the once living thing is recognizably retained. I have made a collection of such "autographic likenesses" of animals. They range from upstate—New York road kills, flattened and sun-baked, to dried fish and squid in oriental food markets: a single general process and appearance, metaphorically reminiscent of the photographic image, covers a range from the blatantly morbid through the grotesque and sentimental to the edible. Like photographs, as well, they are remarkable objects in themselves.

The proposed project will close the circle between these two sorts of likeness. I will make a portfolio of about fifteen 16-by-20 color prints of photographs of these formerly living objects; the photographs will be accompanied by a printed text. The edition will be limited to sixteen sets, of which one will be donated to Light Work/Community Darkrooms in Syracuse and another to the Visual Studies Workshop Research Center in Rochester. Two sets will be retained as Artist's Proofs, and the remaining twelve offered for sale at a currently competitive price. All of the portfolios will be individually signed and numbered.

A single set of photographs will be matted and framed. Light Work/Community Darkrooms is committed to exhibiting the series on completion.

I anticipate this project will be completed within six months of funding.

A note may be in order about my qualifications for carrying out such a project. Although the largest part of my work for the past fourteen years has been in film, I have continued to work in still photography on an occasional basis. I would point out that I once worked for ten years as a laboratory technician, making what were then called "Type C" prints and dye transfers. I have taught color and black-and-white still photography at the university level, and have published a body of critical writing on photography. A copy of my current vita is enclosed.

Grant proposal submitted to Light Work/Community Darkrooms, Syracuse, New York, 1981.

## ADSVMVS ABSVMVS

In memory of Hollis William Frampton, Sr.
1913–1980
*abest*

The author has come to suppose that he conserved the things represented herewith against the day when they were to be photographed, understanding them to harmonize with photographs then unmade according to a principle within the economy of the intellect. A photographic text and its proper pretext bear the following resemblance to one another: each is a sign of the perfective absence of the other.

In the unimaginable or ordinary case of their copresence, an object and its picture, contending for the center of the spectatorial arena, induce, out of mutual rejection, an oscillation of attention whose momentary frequency is the implicit *cantus firmus* of our thought. If we understand but poorly our own notion of likeness between paired entities, we understand even less the manner in which entities are like, or unlike, or may come to be like, or unlike, themselves. This indisposition depends from a temporary defect: that we have not yet evolved to comfort in the domain of time, our supreme fiction, which parses sets of spaces in favor of successiveness.

But before there were photographs, there were autographs, or happenstances whereunder bounded vacations of matter generate asexual artifacts, reproductions of themselves, necessarily incomplete: desiccations, fossils, memories, mummies, traces indistinguishable from residues. Appearances like these, found free in nature, command our attention, for they present to us, hovering at the margins of legibility, a collocation of failed instants when matter seems about to invent, in comparison and its precedent recollection, the germ of consciousness. Nature, or the customary behavior of matter, implies the photographic image at least as certainly as it implies ourselves. Accordingly, since they predate us, photographs may be treated scientifically.

Fourteen argued plates are appended. The author acknowledges that their identifications are as probabilistic as the captions of all photographs, thereby suggesting that taxonomy is an incomplete discipline.

Hollis Frampton, 1982

## Untitled I–XIV from *ADSVMVS ABSVMVS*, 1982

Ektacolor photographs. Collection Walker Art Center,
Minneapolis, Clinton and Della Walker Acquisition Fund, 1993
Courtesy Walker Art Center

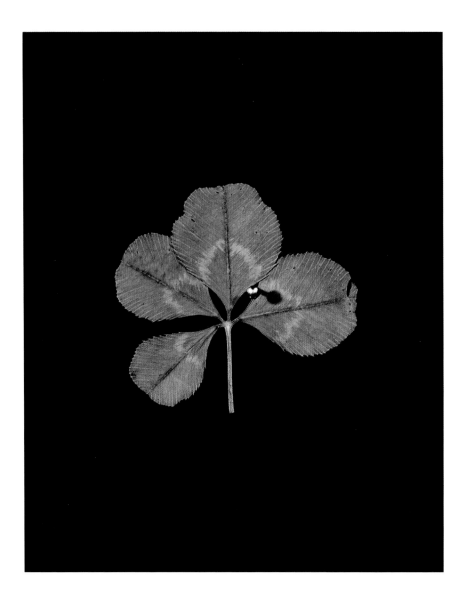

I. WHITE CLOVER (*Melilotus alba*)

This specimen was found by Marion Faller in an established escape well within
the drip-line perimeter of a crack willow in the Town of Eaton, New York,
in July 1977. Good fortune emanates from ownership of the consequence of a
chromosomal ambiguity in this leguminous herb. As the number of leaves
is incremented, luck increases exponentially. For related but inferior species,
that increase is merely arithmetic. Even numbers greater than three
govern cards, odd numbers, love. The nectar is edible, but disappointingly
weak considering the exercise required to extract it.

## II. JELLY (*Physalia physalis*)

This remnant of a specimen was purchased by the author in February 1982 from
J & S Oriental Grocery on Erie Boulevard in Syracuse, New York. The stinging
coelenterate, not a true jellyfish, is perfectly congruent with the virulent Portuguese
Man O'War of the Atlantic and is fished for food in the Sea of Japan. Only the
flotation bladder is available at market, since the jellyfishermen reserve for their
own households the finest portion, the mouth parts, which they call the head.
Once desalinated and rehydrated, the bladder is sliced into strips and eaten raw,
alone, or perhaps with cold chicken, juliennes of cucumber, and a light purée
of sesame. In appearance and first texture, this food resembles classic india rubber
bands, but it retrieves for the palate something of the childish adventure of
jumping on beached bell jellies after a hard sea storm: ever so momentarily, they
resist, and then, suddenly, pressed, liquefy and vanish, leaving behind an
everlasting sensation.

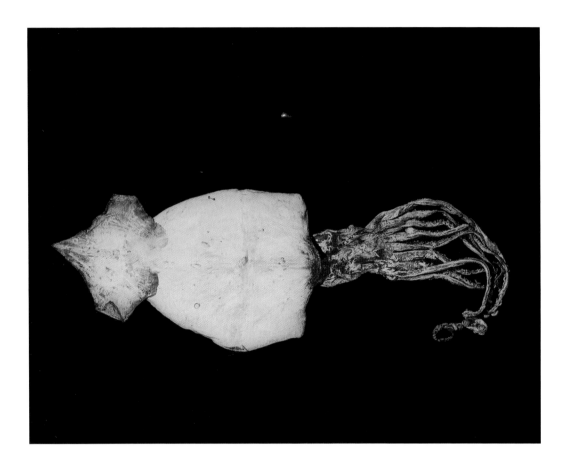

### III. CUTTLEFISH (*Rossia mastigophora*)

This specimen, one of a pair costing $1.39, was purchased by the author at King
Chong Company, Bayard Street, Manhattan, in November 1981. Its chalky or
calcærous braincap, called ossa sepia, has been excised for sale to the canary trade,
as well as the little sac in which it carried with it a calamitous portable tint of
night. The flesh of the genus is more savory, more pensive, less yielding to the
teeth than that of other cephalopods, who invite being eaten carelessly,
with quick, flashing bites.

IV. CHIMÆRA (*Callorhynchus capensis*)

This specimen was purchased by the author at a marine curio shop on Fisherman's
Wharf, San Francisco, in April 1980, for five dollars. Its stated provenance
was Hong Kong, and we may conjecture that the genus appears as an adulterant
among edible catches dragnetted in easterly effluents from the Indian Ocean.
The present apparition is an artificial fetish, made by incising the fish along its
dorsal edge. It is then opened like a pamphlet, drawn, dried, varnished, and
the result prepared for hanging as a wall decoration by twisting a noose of thin
copper wire about what passes for a neck. That wire has been removed: its presence
implied a false narrative, since fish are never garroted or executed by hanging.

### V. LOTUS (*Nelumbo nucifera*)

These specimens were purchased by the author in June 1980 from J & S Oriental Grocery on Erie Boulevard in Syracuse, New York, as part of a packet of fourteen costing seventy-nine cents. The species is prized only for the edibility of the immature tuber represented here; unlike the sort from Gondwanaland, it never harbors jewels. The ancient euphoric psychotropic of the Nile valley derived from the fruit of a tree, *Zizyphus lotus*, of the buckthorn family.

## VI. MIDSHIPMAN (*Porichthys notatus*)

This specimen, one of a pair costing $1.49, was purchased by the author at William's Market in Mattydale, New York, in October 1979. Its tail is bowdlerized, having been surreptitiously gnawed some months later by Maxwell, a cat. The species, a notorious whistler and a schooler of subtropical shallows, is customarily seined, by hand or from rowboats, in Thai waters, where it is often chopped or shredded and pickled in a sour, peppery escabeche. From anatomical evidence, it is clear that this fish subsists on a diet of smaller fish and possesses only moderate vertical mobility. It was mislabeled, though, as pollack (*Pollachius virens*), a commercially important codlike fish of the North Atlantic, shaped less like a cudgel, which appears at table even more seldom than hake.

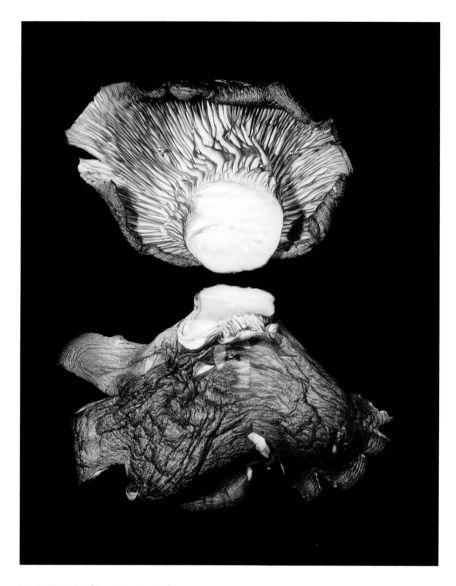

VII. OYSTER SHELL (*Pleurotus ostreatus*)

These specimens were gathered, among a vast recurrent troop, by the author, in the company of Gerald Church, Postmaster in the village of Eaton, New York, on a raw morning at the beginning of November 1981. Fresh or dried and reconstituted, the abundant meat of this fungus is of unusual tensility. At least three races may be distinguished by the tone of the slightly viscid cap, which may vary from opalescent white through pale gray to a strong yellowish beige. Invariably, the gills of mature bodies are foraged by a small beetle whose presence is positively diagnostic of a choice species well distributed throughout the North temperate zone. It is one of two fully domesticated edible fungi, the other being a strain of *Agaricus campestris* propagated on beds of clay and composted horse dung in the abandoned anthracite mines of Pennsylvania. In Japan, this *Pleurotus* is domesticated on rotting elm logs. The author has obtained it wild, as well, from senescent maples and from standing beech (*Fagus americana*) in seeming health; but the establishment of its mycelium is always a sign of pathology in the host.

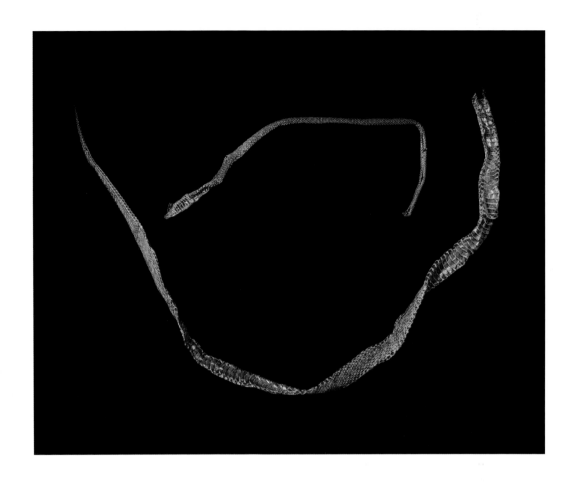

VIII. COMMON GARTER (*Thamnophis sirtalis*) and EASTERN COACHWHIP
(*Masticophis flagellum*)

Vacated winter skins, found in the summer of 1980, in a vegetable garden in
the Town of Eaton, New York, are proposed as standards for a new system of
measurement. These benign reptiles, insectivore and constrictor respectively,
are alleged to hear through their tongues. They are enjoyed by diurnal
predatory birds and universally deprecated by fools.

IX. GARDEN TOAD (*Bufo americanus*)

This specimen was donated by Mary Emmaline Bryant, then of Poolville, New York, in August 1979. The author suspects that her gift was prompted by the creature's imaginary tactile symmetry with certain grotesque or exotic fungi, of indeterminate identity, which he had gathered on that pleasant day, whereafter he stopped in Poolville to show them to her family and drink a bottle of beer. Constantin Brancusi maintained that toads are more handsome than Michelangelo's statues, but he referred to the modest French park toad. The drug bufagin, a cardiac stimulant and vasodilator, brewed from Chinese toads during the Chou and Former Han, and rediscovered in the West in the early 1950s, has never been synthesized and may have fallen into medical desuetude or disrepute. Its scarcity in purified form is pendant to the deserved unpopularity of toad catching as an adult vocation: toads defend themselves in a perennially surprising way.

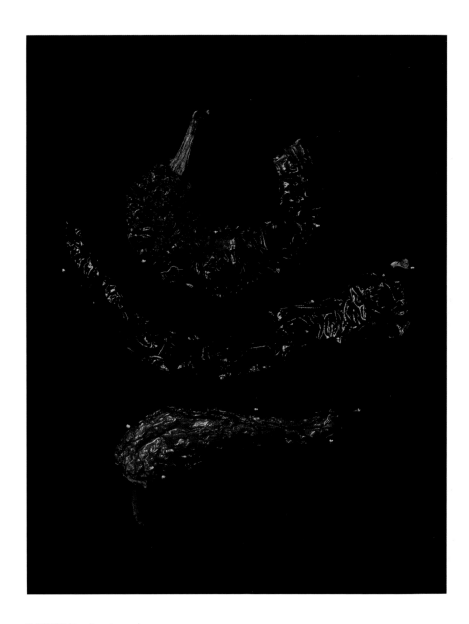

**X. PEPPER** (*Capsicum longum*)

These specimens, dried at various ages, were grown by Marion Faller in her
vegetable garden in the Town of Eaton, New York, during the summer of 1981.
This preservative method steals something of the peppers' piquancy, but it
enhances their essence and imparts to them a lucency of unexcelled saturation.
Because it is a triumph to raise jalapeños on the Allegheny Plateau, where
the growing season is barely a hundred days long, we determined to celebrate
the first big harvest with a feast. For an afternoon, I parched and flayed,
she stuffed with three farces, we sauced and baked. Ah!

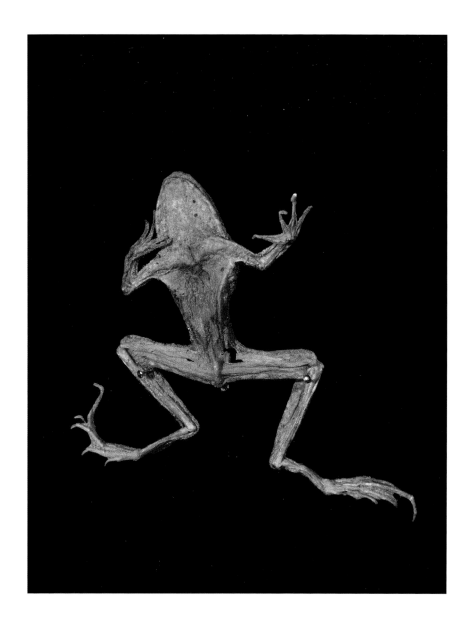

XI. GRASS FROG (*Rana pipiens*)

This specimen was discovered by Will Faller, Jr., in May 1981, on the shoulder
of a macadam road in Randallsville, Town of Lebanon, New York. The timid soprano
amphibian becomes highly vocal under collective sexual arousal, improvising
stochastic nocturnal choruses of considerable elegance. It is nominally edible
but meager.

**XII. MOURNING DOVE (*Zenaidura macroura*)**

This immature specimen was found by Bill Brand during the demolition of a wall in the Town of Eaton, New York, in July 1975. The genus is never iridescent, but it is soothing in appearance as in voice and graceful in its habits. The squabs are reputedly delicious but are rarely to be gathered in quantity.

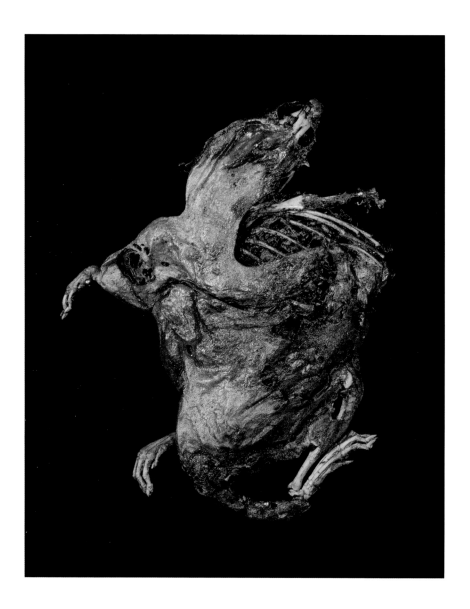

## XIII. BROWN RAT (*Rattus rattus*)

This young adult specimen, enhanced by two spray applications of a cellulose acetate fixative, was discovered by Adam Mierzwa in May 1973 in the course of partially dismantling a house in the Town of Eaton, New York. The cause of its virtually total depilation is unknown. A rural pest, graminivorous by preference, the species constitutes the permanent North American reservoir of bubonic plague, and must not be confused with *Rattus norvegicus*, its urban counterpart. Inedible by custom, the genus *Rattus* is prized as a delicacy in Easter Island, whither it was brought by European explorers. The author wishes that its site of delectation might have been displaced to Yap, in proximity to superior megaliths.

## XIV. ROSE (*Rosa damascena*)

This specimen was taken by the author as a keepsake from a funeral wreath at
Millersburg, Ohio, on March 5, 1980. The mature fruit, a hip, anatomically
cognate with apples and pears but unusual among most cultivars of this species,
is edible and contains appreciable quantities of ascorbic acid. Formerly, petals
were smoked by the Queen of Siam and offered for that use to guests during
royal audiences; when strewn in the paths of the brilliant, or of heads of state,
they are a sign of acclaim.

Untitled from *A Visitation of Insomnia*, 1970–1973
Black-and-white photograph. Collection Walker Art Center,
Minneapolis. © Estate of Hollis Frampton
Courtesy Walker Art Center

# FILM

# A Lecture

Please turn out the lights.

As long as we're going to talk about films, we might as well do it in the dark.

We have all been here before. By the time we are eighteen years old, say the statisticians, we have been here five hundred times.

No, not in this very room, but in this generic darkness, the only place left in our culture intended entirely for concentrated exercise of one, or at most two, of our senses.

We are, shall we say, comfortably seated. We may remove our shoes, if that will help us to remove our bodies. Failing that, the management permits us small oral distractions. The oral distractions concession is in the lobby.

So we are suspended in a null space, bringing with us a certain habit of the affections. We have come to do work that we enjoy. We have come to watch *this*.

*The projector is turned on.*

So and so many watts of energy, spread over a few square yards of featureless white screen in the shape of a carefully standardized rectangle, three units high by four units wide.

The performance is flawless. The performer is a precision machine. It sits behind us, out of sight usually. Its range of action may be limited, but within that range it is, like an animal, infallible.

It reads, so to speak, from a score that is both the notation and the substance of the piece.

It can and does repeat the performance, endlessly, with utter exactitude.

Our rectangle of white light is eternal. Only *we* come and go; we say: This is where I came in. The rectangle was here before we came, and it will be here after we have gone.

So it seems that a film is, first, a confined space, at which you and I, we, a great many people, are staring.

It is only a rectangle of white light. But it is all films. We can never see *more* within our rectangle, only *less*.

*A red filter is placed before the lens at the word "red."*

If we were seeing a film that is *red*, if it were only a film of the color red, would we not be seeing more?

No.

A red film would *subtract* green and blue from the white light of our rectangle.

So if we do not like this particular film, we should not say: There is not enough here, I want to see more. We should say: There is too much here, I want to see less.

*The red filter is withdrawn.*

Our white rectangle is not "nothing at all." In fact it is, in the end, all we have. That is one of the limits of the art of film.

So if we want to see what we call *more*, which is actually *less*, we must devise ways of subtracting, of removing, one thing and another, more or less, from our white rectangle.

The rectangle is generated by our performer, the projector, so whatever we devise must fit into it.

Then the art of making films consists in devising things to put into our projector.

The simplest thing to devise, though perhaps not the easiest, is nothing at all, which fits conveniently into the machine.

Such is the film we are now watching. It was devised several years ago by the Japanese composer Takehisa Kosugi.

Such films offer certain economic advantages to the filmmaker.

But aside from that, we must agree that this one is, from an aesthetic point of view, incomparably superior to a large proportion of all films that have ever been made.

But we have decided that we want to see *less* than this.

Very well.

*A hand blocks all light from the screen.*

We can hold a hand before the lens. This warms the hand while we deliberate on *how much less* we want to see.

Not so much less, we decide, that we are deprived of our rectangle, a shape as familiar and nourishing to us as that of a spoon.

*The hand is withdrawn.*

Let us say that we desire to *modulate* the general information with which the projector bombards our screen. Perhaps this will do.

*A pipe cleaner is inserted into the projector's gate.*

That's better.

It may not absorb our whole attention for long, but we still have our rectangle, and we can always leave where we came in.

*The pipe cleaner is withdrawn.*

Already we have devised four things to put into our projector.

We have made four films.

It seems that a film is anything that may be put into a projector that will modulate the emerging beam of light.

For the sake of variety in our modulations, for the sake of more precise control of what and how much we remove from our rectangle, however, we most often use a specially devised material called: *film.*

Film is a narrow transparent ribbon of any length you please, uniformly perforated with small holes along its edges so that it may be transported handily by sprocket wheels. At one time, it was sensitive to light.

Now, preserving a faithful record of where that light was, and was not, it modulates our light beam, subtracts from it, makes a vacancy that looks to us like, say, Lana Turner.

Furthermore, that vacancy is doing something: it seems to be moving.

But if we take our ribbon of film in hand and examine it, we find that it consists of a long row of small pictures, which do not move at all.

We are told that the explanation is simple: *all* explanations are.

The projector accelerates the small still pictures into movement. The single pictures, or frames, are invisible to our failing sense of sight, and nothing that happens on any *one* of them will strike our eye.

And this is true, so long as all the frames are essentially similar. But if we punch a hole in only one frame of our film, we will surely see it.

And if we put together many dissimilar frames, we will just as surely see all of them separately. Or at least we can *learn* to see them.

We *learned* long ago to see our rectangle, to hold all of it in focus simultaneously. If films consist of consecutive frames, we can learn to see *them* also.

Sight itself is learned. A newborn baby not only sees poorly—it sees upside down.

At any rate, in some of our frames we found, as we thought, Lana Turner. Of course she was but a fleeting shadow—but we had hold of something. She was what the film was *about*.

Perhaps we can agree that the film was about *her* because she appeared oftener than anything else.

Certainly a film must be about whatever appears most often in it.

Now, suppose Lana Turner is not always on the screen.

Suppose further that we take an instrument and scratch the ribbon of film along its whole length.

Then the scratch is more often visible than Miss Turner, and the film is about the scratch.

Now suppose that we project all films. What are they about, in their great numbers?

At one time and another, we shall have seen, as we think, very many things.

But only one thing has *always* been in the projector.

Film.

That is what we have seen.

Then that is what all films are about.

If we find that hard to accept, we should recall what we once believed about mathematics.

We believed it was about the number of apples or peaches owned by George and Harry.

But having accepted that much, we find it easier to understand what a filmmaker does.

He makes films.

Now, we remember that a film is a ribbon of physical material, wound up in a roll: a row of small unmoving pictures.

He makes the ribbon by joining large or small bits of film together.

It may seem like pitiless and dull work to us, but he enjoys it, this splicing of small bits of anonymous stuff.

But where is the romance of movie-making? the exotic locations? the stars?

The film artist is an absolute imperialist over his ribbon of pictures.
But films are made out of footage, not out of the world at large.

Again: Film, we say, is supposed to be a powerful means of communication.
We use it to influence the minds and hearts of men.

But the artist in film simply goes on building his ribbon of pictures, which is at least something he understands a little about.

The pioneer brain surgeon, Harvey Cushing, asked his apprentices:
Why had they taken up medicine?

To help the sick.

But don't you enjoy cutting flesh and bone? he asked them. I can't teach men who don't enjoy their work.

But if films are made of footage, we must use the camera. What about the romance of the camera?

And the film artist replies: A camera is a machine for making footage.
It provides me with a third eye, an acutely penetrating extension of my vision.

But it is also operated with my hands, with my body, and keeps them busy, so that I amputate one faculty in heightening another.

Anyway, I needn't really make my own footage. One of the chief virtues in so doing is that it keeps me out of my own films.

We wonder whether that interferes with his search for self-expression.

If we dared ask, he would probably reply that self-expression interests him very little.

He is more interested in recovering the fundamental conditions and limits of his art.

After all, he would say, self-expression was only a separable issue for a very brief time in history, in the arts or anywhere else. And that time is about over.

Now, finally, we must recognize that the man who wrote the text we are hearing read has more than a passing acquaintance and sympathy with the filmmaker we have been questioning.

For the sake of precision and repeatability, he has substituted a tape recorder for his personal presence—a mechanical performer as infallible as the projector behind us.

And to exemplify his conviction that nothing in art is as expendable as the artist himself, he has arranged to have his text recorded by a different filmmaker, whose voice we are hearing now.

Since the speaker is also a filmmaker, he is fully equipped to talk about the only activity the writer is willing to discuss at present.

There is still time for us to watch our rectangle a while.

Perhaps its sheer presence has as much to tell us as any particular thing we might find inside it.

We can invent ways of our own to change it.

But this is where we came in.

Please turn on the lights.

New York City, 1968

Text of lecture, Hunter College, October 30, 1968. Published in *Avant-Garde Film: A Reader of Theory and Criticism*, ed. P. Adams Sitney (New York: New York University Press, 1978), pp. 275–280. Reprinted in *Circles of Confusion* (Rochester, N.Y.: Visual Studies Workshop Press, 1983), pp. 193–199.

　　　For this lecture/performance, Frampton prerecorded his text on audiotape, using the voice of film-maker Michael Snow. A 16mm projector set to silent speed, a red gel and a pipe cleaner, the audio playback equipment, and a large screen were installed in the room. Frampton started the tape recorder and retired to the back of the hall to operate the projector. The version of the text used here follows minor revisions that appeared in its 1983 publication in *Circles of Confusion*. (B.J.)

# For a Metahistory of Film: Commonplace Notes and Hypotheses

The cinematograph is an invention without a future.

—Louis Lumière

Once upon a time, according to reliable sources, history had its own Muse, and her name was Clio. She presided over the making of a class of verbal artifacts that extends from a half-light of written legend through, possibly, Gibbon.

These artifacts shared the assumption that events are numerous and replete beyond the comprehension of a single mind. They proposed no compact systematic substitute for their concatenated world; rather, they made up an open set of rational fictions within that world.

As made things strong in their own immanence, these fictions bid as fairly for our contemplative energy as any other human fabrications. They are, finally, about what it felt like to reflect consciously upon the qualities of experience in the times they expound.

In order to generate insights into the formal significance of their pre-text (that is, "real history"), such fictions employ two tactics. First of all, they annihilate naive intuitions of causality by deliberately ignoring mere temporal chronology. And then, to our cultural dismay, they dispense, largely, with the fairly recent inventions we call facts.

These fictions were what we may call *metahistories* of event. They remain events in themselves.

[ ]

It is reasonable to assume that Dean Swift, desiring in his rage to confound the West, invented *the fact*.

A fact is the indivisible module out of which systematic substitutes for experience are built. Hugh Kenner, in *The Counterfeiters*, cites a luminous anecdote from the seed-time of the fact. Swift's contemporary savants fed dice to a dog. They (the dice) passed through the dog visibly unchanged, but with their weight halved. Thenceforth a dog was to be defined as a device for (among other things) halving the weight of dice.

The world contained only a denumerable list of things. Any thing could be considered simply as the intersection of a finite number of facts. Knowledge, then, was the sum of all discoverable facts.

Very many factual daubs were required, of course, to paint a true picture of the world; but the invention of the fact represented, from the rising mechanistic point of view, a gratifying diminution of horsepower requirement from

a time when knowledge had been the factorial of all conceivable contexts. It is this shift in the definition of knowledge that Swift satirizes in *Gulliver's Travels*, and Pope laments in *The Dunciad*.

The new view went unquestioned for generations. In most quarters it still obtains: from which it should be quite clear that we do not all live in the same time.

[ ]

Who first centered his thumbs on Clio's windpipe is anyone's guess, but I am inclined to blame Gotthold Lessing. His squabbling progeny, the quaintly disinterested art historians of the nineteenth century, lent a willing hand in finishing her off. They had Science behind them. Science favored the fact because the fact seemed to favor predictability. Hoping to incorporate prophecy wholesale into their imperium, nineteenth-century historians went whole hog for the fact, and headfirst into what James Joyce later called the "nightmare" of history.

There were, quite simply, too many facts.

They adopted the self-contradictory stratagem of "selecting" quintessential samples, and conjuring from them hundred-legged theories of practically everything. They had backed themselves into a discriminatory trap, and Werner Heisenberg wasn't there to save them: it was a time of utmost certainty.

[ ]

Isaac Newton spent the last part of his life writing a score of Latin volumes on religion: the nascent atomization of knowledge was a fierce wind from which he took shelter in his age. As young physicists, he and Leibniz had inherited the analytic geometry of Descartes, and the triumph of its use by Kepler to predict the motions of the planets. Algebraic equations dealt well enough with the conic sections, but Newton was absorbed by the motion of bodies that describe more intricate paths.

Complex movement in space and time was difficult to make over into numbers. The number "one" was much too large; the mathematical fact must be vastly smaller. Even the arithmetic unit was surely an immense structure built of tiny stones: infinitesimal *calculi*, indivisible increments.

Given that much, it was a short step to the assumption that motion consists of an endless succession of brief instants during which there is only stillness. Then motion could be factually defined as the set of differences among a series of static postures.

Zeno had returned with his paradoxes to avenge himself through the deadpan Knight of Physics.

[ ]

In the 1830s, Georg Büchner wrote *Woyzeck*. Évariste Galois died, a victim of political murder, leaving to a friend a last letter, which contains the foundations of group theory, or the metahistory of mathematics. Talbot and Niépce invented photography. The Belgian physicist Plateau invented the phenakistiscope, the first true cinema.

In the history of cinema, these four facts are probably unrelated. In the metahistory of cinema, these four events may ultimately be related.

Talbot and Niépce invented photography because neither of them could learn to draw, a polite accomplishment comparable to mastery of the tango later and elsewhere.

Plateau had the calculus in his mother's milk, so that its assumptions were for him mere reflex. He took an interest in sense perception and discovered, by staring at the sun for twenty minutes, one of our senses' odder failings, euphemistically called "persistence of vision."

His hybridization of a sensory defect with the Newtonian infinitesimal began vigorously to close a curve whose limbs had been widening since the invention of the alphabet.

Plateau's little device started putting Humpty Dumpty together again. Like dozens of other dead-end marvels, it became a marketable toy, and was succeeded by generically similar novelties: zoetrope, praxinoscope, zoopraxiscope.

All of them, unconsciously miming the intellectual process they instigated, took the form of spliceless loops: an eternity of hurdling horses and bouncing balls.

And they were all hand-drawn. Photography was not mapped back upon the sparse terrain of paleocinema until the first photographic phenakistiscope was made, three generations later.

[ ]

The union of cinema and the photographic effect followed a clumsy mutual seduction spanning six decades. There was a near assignation in the vast oeuvre of Eadweard Muybridge, before whose fact-making battery of cameras thousands paraded their curiously obsolete bodies.

In one sequence, piercingly suggestive of future intricacies, the wizard himself, a paunchy naked old man, carried a chair into the frame, sat down, and glared ferociously back at his cameras.

But the series suggested to Muybridge only the ready-made analogy of book space: successive, randomly accessible, anisotropic with respect to time. Accordingly, he published them as editions of plates.

The crucial tryst was postponed, to await the protection of two brothers bearing the singularly appropriate name of Lumière.

[ ]

The relationship between cinema and still photography is supposed to present a vexed question. Received wisdom on the subject is of the chicken/egg variety: cinema somehow "accelerates" still photographs into motion.

Implicit is the assumption that cinema is a special case of the catholic still photograph. Since there is no discoverable necessity within the visual logic of still photographs that demands such "acceleration," it is hard to see how it must ever happen at all.

It is an historic commonplace that the discovery of special cases precedes in time the extrapolation of general laws. (For instance, the right triangle with rational sides measuring 3, 4, and 5 units is older than Pythagoras.) Photography predates the photographic cinema.

So I propose to extricate cinema from this circular maze by superimposing on it a second labyrinth (containing an exit)—by positing something that has by now begun to come to concrete actuality: we might agree to call it an *infinite cinema*.

A polymorphous camera has always turned, and will turn forever, its lens focused upon all the appearances of the world. Before the invention of still photography, the frames of the infinite cinema were blank, black leader; then a few images began to appear upon the endless ribbon of film. Since the birth of the photographic cinema, all the frames are filled with images.

There is nothing in the structural logic of the cinema filmstrip that precludes sequestering any single image. A still photograph is simply an isolated frame taken out of the infinite cinema.

[ ]

History views the marriage of cinema and the photograph as one of convenience; metahistory must look upon it as one of necessity.

The camera deals, in some way or other, with every particle of information present within its field of view; it is wholly indiscriminate. Photographs, to the joy or misery of all who make them, invariably tell us more than we want to know.

The ultimate structure of a photographic image seems to elude us at the same rate as the ultimate structure of any other natural object. Unlike graphic images, which decay under close scrutiny into factual patterns of dots or lines, the photograph seems a virtually perfect continuum. Hence the poignancy of its illusions: their amplitude instantly made the photograph—within the

very heart of mechanism—the subversive restorer of contextual knowledge seemingly coterminous with the whole sensible world.

Cinema could already claim—from within the same nexus—a complementary feat: the resurrection of bodies in space from their dismembered trajectories.

The expected consummation took place at quitting time in a French factory, on a sunny afternoon toward the end of the century, as smiling girls waved and cheered. The immediate issue was an exceptional machine.

[ ]

Typically, all that survives intact of an era is the art form it invents for itself. Potsherds and garbage dumps are left from Neolithic times, but the practice of painting continues unbroken from Lascaux to the present. We may surmise that music comes to us from a more remote age, when the cables were first strung for the vertebrate nervous system.

Such inventions originally served the end of sheer survival. The nightingale sings to charm the ladies. Cave paintings presumably assisted the hunt; poems, Confucius tells us in the *Analects*, teach the names of animals and plants: survival for our species depends upon our having correct information at the right time.

As one era slowly dissolves into the next, some individuals metabolize the former means for physical survival into new means for psychic survival. These latter we call art. They promote the life of human consciousness by nourishing our affections, by reincarnating our perceptual substance, by affirming, imitating, reifying the process of consciousness itself.

What I am suggesting, to put it quite simply, is that no activity can become an art until its proper epoch has ended and it has dwindled, as an aid to gut survival, into total obsolescence.

[ ]

I was born during the Age of Machines.

A machine was a thing made up of distinguishable "parts," organized in imitation of some function of the human body. Machines were said to "work." How a machine "worked" was readily apparent to an adept, from inspection of the shape of its "parts." The physical principles by which machines "worked" were intuitively verifiable.

The cinema was the typical survival-form of the Age of Machines. Together with its subset of still photographs, it performed prizeworthy functions: it taught and reminded us (after what then seemed a bearable delay) how things looked, how things worked, how to do things . . . and, of course (by example), how to feel and think.

We believed it would go on forever, but when I was a little boy, the Age of Machines ended. We should not be misled by the electric can opener: small machines proliferate now as though they were going out of style because they are doing precisely that.

Cinema is the Last Machine. It is probably the last art that will reach the mind through the senses.

It is customary to mark the end of the Age of Machines at the advent of video. The point in time is imprecise: I prefer radar, which replaced the mechanical reconnaissance aircraft with a static, anonymous black box. Its introduction coincides quite closely with the making of Maya Deren's *Meshes of the Afternoon*, and Willard Maas's *Geography of the Body*.

The notion that there was some exact instant at which the tables turned, and cinema passed into obsolescence and thereby into art, is an appealing fiction that implies a special task for the metahistorian of cinema.

[ ]

The historian of cinema faces an appalling problem. Seeking in his subject some principle of intelligibility, he is obliged to make himself responsible for every frame of film in existence. For the history of cinema consists precisely of every film that has ever been made, for any purpose whatever.

Of the whole corpus, the likes of *Potemkin* make up a numbingly small fraction. The balance includes instructional films, sing-alongs, endoscopic cinematography, and much, much more. The historian dares neither select nor ignore, for if he does, the treasure will surely escape him.

The metahistorian of cinema, on the other hand, is occupied with inventing a tradition, that is, a coherent, wieldy set of discrete monuments, meant to inseminate resonant consistency into the growing body of his art.

Such works may not exist, and then it is his duty to make them. Or they may exist already, somewhere outside the intentional precincts of the art (for instance, in the prehistory of cinematic art, before 1943). And then he must remake them.

[ ]

There is no evidence in the structural logic of the filmstrip that distinguishes "footage" from a "finished" work. Thus, any piece of film may be regarded as "footage," for use in any imaginable way to construct or reconstruct a new work.

Therefore, it may be possible for the metahistorian to take old work as "footage," and construct from it identical new work necessary to a tradition.

Wherever this is impossible, through loss or damage, new footage must be made. The result will be perfectly similar to the earlier work, but "almost infinitely richer."[1]

[ ]

*Cinema* is a Greek word that means "movie." The illusion of movement is certainly an accustomed adjunct of the film image, but that illusion rests upon the assumption that the rate of change between successive frames may vary only within rather narrow limits. There is nothing in the structural logic of the filmstrip that can justify such an assumption. Therefore we reject it. From now on we will call our art simply: film.

The infinite film contains an infinity of endless passages wherein no frame resembles any other in the slightest degree, and a further infinity of passages wherein successive frames are as nearly identical as intelligence can make them.

[ ]

I have called film the Last Machine.

From what we can recall of them, machines agreed roughly with mammals in range of size. The machine called film is an exception.

We are used to thinking of camera and projector as machines, but they are not. They are "parts." The flexible filmstrip is as much a "part" of the film machine as the projectile is part of a firearm. The extant rolls of film out-bulk the other parts of the machine by many orders of magnitude.

Since all the "parts" fit together, the sum of all film, all projectors, and all cameras in the world constitutes one machine, which is by far the largest and most ambitious single artifact yet conceived and made by man (with the exception of the human species itself). The machine grows by many millions of feet of raw stock every day.

It is not surprising that something so large could utterly engulf and digest the whole substance of the Age of Machines (machines and all), and finally supplant the entirety with its illusory flesh. Having devoured all else, the film machine is the lone survivor.

If we are indeed doomed to the comically convergent task of dismantling the universe and fabricating from its stuff an artifact called *The Universe*, it is reasonable to suppose that such an artifact will resemble the vaults of an endless film archive built to house, in eternal cold storage, the infinite film.

[ ]

If filmstrip and projector are parts of the same machine, then "a film" may be defined operationally as "whatever will pass through a projector." The least thing that will do that is nothing at all. Such a film has been made. It is the only unique film in existence.

[ ]

Twenty years ago, in the grip of adolescent needs to "modernize" myself, I was entranced by Walter Pater's remark that "all the arts aspire to the condition of music," which I then understood to approve of music's freedom from reference to events outside itself.

Now I expound, and attempt to practice, an art that feeds upon illusions and references despised or rejected by other arts. But it occurs to me that film meets what may be, after all, the prime condition of music: it produces no object.

The Western musician does not ordinarily make music; his notation encodes a set of instructions for those who do. A score bears the sort of resemblance to music that the genetic helix bears to a living organism. To exist, music requires to be performed, a difficulty that John Cage abjures in the preface to *A Year from Monday*, where he points out that making music has hitherto largely consisted in telling other people what to do.

The act of making a film, of physically assembling the filmstrip, feels somewhat like making an object: that film artists have seized the materiality of film is of inestimable importance, and film certainly invites examination at this level. But at the instant the film is completed, the "object" vanishes. The filmstrip is an elegant device for modulating standardized beams of energy. The phantom work itself transpires upon the screen as its notation is expended by a mechanical virtuoso performer, the projector.

[ ]

The metahistorian of film generates for himself the problem of deriving a complete tradition from nothing more than the most obvious material limits of the total film machine. It should be possible, he speculates, to pass from *The Flicker* through *Unsere Afrikareise*, or *Tom, Tom, the Piper's Son*, or *La Région Centrale*[2] and beyond, in finite steps (each step a film), by exercising only one perfectly rational option at each move. The problem is analogous to that of the Knight's Tour in chess.

Understood literally, it is insoluble, hopelessly so. The paths open to the Knight fork often (to reconverge who knows where). The board is a matrix of rows and columns beyond reckoning, whereon no chosen starting point may be defended with confidence.

Nevertheless, I glimpse the possibility of constructing a film that will be a kind of synoptic conjugation of such a tour—a Tour of Tours, so to speak, of the infinite film, or of all knowledge, which amounts to the same thing. Rather, some such possibility presents itself insistently to my imagination, disguised as the germ of a plan for execution.[3]

[ ]

Film has finally attracted its own Muse. Her name is Insomnia.

H.F.
Eaton, New York
June 1971

## Notes

1. The quotation is a reference to Jorge Luis Borges's 1939 short story "Pierre Menard, Author of Don Quixote," in which Borges describes the (fictional) character Menard's attempts to exceed the act of mere translation by producing a text that "would coincide—word for word and line for line—with those of Miguel de Cervantes." According to Borges, "The text of Cervantes and that of Menard are verbally identical, but the second is almost infinitely richer." See *Ficciones*, ed. Anthony Kerrigan (New York: Grove Press, 1962), p. 52. (B.J.)

2. Tony Conrad's *The Flicker* (1966), Peter Kubelka's *Unsere Afrikareise* (1961–1966), Ken Jacobs's *Tom, Tom, the Piper's Son* (1969), and Michael Snow's *La Région Centrale* (1971) were films made by Frampton's contemporaries that explored the materiality of the medium. (B.J.)

3. This is an early reference to Frampton's massive film cycle *Magellan*, which he began in 1972, the year after he wrote this essay. *Magellan* remained unfinished at the time of his death in 1984. (B.J.)

*Artforum* 10, no. 1 (September 1971): 32–35. Reprinted in *Circles of Confusion* (Rochester, N.Y.: Visual Studies Workshop Press, 1983), pp. 107–116.

A specter is haunting the cinema: the specter of narrative. If that apparition is an Angel, we must embrace it; and if it is a Devil, then we must cast it out. But we cannot know what it is until we have met it face to face. To that end, then, I offer the pious:

## A Pentagram for Conjuring the Narrative

I

Lately, a friend has complained to me that his sleep is troubled by a recurrent nightmare, in which he lives through two entire lifetimes.

In the first, he is born a brilliant and beautiful heiress to an immense fortune. Her loving and eccentric father arranges that his daughter's birth shall be filmed, together with her every conscious moment thereafter, in color and sound. Eventually he leaves in trust a capital sum, the income from which guarantees that the record shall continue, during all her waking hours, for the rest of her life. Her own inheritance is made contingent upon agreement to this invasion of privacy, to which she is, in any case, accustomed from earliest infancy.

As a woman, my friend lives a long, active, and passionate life. She travels the world, and even visits the moon, where, due to a miscalculation, she gives birth to a normal female baby inside a lunar landing capsule. She marries, amid scores of erotic adventures, no fewer than three men: an Olympic decathlon medalist, a radio astronomer, and, finally, the cameraman of the crew that follows her everywhere.

At twenty-eight, she is named a Nobel laureate for her pioneering research on the optical cortex of the mammalian brain; on her forty-sixth birthday, she is awarded a special joint citation by the Congress of the United States and the Central Committee of the People's Republic of China, in recognition of her difficult role in mediating a treaty regulating the mineral exploitation of Antarctica. In her sixty-seventh year, she declines, on the advice of her lawyers, a mysterious offer from the decrepit Panchen Lama, whom she once met, as a very young woman, at a dinner given in honor of the Papal Nuncio by the Governor of Tennessee. In short, she so crowds her days with experience of every kind that she never once pauses to view the films of her own expanding past.

In extreme old age—having survived all her own children—she makes a will, leaving her fortune to the first child to be born, following the instant of her own death, in the same city . . . on the single condition that such child shall spend its whole life watching the accumulated films of her own. Shortly thereafter, she dies, quietly, in her sleep.

In his dream, my friend experiences her death; and then, after a brief intermission, he discovers, to his outraged astonishment, that he is about to be reincarnated as her heir.

He emerges from the womb to confront the filmed image of *her* birth. He receives a thorough but quaintly obsolete education from the films of *her* school days. As a chubby, asthmatic little boy, he learns (without ever leaving his chair) to dance, sit a horse, and play the viola. During his adolescence, wealthy young men fumble through the confusion of *her* clothing to caress his own unimaginable breasts.

By the time he reaches maturity, he is totally sedentary and reclusive, monstrously obese (from subsisting on an exclusive diet of buttered popcorn), decidedly homosexual by inclination (though masturbation is his only activity), hyperopic, pallid. He no longer speaks, except to shout "FOCUS!"

In middle age, his health begins to fail, and with it, imperceptibly, the memory of his previous life, so that he grows increasingly dependent upon the films to know what to do next. Eventually, his entire inheritance goes to keep him barely alive: for decades he receives an incessant trickle of intravenous medication, as the projector behind him turns and turns.

Finally, he has watched the last reel of film. That same night, after the show, he dies, quietly, in his sleep, unaware that he has completed his task . . . whereupon my friend wakens abruptly, to discover himself alive, at home, in his own bed.

## II

Whatever is inevitable, however arbitrary its origins, acquires through custom something like gravitational mass, and gathers about itself a resonant nimbus of metaphoric energy.

I can recall, from my childhood, a seeming infinitude of Japanese landscape photographs that included, inevitably, the image of Fujiyama. Naively, I attributed this to native reverence for the holy mountain. The rare or imaginary exception ached mysteriously, in the distant planes of its illusion, for the absent mass—as if a great truncated cone of displaced air could somehow refract the energy of consciousness, as surely as solid rock reflected more visible light.

Later on, I came to understand that Fujiyama is visible from absolutely every place in Japan, and that it looms from every direction at once. In that distant country, every single act of perception must include (must indeed be fused inextricably with) its proper coeval segment of an enterprise of the mind incomparably vast and continuous: the contemplation of the inevitable Mountain.

A stable pattern of energy had once locked granite and ice into a shape immutable beyond human recollection or surmise; that same pattern formed, over long ages, the very physical minds of its beholders, as magnetic forces trace in steel dust the outline of a rose. So that, eventually, all things were to be construed according to the number of qualities they could be seen to share with Fujiyama, the supreme metaphor.

Naturally enough, the Japanese themselves have known about this for centuries. Hokusai, in a magnificent inventory of the mind's ways of knowing through the eye, displays the whole compound of terror and humor: I refer to the "Hundred Views."

## III

Euclid is speaking: "Given a straight line, and a point exterior to that line, only one line may be drawn through the point that is parallel to the line." The West listens, nodding torpid assent: the proposition requires no proof. It is axiomatic, self-evident.

It is not.

The famous Postulate rests upon two unstated assumptions concerning the plane upon which the geometer draws: that it is infinite in extent; and that it is flat. Concerning the behavior of those redoubtable fictions, the point and the line, in spaces that are curved, or bounded, Riemann and Lobachevsky have other tales to tell.

Thought seeks inevitable limits—irreducibly stable patterns of energy— knowing that it prospers best within axiomatic perimeters that need never be patrolled or repaired.

I am told that, in 1927, a Louisiana lawmaker (haunted by the ghost of Pythagoras, no doubt) introduced into the legislature of that state a bill that would have made the value of *pi* equal to precisely three. No actual circle could pass unscathed through that equation. The Emperor Ch'in Shih Huang Ti attempted an axiomatic decree of similar instability: his Great Wall, subject to entropy, never kept out an invader. Instead, the language and culture of China, an energy-pattern of appalling stability, simply engulfed one conqueror after another. Everyone who ventured south of the Wall became, in time, Chinese.

Marcel Duchamp is speaking: "Given: 1. the waterfall; 2. the illuminating gas." (Who listens and understands?)[1]

A waterfall is not a "thing," nor is a flame of burning gas. Both are, rather, stable patterns of energy determining the boundaries of a characteristic sensible "shape" in space and time. The waterfall is present to consciousness only so

long as water flows through it, and the flame, only so long as the gas continues to burn. The water may be fresh or salt, full of fish, colored with blood; the gas, acetylene or the vapor of brandy.

You and I are semistable patterns of energy, maintaining in the very teeth of entropy a characteristic shape in space and time. I am a flame through which will eventually pass, according to Buckminster Fuller, thirty-seven tons of vegetables . . . among other things. Curiously enough, then, I continue to resemble myself (for the moment at least). Thus reassured, I will try to ask a question.

What are the irreducible axioms of that part of thought we call the art of film?

In other words, what stable patterns of energy limit the "shapes" generated, in space and in time, by all the celluloid that has ever cascaded through the projector's gate? Rigor demands that we admit only characteristics that are "totally redundant," that are to be found in all films.

Two such inevitable conditions of film art come immediately to mind. The first is the visible limit of the projected image itself—the frame—which has taken on, through the accumulation of illusions that have transpired within its rectangular boundary, the force of a metaphor for consciousness. The frame, dimensionless as a figure in Euclid's *Elements*, partitions what is present to contemplation from what is absolutely elsewhere.

The second inevitable condition of film art is the plausibility of the photographic illusion. I do not refer to what is called representation, since the photographic record proves to be, on examination, an extreme abstraction from its pretext, arbitrarily mapping values from a long sensory spectrum on a nominal surface. I mean simply that the mind, by a kind of automatic reflex, invariably triangulates a precise distance between the image it sees projected and a "norm" held in the imagination. (This process depends from an ontogenetic assumption peculiar to photographic images: namely, that every photograph implies a "real" concrete phenomenon—and vice versa!; since it is instantaneous and effortless, it must be "learned.")

Recently, in conversation, Stan Brakhage (putting on, if you insist, the mask of an *advocatus diaboli*) proposed for film a third axiom, or inevitable condition: narrative.

I admit that Brakhage's preferred argument in support of this intuition devolves upon a metaphor drawn from music. But I fear having my throat cut by Occam's razor, so I'll stick to a figure of my own, stating, as compactly as possible:

*BRAKHAGE'S THEOREM: For any finite series of shots* ["film"] *whatsoever there exists in real time a rational narrative, such that every term in the series, together with its position, duration, partition, and reference, shall be perfectly and entirely accounted for.*

(An example: consider for a moment the equation

$$p = 30$$

which may be expanded to yield

$$p = \frac{p}{3} + \frac{p}{5} + \frac{p}{6} + \frac{p}{10} + 6$$

Here is a rational narrative that accounts for the expansion: "A necklace was broken during an amorous struggle. One-third of the pearls fell to the ground, one-fifth stayed on the couch, one-sixth was found by the girl, and one-tenth recovered by her lover: six pearls remained on the string. Say of how many pearls the necklace was composed." Such was the algebra of the ancient Hindus.)

An algorithm derived from Brakhage's Theorem has already been tested on a number of difficult cases, including Kubelka's *Arnulf Rainer*, Conrad's *The Flicker*, and the films of Jordan Belson. All have responded. At this writing, narrative appears to be axiomatically inevitable.

"Whatever is inevitable, however arbitrary its origins, acquires through custom something like gravitational mass. . . ."

It is precisely universal gravitation that makes the skills of the acrobat or aerialist both possible and meaningful. The levitation of our dreams confirms the gravity of our wakefulness.

## IV

Samuel Beckett gives us *Malone*, a fiction with whom (as we Facts must finally admit) we share at least one humiliating trait: we are all waiting to die. Malone waits, literally alone, comfortably supine but immobile, in a small room. How he came to be there, together with some odd bits of rubbish (a boot, for instance, and the cap of a bicycle bell) is uncertain. We are not many pages into his company before we recognize our meeting place: it is intolerably familiar.

"I" is the English familiar name by which an unspeakably intricate network of colloidal circuits—or, as some reason, the garrulous temporary inhabitant of that nexus—addresses itself; occasionally, etiquette permitting, it even calls

itself that in public. It lies, comfortable but immobile, in a hemiellipsoidal chamber of tensile bone. How it came to be there (together with some odd bits of phantasmal rubbish) is a subject for virtually endless speculation: it is certainly alone; and in time it convinces itself, somewhat reluctantly, that it is waiting to die.

The wait turns out to be long, long. The presence, in its domed chamber, masters after a while a round of housekeeping and bookkeeping duties. Then it attempts to look outside. Glimpses are confusing: the sensorium reports a fractured terrain whose hurtling bits seldom coalesce, "make sense," as pregnant idiom has it—and the sense they make is itself fugitive and randomly dispersed throughout an unguessable volume of nothing in particular. What is to be done?

Beckett lets us overhear Malone promising himself to pass the time by telling himself stories. Then Malone proceeds to digress, with a fecundity that is clearly circumscribed only by the finite size of the book; we realize that we are being made privy to nothing less (or more) than the final cadence of a larger digression that extends, by extrapolation, back to the primal integer of Malone's consciousness.

And that integer is halved by an inevitable convention of storytelling: whatever is said implies not only a speaker, but also a listener. The fiction we call Malone divides, like an ovum fertilized by our attention, into two such complementary partners.

The speaker, a paragon of loquacity who calls himself "I," uses every rhetorical trick in the book to engage his listener's attention, even going so far as to ignore him; only rarely does he let slip his suspicion that he may be only a figment of the listener's imagination.

The listener, contrariwise, is a model of taciturnity, invincibly unnameable and invisible, whose presence is felt only in the numbing quietude we normally expect of any discerning auditor forced to listen to a long-winded joke in poor taste . . . or of a reader who passes the time by skimming, for his own perverse reasons, the sort of confessional literature that remorselessly asserts its own authenticity in flat declarative sentences.

On the subject of who might be inventing whom, the listener maintains at all times a hissing silence, as of an open telephone line.

Listen, now: what you have just read is no invention of my own.

But I must prefer it to any matrix I myself might choose to generate (from more cheerful assumptions) in the hope of defining the predicament of consciousness, because it locates the genesis of storytelling among the animal necessities of the spirit. Whereas received opinion seems always to represent the storyteller as insinuating his views into the mind of another party, preferably for commercial purposes.

## V

One cannot escape the feeling that these mathematical formulae have an independent
existence and an intelligence of their own, that they are wiser than we are, wiser even than
their discoverers, that we get more out of them than was originally put into them.
—Heinrich Hertz

One fine morning, I awoke to discover that, during the night, I had learned to
understand the language of birds. I have listened to them ever since. They say:
"Look at me!" or: "Get out of here!" or: "Let's fuck!" or: "Help!" or: "Hurrah!"
or: "I found a worm!" and that's *all* they say. And that, when you boil it down, is
about all we say.

(Which of those things am I saying now?)

Joseph Conrad insisted that any man's biography could be reduced to a series
of three terms: "He was born. He suffered. He died." It is the middle term that
interests us here. Let us call it "x." Here are four different expansions of that
term, or true accounts of the suffering of x, by as many storytellers.

Gertrude Stein: $\quad x = x$

Rudyard Kipling: $\quad x = \dfrac{c-b}{a}$

Ambrose Bierce: $\quad x = \sqrt[3]{\dfrac{2c\,(c-b)}{a^2}}$

Henry James: $\quad x = \dfrac{2c\,(c^2 - 2bc + 2b^2)}{c^3 - 3bc^2 + 3b^2c - b^3}$

Any schoolboy algebraist will readily see that all four are but variations upon
the same hackneyed plot:

$$ax + b = c$$

which may also be solved for the viewpoint of any of its other main characters,
thus:

$$a = \frac{c-b}{x} \quad \text{or,} \; b = c - ax \; \text{or,} \; c = ax + b$$

or for that of the Supreme Unity:

$$1 = \left( \frac{c-b}{a} \right) - x$$

Manipulation will even yield us the unbiased spectator:

$$0 = \frac{c-b}{ax}$$

All right. Any discerning reader will be finding this a longwinded, pointless joke in poor taste. (It is possible, even, to approach my examples with serious-ness. The equation I attribute to Miss Stein may be inverted to read as follows:

$$x - x = 0$$

That says, in English, that anything diminished by something of its own magni-tude amounts to nothing. If we care to personify, it suggests that, in the absence of equals, any man is diminished to a cipher. And *that* smacks painfully enough of folk wisdom to have interested Gertrude Stein . . . even if I can't state it in her own idiom.)

The algebraic equation

$$ax + b = c$$

is our name for a stable pattern of energy through which an infinity of numerical tetrads may pass. A story is a stable pattern of energy through which an infinity of personages may pass, ourselves included.

The energy patterns we call physical laws are named after their discoverers: Avogadro, Boyle, Snell. The energy patterns we call stories are named after their protagonists: Faust, Jesus, Philoktetes. Certain stories seem related to one another, as though the same general equation had been solved for successive roots. We might call such a general equation a myth.

But instead, let us imagine every myth as a crystalline regular polyhedron, suspended, weightless, in a void, with each of its vertices touching, in perfect geodesic equilibrium, the surface of an iridescent imaginary sphere. The exis-tence of the whole body is utterly dependent upon the integrity of all its facets: every facet represents a story.

Near the ecliptic of our universe we find, for example, the mythic Poly-
hedron of the Father and the Son: on it, the stories of Odysseus and Hamlet
occupy adjacent facets, since they are really the same story, told in the former
instance from the point of view of the father, and in the latter, from that of the
son. Nearly opposite these two, on the dark side, the stories of Oedipus and
Agamemnon are nearly contiguous.

The center of the cosmos is occupied by the Polyhedron of the Storyteller.
Here we find, imaged upon various facets, the stories of Malone, waiting to die;
of Scheherazade, waiting to be killed; of the *Decameron*, whose narrators wait
for others to die; of the *Canterbury Tales*, told to ease a passage through space
as well as time.

The universe is but sparsely populated by these Polyhedra, enormous
though they are. Here and there, a faint nebula marks, perhaps, the region where
a new myth struggles to cohere; elsewhere, dark cinders barely glow, remnants
of experience lost forever to consciousness. A hole torn in the very fabric of
space, whence no energy escapes, is rumored to mark the place where AGNOTON,
the black Polyhedron of the Unknowable, vanished.

Nor do all the facets bear images. Some are dusty, some cracked; some are
filled with senseless images of insects, or else with a vague, churning scarlet, shot
with sparks. Some are as transparent as gin. Some are bright as mirrors and
reflect our own faces . . . and then our eyes . . . and behind our eyes, distantly,
our polyhedral thoughts, glinting, wheeling like galaxies.

**Note**

1. The reference is to Duchamp's famous tableau, *Étant donnés: 1° la chute d'eau/2°
le gaz d'éclairage*, on which he worked from 1946 to 1966 and which was first publicly
displayed, at the Philadelphia Museum of Art, in 1969. It was the artist's last work.
(B.J.)

*Form and Structure in Recent Film*, ed. Dennis Wheeler (Vancouver: Vancouver Art Gallery, 1972),
unpaginated. Reprinted in *Circles of Confusion* (Rochester, N.Y.: Visual Studies Workshop Press, 1983),
pp. 59–68.

# Notes on Composing in Film

In a letter of the year 1914, the poet Ezra Pound tells his correspondent that it took him ten years to learn his art, and another five to unlearn it. The same year saw the tentative publication of three cantos for a "poem of some length" that was to become, though nameless and abandoned, the longest poem in English . . . prominent among whose denumerable traits are a lexicon of compositional tropes and a thesaurus of compositional strategies that tend to converge in a reconstitution of Western poetics.

Since it has been widely asserted that art can be neither taught nor learned, that it is a gift from Jehovah or the Muse, an emanation from the thalamus, or a metabolite of the gonads, we may pause to wonder what Pound, a failed academic and lifelong scholar of diverse literatures and arts, meant by the verb *to learn* . . . let alone *unlearn*. In the same letter, Pound himself is obliquely illuminating; he had begun, he says, around 1900, to study world literature, with a view to finding out *what* had been done, and *how* it had been done, adding that he presumes the motive, the impulse, to differ for every artist.

A few years later, in the essay *How to Read*, Pound diffracts the roster of poets writing in English into a hierarchic series of zones, of which the most highly energized comprise "inventors" and "masters." The essay, like most of Pound's prose writing of the period, is addressed primarily to other (presumably younger) writers; it is permeated by Pound's highly practical concern for what might be called an enhanced efficiency in the process of "learning" an art. We need not look very deeply to find, inscribed within the pungent critical enterprise that extends and supports his concern, a single assumption: that one learns to write by reading. Moreover, one learns to write mainly by reading those texts that embody "invention," that is, the vivid primary instantiation of a compositional strategy deriving from a direct insight into the dynamics of the creative process itself.

Implicit, finally, is the assertion that the compositional process is the oversubject of any text whatever: in short, what we learn when we read a text is *how* it was written. To put it more generally, a paramount signified of any work of art is that work's own ontogeny. Partially masked though it may be by the didactic thrust of Pound's critical writing, this insight is by no means atypical; in fact, where we do not find it among the procedural givens of any major artist of this century, we experience a certain malaise, as if confronting a mental anomaly whose gestural consequences somehow elude detection. Indeed, at this moment we find ourselves at a critical pass that divides work that is serious from work

that is not, quite precisely along the boundary between reflexiveness and naiveté.

According to a new transposition of the ancient notion that the artist is nothing other than a conduit for energies that he incarnates in the things he makes, the Elsewhere whence those energies come is now imagined to be, in the largest sense, the "material" of the art itself. For example, the notion that language, considered as a discorporate faculty of an entire psycholinguistic community, should, of its own nature, tend to secrete poems, is our legacy from the Symbolists. By implication, the work of the poet must be an investigation into the internal economics and dynamics of language; a theory of poetry, an enunciation of the axiomatics of language; and the poem, a demonstration consequent upon the self-interference of these axiomatics.

As for the activity of poetry, so also for poesis at large. Without a similar understanding with regard to music, to painting, or to film, the work of a Varèse or a Berg, a Mondrian or a Pollock, an Eisenstein or a Brakhage, is not only impenetrable, it is utterly unapproachable. But, given that much, *and nothing more*, the individual work of art is virtually self-explicating: to understand it is to be struck by the nature of art, and indeed, in some measure, by the nature of thought itself.

Thus the artist of the modernist persuasion outlines, if he does not utterly preempt, the terrain, the contours, of that critical activity which shall best serve language in its anguished compulsion to encompass and account for every other code: a criticism, that is, that shall direct its attention to the energies deployed in the compositional process rather than to the matter disposed in its result.

And if it is true that the object before us thus clearly predicts the vector of our research, then we might expect as well that close observation of that object will yield specific methodological prescriptions.

Since the learning, the understanding of an art consists in the recovery of its axiomatic substructure, we can begin to say that the "unlearning" that Pound cites as indispensable to new creation consists in the excernment, castigation, and transvaluation of that axiomatic substructure. New composition, then, may be seen as an activity synonymous, if not coterminous, with the radical reconstitution of the embedding code. It is in the context of such a reconstitution that we must understand Eliot's celebrated observation that every really new work modifies, however subtly, the equilibrium of every other term in its traditional matrix. Indeed, at its most fecund, a drastically innovative work typically calls into question the very boundaries of that matrix, and

forces us to revise the inventories of culture . . . to find out again, for every single work of art, the manner in which it is intelligible.

Our examination of the process of composition must radiate from a close scrutiny of the ways in which artists have anatomized and transubstantiated the assumptions of the several arts. Rather than simply postulating the existence of this compound activity as an undifferentiated field, we should attempt at the very outset to construct an explicit paradigm of the ways in which axiomata are transformed. The revision appears to transpire in one or another of two modes, the first of which we might agree to call reading and the second, misreading.

The mode we call reading entails a correct extrapolation of the axiomatic substructure from the artist's immediately apprehensible tradition. Once the set of axioms has been isolated and disintricated, the artist may proceed to modify it in any of four ways: by substitution, constriction, augmentation, or by displacement. A single example will illustrate each of these ways.

1. When Schoenberg, Webern, and Berg received the tradition of music into their hands, a norm of composition stipulated that the deforming criterion of tonality must be superimposed upon the centerless grid of the chromatic scale. Reasoning that the extraction of a subset of diatonic intervals from that scale amounted to the acceptance, *a priori*, of a nucleus of melodic material, the serialists deleted entirely the axiom of tonality and *substituted* for it another: that every work must be generated in its entirety from melodic material that would guarantee its access, at any moment, to an unconstricted field of compositional options. Only a row that comprised the entire chromatic octave could do this.

2. In reply to a publisher who demanded that he expunge or modify certain portions of his *Dubliners*, James Joyce wrote that it was not possible to change or subtract so much as a single word. He had written his stories, he said, according to his own best understanding of the "classic canons" of his art. But every serious writer tries to do as much; and yet very few may be construed as setting such store by these single words. If it is self-evident that the canons of writing may be derived from the works that make up a tradition, nonetheless what works and what authors are included in that tradition is by no means obvious. For his own purposes, Joyce has *constricted* the axiom: the works from which he has derived the laws that govern his writing are those of one author, Gustave Flaubert, the encyclopedic comedian who once spent six days on the engineering of a single paragraph that imperceptibly negotiates a transition from the active to the passive voice . . . and who dreamed of writing a novel about Nothing.

3. From Fielding onward, it is a discernible assumption of prose fiction, understood as a homeostatic system, that no element that enters the work may

exit until it has been accounted for. Prior to Joyce, this assumption had not been extended to cover very much beyond the *dramatis personae*. In *Ulysses*, Joyce seizes upon this axiom, and *augments* its force, applying it without exception to every detail of the work, both structural and textural. On the structural level, the title of the book is no casual allusion; rather, every episode in the voyage of Odysseus has its precise counterpart in Joyce's palimpsest. Early on, among Bloom's ruminations, we hear him mindspeak: "Potato. I have." What about potato? We are sure to find out, some three hundred pages later.

4. It has been customary to assert, of words interacting with one another, that each word is, as it were, segmented into a dominant part, or denotation, and a subordinate attenuated series of connotations. Some have reasoned that writing consists in joining denotations in such a way as to suppress connotation; others have been content to let the connotational chips fall where they may; and a third school proposes to fabricate the connotational subtext and to let the denotative text take care of itself. But if we examine words, whether as a system of marks ordered upon a surface, or a system of sounds disturbing the air, we can discover no difference between the manner in which they denote and the manner in which they connote. It is possible, then, to view the denotation of a word as no more than that particular term in a series of connotations which has, through the vicissitudes of history, won the lexicographical race. In a word, a denotation is nothing more than the most privileged among its fellow connotations. In *Finnegans Wake* Joyce, while implicitly accepting the assumption that words are made up of parts, *displaces* the privilege of the denotation, making of the word a swarm of covalent connotations equidistant from a common semantic center. Which such connotations will be identified with the notation, then, is decided in each case not within the cellular word but through interaction with its organic context.

All axiomatic sets that derive in any of these four ways from the mode we have called "reading" have one thing in common: they entirely supersede their predecessors, and thus, sooner or later, assume the historical role of all norms. In the moment that a new axiom vanishes into the substrate of an art, it becomes vulnerable. On the other hand, this is not true of those novel structural assumptions that derive from the mode that we have called "misreading." The incorrectly read or imperfectly disentangled compositional assumption invariably remains to haunt the intellectual space usurped by its successor. Thus new works building upon axioms derived by misreading from the structural assumptions of older works must be forever contingent. Our experience of such works— that is, our recovery of the rules governing their composition—goes forward

with the strain of a double effort, for we must ourselves simultaneously read and misread. In such a predicament, where the sum of compositional options never fully presents itself as a single figure clearly separated from the ground of cultural givens, the new work risks impenetrability, presenting itself in the aspect of an open set that elides, rather than emphasizes, the articulations among the elements and operations of which it is composed.

For an artist who would question the conventional boundaries of the artist's relation to the act of making, the risks consequent upon intentional misreading will seem justified. Crucial to one normative view of the relation between artist and artifact is the assumption that every trait of a work owes its presence to a deliberate decision made by the artist. The composer John Cage, by way of a constellation of intricate stratagems of abdication, has deflected the force of this assumption. The adoption of a whole phylum of procedures, called "chance operations," as a pathway alternative to rationalizing intentionality, has resulted in making the artist more conspicuous by his presumed absence. That Absence which replaces the artist cannot, by definition, "choose"; it can only make non-choices. To choose is to exclude; to negate choice is, by implication, to include everything. But to subvert the notion of choice is to invert the intellectual perspective within which choice operates. To make non-choices is to situate oneself, as an artist, at an intersection of inclusion and exclusion where, in the absolute copresence of every possible compositional option and every conceivable perceptual pathway, the notion of choice becomes irrelevant. For example, to inquire whether or not any particular realization of *Fontana Mix* is superior to any other is to pose a meaningless question, for there is no fixed thing called *Fontana Mix*. Cage has derived seminal work from an intentional misreading of the axiomatics that have encapsulated the artist's task, contending that composition is the devising of ways to recognize, and annihilate, every test for distinguishing art from non-art. This is not to say that there is no such thing as art, or that everything is art; rather, it is to state that there can be no certainty, no final determination, about where we may expect to find art, or about how we are to recognize it when we do find it.

[ ]

That our examples, in the present writing, have been drawn either from literature or from music (an art that has had a long and various commerce with language) reflects doubly upon the state of research, and indeed upon the possibilities for research, in film. In the first instance, it is obvious that language and film subsist within incommensurable spaces. To render film accessible to written discourse, it is necessary that it be studied under conditions that

permit random access to the text in both space and time. In the second instance, it is imperfectly obvious that film, an art that we might characterize as verging upon adolescence, remains profoundly conditioned by mutually contradictory or inhibitory axiomatic substructures derived by both reading and misreading from every literary type, from music, and from the more venerable visual arts.

If we grant that the goal of our research is to recover the axiomatics of composition in film, and to discover among them a dynamic morphology, then we must necessarily find the following conditions indispensable:

1. We must reject at the outset any suggestion that film, thus far, exhibits a coherent normal paradigm. Most especially, we must meet with skepticism the assertion that the narrative fiction film, with synchronous sound track, offers such a paradigm. Even during the heyday of its empire, the hegemony of the fiction film was seriously challenged on the axiomatic level by competing genres: instructional, documentary, newsreel.

2. We must have available to us, in a manner that encourages and facilitates deliberate investigation, the cinematic material. That is, we must be able to take the filmstrip in hand, at our extended leisure, and examine it frame by frame and splice by splice.

3. We must bring to our research into the working assumptions of film a thorough grasp of the axiomatics of every discipline from which film has, willingly or unwillingly, borrowed . . . because, for our purpose, the whole history of art is no more than a massive footnote to the history of film.

It is only after we have accomplished these three conditions that we shall be able to attempt the most important:

4. We must invent a terminology, and a descriptive mode, appropriate to our object: a unique sign that shall have as its referent the creative assumptions proper to film and to film alone. The compound sign and referent is, of course, a closed system; and all closed systems, as we know, tend to break down and to generate discrepancies and contradictions at their highest levels. On the other hand, inquiry into the nature of film has reached its present impasse on account of contradictions at the very lowest levels of discourse, instigated by the casual expropriation of terminologies from other arts.

Hitherto, the study of film has been compartmentalized horizontally, in a search for diachronically parallel evolutions, and vertically, by a rough typology that distinguishes cinematic species from one another according to their social use. Such a morphology assumes that individual films, and indeed entire bodies of work in film, are isolated objects; it implies that understand-

ing a film involves nothing more than determining its precise location on a predetermined grid.

We propose another, radically different morphology . . . one that views film not from the outside, as a product to be consumed, but from the inside, as a dynamically evolving organic code directly *responsive* and *responsible*, like every other code, to the supreme mediator: consciousness.

We base our morphology upon direct observation of how films are actually made. The making of a film is an action that may be seen as comprising two stages. At first, the material of a film is generated. That material is nothing else but the image-bearing filmstrip; to generate it is to film a pretext, that is, to impress images upon the photographic emulsion. Then, the cinematic material is structured. To structure the cinematic material is to determine, by whatever means, which filmstrips shall enter the composition and which shall not; whether they shall enter the composition entirely or in part; and in what order the filmstrips shall be joined. This second stage in the activity of filmmaking is usually called editing; a number of filmmakers have argued that the editing process, sufficiently generalized, may extend into, and even engulf, the gathering of cinematic material (filming). For some filmmakers, editing is nothing more than the closure of a scheme that has pre-established every quality of the cinematic material and every aspect of its gathering. For others, to edit is to decode into rationality the implications of cinematic material gathered in an intentional void. Between these two poles, as between filming and editing, there is no zone of demarcation but rather a horizontally modulated continuous field.

Again, the process of filmmaking has variously been seen as independent from or contingent upon the imperatives of other codes. Where film has been seen as subordinate to language, film composition has amounted to nothing more than the realization of a minutely specific scenario. Whenever the act of filmmaking has achieved full independence from language, a *découpage*, or metric shot list, empirically synthesized after the fact of the completed work, displaces the scenario in a gesture of temporal inversion. Often, the scenario becomes rarefied, taking the shape of brief verbal directions, graphic sketches, or even numerical notations; at its most remote, the "script" dwindles to a more or less complete previsualization within the eye of the mind. The intellectual space between these meridians of intentionality is, again, modulated continuously, and vertically.

From a cartoon of this alternate morphology, we may easily construct a model for detailed investigation, selecting four filmmakers whose work suggests that they diverge from one another as far as possible with respect to the vertical

axis of intentionality, and with respect to the distribution of their energies in the structuring of a work mapped along the horizontal axis. We might elicit from these four artists all the materials pertaining to a single film; such materials must necessarily include not only prints of uncut footage to match against the finished work, but also every retrievable scrap of concrete evidence relating to the compositional process.

Of course, if these four personages do not exist, then it is our humane duty to invent them.

[ ]

**And I will tell, by the same token, for those kind enough to listen,**
**according to a system whose inventor I forget, of all those moments when,**
**neither drugged, nor drunk, nor in ecstasy, one feels nothing.**
—Samuel Beckett, *First Love*[i]

**Note**

1. The original 1976 publication of this text, in *October*, used an alternative quote attributed to Beckett's *First Love*:

> It had something to do with lemon trees, or orange trees, I forget, that is all I remember, and for me that is no mean feat, to remember it had something to do with lemon trees, or orange trees, I forget, for of all the other songs I have ever heard in my life, and I have heard plenty, it being apparently impossible, physically impossible, short of being deaf, to get through this world, even my way, without hearing singing, I have retained nothing, not a word, not a note, or so few words, so few notes, that, that what, that nothing, this sentence has gone on long enough.

Text delivered at the "Conference on Research and Composition," State University of New York at Buffalo, October 1975. Published in *October* 1 (Spring 1976): 104–110. Reprinted in *Circles of Confusion* (Rochester, N.Y.: Visual Studies Workshop Press, 1983), pp. 117–125.

# Letter to Stan Brakhage

Eaton, New York
January 26, 1972

Dear Stan,

Had I but world enough and time, I should right now be excogitating a rigorous critical essay under the title "The Act of Seeing *The Act of Seeing with One's Own Eyes* with One's Own Eyes."[1] But "time enough" would extend analysis beyond the bounds of this particular work, into films very much earlier (I see surfacing concerns implicit at least as far back as *Wedlock House: An Intercourse*, for instance, or *Nightcats*) and also forward into work that you are doing (already, in my greedy imagination) years from now.

And then "world enough" must take me sprawling past the edges of the most strenuously finite *belles lettres* into . . . what? Well, naturally, I've gotta use *words* when I talk to you; but I think the answer to *that* question is: "into film." Let me, if I am able, explain how I feel that.

A friend said to me once that the great natural poem about anything was its *name*. The lyricism of that statement is not altogether insipid: for any process within the passionate weather of the beholding intellect is surely as much a "thing" as is a boot or a pie. From that vantage, if I may be pardoned a jump-cut, *Finnegans Wake* is also a "name" . . . for something which *has no other name*.

A difficulty seems to arise (Could any poet agree with me?) from within language itself. Like a soap bubble, it is most iridescent and tense at its bursting point, that is, at the extreme limit of its elastic acceptance of the inspiration that formed it in the first place. But the bubble of language bursts in extreme slow motion. I recall a puzzlement from 2400 years ago: Aristotle, turned henhouse robber, attempts to deal precisely, *in words*, with the embryology of the chicken.

That was something poor old 'Arry saw with *his* own eyes, and the result of his effort to "describe" it (presumably he wasn't trying for art) amounts to a major cultural disaster. He needed, at the least, a draughtsman's skill. And isn't it curious that the Greeks, who took such pride in *illusions*, in encaustic fruit that could charm birds from the trees, couldn't spare one calorie to document! Their plastic "art" was aimed, like voodoo dolls, at *manipulating* the universe; the tasks of investigation and discovery were left to "mere prose."

Long dissolve to: Andreas Vesalius.

After centuries of perfervid disputation, a single man dissected the corpses of dead paupers and hanged murderers. We still live with his drawings' offspring. Vesalius saw with *his* own eyes, and most assuredly they were scarcely ours: for instance, his drawing of a womb looks so like a penis that the resemblance has drawn comment ever since.

Vesalius' drawings surpass Aristotle's abstract prose in their capacity to *include*, tersely. (When it comes to containment, to *comprehension*, in that word's ancient sense, all our arts' bubbles tremble with the colors of infinity.) But something still is not *in* these drawings: I mean the utter *particularity* that draws our sensibilities to photographic images.

The fair Greek probably believed entirely that he found All Chickens inside his every egg, just as he saw all triangles in each. And the man of the Renaissance was a scientist, which is to say that he was given to deriving curves from as few points as possible, whereas the curves (and axes as well) of art must coalesce as luminous knots in a web that *is* all the discoverable qualities of all the things of the world. (The web weaves ourselves into itself.)

A second long dissolve, then, to Stan Brakhage, entering, *with his camera*, one of the forbidden, terrific locations of our culture, the autopsy room. It is a place wherein, inversely, life is cherished, for it exists to affirm that no one of us may die without our knowing exactly why. All of us, in the person of the coroner, must see that, for ourselves, with our own eyes. It is a room full of appalling particular intimacies, the last ditch of individuation. Here our vague nightmare of mortality acquires the names and faces of others.

This last is a process that requires a *witness;* and what "idea" may finally have inserted itself into the sensible world we can still scarcely guess, for *the camera* would seem the perfect Eidetic Witness, staring with perfect compassion where we can scarcely bear to glance.

What was to be done in that room, Stan? and then, later, with the footage? I think it must have been mostly to *stand aside;* to "clear out," as much as possible, with the baggage of your own expectations, even, as to what a work of art must look like; and to see, with your own eyes, what coherence might arise within a universe for which you could decree only the boundaries.

Well now. Earlier on I said that *The Act of Seeing with One's Own Eyes* leads directly back into film. Now the reason seems quite simple: this film is the first completely *clear* enunciation (to my hearing) of the "family" name of a process within thought that may have other "given" names. But they are not to be sought in (even) the most illuminated palaver. Decades ago, Ezra Pound wrote that the most intense criticism is in *new composition*.

I think this new work merits intense criticism; and that is what we shall all of us, willy-nilly, have to undertake.

Benedictions,
[signed Hollis Frampton]
H.F.

#### Note
1. Brakhage's film *The Act of Seeing with One's Own Eyes* (1971), shot in a morgue in Pittsburgh, depicts the process of autopsy in stark detail.

Typewritten letter. Reproduced in *Millennium Film Journal*, nos. 16/17/18 (Fall–Winter 1986–1987): 212–213.

# Letter to Donald Richie

Eaton, New York
January 7, 1973

Mr. Donald Richie
Curator of Film
The Museum of Modern Art
11 West 53 Street
New York, New York 10019

Dear Donald:

I have your letter of December 13, 1972, in which you offer me the honor of a complete retrospective during this coming March. Let me stipulate at the outset that I am agreed "in principle," and more: that I appreciate very deeply being included in the company you mention. I am touched to notice that the dates you propose fall squarely across my thirty-seventh birthday. And I am flattered by your proposal to write notes.

But, having said this much, I must go on to point out some difficulties to you.

To begin with, let me put it to you squarely that anyone, institution or individual, is free at any time to arrange a complete retrospective of my work; and that is not something that requires my consent, or even my prior knowledge. You must know, as well as I do, that all my work is distributed through the Film-Makers' Cooperative, and that it is available for rental by any party willing to assume, in good faith, ordinary responsibility for the prints, together with the price of hiring them.

So that something other than a wish to show my work must be at issue in your writing to me. And you open your second paragraph with a concise guide to what that "something" is when you say: "It is all for love and honor and no money is included at all. . . ."

All right. Let's start with love, where we all started. I have devoted, at the nominal least, a decade of the only life I may reasonably expect to have, to making films. I have given to this work the best energy of my consciousness. In order to continue in it, I have accepted . . . as most artists accept (and with the same gladness) . . . a standard of living that most other American working people hold in automatic contempt: that is, I have committed my entire worldly resources, whatever they may amount to, to my art.

Of course, those resources are not unlimited. But the irreducible point is that *I have made the work*, have commissioned it of myself, under no obligation of any sort to please anyone, adhering to my own best understanding of the classic canons of my art. Does that not demonstrate love? And if it does not, then how much more am I obliged to do? And who (among the living) is to exact that of me?

Now, about honor: I have said that I am mindful, and appreciative, of the honor to myself. But what about the honor of my art? I venture to suggest that a time may come when the whole history of art will become no more than a footnote to the history of film . . . or of whatever evolves from film. Already, in less than a century, film has produced great monuments of passionate intelligence. If we say that we honor such a nascent tradition, then we affirm our wish that it continue.

But it *cannot* continue on love and honor alone. And this brings me to your: ". . . no money is included at all. . . ."

I'll put it to you as a problem in fairness. I have made, let us say, so and so many films. That means that so and so many thousands of feet of raw stock have been expended, for which I *paid* the manufacturer. The processing lab was *paid*, by me, to develop the stuff, after it was exposed in a camera for which I *paid*. The lens grinders got *paid*. Then I edited the footage, on rewinds and a splicer for which I *paid*, incorporating leader and glue for which I also *paid*. The printing lab and the track lab were *paid* for their materials and services. You yourself, however meagerly, are being *paid* for trying to persuade me to show my work, to a *paying* public, for "love and honor." If it comes off, the projectionist will get *paid*. The guard at the door will be *paid*. Somebody or other *paid* for the paper on which your letter to me was written, and for the postage to forward it.

That means that I, in my singular person, by making this work, have already generated wealth for scores of people. Multiply that by as many other working artists as you can think of. Ask yourself whether my lab, for instance, would print my work for "love and honor"; if I asked them, and they took my question seriously, I should expect to have it explained to me, ever so gently, that human beings expect compensation for their work. The reason is simply that it enables them to continue doing what they do.

But it seems that, while all these others are to be paid for their part in a show that could not have taken place without me, nonetheless, I, the artist, am *not* to be paid.

And in fact it seems that there is no way to pay an artist for his work *as an artist*. I have taught, lectured, written, worked as a technician . . . and for all those collateral activities, I have been *paid*, have been compensated for my work. But *as an artist* I have been paid only on the rarest of occasions.

I will offer you further information in the matter:

Item: that we filmmakers are a little in touch with one another, or that there is a "grapevine," at least, such as did not obtain two and three decades ago, when the Museum of Modern Art (a different crew then, of course) divided filmmakers against themselves, and got not only screenings but "rights" of one kind and another, for *nothing*, from the generation of Maya Deren.

Well, Maya Deren, for one, *died young*, in circumstances of genuine need. I leave it to your surmise whether her life might have been prolonged by a few bucks. A little money certainly would have helped her work: I still recall with sadness the little posters begging for money to help her

finish *The Very Eye of Night* that were stuck around when I was first in New York. If I can help it, that won't happen to me, nor to any other artist I know.

And I *know* that Stan Brakhage (his correspondence with Willard Van Dyke is public record) and Shirley Clarke did not go uncompensated for the use of their work by the Museum. I don't know about Bruce Baillie, but I doubt, at the mildest, that he is wealthy enough to have traveled from the West Coast under his own steam, for any amount of love and honor (and nothing else). And, of course, if any of these three received *any* money at all (it is money that enables us to go on working, I repeat) then they received an *infinite* amount more than you are offering me. That puts us beyond the pale, even, of qualitative argument. It is simply an unimaginable cut in pay.

Item: that I do not live in New York City. Nor is it, strictly speaking, "convenient" for me to be there during the period you name. I'll be teaching in Buffalo every Thursday and Friday this coming spring semester, so that I could hope to be at the Museum for a Saturday program. Are you suggesting that I drive down? The distance is well over four hundred miles, and March weather upstate is uncertain. Shall I fly, at my own expense, to face an audience that I know, from personal experience, to be, at best, largely unengaging and, at worst, grossly provincial and rude?

Item: it is my understanding that filmmakers invited to appear on your "Cineprobe" programs currently receive an honorarium. How is it, then, that I am not accorded the same courtesy?

Very well. Having been prolix, I will now attempt succinctness. I offer you the following points for discussion:

1. It is my understanding, of old, that the Museum of Modern Art does not, as a matter of policy, pay rentals for films. I am richly aware that, if the museum paid us independent film artists, then it would be obliged also to pay rentals to the Hollywood studios. Since we all live in a free-enterprise system, the Museum thus saves artists from the ethical error of engaging in unfair economic competition with the likes of Metro-Goldwyn-Mayer. (I invite anyone to examine, humanely, the logic of such a notion.) Nevertheless, I offer you the opportunity to pay me, *at the rate of one-half my listed catalog rentals*, for the several screenings you will probably subject my prints to. You can call the money anything you like: a grant, a charitable gift, a bribe, or dividends on my common stock in Western Civilization . . . and I will humbly accept it. The precise amount in question is $266.88, plus $54.– in cleaning charges, which I will owe the Film-Makers' Cooperative for their services when my prints are returned.

2. If I am to appear during the period you propose, then I must have round-trip airfare, and ground transportation expenses, between Buffalo and Manhattan. I will undertake to cover whatever other expenses there may be. I think that amounts to about $90.–, subject to verification.

3. If I appear to discuss my work, I must have the same honorarium you would offer anyone doing a "Cineprobe." Correct me if I'm wrong, but I think that comes to $150.–.

4. Finally, I must request your earliest possible reply. I have only a limited number of prints available, some of which may already be committed for rental screenings during the period you specify. Since I am committed in principle to this retrospective, delay might mean my having to purchase new prints specifically for the occasion; and I am determined to minimize, if possible, drains on funds that I need for making new work.

Please note carefully, Donald, that what I have written above is a list of requests. I do not speak of demands, which may only be made of those who are *forced* to negotiate. But you must understand also that these requests are not open to bargaining: to bargain is to be humiliated. To bargain in this, of all matters, is to accept humiliation on behalf of others whose needs and uncertainties are greater even than mine.

You, of course, are *not* forced to negotiate. You are free. And since I am too, this question of payment is open to discussion in matters of procedure, if not of substance.

I hope we can come to some agreement, and soon. I hope so out of love for my embattled art, and because I honor all those who pursue it. But if we cannot, then I must say, regretfully, however much I want it to take place, that there can be no retrospective showing of my work at the Museum of Modern Art.

Benedictions,

Hollis Frampton

Unpublished typewritten letter, 1973.
The retrospective of Frampton's films took place as proposed on March 8–12, 1973, with program notes written by Donald Richie. This was not Frampton's first critique of institutional practices at the Museum of Modern Art. He attended meetings of the Art Workers' Coalition beginning in 1969 and was a signatory to an early statement on museum policies. See Andrea Fraser, *Museum Highlights* (Cambridge, Mass.: MIT Press, 2005), pp. 58–76. (B.J.)

# Letter to the Editor, *Artforum*

To the Editor:

One of your reviewers seems to be proceeding under the familiar (and barbaric) assumption that the text of film art is coterminous with his experience of it. I refer to Alan Moore, who writes (January 1975, p. 68), in the midst of some remarks about Frank Gillette's recent video show at The Kitchen:

> The disjunction of audio and visual, I would guess, derives from Jean-Luc Godard's Brechtian non-coincidence of action and mood music in films like *Weekend* (1967). It has been continued in the work of many filmmakers as just such an indication of the act of artifice, or, as in Hollis Frampton's *Nostalgia* (1971), to discourse on the nature of memory in time.

Guess again! Mr. Moore is correct in his surmise that I do not hold a patent on disjunction, whatever role it has played throughout my work; indeed, that very disjunction that Moore notices first in Godard's films of the late 1960s has always struck me as a fundamental strategy of modernism. If Godard invented audio-visual disjunction, that fact belongs in the same chapter of our universal almanac with the *conquistadores'* "discovery" of gold in the Americas ... long after the Incas had dug it out of the ground. But Godard need not have gone to America for his discovery, nor, even, so far afield as the epic drama of Brecht. A suggestion, even an injunction concerning disjunction, was already there to be mined from the primordial tradition of his own art.

"THE FIRST EXPERIMENTAL WORK WITH SOUND MUST BE DIRECTED ALONG THE LINE OF ITS DISTINCT NON-SYNCHRONIZATION WITH THE VISUAL IMAGES." I quote, of course, from privileged discourse: a single sentence from a statement written by Sergei Eisenstein, co-signed by two such strange bedfellows as Alexandrov and Pudovkin, and published in *Zhizn Iskusstva* on August 5, 1928 ... nearly forty years before the making of *Weekend*. Eisenstein extends into the domain of the sound film his axiomatic view of human thought as dialectical; the montage-structures that were to instantiate the process of thought must necessarily be *congruent* with the dialectic.

Need I remark that Godard, a Marxist of a later rhetorical cast, everywhere gives evidence of a thorough knowledge of the film tradition, and of its history of written polemic? I encountered Eisenstein's writings on sound in about 1950; I first saw *Alexander Nevsky* in the same year, and the collision of text and film produced in me a *malaise* that was long in departing. Godard, a few years older than myself and coming to young adulthood and his first work in a milieu that was intellectually active, politically just *utterly different*, would have been able to learn more efficiently from the Soviet master. "Derive" is not an informative verb ... but I would gladly assent to a suggestion

that whatever I myself have thought about sound can be charted against axes first laid out in 1928. To this day, *no* filmmaker known to me (Eisenstein included) has given full and systematic attention to the questions raised at that time (unless I am to be confounded by Kirsanov's *Rapt*, which I have not seen).

Eisenstein's primary concern was that *language* (and especially staged *drama*, a linguistic mode that had strongly contributed to his own formation) was about to engulf the new art. Now spoken language might be said to lie at one end of an auditory spectrum, at the other end of which we find *music* ... and the typical silent film was not *silent* at all, as are, for instance, the films of Stan Brakhage. Musical "accompaniment" was ubiquitous, and it was tacitly accepted for the most part; on exceptional occasions, specially composed scores replaced the piano-player's improvisations. And music in the sound film, except in the special case where its acoustical origins are visible on the screen, must *by definition* be disjunct from the visual image—since *all* sound is so disjunct when it originates in off-screen space and is not narratively explained (i.e., causally related to) what is simultaneously seen. Elaborate sound stages, perfectly degraded acoustical universes, are built in order to keep such disjunctions at bay. So it would seem, at first thought, that to apply the epithet *disjunct* to "non-coincidence of action and mood music" is to speak in tautologies.

The phrase "mood music" brackets a musical typology so low on the entropic scale as to lie beyond even the fearless artistic metabolism of a Charles Ives. In the entertainment film industry it has two main functions. First, it is an inhibitor of random communication, masking the shuffling, crackling, and coughing of a crowd of spectators ... and thus effectively isolating the individual viewer in the presence of the projected image. The second, and more important, function of such "music" is the crude sequestering of a single "meaning" out of the welter of significances, semantic and affective valences, by which images may combine and come to articulation *among themselves*.

(Consider an example from a standard Western. In shot #1, the wary settlers have formed their Conestoga wagons into a redoubt. *Splice*. In shot #2, we are given a bald, scrubby hill that might be in Wyoming, Spain, Korea. In silence, the imagination bathes in the energies radiating from this collision. But no: there is sound. Galloping hooves and bugles signal the cavalry. Alternate scenario: the heathen tom-toms of the dreaded ...)

The musical stereotype, as surely as the spoken word, adheres limpetlike to its coeval image. We need not look far in this engineered "adhesion" for a fundamental principle of alienation, which addresses us at once in the terms of a gross contempt for our capacity to *participate* in that articulation of consciousness which is a work of art ... and again, in the terms of a vulgar irreverence toward that intricacy which is the most noticeable trait of everything, and of which film art deeply partakes.

In annihilating the customary (for how long?) bond between banal music and banal image, Godard calls both into question. Eisenstein would agree, I think, that this factoring of the *condition* of alienation, secreted at the very center of a popular art, is not *only* a formal insight, and it is not

*also* a formal insight, but rather that the two are the same thing. Is this what Godard meant when he spoke of making a film that was a political act? If it is, I believe your reviewer has, paradoxically, detected a moment when he did so.

Hollis Frampton
Eaton, New York

Letter dated January 21, 1975, published in *Artforum* 13, no. 7 (March 1975): 9.

# Film in the House of the Word

In 1928 Sergei Eisenstein published a brief manifesto on film sound that has met with no direct critique or reply in more than half a century.[1] In his statement, written within a euphoric moment of convergence between theory and practice that gave us *October* and *The General Line* and suggested to him the grand project of an "intellectual montage," Eisenstein began an effort that precipitated in a group of empty centers and their satellite notes and essays—the hypothetical cinematic "realizations" of three written texts: *An American Tragedy*, *Ulysses*, and *Capital*. Eisenstein himself, under the extreme pressures of the Stalinist "restoration," largely abandoned his research into intellectual montage for extended meditations on synesthesia, the microstructure of the frame, and the architectonics of film narrative, in a resurrection of the quest for a fusion of the arts; the man who directed a production of *The Valkyrie* in Moscow must have seen, in the musical drama of Wagner, a prefiguration of some of film's boldest ambitions. These ambitions still obtain; that research, advanced by Vertov, has never entirely languished.

"The dream of a sound film has come true. . . . The whole world is talking about the silent thing that has learned to talk." Eisenstein awakened to the factualization of desire with surprised ambivalence, as if discovering the Silent Thing to have been carved by Pygmalion—for film, perennially associated with music, had never been generically silent. It had been mute, once an apprentice mime in a precinematic (and prelinguistic) theater, now a journeyman aspiring to an intricate mimesis of thought, to whose construction a sound-on-film technology was as vital as cinematography itself.

It was not simply sound, then, that threatened to destroy all the "present formal achievements" of montage, but the dubious gift of speech, the Prime Instance of language, the linear decoding of the terrain of thought into a stream of utterance. Thus film, from its first word, was to be perceived in a double posture of defilement and fulfillment, and Eisenstein found himself present at a rite of passage; the end of the Edenic childhood of montage was accompanied by a wistful vision of "fading virginity and purity."

The syndrome of logophobia has been pandemic throughout recent practice in the visual arts. "How many colors are there in a field of grass," Stan Brakhage asks in *Metaphors on Vision*, "for a crawling baby who has never heard of green?" We are prompted to enter into complicity with the author: the word is anaesthetic, truncating the report of an innocent sensorium, depriving thought of that direct Vision of a universe of ideal forms that would pierce, sweep away,

the clutter of denatured simulacra created by language; and so the infant, traversing the fulsome excellence of a Garden that somehow exists without the intervention of the Word, must see an infinitude of colors.

Others reason that the crawling baby sees no "colors" at all, since the notion of color is a complex abstraction—closely bound to language and culture (there are natural languages that make no distinction between "green" and "blue")—that brackets a neurophysiological response to a portion of the electromagnetic spectrum. The field of grass is without form, and void.

During painting's culminating assault on illusion, in the 1950s and '60s, one often heard the epithet "literary" applied as a pejorative to work that retained vestiges of recognizable (and thereby nameable) pretext sufficient to the identification of an embedding deep space—although the presence of the word as a graphic sign (in Robert Motherwell's *Je t'aime* paintings, for instance, or Frank Stella's *Mary Lou* series) was accepted with routine serenity. One heard Barnett Newman admonish Larry Poons when the younger painter had published, as a show poster, a photograph incorporating an assertive pun on his own name;[2] saw Carl Andre in ardent moral outrage at the very mention of Magritte's name; witnessed the monolithic public silence of the generation of Abstract Expressionists.

The terms of the indictment were clear: language was suspect as the defender of illusion, and both must be purged together in the interest of a rematerialization of a tradition besieged by the superior illusions of photography. Only the poetics of the title escaped inquisition, for a time. If there is some final genetic bond between language and illusion, then the atavistic persistence of illusion—fossil traces, upon the painterly surface, of thickets, vistas of torn gauze, spread hides, systems of tinted shadows, receding perspectives of arches—affirms, at the last, the utter permeance of language.

Now we are not perfectly free to make of language an agonist in a theater of desire which is itself defined by the limits of language. Every artistic dialogue that concludes in a decision to ostracize the word is disingenuous to the degree that it succeeds in concealing from itself its fear of the word—and the source of that fear: that language, in every culture, and before it may become an arena of discourse, is, above all, an expanding arena of power, claiming for itself and its wielders all that it can seize, and relinquishing nothing. In this regard, Eisenstein is characteristically abrupt, claiming for film, in accord with Lenin's own assessment of the Revolution's priorities, something of the power of language: "At present, the film, working with visual images, has a powerful affect on a person and has rightfully taken one of the first places among the arts."

Film, like all the arts, was to instruct, to move; its considerable privilege derived, ironically, from a double illiteracy: its diegesis was legible to a mass populace that could not read, and its formal strategies were largely illegible to a burgeoning elite that could. Eisenstein was at some pains to preserve film's claim to political efficacy: in the midst of the short text he paused to offer a gratuitous recantation for the "formalist" errors of *October*, submitting that the advent of sound would spare the director from resorting to "fanciful montage structures, arousing the fearsome eventuality of meaninglessness and reactionary decadence." Invoking the power of language, he issued preliminary disclaimers for near occasions of sin not yet contemplated; in 1932, in "A Course in Treatment," he was to write of "wonderful sketches," never to be expanded, for montage structures that anticipate a much later historical moment in film, fanciful enough to normalize the "formalist jackstraws" of *Man with a Movie Camera*.[3]

Sound, we read, will ameliorate film's "imperfect method," improve its thermodynamic efficiency: what brings the menace of speech abolishes writing and the mode of reading that accompanies it, eliding those discontinuities in an illusionist continuum introduced by the intrusion of the graphic intertitle. Parenthetically, as well, it will restore to equilibrium an imbalance in film's psychological distance from the spectator by obviating "certain inserted close-ups" that have played a merely "explanatory" role, "burdening" montage composition, decreasing its tempo. However, and above all, complete dissynchrony between sound and image is to be maintained (Eisenstein did not, for the moment, insist on more drastic disjunctions), since the permanent "adhesion" of sound to a given image, as of a name to its referent, increases that image's "inertia" and its independence of meaning.

Thus far, we find no single imperative that requires Eisenstein's logophobia. But suddenly (the adverb is peculiarly his own: an intertitle that announces the massacre on the Odessa Steps in *Potemkin*) one may recognize, within the diction of a text that adroitly warns us away from language, a crucial agenda: the preservation of a dim outline of what it is that he is so anxious to protect from language. One may imagine something whose parts are to be denied, and protected from, independence and mutual adhesion; it is not to be burdened, nor its inertia increased, nor its tempo retarded; it is to remain portable across cultural boundaries, and its elaboration and development are not to be impeded.

There are only two hypothetical symbolic systems whose formal descriptions meet such requirements. One is a universal natural language; the other is a perfect machine. As one recalls that the two are mutually congruent, one

remembers that Eisenstein was at once a gifted linguist and an artist haunted by the claims of language—and also, by training, an engineer. It seems possible to suggest that he glimpsed, however quickly, a project beyond the intellectual montage: the construction of a machine, very much like film, more efficient than language, that might, entering into direct competition with language, transcend its speed, abstraction, compactness, democracy, ambiguity, power— a project, moreover, whose ultimate promise was the constitution of an external critique of language itself. If such a thing were to be, a consequent celestial mechanics of the intellect might picture a body called Language, and a body called Film, in symmetrical orbit about each other, in perpetual and dialectical motion.

It is natural that considerable libidinal energy should be expended to protect such fragile transitions in thought. The ritual gesture that wards off language also preserves language, as well as film, for a later moment of parity, of confrontation.

All of Eisenstein's bleakest predictions came true; the commercial success of the talkies polarized the development of a system of distribution that virtually guaranteed the stagnation of the sound track as an independent and coeval information channel sustaining the growth of a complex montage in consensual simultaneity.

Even if the requirements of Socialist Realism had not supervened, the vicissitude of specialism might well have prevented even Sergei Eisenstein, the director, from attempting the expected "first experimental work" with sound along the lines of "distinct non-synchronization" with images.

Nevertheless, the work goes on, and filmmakers have responded, with increasing rigor, to the urgent contradictions he first expounded. Not through immediate design and cathexis but by way of an historical process of the exhaustion of its alternatives, the deferred dream of the sound film presents itself to be dreamed again.

[ ]

A man condemned to death begged Alexander to pardon him, vowing, given a year's reprieve, that he would teach Bucephalus (who already spoke Bulgarian, Farsi, and Greek) to sing. When his friends derided him for a fool who merely postponed the inevitable, he replied: "A year is a long time. The king may die; I may die. Or . . . who knows! . . . maybe the horse will learn to sing!"

Buffalo, New York, April 1981

## Notes

1. The manifesto on the sound film, titled "Statement," was jointly issued by Eisenstein and the directors Vsevolod Pudovkin and Gregori Alexandrov in the Leningrad magazine *Zhizn Iskusstva* in 1928 and appeared in English translation in the *New York Herald Tribune*, the *New York Times*, and the London magazine *Close Up* in the same year. It was Frampton's belief that the statement represented Eisenstein's thinking and writing, despite the presence of the other signatories. (B.J.)

2. The poster, depicting the artist with a pair of spoons placed like goggles over his eyes ("Poons/Spoons"), was based on a photograph that Frampton had made. (B.J.)

3. The reference is to Dziga Vertov's 1929 film, an urban portrait that combines nonfiction with such "jackstraws" as stop-motion, double exposure, slow motion, and other effects. (B.J.)

*October* 17 (Summer 1981): 61–64. Reprinted in *Circles of Confusion* (Rochester, N.Y.: Visual Studies Workshop Press, 1983), pp. 81–85.

# The Invention without a Future

My tentative working title was "The Invention without a Future." As the date has drawn nearer the true title has grown longer and now probably should be "A Partial Disassembling of an Invention without a Future: Helter-Skelter and Random Notes in which the Pulleys and Cogwheels Are Lying around at Random All over the Workbench." It seems difficult to make this entity congeal into one or a dozen exact representations or exact theses. The more I look at it, in particular the more I look at that diaeresis in the entropy of the arts during the last couple of centuries that we call the early cinema, the more it looks like a kind of goosebaggy monster. So this is all entirely a tentative projection in which I will begin by reciting an epigraph. This epigraph is a quotation that could, it seems, have been written at almost any moment from the beginning of the Industrial Revolution, or at least its very early years, to within, let's say, not the past week but the beginning of the past decade:

> Our fine arts were developed, their types and uses were established, in times very different from the present, by men whose power of action upon things was insignificant in comparison with ours. But the amazing growth of [our] techniques, the adaptability and precision they have attained, the ideas and habits they are creating, make it a certainty that profound changes are impending in the ancient craft of the Beautiful.

Well, to use that phrase in the present time I think we would have to strain certain conventions of terminology. "Beautiful" is even capitalized. Nevertheless, one still hears the word used.

> In all the arts there is a physical component which can no longer be considered or treated as it used to be, which cannot remain unaffected by our modern knowledge and power. For the last twenty years neither matter nor space nor time has been what it was from time immemorial. We must expect great innovations to transform the entire technique of the arts, thereby affecting artistic invention itself and perhaps even bringing about an amazing change in our very notion of art.

And from a little farther on in the same essay:

> Just as water, gas, and electricity are brought into our houses from far off to satisfy our needs in response to a minimal effort, so we shall be supplied with visual or auditory images, which will appear and disappear at a simple movement of the hand, hardly more than a sign.

That quotation is of course from Paul Valéry. It is most widely associated with another text for which it serves as the epigraph, and that is a 1936 essay by Walter Benjamin called "The Work of Art in the Age of Mechanical Reproduction."[1] Now I don't think this is the moment to attempt to unpack, repack, explicate, reaffirm, or criticize Benjamin. It is striking, though, I think, that we still seem to be haunted, almost plagued, by the same concerns, and I mean not only what I might call the anthropological concerns of that essay but as well the political concerns of that essay, which I think we might simply say has aged relatively well in that it continues to irritate us thirty-five or forty years later.

Water and gas and electricity are, it would seem, distinctly allied in Valéry's mind (as needs, rather than desires, let's say, or some form of entertainment) with a need, personal and social, for images, auditory and visual images. That need is one that has been fostered, has assumed its present state of power, by the very inventions that we may imagine Valéry was talking about. It's also, I think, striking that Valéry situates the new technologies of which he speaks (and it hardly matters what those technologies are) not only within an arena of desire but specifically within one of power, one in which he sees power wielded, formed, organized, as it were, and I would simply point out that it is a relatively novel insight. It is still true in this culture that, aside from those poor powers that are wielded in the realm of the purely physical, the supreme arena of power is language, the dominant code of culture, as they are fond of telling us. And I find it quite striking that Valéry at this moment discerns a corresponding arena of power, an extension of the old arena of power of language, a new domain for the wielding of power, if that power only be that of persuasion, within what he refers to as visual and auditory images, one which is furthermore created by the very existence of a reproductive technology, a mechanical technology very much of the scope and somewhat of the kind that had at a much earlier moment made his own craft, that of a public and disseminated literature and criticism, possible.

The essay to which this was an epigraph (well, I guess it still is its epigraph) is one from which I would like to conserve only a single line for the moment. This is Benjamin: "For the first time in world history, mechanical reproduction emancipates the work of art from its parasitical dependence on ritual." The argument with which he prepares and supports that is, I think, quite familiar, and it has been subject to a certain amount of challenge within the past few decades. It is, roughly, that the ancient and traditional arts, or at least the visual arts, began as a kind of sympathetic magic; one painted the elk on the wall of the cave surrounded by little men with bows and arrows in the

hope of catching more elk the next day (or what have you). That, I think, now is probably seen as a questionable assertion, but in the 1930s perhaps it was not. And as the thing to be caught, the goal of the sympathetic magic, becomes more intangible, if the game afoot is the trapping not of an elk but of the good will of the Almighty, then the ritual that art serves is translated, becomes somewhat abstract, becomes, so to speak, the ritual of systemic religious belief and practice.

There are, however, other rituals. The supreme ritual of our time is not probably either that of bagging live meat on the hoof or appeasing the alleged mysterious forces of the universe. It is the ritual of possession, the creation of possessible things, the conservation of the possessible, the ritual process by which the things of the world and then their reproductions or representations are validated so that they can become ownable, so that they can become possessible. I would point out in passing that we are engaged here today in a fairly complex variation on exactly that ritual in an edifice [the Whitney Museum] that houses all manner of validated, possessible works of art, I believe they are called.

Benjamin, in his essay, says that the new image-making and reproducing technologies challenge, at the root, the notion of authenticity, or the unique aura of the possessible thing, and thereby tend to subvert, to undermine the vintage, ownable thing. The new work of art, the work made through the agency of the machine, because of at least its alleged infinite reproducibility, escapes, or at least has the possibility of escaping, the problem, or the characteristic uniqueness, by which something that is in *potentially* infinite supply—that is to say, the work of art (we can go on making it in one form or another to our heart's content)—is moved laterally in its characteristics to resemble something that is in *strictly* infinite supply, that is, real estate. The real-estate industry, I believe, has never succeeded in manufacturing any more of its commodity. It has only manipulated the manner in which that commodity is valued. So that it is a collateral assertion, or at least suggestion, of Benjamin's that because reproducibility rescues the work of art from the predicament of real estate, it democratizes it. If it is impossible to own the *Mona Lisa* (in fact, it is inadvisable to, since presumably the responsibility is much too large, whether you like the thing or not), nevertheless it is possible to have for free, if you are willing to dispense with its unique aura (he uses the word *aura*), with the specific fact of that specific mass of pigment on that particular panel guided by the fine Italian hand of that particular aura-ridden artist ... if you are able to dispense with that, if you can give it up, then you can have something like the *Mona Lisa*. You

can have it, so to speak, for nothing, or next to nothing. Its cost is low. You don't have to have a palace to house it in; then you don't have to heat the palace; then you don't have to hire armed guards to defend it. And we can ask ourselves whether it's worth it or not to dispense with that aura in the interest of the likeness. I think it is probably in the general vicinity of the arguments with which Benjamin surrounds the notion that the reproducible tends to democratize the work of art that he is most vulnerable. He is, of course, eager in that circumstance, and it is an eagerness that we reaffirm, to produce some tentative proof, if not a fully rigorous one, that *something* has democratized the work of art, that it is not now in that time, and had not been for quite some time, that thing which it had been before.

In fact, something had happened by 1936, indeed had begun to happen a hundred years before, which was not, I think, in the least special. The arts had begun what might be understood from a look at the rest of the culture a process of normalization. By normalization I mean a very, very simple thing. By a particular moment in the seventeenth century, let us say, it was no longer necessary to pump the water out of coal mines and tin mines in England by animal power or by bailing or by complicated processes of drainage and siphoning and so forth. The walking-beam engine had taken over that process. By a very short time later, three or four decades, a large proportion of Western manufacture of all kinds had been, as we say, industrialized, or it had at least been mechanized. The process was a slow and very helter-skelter one. Transportation, for instance, our current plague, only became mechanized very late. In fact, I think we could say that the arts were among the very first generalized activities to undertake that process of normalization, as I will call it, and it is thus the more striking, and in an intelligently managed universe the more puzzling, that that process of normalization within the arts has been the last—it is now, I think, almost the only—process in which mechanized normalization is still seen as problematical. It was true by 1936, for instance, as Gertrude Stein put it, that we had all forgotten what horses are. We seem, however, not to have forgotten to this day what pre-normalized art is like. We even seem to hear still the niggling objection to it.

I was at a conference a week ago in Rochester which was a different sort of ritual, one in which xerography, and in particular the color Xerox image, began its process of validation, of valuation, in a museum given over to photography[2]—to, if nothing else, very large holdings of objects, possibly works of art, which definitely have intrinsic value because they're silver prints; if nothing else, you can reclaim the metal. (We'll get to that later on, literally, as well as in my remarks.) Xeroxes are a kind of thing that anyone can make by walking up to a

machine and dropping in fifty cents. Not only are Xeroxes made out of paper and a little bit of hydrocarbon but, worse, nothing much more than pigmented paraffin, and bad paper at that, at least as far as the standard Xerox goes.

I was experiencing a little trouble, a little pain, in being forcibly jerked up the slopes of Helicon, as if with a winch. In fact, it didn't work. There was constant objection on the part of the Xerox artists themselves. We now have, it seems, a unique class or tribe of artists for every single medium and sub-medium. They found themselves feeling extremely uncomfortable in those cir-cumstances, and finally there came a moment of hysterical crisis, as one might say, an interlude, in which one of the chief exponents of the practice stood up in the audience in the midst of a panel and delivered herself of a twenty-minute encomium to the effect that, as a Xerox artist, she wished to say that Xerox cop-ies, Xerox images, definitely were not works of art, and she hoped that, after the grant from the Xerox Corporation, which had created the exhibition and the symposium to begin with, had run out, the whole matter would be dropped as quickly as possible because she was not, and she felt no one else was, prepared for the onslaught of yet another art within living memory.

We seem, of course, to have had quite a few of them, but the one that con-cerns us here—and presumably there are still a few Civil War veterans around who can remember its very beginnings—is that of film. And I think perhaps there are a few things after all to be said about film (in fact, I know there are, if I can find out what they are on these pieces of paper here) that are not as they seem, or they are not at least as we are accustomed to think of them. I suppose we could group our discussion under a rubric of contrasts—old and new, *staroe i novoe*[3]—and try to examine the predicament *then*, that is, in that opalescent time before D. W. Griffith had cast the shadow of his mighty bulk upon film, the proto-cinema; and *now*, an extended period which has seen the growth of that moment that we have called the New American Cinema or the avant-garde (an art paramilitary organization). We are accustomed to think that now we are in possession, in the practice of film, of a high technology. In fact, that is not true. In the 1890s, at a time when every project amounted to a fresh creation under a new logos, everyone who made films did so not only under the re-normalization of a genuinely new technology but one of which they were entirely possessed. That is to say, if you had a camera (or if, like [Griffith's cameraman] Billy Bitzer, you had a camera that actually made perforations in the film at the same time it was making images on it, spitting the one thing out a little chute at the bottom and winding the other up in a roll at the top), and a tripod to put it on more or less, and some way to develop the stuff, you were at that time living at the cutting

edge of a new technology, and you were in complete possession of it. That now is simply not so.

Film is probably a high technology. It is, of course, a deeply hybridized, bastard technology as well, as rickety a collection of electromechanical devices as a Model T Ford, of which anyone who engages in film practice has available at any given moment only a very constricted segment. Obviously I'm talking about those practitioners we call filmmakers; I'm not talking here about those practitioners we call Francis Ford Coppola, who presumably believe themselves to be in full possession of the high (and stagnant) technology of film. But in fact, within filmmaker practice there has been not only a constriction of the available but also a factionalization within that constriction, so that one hears denounced in certain quarters, for instance, all those persons who engage in the impurity of the optical printer. Let us return to old times and simple means, the argument seems to go, and that will be progress. In fact, the early cinema insisted absolutely, as it properly should have, upon the entire possession of its tools, of its materials, if you will, of its means of production. So that within films even at the present time, I think we can see atavistic remnants of the reaction against mechanization, normalization, from photographers, filmmakers, certain others whom we will not mention—it begins with a "v" [video] or it begins with a "c" [computer], and that's a little more rarefied, but the juncture's still there—an internal crystallization of a reaction that has so often been brought to bear upon those new image-making arts of which Valéry speaks from without. Again, I don't think this is the moment to unpack the psychological implications of that. Perhaps it is just the hollow and unctuous tones of the cultural superego speaking out of an unexpected mouth, let us say.

Another notion that I think should be challenged has to do with the cost of the work of art. First of all, in general, it's alleged that film is expensive. That probably is open to debate. As far as I know the most expensive art currently practiced in the West in total cost is symphonic music, because you're supposed to hire a hundred and twenty people for six weeks in order to do this, and put them in a big building, and heat the building, and so forth. It is only for the composer that it's cheap. In an economic environment that tends to demand that nothing can be printed unless you print a hundred thousand copies of it, whole forests fell for Saul Bellow to become a Nobel laureate, for example; vast tracts in Idaho were the raft that floated Mr. Bellow to Sweden on that occasion. Then, the notion of the cost of the work of art was defined to a certain degree—it still may be on a certain horizon—because it was initially a technology that was a by-product. I would remind you first of all that the old film support, cellulose nitrate, was military fallout just as surely as

microelectronics are today. It was guncotton, very simply. A large manufac-
turing technology existed to produce the stuff in quantity. The flexibility and
transparency of the stuff were what was at issue in this case, not its explosive-
ness, but that has continued to be a problem. Nitrate, as we know, still under-
goes slow-motion explosion, and nineteenth-century military technology is
(after all) working its revenge upon the early cinema silently in millions of
dark tin cans all over the West.

The emulsifying or suspending agent is gelatin. The Eastman Kodak
Company still insists that the very best photographic gelatin is made from
selected ear and cheek clippings of Argentinean beef cattle that are fed on
mustard greens. How's that for magic? Take one cow—steer, I beg your pardon
(that's quite important, too, probably, in some total reckoning of the thing)—
five pounds of mustard greens. . . . There's a recipe book for the imagery of a
high art. But that gelatin could only become available in quantity after a specific
economic moment had been reached in the West. That was the development of
vast latifundia for the raising of beef cattle in the Western United States and
in the Argentine. The gelatin was, again, a fallout from a process of exploita-
tion of an entirely different kind. And finally there was a brief moment during
which the photographic industries fastened upon silver-halide technology as
the material basis of the image, which proceeded also from an unusual circum-
stance, and that was the great silver strikes of the 1870s and '80s in Colorado
and in Idaho, which released vast quantities of that element into the market
within the period of a decade. The total quantity of silver in the world increased
by something like three decimal orders of magnitude. Nevertheless, it had
always been rare. It was made available again, briefly and in quantity, through a
process of real-estate exploitation. So that it would appear, in a way, and there's
nothing unusual in this for our arts (if the Romans had not practiced slavery in
Spain, the sulfide of mercury called cinnabar would never have been found in
quantity in the Mediterranean, and thus certain reds that we treasure in the
paintings of the Renaissance would not be around to this day), that the usual
bad commercial karma settled from the beginning on film just as it had upon
everything else.

Now, however, we have crossed into a temporal domain where the cost is
not deferred, and probably we should give momentary attention at least to what
a film costs now, or to what something that is called a film costs now. The socia-
ble presentation of film, which is itself a ritual of the right of free assembly,
produces some rather odd side effects. I calculated that in the small upstate
town that I live a few miles from, one single screening of *Apocalypse Now* pro-
duced, among other apocalyptic figures, the use of approximately three

hundred and ninety gallons of gasoline to take an audience of two hundred and fifty people to see it (this is one screening), about seven thousand road miles of travel for those people. If you translate that into the number of times that film will be screened before Francis Ford Coppola gets his money back (it's a process of infinite convergence, of course) and do the bookkeeping on it, you will cease to wonder why the petroleum industry or indeed the manufacturers of automobiles in Detroit seem to approve of the movies and indeed perhaps understand something of the not-very-secret affinities between those manufacturing processes. There are also, of course, movies that teach you how to drive automobiles, you understand, so there's some reciprocation there.

The real competition is from the electronics industry, not from coinage, which was once its only competition, and that is an industry that, if it builds it into the right circuits, can convert two milligrams of silver into a potentially endless series of images. That same two milligrams ends up being about one frame of 35mm camera negative, which is tied up; is, as it were, quarantined forever, or as long as we are quite sure that we wish to hold onto that image. In order to get the material back, we must release the image itself from the culture, we must cast it out.

So what has happened is that what was once seen as a copious popular art is very rapidly becoming paradoxically fragile, rare, and bounded in time. The figures that are usually given (and they are not mine; I heard this two weeks ago from Beaumont Newhall, who is, at the very least, venerable enough to quote) are that the silver print (he was talking about still photography, but this means our film process as well) will be all washed up in thirty years, that is to say, within the lifetime of most of the people in this room. So that it probably behooves us—yes, I know, Bucky Fuller: we will make movies out of cornstarch or something like that—[to acknowledge that] it is incorrect, it is inaccurate for us to speak of copiousness, of ready availability of a common product. Ironically, the very fact that film and the photograph escape certain conditions of ritual, the fact of their reproducibility, has virtually assured their disappearance. The more copies we can make, the more we are assured we don't have to make any, because we can always make them, and eventually, of course, none will have been made, and it will disappear. So it seems that, like the exercises of speech and sexuality, film and its allied arts of illusion are at once limitlessly plentiful and painfully fugitive.

Unless, of course, we wish to massively intervene, and the cost of that massive intervention is itself something that we had probably better examine pretty carefully. The industry—that is, that of the Detroit of the image, certain hills around the Los Angeles basin—has managed their share of the problem very

nicely, that is to say, it has arranged to have their product retrieved, archived, reproduced, cared for at the public expense. But the early cinema that we are talking about, and the present one, are, in that regard, totally vulnerable. It tends to be true of most of the proto-cinema that one print, or two, or half a dozen exist. It tends to be true also now that that infinitely reproducible artifact exists in one copy or fewer than a dozen. There may be a hundred *Window Water Baby Moving*s [Stan Brakhage's 1959 film] strewn around the planet in various states of disrepair, but that itself is a completely anomalous situation, which will tend to mean, in about the year 2050, for instance, if we're still interested in such things, that *Window Water Baby Moving* will appear to constitute virtually, in its entirety, thirty-five years of cinematic arts. Thus, we will seem to have ground slowly but exceedingly fine.

At the very onset, then, of this tremulous, momentary phenomenon, one of its real inventors—no, I certainly don't mean Edison—said that the cinematograph was an invention without a future. And that remark continues to puzzle me. It puzzled me for a very long time, but after a while I began to construct a tentative reading of it. What did Lumière mean when he said that the cinematograph, and of course he was referring to his machine, had no future? I think there are two possible readings, or I can imagine two at least, of that remark which are neither complementary nor convergent but are coeval, and I will present them in a brief sketch.

There's a story, and I might as well quote it since I always do, a story by Jorge Luis Borges—yes, he's going to quote Borges again—in which he speaks of a series of circumstances that surround a project that was never completed, and that project was the pleasure dome or pleasure garden or system of palaces or what have you of Kublai Khan.[4] I think most of us know the circumstances surrounding Coleridge's attempt to say something about that project. He had received, very much in the terms of the times, the entirety of the poem, all its assonances and alliterations, during an opium dream from which he awoke, and, like a good servant of the Muse, he began to transcribe the instructions. This is rhetoric familiar enough, I think, from our own time. And a knock at the door interrupted him. A person from the neighboring village of Porlock, whom he did not know, barged into the house, took up his afternoon, and then vanished back into that Porlock from which that person had proceeded. And when the stranger was gone, Coleridge found that his poem had evacuated along with him. Borges then goes on to point out that not only was the poem never completed, not only was the pretext never built, but the original architect of Kublai Khan's system of palaces received his instructions, his blueprints so to speak, also in a dream, a dream that he, the architect, was never quite able to remember

in its entirety either. And Borges closes his brief pseudo-essay with the remark that we may have here a series of events in which a new idea was struggling to come into the world, not necessarily the specific palace perhaps [but] something glimpsed thus far only in outline. There is, of course, an implied prediction in that: that presumably some centuries hence, when we have perhaps changed the forms of our ratiocinations and reserve our dreams for less technical matters, someone may find himself or herself confronted with Kublai Khan's system of palaces, whatever it is, in broad daylight, so to speak, and at that point the idea, heaven help us, will have found its way into the world.

I might conjecture in parallel with that—and this is entirely conjecture, but one whose eventuation will be drastically forced in the near future in any case—that the photograph, and then film, and now, heaven help us, that thing that begins with "v" may eventually be seen not as a series of separate things but somehow mysteriously related (what to call them? in the technical sense, perhaps, "excrements" would be reasonable), more indeed as parts of something, as tentative attempts, at once complete and approximate, to construct something that will amount to an arena for thought, and presumably, as well, an arena of power, commensurate with that of language.

My other conjecture makes Lumière perhaps a more philosophical figure than he was. One finds out, I guess, who the philosophers were by a process of historical Monday-morning quarterbacking. Philosophy is not of the present. After all, a decade ago, Andy Warhol was a philosopher for five minutes. But not only a philosopher perhaps, in Lumière's case, but touched for a moment with an insight, newly implied if not original, about history. From a certain point of view it was impossible at the beginning, as Lumière said "let there be light," for the cinematograph to have a future because it did not have a past. Now the future is, after all, something that we manufacture. We can be willful about it and perverse, if we wish, but nevertheless even our willfulness, even our perversity is ordinarily understood, I think, to be subsumed by a temporal machine, containing and originated and guided by human beings, called historical process. Until such time as there is a past of some sort—a history, furthermore, of some sort—a past which has been examined, has been subjected to a critical, a theoretical analysis, there can be no future, because there is no apparatus for prediction and for extrapolation.

I do not mean, of course, that history in any exact sense is something that is guaranteed by the possession of a past. Only its possibility is guaranteed. But the first work of the proto-cinema, in that light, was to begin to provide films with a past. Well, heaven knows, it has done so. In fact, it has quite a few pasts. There is now the gradual sketchy discernment of something that we might call

a history. There is also that quite regular past that everything has, which is a big pile of rubbish. There was a long period in between during which film as a general practice even has finally managed to acquire its share of guilt by having worked both sides of every street it could find.

So that it is only now, I think, that it begins to be possible to imagine a future, to construct, to predict a future for film, or for what we may generically agree to call film and its successors, because it is only now that we can begin to construct a history and, within that history, a finite and ordered set of monuments, if we wish to use T. S. Eliot's terms, that is to constitute a tradition. After a century, nevertheless, it is still true that no one knows even how to begin to write the sort of thing that film, through its affiliation with the sciences, might expect of itself, that is, a *Principia Cinematica*, presumably in three fat volumes entitled, in order: I. Preliminary Definitions; II. Principles of Sequence; III. Principles of Simultaneity. The wish for such a thing is somewhat like the wish of a certain aphorist who said—I believe it was the last of his aphorisms, or at least the last that I have read—that he would like to know the name of the last book that will ever be published.

So that, in fact, finally there is one last thing we should stop doing. We should stop calling ourselves new. We are not. They were new. We are old, and we have not necessarily aged as well as we should. To cite Eliot again: he reports himself as answering someone who objected to, I suppose, Shakespeare, Dante, and Homer on the grounds that we know more than they did by replying, "yes, we do, and they are precisely what we know." We also know more than that very early cinema did. Unfortunately, they are not precisely what we know. We are only beginning to penetrate the phantom, the fiction of the copious and the readily available, to poke around in dusty attics, into the sort of mausoleums guaranteed by a rapacious copyright system, for example, and to retrieve heaven knows what—probably not Shakespeare, Dante, and Homer (it would be nice to know who the Homer of films will ultimately be perceived as, by the way, let alone the Dante) but at least something of the context in which those texts, if they ultimately are exhumed, will be perceived.

To that end, then, I have brought along thirty minutes or so of such rubbish, which presumably contains embedded in it a Stradivarius or a scarab or something priceless. This is simply a roll, upon which I won't comment at all, from the Paper Print Collection at the Library of Congress. I wouldn't be surprised if other such things have been exhumed at this party earlier in the week. My principle of selection is so embarrassing that I don't propose to tell you anything about it at all, but it demonstrates something of that past which, like all pasts, is self-proclaiming, repetitive, redundant, naughty, sometimes astonishing,

and, in this case, on the principle that nothing much was made of it at the time, essentially impenetrable to us. It is by that mechanism that this body of material, whatever it is, then imposes upon us the responsibility of inventing it.

### Notes

1. The first two quotations appear as the epigraph to Benjamin's "The Work of Art in the Age of Mechanical Reproduction," in *Illuminations*, ed. and with an introduction by Hannah Arendt, trans. Harry Zohn (New York: Schocken, 1969), p. 217. The last quotation appears on p. 219. The quotations are taken from Valéry's 1928 essay "The Conquest of Ubiquity," in *Aesthetics*, trans. Ralph Mannheim (New York: Pantheon, 1964), pp. 225, 226.

2. The conference was held at the International Museum of Photography at the George Eastman House, in Rochester, New York, on November 10 and 11, 1979, in conjunction with the exhibition *Electroworks*, which featured some 250 artworks produced with copying machines. (B.J.)

3. The reference is to Sergei Eisenstein's *The Old and the New*, also known as *The General Line* (1929, Sovkino, USSR).

4. The reference is to Borges's story "The Dream of Coleridge," in *Other Inquisitions, 1937–1952*, trans. Ruth L. C. Simms (New York: Simon and Schuster, 1965).

Transcription of an audio recording (now lost) of a lecture for the series "Researches and Investigations into Film: Its Origins and the Avant-Garde," Whitney Museum of American Art, New York, November 17, 1979. Published in *October* 109 (Summer 2004): 64–75, edited and annotated by Michael Zryd.

# Interview at the Video Data Bank

**ADELE FRIEDMAN:** When did you meet Ezra Pound?

**HOLLIS FRAMPTON:** Well, I was twenty-one; Pound was seventy-one or seventy-two.[1] At that time he had finished the part of the *Cantos* called *Section: Rock-Drill* and was working on *Los Cantares 95–109*. And he was of course involved in trying to get out of the funny farm, more so than he usually had been in previous years. There was an incessant stream of visitors, some of whom were interesting, some of whom were remarkable in other ways. One in particular [Marcella Spann] was a female disciple a couple of years older than I was with whom Pound in fact collaborated on an anthology called *Confucius to Cummings* at about that time: a young woman from Texas, for whose uplifting education, enlightenment, or what have you, Pound undertook to read aloud and to footnote live or to make oral scholia on the entirety of the *Cantos*—the whole shooting match. And it was mostly through that that I sat, and it was indeed an extraordinary experience.

If very much of modernist poetics rests upon an extension of the rhetorical figure called metonymy, the substitution of the part for the whole, the *Cantos* is the supreme test of that. It is the vastest of all metonymic works. In its failure—and I believe that as a poem, as a whole work of art, it is a failure, as Pound believed—it represents an incredible catastrophe within modernist poetics. It is one of the supreme attempts, and it is one of the supreme failures. It is an immense catastrophe.

I don't think that it's possible—and I suppose here my theoretical Marxist leanings begin to emerge, at least—possible or feasible to bring off a project of those dimensions without a theory of history, in a word. And I don't think Pound had one. Thereby unfortunately depends the anti-Semitism. Pound didn't have a theory of history; he had a child's view of history—namely, that it was quite clear that everything was going downhill. And he set out to look for the culprit. And, of course, he found the culprit, because when one sets out to look for the villain of the piece, one always finds that villain. And that villain, of course, was not the Jew; that villain was a kind of recurrent state of mind that Pound came to call "usury."

I can also understand and sympathize with how that came about. And I think that that is very sad. Imagine a relatively young man. He was thirty (twenty-nine in 1914, at the beginning of the First World War) and had imagined, as only a young Romantic from the Idaho wilderness (but more of course from Philadelphia) enamored with European culture could have imagined, a new Renaissance. There was an extraordinarily brilliant group of people, immensely gifted, faced with what all of them perceived in all the arts, at the very least, as a kind of tabula rasa. It was virtually impossible by the eve of the First World War even for Browning, let alone Algernon Charles Swinburne and Milton and Wordsworth, to have very much claim on the attention of the young poet any more than it was possible for Brahms to have an absolute claim on the attention of such a composer as Schoenberg, for instance. The world, as it were, lay all before them; it seemed fairly clear what was

to be done. And then of course came the War, and, in a sense that has been explained so often by so many people of that generation and half a generation earlier, the world ended. As it had been slowly constructed from, let us say, the Renaissance through the Enlightenment and on into the period of the Industrial Revolution and the formation of the great empires of that period, that order ceased to exist. It seemed like a major collapse within Western civilization, and indeed it was. Most particularly, there was the personal loss of at least two very close personal friends of Pound: Henri Gaudier [Gaudier-Brzeska, the Vorticist sculptor] and T. E. Hulme [the British poet and critic]. Of Gaudier it would be premature I think to say very much; he was very young. Of T. E. Hulme, on the other hand, it is fair to say that critical thought of the philosophy of art sustained a very critical loss at the time. And what really happened to Pound after that time (he had been before then, after all, an aesthete with flying hair talking about Dante and so forth) was that he became a pacifist. And being the person he was, as a pacifist, set out to retrieve the origins of war, which he considered, as we all consider, supremely evil. He then retrieved those origins, as we now feel, incorrectly.

AF: How did you become interested in art?

HF: I was an adolescent poet because it was the thing to be. Abstract Expressionism, or let us say New York–type painting, while I was in secondary school, had begun to show real muscle. That moment, which was as we know quite extended, still strikes me as extraordinary; it did then, and I tried off and on for a while to be a painter as well. But it simply was not—as Gertrude Stein said to William Carlos Williams—my métier. I finally had to admit that it was something I simply didn't like to do. I didn't like paint. I didn't find any pleasure in smearing gooey substances over flat surfaces, which is after all what painters do. Somewhere I continue to maintain that there has to be something deeply attractive in the idiot level of whatever you do or it's impossible to sustain it, you see.

AF: What were your aspirations toward filmmaking?

HF: It could not be done; one had to be a millionaire and so forth. However, I did take the view that it could be done eventually, maybe with luck in some way; I had no idea how. The nearest place to embark, to acquire, say, a journeyman's knowledge of something that tended toward film, was the still photograph.

AF: What was the environment like in New York at this time?

HF: To try to be a still photographer in the late '50s and on into the middle '60s in New York was to live in a kind of vacuum. Still photographers were people like [Richard] Avedon or something like that. In other words, they were people who corresponded more or less to Hollywood directors. They were beautiful people who took pictures of rather snotty-looking other beautiful people for the magazines.

There was no photographic milieu, or virtually none that I thought could be taken seriously. There was one very small gallery on East Tenth Street (I don't remember what it was called). It was kind of two rooms painted white, and it was very much a kind of coterie situation. The photographs weren't very interesting. And a guy named Norbert Kleber, who lived under the stairs in the Village and had a very long front hallway that led back into his apartment, opened something called the Underground Gallery, which was this hallway.

That was it. The rest was MoMA, and MoMA was then, as it is now—except that it was [Edward] Steichen instead of [John] Szarkowski, and it was *The Family of Man* instead of what have you—the current product there. From the point of view of the museum, it was . . . photographers were scarcely landed gentry any more than they are now.

**AF: Were you influenced by other photographers?**

**HF:** In my then still perennial search for the father figure, I opted for Weston—more or less climbed the coconut tree of view-camera, zone-system stuff. I never had too much stomach for [Minor] White, thank you. Having done that, I really couldn't very well handily find my way down out of that tree. I didn't really like the work that I thought was my best work. I liked the stuff that I didn't like a lot more.

**AF: What was the dialogue like within your community of artists?**

**HF:** There I was, essentially having fallen amongst sculptors and painters in New York, among sculptors and painters who were my direct peers, and in a couple of cases at least school chums: Carl Andre and Frank Stella, in particular, who were in the nature of the thing dogmatic anti-illusionists. And I found myself in the very peculiar and uncomfortable situation of being a committed illusionist.

And of course they had reason on their side, you see. I mean they could marshal not only their own arguments, which were excellent, but those of the venerable Clement Greenberg and so forth. It left one very little room for being the devil's advocate. Because, if anything, I felt myself to be not the advocate but the devil himself.

**AF: How did you move into filmmaking?**

**HF:** Eventually what I found in making still photographs was that I was working not only in series and/or in sequences but was imagining sequences of photographs that were time-regulated. Now that is impossible to enforce. You have things up on a wall and you would like to say to someone, "Now go back to photograph number thirteen and look at it for eight seconds." All right. At that point within the work I was doing, the vehicle more or less collapsed, and I was tossed out of it into film whether I wanted to or not.

Then there was some problem in my mind about trying to purge my own work, or at least the internal geometry of my frame, of the still photograph. That process is still going on in *Zorns Lemma* [1970].

I spent a long time, of course, theoretically paying my debts to still photography. Then, as at least one friend remarked, the Weston essay ["Impromptus on Edward Weston: Everything in Its Place"] was the ritual murder of the father, which I then of course had to, being a grown man, at least decently bury with my own hands. At the same time I did want to do Weston the service of offering that body of work some criticism, some critical attention, rather than lighting simply another candle at the shrine of Wildcat Canyon or something like that.

I don't think that film and photography are two halves of something. My sensation now, right now, is that they are both parts of something for which we do not have a name at the present time— it would be amusing to try to give it a name—which thing, once it is fully constituted, will I expect finally to constitute a kind of counter-machine for the machine of language. That is to say that I suspect that the intellect of the West at least has been struggling for quite some time to invent a natural counterbalance for language as a way of accounting for the world, a way of doing it through images. And it has done so with its usual hysterical enthusiasm of productivity, with its usual confidence, and with its usual clumsiness. It is interesting to note, for instance, that at least primitive— very, very primitive—cinemas predate the invention of photography not by long, mind you, but by a few years, that it was quite some time before the two things united, the one in this case as the tool of the other. I think it's very clear for lots of reasons (I could give a few) that in the sense that we have had them since the 1830s and the 1890s, respectively, both still photography and film are obsolete and are going to vanish.

**AF: What filmmakers have influenced you?**

**HF:** I am in point of gratitude to quite a number of people who first hacked their way through the jungles of independent film. And if there had not been the encouragement by example of quite a few people who had somehow managed to make films . . .

**AF: Would you care to mention them?**

**HF:** Sure, of course. Glad to. First and foremost, Stan Brakhage, without question. They didn't have to be films that I agreed with, you understand, but it was nevertheless work of the first interest made with integrity and conviction. Then it had been done, and I'm sure that Brakhage would not agree with the phrase, by a classic gesture of seizing the means of production. But others as well, less prolific than Brakhage, very clearly: [Robert] Breer, Kenneth Anger, I suppose, who had certainly persevered against extraordinary odds. Most of all perhaps, in maintaining a space in which it was possible to entertain the notion of making film independently, Jonas Mekas. I knew none of those people at that time. I went to their screenings and so forth.

There was then something called the [Film-Makers'] Cinematheque in New York, which became a kind of hangout. I met other people who were trying to make films: Joyce Wieland, Michael Snow,

Ken Jacobs, Ernie Gehr after a while, although he was somewhat younger. Later on Paul Sharits, who was at that time living in Baltimore.

And there existed at least for a time, and that time lasted for some years in New York City, a kind of constant contact among us. One might almost—*almost*—venture to call it a sense of being united in some way, probably by the conviction that there should be good films. Preferably films so good that they hadn't been made yet. That the intellectual space open to film had not entirely been preempted. There had to be some films worth making or interesting to make that had not been made even by the master of Rollinsville [Colorado, where Brakhage then lived] or what have you. So that there was in that a kind of encouragement. There was a dialogue, in a word. All right, there was a dialogue that had not existed in still photography.

**AF: What is the role of narrative in film?**

**HF:** Just because it is possible to invent a narrative excuse for the way something presents itself doesn't, I think, mean that it *is* narrative. I don't want to be stuck that closely to the summary joc-ularities of the "Pentagram for Conjuring a Narrative." It was possible, for instance, to imagine the patterning of static, of white noise in Peter Kubelka's *Arnulf Rainer* as the breathing of a heavy and unwieldy man constantly running up and down stairs, which was Brakhage's actual invention, by the way, to account for that. At one time I didn't have very much difficulty in suddenly detecting in the kind of double-bell-curve rate-of-change structure in Tony Conrad's *The Flicker* a thickening and thinning of density of event, which is very much like the abstract curve, let's say, of a short story by Chekhov, in which, for instance, one has a crisis where two people or a family are separated. All right, that's the main bell-curve, typical Chekhov situation. And then years later there's a secondary peak of density of event in which they are reunited, after which the curve slopes back out to zero. So that I was seeing even there a kind of very rarefied trace of a narrative structure . . . about as much narrative, say, as there is hydrogen between galaxies, or something like that . . . quite a bit, anyway. But it requires a fairly delicate measuring instrument to detect it, or you have to be very observant, you have to be tuned to the radio band that those hydrogen atoms are giving off, and then they're everywhere. And so if you start looking for narrative out of curiosity, not as a disease, some kind of unspeakable ancestral disease, tertiary syphilis let's say—which was something like what painters of my generation recoiled from when they detected an illusionist reference in an abstract painting, as if from someone whose nose has just fallen off or something like that, some fright—but simply out of some question as to whether it was escapable or not, quite parallel to the question of whether or not illusionist reference is absolutely escapable in painting . . . I contend that probably it's not.

The decision never was, in my case, whether to make or not to make narrative films. I contend (this is simply, of course, the voice of the author, another imperfect reader) that all my work—and that includes *Magellan*, includes even the portions of *Magellan* that have been made and released—are perverse or oblique narratives. It's possible, after all, to have a narrative account of a very brief

period of time, for instance, and to expand that brief period of time until it's unrecognizable, and to fragment it and to rearrange it, and so forth. Nevertheless, I think it's possible always, if it seems relevant to do so, to expend that kind of diligence to retrieve the standard of the rational narrative which accounts for it in some way or other. To take an example that is by no means extreme, let me turn the tables and ask you if you believe, for instance, that [Alain Resnais's] *Last Year at Marienbad* is a narrative film. Well it is, of course. [Alain Robbe-Grillet's] *A Project for a Revolution in New York* is a narrative book; it is a narrative fiction. In the case of both of them, one is directed constantly toward an effort to retrieve the uninflected account of the events as they actually were, whatever they were, because one perceives immediately that they are highly inflected. And part of the process of seeing that Resnais film with its scenario by Robbe-Grillet, or reading that novel of Robbe-Grillet's, is a process of trying to retrieve the actual events, whatever they were. Then they may turn out to be not very interesting.

The things I'm doing now are sometimes more and more, sometimes less narrative-like. If you read the Weston text in *October*, then it's possible that you read the issue of *October* following that, which has a group of seven short fictions called "Mind over Matter," all of which are, in a manner of speaking, narratives—though in part what those are about is the transparency or opacity of the text relative to the event. None of them are very clearly writing at degree zero or, heaven help us, what Sartre commended in Camus, *écriture blanche*, white writing. They deviate in the direction of ultraviolet in that regard. But narratives indeed they are, of some kind or another.

**AF: How do your opinions about narrative differ from those of Brakhage?**

**HF:** There's a suggestion or utterance of Brakhage's some years ago, which I find very problematical, with which indeed I take issue, although not very extensively here. I remember his saying that as an example of something in a film of his own, a certain queen sent forth a certain knight of the Round Table on a search for the Holy Grail. In the tale of that quest one is . . . it is set on mythic ground; that is to say, that story seems to be the fleshed-out general type of a class of stories. Stan then asserted on that occasion that if in a work of art, let us say a film, a woman says to a man, "Will you please go over there and get me a glass of water?" . . . because it is a situation in which a woman sends a man on a journey to fetch a container out of which one might drink, that situation, that moment, occupies the same mythic ground as the quest for the Grail. One has therefore a blank reenactment of the myth. It's a curious insight into what Brakhage means by myth. I doubt it. Aside from doubting it, I would just say very momentarily that it is a curiously Jungian or kind of hyper-Jungian view of the thing one is looking at: that one understands it according to whether its segments or components constitute a peg that fits more or less perfectly into a mythic hole of the proper shape. Or that all human action, however casual and ordinary, is stamped out by a set of mythic cookie-cutters that cut the cookies of Oedipus or Agamemnon or what have you. I hope not, you see, because that

journey across the room then to fetch the lady a glass of water is not something that I want to make, because clearly there are too many sharp things to fall on when one stumbles over the footstool or something like that. And when one gets to the table and finds that the table is not your regular table but a high altar suffused with violet light and defended by bats with baby faces and so forth, in the ordinary world you are likely to say, "Oh fuck it, she don't get no water. Get your own god-damn cup." I'm just not sure that it's possible to live the quotidian life in terms of such high tone quite all the time.

**AF:** Where do you see media heading in the future?

**HF:** People, I suppose, still think of computers as being enormous IBM mainframes in rooms blazing with fluorescent lights and full of roaring cabinets. But in fact that's not true; they are little and cheap. I think that it is fair to say that within two years we will have intelligent toasters, for instance, that will always brown your toast to exactly the way you want it, you understand. Because the giant computer of twenty years ago is now a little integrated circuit, it's a little chip that looks kind of like a porcelain Band-Aid and costs about nine dollars. So if you want a really smart toaster, let alone a Waring blender or an intelligent frying pan that will flip the omelet at exactly the right time, you are going to have it. And in fact, of course, it's probably going to be difficult to have anything else quite soon. And I suspect that that is going to have social consequences and consequences with regard to the fate of the counter-machine of language—the image machine—at least as far-reaching as video has, as broadcast television has, and probably more so eventually.

**Notes**

1. In 1956, while a student at (Case) Western Reserve University, Frampton began writing to Pound, who had been committed to St. Elizabeths Hospital in Washington, D.C., since 1946. The following year, Frampton moved to Washington and visited the poet almost daily. (B.J.)

Transcription of a videotaped interview by Adele Friedman for the Video Data Bank, School of the Art Institute of Chicago, 1978. The tape, titled "Hollis Frampton: An Interview," is available on DVD as part of the *On Art and Artists* collection from www.vdb.org.

# Notes on Filmmakers

### ERNIE GEHR

Of a film seen on my third birthday, I recall only this: a drenching radiance, like the sun's, made somehow carnally intimate. Thirty years later I recovered that ecstasy in the films of Ernie Gehr.

That film—all film—is "about" light is an operational commonplace. In Ernie Gehr's films, light seems an absolute quality of the image. Light is *in* the image. This light is not merely the energy beamed from the projector, by which the film is seen; it is the energy streaming from Ernie Gehr's lucid sensibility, by which virtue *we see*.

### ROBERT HUOT

Some painters and sculptors approach our art with a kind of chauvinistic arrogance. Their use of film, however interesting as documentation, is fundamentally exploitative. Robert Huot has been one of the most inventive and rigorous of the younger generation of radical painters. He brings the same attributes to film, along with an inquisitiveness that is by no means cautious. He tries not to exploit film but to find out what film *is*. Huot's films will seem "simple" to many. In fact, he is doing basic work that we filmmakers ought to have done for ourselves decades ago, work that is both an addition and a reproach to film art.

[In] *Black and White Film* [a] nude woman is revealed, and then obliterates herself entirely, in extreme slow motion. This film is "about" painting. Outside of painting itself, it is the only really intense criticism I have ever seen.

### MICHAEL SNOW

All that survives entire of an epoch is its typical art form. For instance: painting (in all its enormity) comes to us intact from the New Stone Age. Film is surely the typical art of our time, whatever time that is. If the Lumières are Lascaux, then we are, now, in the Early Historical Period of film. It is a time of invention. One of little more than a dozen living inventors of film arts is Michael Snow. His work has already modified our perception of past film. Seen or unseen, it will affect the making and understanding of film in the future. This is an astonishing situation. It is like knowing the name and address of the man who carved the Sphinx.

## JOYCE WIELAND

The thought of some Purgatory wherein I might be deprived of seeing Joyce Wieland's films makes me regret my every sin and dereliction.

[In] *Catfood* [a] cat eats its methodical way through a polymorphous fish. The projector devours the ribbon of film at the same rate, methodically. *The Lay of Grimnir* mentions a wild boar whose magical flesh was nightly devoured by the heroes in Valhalla and miraculously regenerated next morning in the kitchen. The fish in Wieland's film, and the miraculous flesh of film itself, are resurrected on the rewinds, to be devoured again. Here is a Dionysian metaphor, old as the West, of immense strength. Once we see that the fish is the *protagonist* of the action, this metaphor reverberates to incandescence in the mind.

*La Raison avant la passion* [. . .] is about the pain and joy of living in a very large space: in fact, in a continent. It is painful, because such an experience distends the mind; it seems too large for passionate reason to contain. It is joyous, because "true patriot love," a reasonable passion, *can* contain it, after all. But what is remarkable, for me, is that all its urgency is lucidly caught, bound as it were chemically, in the substance of film itself, requiring no exterior argument.

*Film-Makers' Cooperative Catalogue*, no. 5 (New York: New American Cinema Group, 1971).

## *Zorns Lemma*: Script and Notations

Part I: Narration, *Bay State Primer* (c. 1800)[1]

In *Adam's* Fall
We sinnèd all.

Thy Life to mend,
God's *Book* attend.

The *Cat* doth play,
And after slay.

A *Dog* will bite
A Thief at Night.

The *Eagle's* Flight
Is out of Sight.

The idle *Fool*
Is whipt at School.

As runs the *Glass*,
Man's life doth pass.

My Book and *Heart*
Shall never part.

*Job* feels the Rod,
Yet blesses God.

Proud *Korah's* troop
Was swallow'd up.

The *Lion* bold
The *Lamb* doth hold.

The *Moon* gives light
In Time of Night.

*Nightingales* sing
In Time of Spring.

The royal *Oak*, it was the Tree
That sav'd his royal Majesty.

*Peter* denies
His Lord, and cries.

*Queen* Esther comes in royal State,
To save the Jews from dismal Fate.

*Rachael* doth mourn
For her first born.

*Samuel* anoints
Whom God appoints.

*Time* cuts down all,
Both great and small.

*Uriah's* beauteous Wife
Made David seek his life.

*Whales* in the Sea
God's Voice obey.

*Xerxes* the Great did die,
And so must you and I.

*Youth* forward slips,
Death soonest nips.

*Zaccheus*, he
Did climb the Tree,
His Lord to see.

**Part II: Images (subset B)**[2]

A = turning pages of a book

B = frying an egg

C = red ibis flapping its wings

D = cutting star-shaped cookies from a sheet of dough

E = two halves of a woman's face speaking at different rates

F = a single winter tree (static shot)

G = hands washing themselves

H = a man walks one block and turns the corner (handheld)

I = grinding hamburger

K = painting a green wall white

L = child on a swing

M = three men digging a hole

N = dried beans gradually fill the frame

O = a man bounces a ball (quadruple superimposition)

P = hands tying shoes

Q = steam escaping from a street vent

R = hands assemble a Tinkertoy chain

S = two rhinoceri

T = changing a tire

V = peeling and eating a tangerine

W = passing side streets at night (trucking shot)

X = a raging fire (handheld)

Y = a stand of cattails (trucking shot)

Z = sea waves breaking backwards

[handwritten note]: With the exceptions noted, all were carefully framed tripod shots. I wanted Lumière's static camera—for which *all* cinematographic images were *numinous* and *replete*.

**Part III: Narration, *On Light, or the Ingression of Forms* by Robert Grosseteste, Bishop of Lincoln (as translated and edited for *Zorns Lemma* by Hollis Frampton)**[3]

The first bodily form I judge to be Light. For Light, of itself, diffuses itself in every direction, so that a sphere of Light as great as you please is born instantly from a point of Light.

But Form cannot abandon Matter because Form is not separable and Matter cannot be emptied of Form.

Form is Light itself or the doer of its work and the bringer of dimensions into Matter. But Light is of a more noble and more excellent essence than all bodily things.

Since Light, which is the first Form created in first Matter, could not abandon Matter, in the beginning of Time it drew out Matter along with itself into a mass as great as the fabric of the world.

When the first sphere has been completed in this way, it spreads out its daylight from every part of itself to the center of the whole. This daylight, in its passage, does not divide the body through which it passes, but assembles and disperses it. And this assembling which disperses proceeded in order, until the nine celestial spheres were perfected.

Matter for the four Elements was assembled within the ninth sphere, which is the sphere of the moon. The ninth sphere, engendering daylight from itself, and assembling the Mass within itself, has brought forth Fire.

Fire engendering Light has brought forth Air.

Air engendering from itself a bodily spirit has brought forth Water and Earth.

But Earth is all the higher bodies, because the higher daylights were compressed together in the Earth; and the Light of any sphere may be drawn forth from the Earth into act and operation.

Whatever God you wish will be born of the Earth as of some Mother.

The Form and perfection of all bodies is Light. But the Light of the higher is more spiritual and simple, while the Light of the lower is more bodily and multiple.

Nor are all bodies of the same Form, though they have their origins in a simple Light; just as all Numbers are not of the same Form, though they are greater or lesser multiples of Unity.

In the highest body which is the most simple there are four things to be found, namely, Form, Matter, Composition, and Entirety.

Now the Form, as being most simple, has the place of Unity.

On account of the twofold power of Matter, namely, its ability to receive impressions and to retain them, and also on account of Density, which has its beginnings in Matter, Matter is allotted the nature of the Number Two.

Composition makes up the Number Three, because in Composition are evident formed Matter and material Form, and the thing about Composition which is its very own.

And that which besides these three is proper to Entirety is included under the Number Four.

When the Number One of Form and the Number Two of Matter and the Number Three of Composition and the Number Four of Entirety are added together, they make up the Number Ten. Ten is the full Number of the Universe, because every whole and perfect thing has something in itself like Form and Unity; and something like Matter and the Number Two; and something like Composition and the Number Three; and something like Entirety and the Number Four.

And it is not possible to add a fifth beyond these four.

Therefore every whole and perfect thing is a Ten.

But from this it is clear that only the five ratios found between the four numbers One, Two, Three, and Four are fitted to that Harmony which makes every composition steadfast. Therefore only those five ratios exist in musical measures, in dances and rhythmic times.

**Notes on the Film [handwritten manuscript]**

Title: "Zorn's Lemma" Itself

I have grown accustomed to alluding to Zorn's Lemma (which is demonstrably identical with two other mysterious mathematical entities called "The Axiom of Choice" and "The Well-Ordered Principle") by one of its corollaries, *viz.*:

*Every partially ordered set contains a maximal fully ordered subset*

You may multiply instances at your leisure.

For one or more things to be "ordered," they must share a perceptual (provable) element. So there are many ordered *subsets* within the set of all elements that make up the film, e.g., all shots containing the color red.

There is the subset of all "abstractive" elements (the words, if they are seen as merely "list-able") and the subset of all "fictive" elements (the images, if they are seen merely as deliberately "made").

But what you see (consciously) most of all is the one-second cut, or pulse. So that what I imply is that the maximal fully ordered subset of all film (which this film proposes to mime) is *not* the "shot" but the *cut*—the deliberate *act* of articulation.

Beyond that, there is the pulse of twenty-four frames per second, which is truly the maximal fully ordered subset of *all* films—and, obliquely, of our perceptions, since that is the threshold at which they *fail* us.

*But:*

Zorn's own Lemma was and is *not*, as you suggest, a "theory for describing all the possible relations within a . . . set." That is probably the whole task of *mathematics* at large: to describe all the possible relations among the class (or set) of "all numbers."

Zorn's Lemma is, rather, *hierarchic*, in that it proposes a possible meaningful "tour" of all elements within a set with regard to only one operation—discernment of their "ordering," or the relative preponderance of their *shared qualities*.

<div align="center">

The German noun

"Zorn"

means *rage, anger*

</div>

Words:

The film had its beginnings in preoccupation with tension between graphic and plastic/flat versus illusionistic elements in [the] same space. There were more than two thousand black-and-white stills made in 1962/63, which I proposed to stand-animate.

In the film *as it was made*, all word shots are handheld and as many as possible contain movement within the frame as well. I went for maximum *variety* of space, surface, etc. There are conscious references to every painting, drawing, and photographic style I could manage—though they are doubtless subtle in terms of twenty-four-frame viewing time. There are hundreds of shots which refer, secretly, to characteristic postures vis-à-vis space, color, etc. *within the history of film;* i.e., stylistic tendencies of other directors, mostly within the narrative canon.

Naturally, I had to work with the opportunities presented to me within Manhattan.*

\*exceptions:

*Fox:* Brooklyn

$\left.\begin{array}{l} \textit{Exit} \\ \textit{Humble} \\ \textit{Yield} \end{array}\right\}$ Summit and Medina counties, Ohio

"The Word was made Flesh ..."
  —John, I

The film is a kind of long *dissolve*, not quite the way *Wavelength* is a zoom, but nevertheless ...

Elements of autobiography:

a) that I received the same Judaeo-Christian upbringing as nearly everyone else in my culture: rote learning, by authority, in the dark, full of obscure threats of death, moral maxims, exotic animals anthropomorphized, tales of obtuse heroes pointing doubtfully to arcane wisdom.

b) that my adolescence and early adulthood were concerned primarily with words and verbal values. I fancied myself a poet; studied living and dead languages—hence my early contacts with, for instance, Ezra Pound.

c) that thirteen years in New York saw a gradual weaning away of my consciousness from verbal to visual interests. I saw this as *both* expansion and shift.

d) that I began, during the making of the film, to think about leaving the city. Part III is prophetic, in that sense, by about five months.

e) note that the film was begun in late *1962* ... and the growth of the work on the conceptual level quite literally mimes the shift described in (c). The necessities of this film, and of others that rehearsed it, also *accelerated* the process the film simulates.

Subclasses within the class of all "word" images:

Reasoning: in the course of making any long, dense, and if you will, "ambitious" work of art that functions within time and *itself requires much time to make*, a number of misfortunes are bound to occur. I take the *Divine Comedy* of Dante as my model, but many other works would do as well. (Verbal epics make a clearer

case because they share a characteristic with my film: modularity [a word = a shot].) The misfortunes are:

1) Metric errors. Lines that simply will not scan within the parameters of the normal overall metric scheme.

2) Omissions. Information necessary to intelligibility definitely left out.

3) Errors. Mistaken words. Errors of fact and syntax. Solecisms and other grammatical monstrosities.

4) Lapses of taste. Overt phoniness, vulgarity, archness, artiness, etc., which apparently proceed from the artist's character rather than his aesthetic stance (i.e., they are not *tactical*).

5) Faking. The use of a nominal or merely adequate locution to find one's way out of an uncritical node or impasse.

6) Breaches of decorum. Wherein the artist, by design or otherwise, breaks the rules he has himself set up for operating upon the elements of the work.

Since all these misadventures were bound to occur to me in making *Zorns Lemma*, I decided to incorporate them *deliberately*. Then at least I would know where they were. It had to be done "in code," to be sure, and one that had some relation to film as I excern its tradition. This is the scheme I adopted:

1) Metric Errors. All shots in the main section (your "Part II") or matrix are 24 frames long, except for twenty-four: twelve are only 23 frames, and twelve are 25 frames. Their positions were determined by another party (my "key grip," David Hamilton) by chance operations specified by me, and he then destroyed the record of their location (without informing me).

2) Omissions. As if I had thought later of some words that should be in the film, e.g., *dulcet*, *aspirin*, *lute*, etc. These are burn-in titles, superimposed in white. Since I did not wish to break the architectural decorum at this point, they are supered on shots of Lower Manhattan buildings.

3) Errors. I decided to encipher these "as though" the cinematographer had used the wrong color filter. A group of black-and-white graphic collages were prepared and shot on color stock, on a stand; several were made through each of the additive and subtractive primaries: *red, green, blue, cyan, magenta, yellow*.

4) Lapses of taste. A scattered category [of] "real" words (not flat animation material) obviously hoked up in the studio. The hand un-writing *"xylophone"* backwards is one example among many.

5) Faking. A large group. Color collages pasted up from magazines, instead of being "found" in the environs. Homages to many, but chiefly Rosenquist.

6) Breaches of decorum. Encoded as *still* black-and-white photographs, "flat" stuff, amid the welter of color; these are from the original 1962/63 shooting and so are the oldest material in the film. Each has a sentimental or outrageous "real" (colored) object lying on top of it (a green toothbrush on *"wig,"* matches on *"fuck,"* etc.).

These amount, altogether, to about one-sixth of the words, so they are not a negligible group. They become much more visible on *repeated* viewings.

They are of considerable importance to my own view of the film, and reflect forward to things now only half-planned.

"Replacement" Images

"Word-images" are all, by definition, man-made. They are entirely unmanipulated documents (i.e., in my cinematography).

The "replacements"—"natural" images—are nearly all *manipulated*. Exceptions: B, C, Q, S.

I made about twice as many images as I used. There is no *looping*, i.e., all were shot in real time and are seen in real sequence (some are elided or elliptical).

Criteria were essentially three:

1) Banality. Exceptions: S, C.

2) "Sculptural" as distinct from "painterly" (as in the word images) work being done, i.e., the illusion of space or substance consciously entered and dealt with, as against mimesis of such action. Exceptions: D, K.

3) Cinematic, or paracinematic, reference, however oblique. To my mind *any* phenomenon is paracinematic if it shares *one* element with cinema, e.g., modularity with respect to space and time. Consider also the problems of alternating scale, and maintaining the fourfold *Hopi* analysis: *convergent vs. non-convergent/rhythmic vs. arhythmic.*

Notes on specific images:

A: Turning pages. A new cycle, new day, etc. *Secret* correspondence: the particular book is the Old French version of Antonio Pigafetta's diary of the voyage of Magellan, which figures in a future film. The pages were turned to the beat of a metronome at one page per second.

B: Frying egg. Note that you see the egg being cracked. Egg = usual cosmological bullshit *but* a real and vivid image. A new historical cycle, a new epoch: a new phoenix egg.

C: Red ibis. The only shot not made specially for *Zorns Lemma*. Kowtow to exoticism; a rarity, and the rarest shot in the film, or 1 second in 3,606 [seconds].

D: Cookies. Immediate reference to flat-screen vs. illusionist space, via the passage from "figure" to "ground." Annette M. [Michelson] thought the woman was laying black stars on the table. Of course "star" means something in film history.

E: Split face. *Talking*, silently. *Two times* in the same space. The first "person" (in fact the schoolmarm of Part I, reciting the same text by halves).

F: Tree. A leap forward to Part III. A (dormant) vegetative world of *slow* rhythms. The only *static* shot among [the] replacements.

G: Hands washing. The first nominal *"ritual."* Manipulated through "direction" ("Now begin to rinse," etc.).

H: Walking a block. Simile for the whole film = expenditure of an artifact of fixed physical length. Use of telephoto lens, without change of focus, passes shot from deep space through flat and back to deep again. Giving the artifice away at the very end. I had the cowboy hero, who appears from nowhere and then disappears, specifically in mind.

I: Grinding meat. Another simile—this time, the deformative analytical process to which I subject all the material in this film, and to which cinematography subjects the flow of "real" processes. The *camera* is a meat grinder.

K: Painting a wall. Another simile: starting something and finishing it through human *work*. The space ends up white; the wall is the film frame. In the course of the shot, I repeatedly *breathed* on the lens to fog the image, which then repeatedly clears.

L: Child swinging. The early history of film *scale* within a single shot—the passage from *cogitative* to *contemplative* "distance" within one second: paracinematic modularity.

M: Digging a hole. Expenditure of the artifact = attrition of the artifact. One shovelful = one shot.

N: Beans. The film (the frame) as a container. When it is full, ample, replete, the task is done. The beans are anonymously modular, like leader frames. If you look closely, a mirrored image (in the background) of the beans being poured is gradually obscured by the beans themselves.

O: Bouncing ball. Four different attempts to *perform* a modular act (in four different *times*) seen simultaneously. (*Every* pair of superimposed spaces also is presented— two different *times*).

P: Hands tying shoes. A performance. Fourteen takes to do it in exactly ten seconds.

Q: Steam = *air.*

R: Tinkertoys. Paracinematic metaphor obvious. A childhood favorite. To make me look competent, the sequence was shot in reverse at twelve frames per second, so that, actually, I was *taking the chain apart* at a quite comfortable rate.

S: Rhinoceri: pure shock value. What other shaggy animals are up to in "our" era. An *alter ego* image.

T: Changing tire. A simple, convergent sculptural act involving performance values. Also *homage* to Brooklyn Bridge, q.v. in background.

V: Peeling and eating tangerine. Another convergent and sculptural act. But note radial modular symmetry of tangerine vs. axial modular symmetry of striped background, and illusion vs. "flatness."

W: Passing side streets. Deforming the real world via cinema. An allusion (oblique) to *kitsch* "underground" images. I had formerly shot a Norenesque [cf. Andrew Noren] sequence of endless breast-fondling for this slot (which didn't work at all).

X: Fire. Shot at twelve frames per second, handheld, *long* telephoto, while a friend deliberately pushed me and told me jokes, to make the frames smear à la Abstract Expressionism.

Y: Cattails. N.B.: This is actually two shots alternating, one with the other, against the light. Again a figure and ground, planar vs. illusionist alternation.

Z: Sea. Twelve frames per second reversed. The waves are only about six inches high!

## Notes

1. The opening sequence of *Zorns Lemma* consists of a black screen and, on the sound track, a woman's voice reading Frampton's transcription of a colonial-era children's primer. (B.J.)

2. In the central section of the film, a matrix of images (subset A) containing words (on storefronts, street signs, and walls), ordered alphabetically, is gradually replaced by the images described in this list (subset B). (B.J.)

3. The final section of the film consists of the text by Grosseteste read in voice-over as the image of a couple walking across a snow-covered rural landscape appears on screen; a chorus of female voices (including those of artist and filmmaker Joyce Wieland, choreographer Twyla Tharp, and painter Rosemarie Castoro) reads each word in turn. The English Scholastic philosopher and theologian Grosseteste (c. 1175–1253) wrote on matters religious, courtly, and domestic, but is best known for his many treatises on science and the scientific method. Frampton, in his script, has been careful to note his own role in translating and editing this medieval text from the original Latin. According to Frampton's handwritten notes, his version represents approximately 20 to 25 percent of the original. (B.J.)

Typewritten script elements and handwritten notes, undated, in the collection of Anthology Film Archives, New York.

Certain elements of grammar and punctuation in the handwritten manuscripts have been amended. In addition, Frampton's methods for indicating emphasis (capital letters, underscoring) have been uniformly transcribed as italics, and shorthand abbreviations (FPS, cd/, wch/) have been spelled out. For an exact transcription of the documents, see Scott MacDonald, *Screen Writings: Scripts and Texts by Independent Filmmakers* (Berkeley: University of California Press, 1995), pp. 53–69.

# *(nostalgia)*: Voice-Over Narration for a Film of That Name

*Blows into microphone:* Is it all right?
*Voice off mike:* It's all right.[1]
*Pause.*
*Reads:* These are recollections of a dozen still photographs I made several years ago.
*Pause. Blows into microphone. Pause.* Does it sound all right?
*Voice off mike:* Yes, yes, perfectly. It's fine.
*Pause.*
*Reads:* This is the first photograph I ever made with the direct intention of making art.[2]

I had bought myself a camera for Christmas in 1958. One day early in January of 1959, I photographed several drawings by Carl Andre, with whom I shared a cheap apartment on Mulberry Street. One frame of film was left over, and I suggested to Carl that he sit, or rather, squat, for a portrait.

He insisted that the photograph must incorporate a handsome small picture frame that had been given him a year or so before by a girl named North.

How the metronome entered the scheme I don't recall, but it must have been deliberately.

The picture frame reappears in a photograph dated March 1963, but there isn't time to show you that one now. I discarded the metronome eventually, after tolerating its syncopation for quite a while.

Carl Andre is twelve years older and more active than he was then. I see less of him nowadays than I should like; but then there are other people of whom I see *more* than I care to.

I despised this photograph for several years. But I could never bring myself to destroy a negative so incriminating.

[ ]

I made this photograph on March 11, 1959. The face is my own, or rather, it *was* my own. As you see, I was thoroughly pleased with myself at the time, presumably for having survived to such ripeness and wisdom, since it was my twenty-third birthday.

I focused the camera, sat on a stool in front of it, and made the exposures by squeezing a rubber bulb with my right foot.

There are eleven more photographs on the roll of film, all of comparable grandeur. Some of them exhibit my features in more sensitive or imposing moods.

One exposure records what now looks to me like a leer. I sent that one to a very pretty and sensible girl on the occasion of the vernal equinox, a holiday I held in some esteem. I think I wrote her some sort of cryptic note on the back of it. I never heard from her again.

Anyhow, photography had obviously caught my fancy. This photograph was made in the studio where I worked. It belonged to the wife of a friend. I daresay they are still married, but he has not been my friend for nearly ten years. We became estranged on account of an obscure mutual embarrassment that involved a third party and three dozen eggs.

I take some comfort in realizing that my entire physical body has been replaced more than once since it made this portrait of its face. However, I understand that my central nervous system is an exception.

[ ]

This photograph was made in September of 1960. The window is that of a dusty cabinetmaker's shop, on the west side of West Broadway, somewhere between Spring Street and West Houston.

I first photographed it more than a year earlier, as part of a series, but rejected it for reasons having to do with its tastefulness and illusion of deep space.

Then, in the course of two years, I made a half-dozen more negatives. Each time, I found some reason to feel dissatisfied. The negative was too flat, or too harsh; or the framing was too tight. Once a horse was reflected in the glass, although I don't recall *seeing* that horse. Once, I found myself reflected, with my camera and tripod.

Finally, the cabinetmaker closed up shop and moved away. I can't even remember exactly where he was anymore.

But a year after that, I happened to compare the prints I made from the six negatives. I was astonished! In the midst of my concern for the flaws in my method, the window itself had changed, from season to season, far more than my photographs had! I had thought my subject changeless, and my own sensibility pliable. But I was wrong about that.

So I chose the one photograph that pleased me most after all, and destroyed the rest. That was years ago. Now I'm sorry. I only wish you could have seen them!

[ ]

In 1961, for six or eight months, I lived in a borrowed loft on Bond Street, near the Bowery.

A young painter, who lived on the floor above me, wanted to be an Old Master. He talked a great deal about gums and varnishes; he was on his way to impastos of record thickness.

The spring of that year was sunny, and I spent a month photographing junk and rubble, in imitation of action painting. My neighbor saw my new work, and he was not especially pleased.

His opinion upset me . . . and for good reason. He lived with a woman (I believe her father was a Brazilian economist) who seemed to stay with him out of inertia. She was monumentally fair, and succulent, and indifferent. In the warm weather, she went about nearly naked, and I would invent excuses to visit upstairs, in order to stare at her.

My photographs failing as an excuse, I decided to ingratiate myself in the household by making a realistic work of art. I carved the numerals you see out of modeling clay, and then cast them in plaster.

The piece is called *A Cast of Thousands*. The numbers are reversed in the cast, of course, but I have reversed them again in printing, to enhance their intelligibility.

Anyway, I finally unveiled the piece one evening. I suppose the painter was properly horrified. But the girl, who had never said a dozen words to me, laughed, and then laughed outrageously, and then, outrageously, kissed me.

[ ]

Early in 1963, Frank Stella asked me to make a portrait. He needed it for some casual business use: a show announcement, or maybe a passport. Something like that. I only recall that it needed to be done quickly. A likeness would do.

I made a dozen likenesses and he chose one. His dealer paid me for the job.

Most of those dozen faces seem resigned, or melancholy. This one amuses me because Frank looks so entirely self-possessed. I suppose blowing smoke rings admits of little feeling beyond that.

Looking at the photograph recently, it reminded me, unaccountably, of a photograph of another artist squirting water out of his mouth, which is undoubtedly art.[3] Blowing smoke rings seems more of a craft.

Ordinarily, only opera singers make art with their mouths.

[ ]

I made this photograph of James Rosenquist the first day we met. That was on Palm Sunday in 1963, when he lived in a red brick building at number 5 Coenties

Slip. I went there to photograph him, in his studio, for a fashion magazine. The job was a washout, but Rosenquist and I remained friends for years afterward.

He rented two floors in the building. The lower floor, where he lived with his wife, Mary Lou, was cool, neat, and pleasant. Mary Lou was relaxed, cool, neat, very tall, and extremely pleasant. Rosenquist was calm. It was a lovely, soft, quiet Sunday.

We talked for a while and then went upstairs to his workroom. I made ninety-six negatives in about two hours. This was the last. It is unrelated to the others.

Rosenquist is holding open a copy of an old magazine. A map of the United States shows the distribution of our typical songbirds. I admire this photograph for its internal geometry, the expression of its subject, its virtu-ally perfect mapping of tonal values on the gray scale. It pleases me as much as anything I did.

James Rosenquist and I live far apart now, and we seldom meet. But I cannot recall one moment spent in his company that I didn't completely enjoy.

[ ]

This photograph was made at about three o'clock on the morning of June 6, 1963, in lower Manhattan. It may even have been Wall Street.

It is seen from the sidewalk, through the window of a large bank that had been closed for renovation and partially demolished inside. A big crystal chan-delier is draped in a dusty, translucent membrane that recalls the tents of caterpillars. Someone has written with a forefinger, on the dusty pane, the words *I like my new name.*

This seemed mysterious to me. At that time, I was much taken with the photographs of Lartigue, and I wanted to make photographs as mysterious as his, without, however, attempting to comprehend his wit.

All I learned was that the two were somehow bound together. Anyway, my eye for mystery is defective, and so this may be the only example I'll ever produce.

Nevertheless, because it is a very difficult negative to print, I find that I do so less and less often.

[ ]

This photograph of two toilets was made in February of 1964, with a new view camera I had just got at that time.

As you can see, it is an imitation of a painted Renaissance crucifixion.

The outline of the Cross is quite clear. At its foot, the closed bowl on the right represents the Blessed Virgin. On the left is Saint Mary Magdalene: a bowl with its lid raised. The roll of toilet paper stands for the skull of Adam, whose

sin is conventionally washed away by the blood the crucified Savior sheds. The stairs leading up to the two booths symbolize Calvary.

I'm not completely certain of the iconographic significance of the light bulbs, but the halos that surround them are more than suggestive.

[ ]

Late in the fall of 1964, a painter friend asked me to make a photographic document of spaghetti, an image that he wanted to incorporate into a work of his own.[4]

I set up my camera above an empty darkroom tray, opened a number 2 can of Franco-American Spaghetti, and poured it out. Then I stirred it around until I saw a suitably random arrangement of pasta strands, and finished the photograph in short order.

Then, instead of disposing of the spaghetti, I left it there, and made one photograph every day. This was the eighteenth such photograph.

The spaghetti has dried without rotting. The sauce is a kind of pink varnish on the yellow strings. The entirety is covered in attractive mature colonies of mold in three colors: black, green, and white.

I continued the series until no further change appeared to be taking place: about two months altogether. The spaghetti was never entirely consumed, but the mold eventually disappeared.

[ ]

This photograph was made in Michael Snow's studio, sometime in 1965. It was made into a poster announcing a show of his Walking Woman works at the Poindexter Gallery in that year.

As many as possible of the pieces are seen, by reflection or transmission, in a transparent sheet of acrylic plastic which is itself part of a piece. The result is probably confusing, but no more so than the show apparently was, since it seems to have been studiously ignored.

If you look closely, you can see Michael Snow himself, on the left, by transmission, and my camera, on the right, by reflection.

I recall that we worked half a day for two or three exposures. I believe that Snow was pleased with the photograph itself, as I was. But he disliked the poster intensely. He said I had chosen a typeface that looked like an invitation to a church social.

I regret to say that he was right. But it was too late. There was nothing to do about it. The whole business still troubles me. I wish I could apologize to him.

[ ]

This posed photograph of Larry Poons reclining on his bed was made early in 1966, for *Vogue* magazine.

I was ecstatically happy that afternoon, for entirely personal reasons. I set up my camera quickly, made a single exposure, and left.

Later on, I was sent a check for the photograph that I thought inadequate by half. I returned it to the magazine with a letter of explanation. They sent me another check for the amount I asked for: seventy-five dollars.

Months later, the photograph was published. I was working in a color film laboratory at the time. My boss saw the photograph, and I nearly lost my job.

I decided to stop doing this sort of thing.

[ ]

I did not make this photograph, nor do I know who did. Nor can I recall precisely *when* it was made. It was printed in a newspaper, so I suppose that any patient person with an interest in this sort of thing could satisfy himself entirely as to its origins.

The image is slightly indistinct. A stubby, middle-aged man wearing a base-ball cap looks back in matter-of-fact dismay or disgruntlement at the camera. It has caught him in the midst of a display of spheres, each about the size of a grape-fruit and of some nondescript light color. He holds four of them in his cupped hands. The rest seem half-submerged in water, or else lying in something like mud. A vague, mottled mass behind the crouching man suggests foliage.

I am as puzzled and mildly distressed by the sight of this photograph as its protagonist seems to be with the spheres. They seem absolutely alien, and yet not very forbidding, after all.

What does it mean?

I am uncertain, but perfectly willing to offer a plausible explanation. The man is a Texas fruit-grower. His orchards lie near the Gulf of Mexico. The spheres *are* grapefruit. As they neared maturity, a hurricane flooded the orchard and knocked down the fruit. The man is stunned by his commercial loss, and a little resentful of the photographer who intrudes upon his attempt to assess it.

On the other hand, were photography of greater antiquity, then this image might date from the time of, let us say, Pascal; and I suppose he would have under-stood it quite differently.

[ ]

Since 1966 I have made few photographs. This has been partly through design, and partly through laziness. I think I expose fewer than fifty negatives a year now. Of course I work more deliberately than I once did, and that counts for something. But I must confess that I have largely given up still photography.

So it is all the more surprising that I felt again, a few weeks ago, a vagrant urge that would have seemed familiar a few years ago: the urge to take my cam-era out of doors and make a photograph. It was a quite simple, obtrusive need. So I obeyed it.

I wandered around for hours, unsatisfied, and finally turned toward home in the afternoon. Half a block from my front door, the receding perspective of an alley caught my eye . . . a dark tunnel with the cross street beyond brightly lit. As I focused and composed the image, a truck turned into the alley. The driver stopped it, got out, and walked away. He left his cab door open.

My composition was spoiled, but I felt a perverse impulse to make the exposure anyway. I did so, and then went home to develop my single negative.

When I came to print the negative, an odd thing struck my eye. *Something*, standing in the cross street and invisible to me, was reflected in a factory window, and then reflected once more in the rear-view mirror attached to the truck door. It was only a tiny detail.

Since then, I have enlarged this small section of my negative enormously. The grain of the film all but obliterates the features of the image. It is obscure; by any possible reckoning, it is hopelessly ambiguous.

Nevertheless, what I *believe* I see recorded, in that speck of film, fills me with such fear, such utter dread and loathing, that I think I shall never dare to make another photograph again.

Here it is!

Look at it!

Do you see what I see?

## Notes

1. The two voices heard at the beginning of Frampton's 1971 film *(nostalgia)* are those of the narrator, the Canadian artist and filmmaker Michael Snow, and off-mike, Frampton. (B.J.)

2. The photograph that appears on screen as the narrator begins to read this text is not the portrait of Carl Andre being described but rather an unidentified image of a darkroom, displayed atop a hotplate. It slowly chars and burns as the description of the Carl Andre photograph continues. The Andre photograph then appears and burns as the voice-over begins to describe Frampton's self-portrait. This disjunction of sound and image, which continues throughout the film, engages the viewer in the process of recollection often associated with the photographic image, and literalizes the idea of the absence of the photographic pretext that Frampton often invokes in describing the medium. The final section of the film culminates not with an image but with a black screen. (B.J.)

3. The reference is to Bruce Nauman's photograph *Self-Portrait as a Fountain* (1966). (B.J.)

4. The artist is James Rosenquist, who incorporated the image of spaghetti as a motif in a number of his paintings and lithographs. (B.J.)

Film script dated January 8, 1971. Published in *Film Culture*, nos. 53–55 (Spring 1972): 105–111.

*The (nostalgia) Portfolio,* 1971 (photographed 1959–1966)

Thirteen black-and-white photographs
© Estate of Hollis Frampton

Untitled (photography darkroom), n.d.

Untitled (portrait of Carl Andre), 1959

Untitled (self-portrait), 1959

Untitled (dusty cabinetmaker's shop), 1960

214

Untitled (*A Cast of Thousands*), 1961

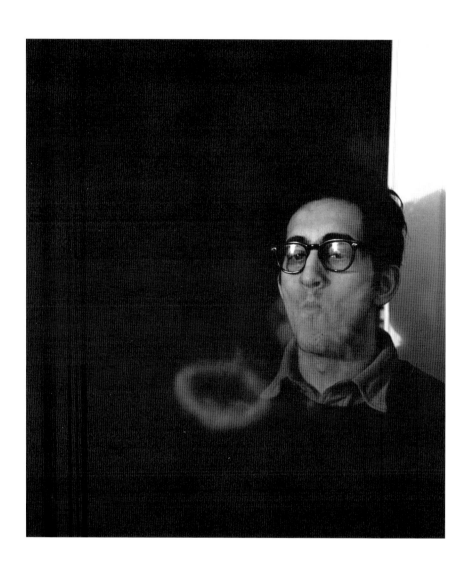

Untitled (portrait of Frank Stella), 1963

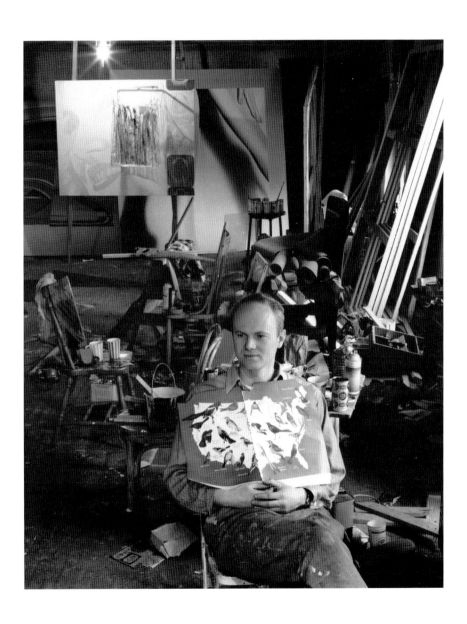

Untitled (portrait of James Rosenquist), 1963

Untitled (bank window), 1963

Untitled (two toilets), 1964

Untitled (Franco-American Spaghetti), 1964

Untitled (Michael Snow's studio), 1965

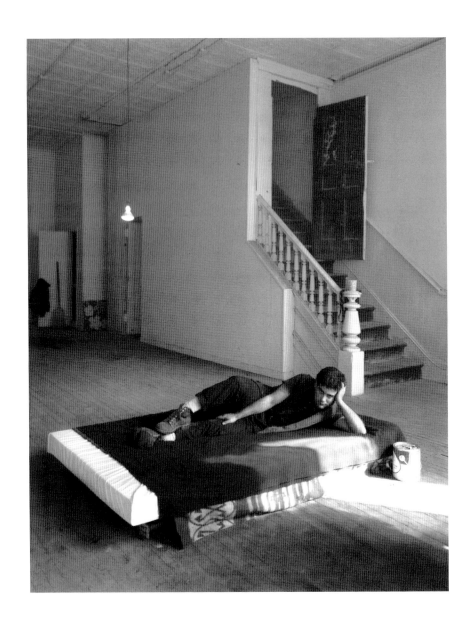

Untitled (portrait of Larry Poons), 1966

Untitled (appropriated newspaper photograph), n.d.

# Notes on *(nostalgia)*

The narrative art of most young men is autobiographical. Since I have had little narrative experience, it seemed reasonable to accept *biography* as a convention, rather, however little information was available to me.

My subject, hoping abjectly to be taken for a man of his time, had practiced rigorous self-effacement for a decade or more. So I was forced into examining his leavings and middens, like an archaeologist sifting for ostracizing pot shards.

Since he had once been myself, I knew exactly where to look. Random debts and documents aside, he had left behind some thousands of still photographs made during his apprenticeship to the art I expound. Because my results were to be made public, I chose a mere dozen of these specimens to examine, leaving the rest for later investigators who would be doubly fortunate: first in their sentiment for their antagonist, and again in their intimacy with his work.

Since I still shared some of his aspirations, I found the photographs I chose (as distinct from those I discarded) fairly embarrassing. So I decided, humanely, to destroy them (retaining the negatives, of course, against unpredictable future needs) by *burning*. My biographical film would be a document of this compassionate act!

And, at the same time, by thus destroying the evidence, I would thwart unforeseen critical disagreement.

Then again, to lend vividness to the circumstances of a subject of no particular general interest, I determined to comment upon the photographs *as if in the first person*. And, finally, to obviate any possible confusion, I decided to have my script read by another party. My subject being indisposed, the narration was generously read by Mr. Michael Snow, who has been familiar with my own activities for some years but quite ignorant of *his*.

The actual making of the film was dogged by misadventures so thoroughly in keeping with my subject's character that, as they accumulated, I gained confidence. One film laboratory scratched the original. At another, technicians went out of their way to comment on the poor mechanical qualities of the sound track.

In the end, when I saw the film myself, I felt that I had made an effigy, at least, of his opaque young-man's life, even if I had not wholly entrained its sadness.

H.F.
Eaton, New York
April 4, 1971

*Film Culture*, nos. 53–55 (Spring 1972): 114.

# Envoi

This book swims upstream, to the place where it was spawned. Twenty years ago, when I disbelieved that it would ever be given me to make films, and when I was a lowercase surrealist, and when I believed that filmmaking started, like making love by telephone, with a script . . . I wrote film scripts. Later, it came time to make a work in seven parts, of which *Poetic Justice* is the uncomfortable (it doesn't *move*) second, and to recapitulate some of the history of film art as though it were my own life to recollect.[1]

Such stereoscopy is not impossible. Ken Jacobs has given us a film in which simultaneous tridimensional spaces confound our various eyes: *perfectly impossible, wholly realized.*[2] Earlier, a poet achieved a double exposure of Ulysses imprisoned in a horned flame, together with certain propositions of Richard of St. Victor[3]—although there obtains by now other (and, for us, perhaps ampler) precedent for intercourse among modalities of vision and metalanguages of the seen.

That any book might share significant qualities with any film surprises me, penetrates to an obscure flaw among rejections crucial enough at one time. Now I suspect that unquestioning acceptance *or* unquestioning dismissal of the narrative propensities of the mind lie to right and left of a major channel along which energy has leaked from film art. This leakage can be dealt with. If it is customary to say that film is young among the arts, it is more responsible to notice that film is the first of the arts that has its roots in consciousness as we know it.

H.F.
Eaton, New York
July 9, 1973

### Notes

1. The film *Poetic Justice* consists of a close-up of a table on which the successive pages of a handwritten screenplay appear. (B.J.)
2. Frampton refers here to an early version of Jacobs's "Nervous System" three-dimensional projections, initial chapters of which were titled *The Impossible*. (B.J.)
3. The reference is a layered one: to Dante, in whose *Inferno* (Canto 26) the image of Ulysses in the "horned flame" appears and in whose *Paradise* the twelfth-century Christian mystic Richard of St. Victor makes an appearance; but also to Ezra Pound, in whose *Cantos* both Dante and Richard of St. Victor figure prominently. (B.J.)

Preface to the screenplay of Frampton's 1972 film *Poetic Justice*, published as the book *Poetic Justice* (Rochester, N.Y.: Visual Studies Workshop Press, 1973).

## Statement of Plans for *Magellan*

I began work, nearly five years ago, upon a project that is subsumed under the synoptic explication of a single metaphor. When it is complete, it will constitute a "serial," or long work in installments, using the elements of *peripeteia* and discovery customary to the serial mode. The central conceit of the work derives from the voyage of Ferdinand Magellan, first circumnavigator of the world, as detailed in the diary of his "passenger," Antonio Pigafetta, and elsewhere. During his five-year voyage, Magellan trespasses (alive and dead) upon every psycholinguistic "time zone," circumambulating the whole of human experience as a kind of somnambulist. He returns home, a carcass pickled in cloves, as an exquisite corpse. The protagonist of my work must be a first-person consciousness that bears resemblances to myself (if only as the amalgam H. C. Earwicker/Anna Livia Plurabelle resembles James Joyce) . . . and, even, to Flash Gordon and Fantômas of the filmic vulgate.

A brief recounting of the concerns of my earlier work may help to clarify the goals of the project to which I am presently committed. They have been:

1. Rationalization of the history of film art. Resynthesis of the film tradition: "making film over as it should have been." The making of a coherent body of work that shall systematically map the terrain of film art, together with its boundaries, according to poetic principles extrapolated or induced from film's irrational natural history.

2. The malleability of the sense and notion of *time* in film. Investigation of the temporal plasticity proper to an art that subsists at once within the colliding modes of memory, absolute "presentness," and anticipation.

3. Establishment of rigorous procedures to generate the several parameters of filmmaking (strictly analogous in intent to the serial and post-serial techniques of advanced musical composition), with a view to the elimination of those *nominally* subjective, "thumbprint" procedures which, in fact, originate not within the artist's sensibility but rather within his cultural ambience and pass unexamined into the axiomatic set of operations that constitutes a generative epistemological subtext for every work of art whatsoever. My procedures have derived, in every case, from long contemplation of a body of camera footage, and a resultant extrapolation of the formal necessities and intellectual resonances implied therein.

4. The function of the written and spoken word in film. I have begun an exploration of the tense mutuality that exists between the arts founded in language (prose, utterance, poetry) and those founded in kinetic visual

illusion (animation, document, cinema) as they seem poised to annex one another, and, together, to annex music, in the interest of founding an art that shall be fully and radically isotropic with the movement and substance of consciousness.

5. The manner in which it may be understood that a single human life, seen as an intricate but apprehensible "figure" in space and time, designates and details, literally and metaphorically, a creative lifework. Uses of autobiographical information, seen in stereoscopic focus with the historic canons of one's art, as a source of shaping mythic reverberation.

I am applying for aid in making a film that will continue these investigations and explore four other interlocking territories:

6. The dialectical relationship between graphic and plastic elements in a cinematic closed field that includes both. The graphic cinema is as old as filmic illusion. I refer not only to the animated film but also to the ancient presence of intertitles, whose intrusion in the midst of the film experience recalls our attention to a frontal picture plane that we feel to be at odds with that deep space whose aggressive recapture more clearly marks the onset of cinematic thought than the mere artifactual appearance of the analytic filmstrip or, even, the illusion of motion. I am interested to effect a direct confrontation between these two coeval cinematic modes.

7. The general "problem of sound" in film. Since 1928, this problem has hung over cinema like a Damoclean sword. A rhetorical spectrum extends from the supreme artifice of "lip sync" (tacitly understood to be transpiring within a perfectly degraded or evacuated auditory universe) to the supreme artifice of silence (proclaimed as the perfect exaltation . . . by default . . . of vision) by way of true synchronous (environmental, stochastic, indeterminate, aleatory) sound; dissynchronous and asynchronous sound; sound disjunct but iconic (the acoustic "image" is of astonishing durability); sound disjunct but synesthetic (that is, bearing to its coeval image a discoverable or imaginable relationship founded in causality); perfectly disjunct sound, from which we might expect discoveries of a magnitude comparable to those proceeding from the surrealist Encounter. I do not propose, of course, to "solve" this problem of sound but rather, simply, to probe its extent, seeking, in particular, the dissolution of those perimeters where sound merges, on the one hand, into "language" and, on the other, into "music."

8. Rhetorical options available to film art through such image-forming and -manipulating tools as optical and video synthesizers, electronic means for synthesizing and modifying sounds, and the digital computer. I am particularly interested in these devices in proportion as they make available to film,

within a framework that has some discoverable relation to "real time," generative or metamorphic options that once lay outside the possibilities of film art simply because they could not handily be entertained during a single lifetime. I am not in the least interested in wandering among the "infinite possibilities" of such devices; I want to press them into the service of cinema as directly as others have done with the mechanical camera.

9. The notion of a hypothetical, totally inclusive work of film art as a model for human consciousness. I propose a work of art (not a scientific or philosophical theory) that shall touch upon a sufficient number of shores to cartoon my own affective world. We may assume that each thing implies the universe, whose most obvious trait is its complexity; on that principle, I conceive, distantly, of an art of cinema that might encode thought as compactly as the human genetic substance encodes our entire physical body.

[ ]

As I envision it, this work (which I provisionally call *Magellan*) will be made up of a cycle of seven complementary but independent complete films, each of which is itself to be composed of a number of detachable subsections and epicycles of separate semantic and formal integrity. The seven large sections are: I. *Dreams of Magellan*; II. *The Birth of Magellan*; III. *The Small Cloud of Magellan*; IV. *Straits of Magellan*; V. *The Large Cloud of Magellan*; VI. *The Death of Magellan*; VII. *The Return of Magellan*.

The first and second parts will be generated, in the main, through animation and video synthesis. Parts III and V will be made entirely by cinematic means derived from my understanding of the canons of filmic montage, as enunciated by Lev Kuleshov, Sergei Eisenstein, and Dziga Vertov and extended and castigated by film artists during the past thirty years. Part VI will be generated largely through cinematic means, with the intervention of optical manipulation; and Part VII is to be made from a fixed set of graphic reductions, derived from images in Part IV, through the agency of a computer.

That portion of the work which is at once largest, pivotal, and most intricate is Part IV, the segment called *Straits of Magellan*; and it is for the completion of a *sound track* for that part of the entire *Magellan* cycle that I am specifically requesting support.

*Straits of Magellan* will consist of 360 subsections, each precisely one minute in length, and composing a resonant work among themselves. The governing metaphor of this part of the work is the cycle of the solar year. A single segment of film is provided for each calendar day . . . so that, ideally, the work constitutes for the perceiver an *environment in time*. (I also plan for shorter viewing schedules.) Special, longer episodes are intended for the four great

pagan celebrations of the equinoxes and solstices; a special work is planned for Leap Year Day (February 29), and another, concerned with the iconicity of light itself, for a temporal site of variable location.

The 360 subsections that make up the matrix of *Straits of Magellan* constitute, first of all, an homage to film's very beginnings, the protocinema of the brothers Lumière; and then, an encyclopedia of modalities of perception ... deliberate, as the Lumières' inventory probably was not. 240 of the segments are to be strict documents, unmanipulated outside the camera and partitioned from a slightly longer camera run by a pair of fixed, equidistant "cuts"; the remaining 120 constitute a lexicon of procedures and tropes from a "history" of film, in part natural and in part conjectural, that refers to narrative, performance, film's own special materiality, a critique of montage, and a host of other matters, seemingly as far afield as bioluminescence and tachistoscopy.

My plan for the film calls for the generation of a sixty-second segment of sound track for each of these 360 one-minute subsections of imagery. In accordance with paragraph (7) above, very little of this sound will be lip-synchronous; and, indeed, it will be possible to produce only about one fourth of the sound material via the means of real-time recording. By far the largest number of elements in this sound montage will imitate, resynthesize, and fictionalize a large spectrum of variations in the production and perception of spoken language and other acoustic sign systems from the animal world, induced by the known inventory of psychopathological and dissociative states of consciousness. Thus, the generation of this sound material will necessarily entail a great deal of editing, and electronic and digital processing, at the post-production level; I anticipate that much of this work will require several generations of re-recording, and of dubbing back from optical sound tracks.

The set of films that make up the cinematic terrain called *Straits of Magellan* is expected to run about twelve hours in real screening time, inclusive of its formally appropriate cinematic prefixes, suffixes, inflections.

Since I have been engaged upon this work, something has got done in every part of the *Magellan* cycle, which will require, when completed, about twenty-four hours of total screening time. I have committed my creative energy, and my total resources, to this work . . . for an indeterminate period of time.

Typewritten manuscript of proposal, undated (c. 1978).

There are at least three versions of this proposal requesting support for various portions of the work, including earlier submissions to the Creative Artists Program Service Inc. and the individual artist program of the National Endowment for the Arts, and a later one to the Guggenheim Foundation. The agency to which this particular proposal was submitted, with an appended budget of $9,250, is unknown. (B.J.)

## Phrases.Mag

COLORED PEOPLE (i.e., nudes painted monochrome hues) (Eaton, 6 JAN 76)

FACTS OF LIFE (Eaton, 13 JUN 76)

SECOND NATURE (Eaton, 4 JUL 76)

LIVING PROOF (Hamilton, 26 JUL 76)

IT'S ALL DONE WITH MIRRORS (Eaton, 28 JUL 76)

TIME IS ON OUR SIDE (Heathrow Airport, 13 SEP 76)

A MEAL IN ITSELF (Eaton, 26 SEP 76)

THE PLOT THICKENS (Eaton, 14 OCT 76)

TURN ABOUT IS FAIR PLAY (Eaton, 14 OCT 76)

BETTER LATE THAN NEVER (Eaton, 24 OCT 76)

THE BENEFIT OF THE DOUBT (New York, 25 OCT 76)

MORE LIGHT ON THE SUBJECT (Eaton, 27 OCT 76)

MORE THAN MEETS THE EYE (Eaton, 29 OCT 76)

THE SPUR OF THE MOMENT (Eaton, 31 OCT 76)

A LITTLE GOES A LONG WAY (Interstate 90, 5 NOV 76)

FOREIGN BODY (Buffalo, 5 NOV 76)

FOREIGN MATTER (Buffalo, 5 NOV 76)

PERIODIC FUNCTION (Eaton, 9 NOV 76)

A SHOT IN THE DARK (Eaton, 27 NOV 76)

TIME AFTER TIME (New York, 29 NOV 76)

THE LAST WORD (Buffalo, 2 DEC 76)

TO GET IT OUT OF MY SYSTEM (5 DEC 76)

TIME ON MY HANDS (Eaton, 7 DEC 76)

ALL THE TIME IN THE WORLD (Boston, 8 DEC 76)

FRENCH CURVES (Eaton, 26 DEC 76)

NO SOONER SAID THAN DONE! (Eaton, 26 DEC 76)

FROM TIME TO TIME (Eaton, 28 DEC 76)

TAKING A DIM VIEW (Eaton, 7 JAN 77)

STRANGE BEDFELLOWS (Eaton, 17 JAN 77)

SIGHT UNSEEN (New York, 15 FEB 77)

SPLITTING THE DIFFERENCE (Eaton, 1 MAR 77)

FINDING TIME (Eaton, 16 MAR 77)

MAKING TIME (Eaton, 16 MAR 77)

IT SPEAKS FOR ITSELF (Eaton, 1 APR 77)

FOR THE TIME BEING (Eaton, 19 APR 77)

A RACE AGAINST TIME (Eaton, 3 JUN 77)

THAT'S ONE FOR THE BOOKS! (Eaton, 28 JUN 77)

SUMMARY EXECUTIONS (Eaton, 6 JUL 77)

DRAWING THE LINE (Eaton, 7 JUL 77)

MISSING THE POINT (Eaton, 7 JUL 77)

TO MAKE A LONG STORY SHORT (Eaton, 7 JUL 77)

BRAIN STORM (Buffalo, 8 SEP 77)

BIRTHDAY SUIT (Eaton, 16 OCT 77)

SIMPLICITY ITSELF (Eaton, 27 DEC 77)

CONVERSATION PIECE (Buffalo, 9 MAR 78)

A NERVOUS WRECK (Buffalo, 13 MAR 78)

A BONE OF CONTENTION (Eaton, 1 APR 78)

COLLECTING HIS THOUGHTS (Eaton, 8 AUG 78)

END OF FILE

Computer file, undated.

The computer file represents a diary Frampton kept of idioms and turns of phrase that caught his attention as potential titles or themes for elements of his *Magellan* cycle. Of the phrases on this list, at least one—*More Than Meets the Eye*—became the title of a completed film in 1979. (B.J.)

# Talking about *Magellan*: An Interview

**BILL SIMON:** I was wondering if we could start with the last film shown in the Whitney programs, the one called *Gloria!*, which I found to be the most moving and otherwise most beautiful film that I've seen in years. The experience of seeing it was really very special, and I have a feeling that part of the effect was that after seeing about five-and-a-half hours or so of the *Magellan* cycle, *Gloria!* seemed like a very special work, involving an important shift in tone. I don't think I have a specific question. I guess it was the very personal quality of the work that was so striking.

**HOLLIS FRAMPTON:** It is personal. At the same time I hope that it manages through one stratagem or another or one obliquity or another to achieve some kind of equipoise. If the things at the Whitney are in calendric order, nevertheless, as the tentative calendar will have informed you, it still doesn't necessarily mean that the films shown were contiguous. The previous segment shown was *Tiger Balm*. The transition from there to *Gloria!* was pretty hard; it's a pretty hard cut. The break in decorum that you see between *Tiger Balm* and *Gloria!* will look a little smoother. *Gloria!* will be considerably less isolated. Between the group of films that *Tiger Balm* will be part of (the rest of which are not done), there is a *Lamentation*, for which I have a certain amount of material, and then not one but three dedications or, better, terminal pieces: an *Alleluia*, a *Gloria*, and a *Hosanna*. Each of them, first of all, has a dominant color. The three primaries that figured largely throughout the rest of the film—the red, green, and blue—are finally relinquished: the *Alleluia* is blue and Mallarmé figures rather largely in it; the *Gloria* is green; and the *Hosanna* is red.

**BS:** Is that Finnegan who comes out of the coffin and causes all the trouble?

**HF:** Oh, absolutely. Among other things, there's a lot of loose punning about Irishness in the whole thing, which means certain things to me personally, but also has a certain flavor within literary modernism. For me, the most important part of English-language literary modernism is Irish. I must say that I am also somewhat moved by the film; it's relatively recent. It's not easy for me to get through it with a completely dry eye, I suppose.

**BS:** I think that was very much part of my experience. It had such a personal level and at the same time seemed to be touching on a lot of the largest themes of the entire work. It's obviously a film about birth and death and it touches on other themes like . . .

**HF:** Language . . .

**BS:** I thought it was an amazing way to capsulize and to reframe the huge major themes of the whole work, plus to do it on such a personal level. I think that is especially striking.

**HF:** There is a certain function within the whole of *Magellan* that I hope it has or will have, and that is that I hope it will neutralize at least the monumentality of it, the sheer size of it, and haul that down into some human scale, which is where I feel it ought to be. There's also a reference of a different kind, which is a good deal homelier. As long as I've known anything about Dante Alighieri and *The Divine Comedy*, I have been at once touched and annoyed by the dedication of that huge work to Beatrice Portinari, who presumably was an extremely attractive person. But Dante only saw her once for sure, and she was nine years old, and it's all very discorporate. And so *Gloria!* is also a very alive and very cumbersome work that is dedicated to a woman, who is extremely important to me but was by no means a spiritual and discorporate creature. She was my Irish Grandma with the style of a drunken sailor, and I think my final decision to do the *Gloria* at that place and in that way devolved more heavily than anything else upon a conflict that I had always felt about the dedication of *The Divine Comedy*. The very large work in any medium is a special case; it's an odd case. I didn't originally set out to undertake something this big. It grew upon a certain group of films, and a great deal of footage conspired among itself to begin to suggest the cycle. But having decided that I was going to do it, I've now spent a certain amount of time going over the problems of the mammoth work of whatever kind.

**BS:** One other thing about *Gloria!* that was especially striking relates to a comment you made to Amy Taubin in your discussion in the *Soho Weekly News* to the effect that you had been struck, as Mr. Joyce was at a certain point after the publication of *Ulysses*, that no one has commented on its being a comic work . . .

**HF:** Yes.

**BS:** And one of the things I think about *Gloria!* and about many films that constituted the first program was that they did strike me very much as comic . . .

**HF:** Good.

**BS:** . . . works. I laughed, though I laugh at strange things. The fact that *Gloria!* starts with the old farcical film obviously cues the comedy. But then the propositions that you state in the film are done in a somewhat portentous manner. And some of them are very personal and humorous. The language that they are stated in adds to the humor. The moment when the propositions stop and the music begins, which is the most moving transition, that's the part when the dry eyes aren't dry anymore. I tended to laugh then too, because, amongst other things, I tend to laugh when the structure of a work comes together in a certain way or when there's a leap in the structure of a work. There's a kind of joyfulness at something like that.

**HF:** It's interesting to hear you trying to talk about it. There are things in what is now at the museum that I, in my perverse manner, find downright funny. But the difficulty that you have at the moment in saying why you laughed or why you perceive something as comical is not unlike the difficulty I have had in trying to say why I think *Magellan* is comical. Joyce, in fact, objected that after all the furor about *Ulysses* and indeed the voluminous attention to it . . . he was annoyed that no one had remarked that the book was funny. And of course, *Ulysses* is still funny. Some of the jokes haven't dated too badly, in fact.

**BS: There are whopping belly laughs throughout.**

**HF:** Yes, sure. I think there are two observations to be made: one is that after all this time, in film or outside, while we have a set of general theories of tragic art, we do not have a general theory of comedy. Period. My own claim is to suggest that—aside from the occasional joke, or giggle or guffaw, or that special gratification that can come at the moment when one perceives that a form has fulfilled itself—comic art resolves in favor of its protagonist. Now, the manner in which it does that can be very, very complicated. It's the only possible justification, for instance, for my own peculiar judgment that *Oedipus at Colonus* is a comedy and the only comedy that Sophocles ever wrote. I cannot understand it as a tragedy at all. It's a nonesuch in any case. How in the world, in the Laurel and Hardy sense, do you square the notion of comedy with the title of Dante's poem, since there are very few real side-splitters in there? But, if you wish to accept my general axiom, that brings on a second question, and I think that in the case of this film it's possibly a paramount question. And that is, of course, to find the identity of the protagonist, since there is none, you see. If you look for a persona of the Renaissance explorer within the film, you are not going to find it. If you seek that at the center, the center will be empty.

**BS: In terms of the protagonist in *Magellan*, it seems to me that I've seen two statements now: one to the effect that the protagonist can be understood somehow as your consciousness, and the other that the spectator is the protagonist. What are the relationships of those two senses of the protagonist?**

**HF:** The spectator is the protagonist when the work is done. I am the surrogate protagonist for the making of the work; I have to be. Somebody has to do it. Presumably there has to be some locus identified for the spectator throughout the making of the work. An important social function for the one who makes the work, at the time of its making, is to occupy and guarantee the eventual space of the spectator and then, presumably, to evacuate it, or to become, as Eliot said of *The Waste Land*, just one more reader. For a time you have to be the only reader, and you're also a supremely corrupt reader, because you can never be innocent to the work. You can never retrieve, for instance, the exact moment when the making of the work began. All you can know is when it's done, so to speak.

So it is in that very general sense that I would claim, or that I'm advertising in advance, that I'm trying to make a comedy. That is to say, whatever labyrinths it involves itself in, I am proposing that it will eventually resolve itself in favor of the protagonist and that the protagonist is the spectator of the work. There's going to be no moment when an identifiable persona appears in the film.

**BS: That obviously makes for a very different experience for the spectator in terms of how the spectator conventionally understands himself or herself in relation to most films.**

**HF:** I think it offers to the spectator the possibility of a posture that's so active in relation to the work that it borders on the utopian or it is utopian.

**BS: Utopian in the sense that your expectation of what the spectator is to do—for example, see it calendrically—is almost impossible to realize?**

**HF:** I think that what is utopian about it is that it posits for the spectator a kind of willingness to see the thing through and a resourcefulness in reading and a certain taste for the chase that has been suggested certainly as a goal for film, but I don't think has ever been pushed quite this far. In that sense, it's utopian. Obviously the successful utopian project—for instance, I think *Finnegans Wake* an entirely utopian project—produces its own spectator, so to speak. It breeds a new genetic strain that has learned from the work how to read the work. Let's take that particular book as a case in point. Although it has to a great extent got bogged down in the back shops of the English Department, a lot of which is very boring, of course, a lot of which plays exactly into Joyce's hands since it's something he only could have anticipated with a certain grim relish, nevertheless, there is now a readership for that book and that readership has learned from that book how to do it, finally. It simply is something that takes time. One has to be pretty relaxed about that.

**BS: Part of the utopianism, then, is involved with the length of the work and with the projected way that a spectator is meant to see it, which is to see a certain amount of film for something like . . .**

**HF:** Well, a year and some days is what it amounts to . . .

**BS: The reason for calling that utopianism obviously is that it doesn't seem to be realizable in the context of present-day distribution and exhibition circuits. So far, the work has been showing in conventional kinds of programs, an hour at a time, two hours at a time. Now, it is being reshaped and reworked, calendrically. In designing it to be shown calendrically, it seems to me, you're challenging the mass experience or the collective experience in which film has been conventionally viewed. Does something like television make the project more realizable? It seems to me that you're anticipating the revolution we are told is going to happen in film viewing, which is that films will be viewed privately on television through various video forms. That way of seeing**

*Magellan* might prove practical, although it would sacrifice tremendously the visual and auditory qualities of the work.

**HF:** There are a lot of questions there. First of all, I don't think it is possible to separate a mode of production from its allied or associated mode of distribution. The scheme of film distribution as we have it—its packaging strategies, its being set apart as a special occasion—cannot in any way be separated from film as we have it. And that, of course, is something that grows, if anything, more exaggerated at the present time. So it is difficult to imagine, first of all, a film which is distributed through a very long period of time and has other stuff, mainly the spectator's life, embedded in it, being achieved without tremendous strain, without extremely anomalous effort, which of course means extremely expensive effort.

It's interesting that you bring up television, because television is respired while film is banquet. I always find it enormously interesting that Americans watch television now more than they work. Really. If we assume a forty-hour work week, the average American watches television forty-eight hours a week. Well, there are plenty of things I don't like about television if we talk about it as the broadcast mass medium. I can't think of anything that I like about it. But if we talk about video and what might be broadcast video, or widely available video, cheap video, permeant video, I'm not quite so offended. If screens were larger and if they had 2000-line resolution instead of 525-line resolution I would be less upset. It's very easy coming from film to feel snotty about the video image. It is of low resolution. It superimposes that graphic raster on everything. It emanates from a piece of furniture instead of something that is before one in an attentive situation. It sits there by itself and does its thing and is surrounded by fake tulips and other furniture and cheese doodles and TV snacks. It's a whole environment. But there is this to be said for television, and that is, it is seen. Which is a matter of enormous importance. I was speaking with someone else this afternoon about Eisenstein and in particular about some of Eisenstein's more maverick pronouncements and interests and so forth, some of which seemed a little fake. Consider, for instance, that Eisenstein was enchanted by Harvey the Rabbit. I would like to know more about that. I would like to know more, if more were to be known, about Eisenstein's extreme interest in television. But we don't know if he even ever managed to see any television except at the most primitive, experimental level. It seems possible at least for him to have entertained a trade-off in order that his work would be seen.

Well, I'll entertain that, or it's something that might experimentally interest me to look at. I will go even a step further and say that I'm testing the possibility in my mind, as the cost of practice in the high technology of film becomes astronomical, that rather than consign the work to another one of those ruined formal gardens, I'd consider finishing *Magellan* in video rather than to not finish it at all. That, of course, would affect a radical and in some ways painful translocation of it. The translocation would be more drastic than the translation of the written word from one natural language to another.

On the other hand, of course, I can't imagine any possibility that I could single-handedly force a change in the mode of film distribution as we have it. But I do feel that I can suggest a critique of that mode. If anyone considers it important that they see *Magellan*, then of course its improper fit with the modes of distribution as we have them immediately becomes apparent and becomes a part of the over-subject of the work. Indeed, if it is possible to say of something like this that it has a social or political inscription—and I assume it is since I assume everything does—then that becomes one of its most important inscriptions. However, I think it's also utopian to imagine or hope for a mode of film experience that is more allied with the use of the book than with the use of the painting. One does pick a book up and set it down. Unless you happen to have the painting in your house, seeing it involves, as seeing a film involves, going to a special palace that is consecrated to that use. The last thing I would think about imposing on anyone is some ecclesiastical duty, as it were, of marching off to somewhere every day for a year to see what is typically two minutes of film. It would be extraordinary if the appropriate two minutes or forty minutes or whatever were some-where in repertory along with, and typically very parenthetical to, whatever else was being shown. But what about missing part of it? One of the most relaxing things I ever read about reading was a remark by Borges that Proust was the most fortunate of authors because in subsequent readings of Proust you never skip the same passages twice. Thus, eventually you actually manage to read Proust, which admits at once that the fact that you're out to lunch a certain amount of the time is part of the condition of reading the written word. Or you skip over passages. But that does not place a stigma-tum of shame upon you. It simply states that it is part of the reading process.

**BS:** As someone who is certainly interested in seeing the whole work and as somebody who is intrigued by the idea of seeing it in the calendrical form, in practical terms it's much easier for me to imagine myself having it in my home on a cassette that I can plug into my television than it is going to Anthology Film Archives or Millennium or the Whitney to see the two minutes every day.

**HF:** It's impossible.

**BS:** So that I think the analogy with reading a novel or a book of poems or reading by chapters, where you would pick it up at any point in the day when you wanted to . . .

**HF:** Or go back and read it over if you wanted to . . .

**BS:** Sure. I'm certain that if I saw one that I really liked and I had ten minutes instead of one minute, I'd look at the one minute ten times.

**HF:** Which would in a way finally disturb the kind of canonical way of viewing films. Because the worshipers of Satan recite the Lord's Prayer backwards in no way inflects the canonical order of the

words; it readjusts our understanding of what they mean to their reciters. No, the one thing that I would hope to dislocate *Magellan* from permanently is the idea that there is going to be some horrifying thirty-six-hour marathon, which is sadistic. I think that at the Whitney this collocation of ordered fragments is probably about six hours. I think that that amount in one sitting is pushing it very, very hard, and I hope that the audience has not felt clamped into the iron maiden of this thing or that they're attending one of those uninterruptible hushed rites among the porcelain teacups of art. If they have to go to the toilet, they walk out. I have felt perfectly free to do that about my own films at my own screenings. I don't always sit through the films myself. I obtain a certain intimacy with them presumably, but there are also afternoons or evenings when I just don't feel like watching them. Six hours is the limit or else I think you'd just OD. I believe I cultivate a certain endurance for these things because I've been interested in extended forms for a long time. I have sat through, which nominally means I have seen, [Michael Snow's 270-minute film] *Rameau's Nephew* four or five times. That guarantees absolutely that I have been out to lunch during at least a third of every one of the screenings. I may, like Borges's reading of Proust, have seen the film once by now. And there are parts I have seen four or five times.

**BS:** The one last point about the idea of having the film at home and being able to read it like a book is that the possibility of my affording it seems very unlikely.

**HF:** Oh, it's impossible for a film print. I think it's worse than that. I think that when and if the time comes that I finish the thing, it is unlikely, even under very special circumstances, that a single institution could afford it. In 1980 dollars, we're talking about a print purchase on the order of seventy or seventy-five thousand dollars. I do not own prints of these films. I do not have them in my house. The prints that are shown at the Whitney represent a chance encounter upon the dissecting table of that screen of prints that have never been together before. And a week from now, those show-reels will be dismembered and they'll go flying off again. So that, literally, the Whitney screening represents a brief intersection of *Magellan*'s physical object, which otherwise could not have been done in any other way.

**BS:** I think that's defining a utopianism of a sort. How do you feel about that?

**HF:** It breaks my heart. To such an extent that if I had thought the whole thing through before I began it I would have been discouraged from the beginning. What's more, assuming that the Philips standard for video disc is adopted (which it probably now will be), then we will begin to see video disc, which is an extremely cheap thing to produce and to own. And at least the video level has very, very high fidelity and an almost incorruptible fidelity since it doesn't get scratchy like a record. Then if a twelve-inch vinyl disc can be bought for four or five dollars, which seems reasonable, and will hold an hour of image material, you could have even a leviathan like this at the strain of spending

a hundred and fifty, two hundred dollars. That's cheaper than the *Encyclopaedia Britannica*. It's probably as much as what I consider to be the supreme work of scholarship of the twentieth century, Joseph Needham's *Science and Civilisation in China*. Well, obviously not everyone wants to have that set of books either for hard work or casual delectation. It's very special but you can squeak it out. It's not impossible to make yourself a great present of it. And by that same token, if it were possible to have this film with that kind of accessibility, then I think that the way in which one would tend to see it would probably more resemble the way in which it was made than the experience of seeing most films resembles the way in which they were made.

**BS: I'm not sure what you mean by that. One of the things that I was struck by in the Whitney screenings is that the structure of the whole work is changing a great deal. For instance, three or four years ago, at Buffalo, you showed *Magellan at the Gates of Death* as a long consecutive piece, and now it has been cut down into smaller individual segments. And what was previously called *Vernal Equinox* is now in short segments under the title *Ingenium Nobis* . . .**

**HF:** One of the reasons I was interested in this calendrical screening was that I had shown parts of *Magellan* as I had made them, not as they fit necessarily. It was always the case that *Magellan at the Gates of Death* was in twenty-four parts. Each one, in fact, is to be seen twice, once right side up and forwards, once upside down and backwards, in the course of the whole cycle. Showing them on what I have called the storage reels as they were completed represents a very central binary choice. Either I can hold everything until the entire work is done or I can show what I had and risk, thereby, an essentially anomalous reading of the work. Figuring that this will take another six or seven years, I chose the latter. I wasn't going to go into retirement and make periodic farts and groans and grumblings to the effect that I was working on some huge film which "no folks, isn't ready yet." You just don't do that. Joyce made the same choice in the thirties in releasing parts of a book called at that time "Work in Progress" to magazines like *Transition*, and so forth. The result was an immense confusion and a very silly one, and some of the consequences were just bizarre. His only other alternative really was to affirm something that I suspect he did not believe, and I certainly do not believe, and that was that the book or the painting or the film was some kind of pearl formed within the delicate tissues of that delectable oyster, the artist, which only appears when he is shucked. The work is to be shared. It is made to be given to others finally. And it doesn't seem reasonable to withhold it even if it is going to cause confusion. The act of withholding it even represents a kind of paternalization I suspect.

The potential misreading in the case of *Magellan at the Gates of Death* is something that Yvonne Rainer voiced very well two or three years ago when she saw it in a block. She said that the method of the film in that extension seemed so relentless and so obtrusive, or at least the effort to hold on to its method seemed so obtrusive, that it finally began to submerge the film. All I could say

at that moment was, "Well, wait. I think that within a few years it will be possible to begin to see it within its context, and I think that will very drastically change the thing."

The question with *Ingenium Nobis* . . . is a little more complicated. It was called *Vernal Equinox* and was part of the four-film *Solariumagelani* for the solstices and equinoxes. I liked the film very much, but I was not satisfied at all with its position there. It is clearly and drastically out of decorum with the other three. It's twice their size, just to begin with, and it's a completely different sort of montage. It's a completely different part of some imaginable universe. So I decided to move it elsewhere. There is a new *Vernal Equinox*, which is shot but not edited, that I am planning to hold back for quite some time. Except that I will say that, quite appropriate to the season, I think it will be judged to be quite pornographic. There are those who have held that *Winter Solstice*, the steel mill film, is somewhat pornographic. I consider it an erotic film myself, almost inescapably so. I once showed it to my own students by surprise on a double bill with [Eisenstein's] *The General Line*, and in those circumstances especially they seemed to be very readily getting a reading that was not entirely industrial.

**BS: Was that purposefully so? That one would get a pornographic or erotic or phallic reading?**

**HF:** I've always hoped so. It's also true, by the way, that given presumably a variety of options about how steel can be worked, the culture has chosen a particularly phallic technology. It was other men, other dreamers upon the phallus than myself, who built steel mills and inscribed that suggestion in there. At the same time, just to dwell on that film for a moment, it is a steel mill, as two of the other films are made on a dairy farm on the one hand and in a slaughterhouse on the other. I would delicately point out that each is a pretextual locus dearly beloved of Sergei Mikhailovich [Eisenstein]. The notion of vertical montage is, after all, not a two-edged sword but a sort of many edged . . .

**BS: I was thinking of Vertov more with the steel mill . . .**

**HF:** Let us say that each is a pretextual locus dearly beloved by our Soviet predecessors . . .

**BS: In the Vertov heavy industrial films, I am especially always struck by his handling of the light quality of the molten metal. The light and color and texture in your steel mill film is also extraordinary.**

**HF:** If I talk about Eisenstein more than I talk about Vertov, it is probably because Eisenstein himself taught more than Vertov did.

**BS: In your notes about the *Magellan* cycle, you continue to pose it in terms of your notions of the metahistory of film. I say continue to pose it in those terms because you have also described at**

least *Zorns Lemma* and *Hapax Legomena* in those terms. Are there more precise ways in which you see *Magellan* as developing those notions that are summed up in the metahistory of film idea?

**HF:** That article ["For a Metahistory of Film: Commonplace Notes and Hypotheses"], which is nine years old, was, in my mind, quite openly a manifesto for a work that I was at that moment thinking quite seriously about undertaking, namely the *Magellan* project. If I can incorrectly cite a couple of references to my own writings, there is one paragraph where "he" wrote that if the necessary films to constitute a full tradition do not exist, then they must be made. Another point very near the end says: while it is perhaps not possible to generate the knight's tour in chess, the absolute tour of the board, it is possible to make a tour of tours, so to speak. In both of those cases, I now serve notice that I was alluding to this project, to at least what I thought its concrete scope of ambition could be. I cannot generate the infinite cinema that I posited then. But I can generate a grammatically complete synopsis of it.

Part of *Magellan*'s film-historical content has to do with what now begins to appear on the screen at the Whitney. That is, there is a great deal of allusion in it to other films, but that allusion is not necessarily at the surface level. I remember having a letter, an oddly apologetic letter, from Lindley Hanlon about a rather quick and forceful and intuitive piece she wrote about *Otherwise Unexplained Fires*.[1] She recounted the experience of watching the film and thinking at first that she might be looking at a Brakhage film and gradually acquiring a sort of deep malaise about that feeling. Finally she came to the conclusion that it was not a film by Stan Brakhage but seemed to have something to do with Brakhage's films and that it represented in her eyes a critique of a part of Brakhagean montage. When I got the Xerox of her text, I was at once gratified on the one hand and shocked on the other. The gratification caused me to send a page and a half of corroboration to her. In fact, it is literally true that the chickens in that film are Jane Brakhage's chickens and they were shot at "Casa Brakhage" in Colorado. On the other hand, the shock caused me to write to her that, pleased as I was to see that someone had walked in on the thing and scored a bull's-eye with one shot in a fairly difficult and kind of queasy reading problem, I also felt that if critical insight had developed to that level at that speed, then I had better start covering my tracks a little better.

In *Magellan*, there is everything from overt homage and imitation and retesting corroboration (in the scientific manner of repeating the experiment) to literal workings-out and speculations-in-practice upon suggestions that were made a very long time ago and which have not been acted upon for reasons that I wouldn't care to surmise on. Now as you clearly understood from your piece on *Zorns Lemma*, nothing tickles me pinker than to take a suggestion literally and to seek the consequences of the working out of a literal reading in detail.[2] And the most interesting single body of suggestions that I have found in film theory which has not been worked out is the rather vague and uncrystallized notion or suggestion or pre-vision of a vertical, as distinct from a horizontal, montage. Now there is in my efforts to test such a thing, to try to find out ways to make

a vertical montage, the most direct debt and the most direct homage—probably not in the customary artistic sense but in the scientific sense—to Eisenstein and Vertov.

**BS:** I assume that this includes working with sound.

**HF:** It sure does.

**BS:** But there are still relatively few sound pieces in the Whitney show. In fact, one of the things that put me in a special frame of mind for *Gloria!* was hearing the sound hum from the projector and realizing there was going to be a sound film after many hours of silent film. But rather than talk more about *Gloria!,* what was going on with sound in the *Mindfall* series was very interesting. You talk in your notes about creating an "acoustic image," in which the sound can create an image of that which presumably produced the image. That notion was very interestingly realized in one group in the *Mindfall*s, where the images are basically from nature—grass, flowers, plants, etc.—and the sounds seemed largely mechanical or technological.

**HF:** More specifically, by the way, where they are mechanical, they tend to be associated with communication—teletypes, printing presses, telephones.

**BS:** The clarity and precision of the sound was amazing. So I certainly heard/saw the "acoustic image." And the interrelationship of image and sound was fascinating. I remember one that started with a drilling sort of sound over an image of a cactus plant. There was a level of correspondence because the cactus is prickly. But then, while continuing the sound, you cut on the image track to out-of-focus water, a very soft image. So over the course of the one sound, the images were changing the relations in complex ways.

**HF:** All right, there is the passage, for instance, in which the pneumatic drill is first superimposed upon the cactus. Now let's run through our Eisenstein paces just a bit on this one. Vertical montage at least permits—I would suggest, almost enforces—the simultaneous availability of essentially covalent chains of causal linkage of one kind or another. We have, on the one hand, a cactus, which is prickly, irritating, an abrasive thing, set against the pneumatic hammer, which is generally, even in the abrasive sonic environment of the city, a particularly noticeable, inescapable annoyance and interruption, likewise abrasive. On the other hand, it is also true that the cactus is phallic in form and thereby, because it is spiny, at least moderately sadistic in its implications. And the pneumatic hammer, of course, is a penetrating agency, which disrupts what it penetrates and functions phalli-cally in a painful and destructive way. But then, of course, the image cut crosses the sound cut and one does have something like the gentle image of flowing water. The valence of the sound immedi-ately changes entirely. This kind of thing started my thinking for the sound in those two parts of *Mindfall.*

For all that came out of the 1928 manifesto, its most important recommendation is to sustain, maintain, insist upon the moveability, the portability, the malleability of the montage piece, the shot, whatever it is. . . . And the author of that manifesto, who is, I think, very clearly Eisenstein and not its other two signatories, speaks in terms of Newtonian mechanics of the consequences of sound attaching itself to the image. He says it will increase the inertia of the montage piece so that it cannot move, cannot couple itself into a new energetic environment as readily. It develops a momentum which carries it and makes it impervious to other interpretations. He warns us that there is a great peril, and then, of course, he offers us an open invitation when he says that the first interesting work that will be done in sound will involve its distinct desynchronization from the image. That suggestion is certainly something that one would like to test at some length. But as you begin to test it, or as I began to spend some time thinking about sound, there were a certain number of things that I started to notice very sharply. The most unsettling concerns the notion of sync sound itself. Because sync sound as we have it in the movies is an absolute artifice that is concerned not with generating synchronous sound but excluding synchronous sound. As we sit here, if there were a camera on us, there would be a lip-sync component as we talk. But unless the microphone were very narrowly focused, we would have proceeding from the same speaker, from the same nominal source, the sound of police sirens going by outside. Now that is synchronous sound after all, and it is the synchronous sound that the central nervous system filters out because it is a stimulus to which we cannot properly respond if we are going to go about our business. If you start responding to every stimulus, then you end up as a nerve-gas case, quite literally. All the neurons fire at once. So what is typically called sync sound transpires in a very special acoustical universe, and real sync sound constantly produces astonishing, disquieting intersections that are absolutely worthy of Lautréamont. The question of synchronicity is a lot more obscure, a lot less clear.

**BS: In the sound pieces that I've heard and seen so far, it's not clear to me that you're working with that kind of thing. Is it something that you are working with in other sections?**

**HF:** Yes, in one segment of *Mindfall* distinctly, I'm tilting at the windmill of desynchronization. Nevertheless, there is the tendency always to couple the sound with its image where possible, to seek connection, to make connection.

**BS: But I was also thinking in terms of what you've just said about the nervous system itself filtering out certain kinds of sounds. In the sound films so far, you've performed that function in the sense of there not being anything more than one sound at a time. Will there be films where vertical montage on the sound track itself is operative?**

**HF:** I think as it develops we will find that it is already there. At the moment, because there is so little of it—there's only thirty-six minutes of *Mindfall*—it's sketchy. There are certain kinds of motifs, for

instance, that are taken up later and more densely. I made the two parts of the seven that will exist first because they were the easiest, they were the simplest. The sound in the intervening sections rapidly grows a lot more complex and dense. And I dread editing them.

**BS:** Is it harder for you to edit sound?

**HF:** Very much so.

**BS:** Why?

**HF:** When I'm editing sound, I'm editing magnetic film, full-coat recording, which has been made from tape. Well, of course, there is no way of looking at the thing to know what's on it. You have to run it through a reader. But you can't run a short piece of full-coat through a reader. You can't get at the boundaries of the montage piece on the sound track because you have to mechanically maintain the integrity of the roll of full-coat, so that it takes five or six or seven or eight passes through in order to finally be able to pull out that thing that looks like a piece of film. It's spliced in the same way but its image is invisible. Locating a cut in sound is very, very hard. To locate it precisely you have to slow the passage of the track down over the reader to the point that you can't identify what it is anymore. So there's always that odd experience of learning to identify the minute features of an acoustical image at very high and very low speeds.

**BS:** You're explaining it in terms of the technical factors being so difficult that they would not lead one to go into complex superimposition as you would on the image track.

**HF:** It's like playing three-dimensional chess. The combining problems of resolving references between image and sound is geometrically more intricate, even in what are in some ways relatively straightforward cases. In the parts of *Mindfall* that now exist, what I have called the acoustical images really are that; they are concise. They're dense in association but not particularly dense in event. And I simply did find it very hard work. It's not work that I object to; it's delicious, of course. I think we always knew that, taken seriously, the problem of sound, that Damoclean sword, was going to be very complex and difficult to work with and, indeed, insofar as I have a foot in that door, it has turned out to be. But it must be done.

**BS:** Can we turn back to Brakhage? You've been citing the Soviets as the major sources of vertical montage. It would seem to me that the other major source in terms of image, at least, because of his uses of superimposition, would be Brakhage. Lindley's observation that *Otherwise Unexplained Fires* is Brakhage-like seems to me almost inescapable in relation to that film and to a lot of your more recent work. The reasons have to do with shooting procedures, camera procedures, the use

of superimposition. Also, it seems that everybody who has written about the slaughterhouse film has not been able to write about it without citing *The Act of Seeing with One's Own Eyes.* There's a sense that Brakhage virtually created a genre in terms of imagery by breaking the taboo, and that once one steps into comparable imagery, the comparison has become inevitable.

**HF:** Well, as to *The Act of Seeing with One's Own Eyes* I think the relevant film of mine is *Magellan at the Gates of Death.*

**BS:** Let me put it a little differently. In most of the discussion of your work—Wanda Bershen's essay on *Zorns Lemma* is perhaps the most explicit but this is also central in Sitney—your work is posed in sharp contradistinction to a whole tradition that culminates with Brakhage.[3] Consequently, for people who see it that way, the importance of Brakhage in your work in the last five years has seemed surprising, perhaps ironic or puzzling. It goes against the historical "line." The question perhaps is how does Brakhage figure? Do you accept my sense that, as with the Soviets, he figures as much more than an allusion?

**HF:** I think there are a couple of distinctions to be made. First of all, there is an extremely ancient principle in Roman law that was summed up in the phrase: "Two may do the same and it is not the same." I will just leave that as a cenotaph for my following remarks. I would like to expand upon the differences. I think that within what is now being screened, the film that most apostrophizes some of those differences, again, is *Otherwise Unexplained Fires.* By framing a Brakhage-like—and I'll explain the word *Brakhage-like* in a moment—film segment within a context without saying anything in particular about Brakhage's cinematographic diction does call into question the rhetoric of the surrounded presence of that diction. I hope it does that fairly forcefully. Now again, the camera diction is in that case very overtly Brakhage-like. But to say that is to beg the question of what Brakhage's camera diction is like. I think it is very clear what that diction is like. It is like the broad-brush diction of Abstract Expressionist painting. Although I would also say that Brakhage has enlarged that diction, has revised it, has made it in some ways more versatile, more malleable, than it was in the hands of the first generation of abstract painters. Nevertheless, that is its fundamental affinity. Like de Kooning, like Kline, like Pollock, like a certain number of other people, Brakhage not only does that, he does it all the time. He does it for plenty of reasons, but he does it, one would suppose, out of some core conviction that that diction is *the* mediator, that it is *the* discipline of the camera, that it is *the* center of the circle.

To carry the argument a step or two further, I think it may be worthwhile to distinguish camera diction from montage. If such a film for instance as *Autumnal Equinox* seems to have the kind of camera diction that a Brakhage film does, it might be worthwhile for me to suggest that perhaps it is not Brakhage's diction but the diction of Abstract Expressionism which is at stake. Unlike the

numerous students who make that body of "poor-man's Brakhage" which at least complements that body of ersatz structural film, I have had some contact with and reference to the primary source material in question. I think it's probably fairly easy to establish or to argue also that the montage is entirely different, that it subjects the motor diction of the cinematography to a kind of challenge and contradiction that Brakhage does not.

*Otherwise Unexplained Fires* is explicitly a film that has to do with Stan's work. It is even about the same size as a normal Brakhage film, with a typical Brakhagean sense of cadence. One of the pleasures of making the film was to work out the kind of high drama with an identifiable portion of the diegesis of the film, which is the kind of thing that Stan routinely claims. Now that has nothing to do with the mechanical horse or the Monterey pine trees or fire, but it does have to do with the chickens. It is an ordinary hen yard. That is to say that there is a rooster, one and only one sexually viable male, immersed in an environment of sexually viable females. And the incessant play of the chicken yard is rather like the incessant play of spiritual economy within the Brakhage household. It seemed to me that there was a strong similarity between the two situations. Well, that drama is about as visible as those dramas that Brakhage habitually finds. If you sample the history of Brakhage show-and-tell about his films, the suggestion would be that a dramatic situation of some kind has been discovered within, excavated from, unearthed out of the fragments of this Abstract Expressionist improvisational gesture—made in some heat. So, in *Otherwise Unexplained Fires* we have something of the same kind that was, in a certain sense, made in cold blood. I am completely cognizant, I think, of a couple of things about Brakhage's work. One is that in the warmest sense of its importance, I feel nothing but sympathy and congratulations for the magnitude of that effort, its relentlessness, its coherence. Another thing I recognize very well about it is the extent to which it is predictable. That work, which also means that aesthetic strain, occupies and is likely to occupy for a very long time, the center of attention. I thought it particularly ironic that Brakhage complained so bitterly a couple of years ago at Millennium that the heir presumptive to the throne of the ice king, structural film, had had a decade of flack, of reaction, of goodies, or what have you, at a moment when there must have been during that week 1,500 screenings of Brakhage films within the boundaries of Christendom. Although it has not been adequate, has not even been intelligent, nevertheless, there has been some immediate attempt over a long period of years to make something of Brakhage's films. Now extrapolating from that, it is possible to imagine in the year 2000 that very much more will be known and understood about a large and important body of work by a filmmaker who expounds, summarizes, and expands the syndrome of Romantic idealism. I am not at all sure that it's plausible to imagine that in that same year anything like as much will be understood about the work of Michael Snow, Yvonne Rainer, and perhaps about my own work. By its continuity, by its size, by its enterprise, and by the fertility of the perpetual soil in this culture, which is always ready to receive the seed of Romantic idealism that is cast upon it from time to time, there will always be a special place for Brakhage's body of work.

I find it interesting that the question about the relation of my camera diction to Brakhage's has not only been asked but in one instance rather peremptorily answered by Sitney, who says that while what he has seen is inconclusive, that it represents an attempt on my part to come to terms with Brakhage. Well, coming to terms with Brakhage is a process for me that is, in part, absolutely impossible and, in other parts, something that will take me the rest of my life. But the notion also seems to mark an equation of Brakhage's import with his cinematography rather than with his montage. The other phrase that I recall from Sitney's article I thought particularly insightful, though it wasn't developed, was a phrase about my camera work as constituting "sumptuous optical rhetoric." Now, the word *rhetoric* means something quite distinct in my mind. It's a term that I'm not at all uncomfortable with. I think, on the other hand, that Brakhage would be extremely uncomfortable to have it suggested that his cinematography, his diction, his camera vocabulary was in any sense rhetorical or that it had been deliberately chosen and adopted for a particular reason. That would neither be his own position by personal conviction or indeed by his cultural heritage of Romantic poetry and Abstract Expressionist painting, among other things.

I also think that with regard to my earlier work there is a certain confusion. Certain dictions and certain kinds of virtuosity were entirely inappropriate for *Zorns Lemma*, for instance, or for *Hapax Legomena*. But those were always there as options. I've been using a camera since I was nine years old. The notion that there is a "style" or a "diction" to me is nonsensical. I think that within what has been shown in the Whitney screenings, there are certain things that refer directly to Brakhage, certain things that refer directly to action painting, and quite a bit that does neither. The cinematography of *Mindfall*, for instance, has a much more complex reference and, while the handheld camera is there, it is quite clear that it means something quite different than it does in the slaughterhouse film. To return briefly to the question at the very start of this, the comparison between *The Act of Seeing with One's Own Eyes* and *Magellan at the Gates of Death* has come up before. There are plenty of differences in the circumstances. For all that the autopsy room may represent a certain kind of liberal taboo—one that Brakhage is extremely fond of, and he has an excellent nose for the liberal taboo—it is a film for which I have a great, great respect. It's also a film that I think of as having a fundamentally didactic strain, which is odd to encounter in Brakhage. I think that in watching that film one could recover the standard method for performing an autopsy. It could function by some stretch of the imagination as an instructional film. At the very least, I think that is not something that could be said of *Magellan at the Gates of Death*. Its concerns, whatever they may be, are clearly other than that.

**BS:** I don't think that that could be said about the slaughterhouse film either. It would be much more difficult.

**HF:** The corresponding case for the slaughterhouse film is, of course, Franju's film *The Blood of Beasts*, which is a film that I admire immensely. Though I think this tends to escape most of its

viewers in the United States, it is deeply and fundamentally a political film. Along with its hair-raising, exquisite, literal beauty, it is made very clear within the film what the source of that beauty is, what it means, when it grows, what it costs. Well, that is not at all true of my slaughterhouse film.

**BS:** It is also not true of the steel mill film. That becomes clear in thinking about it in relation to Vertov.

**HF:** That's true.

**BS:** The similarity that I saw was in formal terms, the luminosity, color, and so on, of molten metal. The immediate difference is in the absence of a strong sense of people working.

**HF:** Oh yes, sure. We find rare appearances of the human figure in the slaughterhouse and steel mill films. If those films encapsulate or carry somehow a political posture, my viewpoint—which I hope they do—then that has a great deal more to do with a fairly clear declaration of which side I'm on with regard to the controversy concerning the spectator's relationship to the work. In that controversy, the two poles of which are Eisenstein and Bazin, I am very clearly on the side of Eisenstein, drastically and, again, utopianly so. But that is not the same thing as making a political film, of course.

**BS:** So that the political sense of it is to be understood in terms of the activity of the spectator, the engagement of the intellect.

**HF:** The special place of the spectator and the nature of the spectator's task.

**BS:** I think the absence of people in those two films is important in that it allows for the possibility of the metaphoric readings that we were talking about—for instance, the steel mill film being a pornographic film. If you had a lot of people working there, you'd at least diminish that level of visual metaphor.

**HF:** One thing that it does is insist upon a certain type of scale for the images. There was a lot more people stuff, though I won't say it dominated, in that footage as I made it. What I did have very much on my mind was its scalelessness or its absolute scale. At the same time, the blandishments of illusionism enticed me to allow a shadowy figure to wander through this scaleless, infinite space from time to time.

**BS:** I think there's a tremendous play on scale when you move from what is clearly a very large piece of the steel to a close-up of flying sparks that are blown up tremendously all within a continuous shot.

**HF:** My sense was that people would interfere with that drastically. It's also true that the circumstances in which I made those films were very different from the Soviets. When the filmmakers of

the Russian Revolution made the films that they did in those industrial situations, they had a right to be there. There was a recognized purpose for their presence in those situations. We do not live in a revolutionary society. My own position in filming these things was very privileged, which is to say it was very alienated. No shots were set up. I was under the greatest possible constraint not to interfere with what was going on. People like shop foremen, as distinct from PR people, were very helpful. I was able to get some close-up stuff in the steel mills because they literally rigged up fire baffles for me so that I was able to get very, very close. Some of that stuff is lethally close. From the point of view of the shop, the point of view of that productive situation, it was filmmaking that was coming from nowhere and going nowhere. There was no kind of contact between my productive work and their productive work at all. That was not only latent in the situation but explicit in its construction. So that even if I had wanted, there were things I could not do, from which I was absolutely excluded. In particular, that applied to any interaction or interference with the work that was going on.

**BS: How did you get into those two places to shoot? Were there problems in the beginning just to get permission?**

**HF:** I got into those two places through the exercise of institutional muscle. What got me into U.S. Steel in Pittsburgh was the muscle of the Carnegie Institute Museum of Art. Presumably, the name Carnegie still carries some clout in Pittsburgh, PA. Sally Dixon just politely requested permission and got it. In the case of the slaughterhouse, I was in South Saint Paul, and that was engineered by the Walker Art Center so that it was absolutely the personified voice of the trustees of cultural institutions that inserted me briefly into those surroundings. I cannot imagine an abyss deeper than that which separated my predicament as a filmmaker in that steel mill and Vertov's predicament as a filmmaker in that other steel mill. That alone could serve to virtually guarantee the relevance or the irrelevance of the human figure in the film. So that even if my political beliefs are congruent with those of another time, there is no direct way, no opportunity to construct a direct way, to matte them on the film that is made and to be seen. That entire possibility has been preempted and evacuated before I ever entered the situation.

**BS: Is there a level where you feel that you can alter that kind of situation?**

**HF:** What I did, because I was in Minnesota for a week and a half, was to process the film and make a work print immediately. I took it back to the slaughterhouse with a projector and offered to show it to the people that work there. It is fair to say that these slaughterhouse workers work in a dangerous and highly skilled trade and work somewhere near the bottom of the commodity chain, performing a task that most people think of as disgusting and shameful. At the same time, they were very, very good at what they did. In fact, it was an excellent modern shop. It was quite small. Not only was it very well set up, but insomuch as it is possible for such a thing to be very safe, it was. It certainly

wasn't as primitive as the abattoirs in which Franju filmed. There wasn't much discussion or much time; the guys were sitting there eating their baloney sandwiches on their lunch hour, watching this movie. And it wasn't a movie, just footage. The vibes quite generally were that they had been nervous about my work because they thought I might be doing some kind of vegetarian exposé of the horrors of the slaughterhouse or something like that, which would tend to further degrade and humiliate them. A couple of them said, rather bashfully, that they had always thought that if you disregarded what it was that they were working on, they liked looking at it very much. Then one man, who's quite old, said something that I rather cherished. He said, "You don't see us in the film, you see what we see." Which pleased me a lot. I myself did once work in a slaughterhouse. I grew up on a dairy farm; I have worked in a slaughterhouse; I worked in steel mills while I was in college. They're old stomping grounds of mine. Aside from the cherished Soviet pretext, why I wanted to go back was that I had seen those things. If the steel worker, for instance, has a grave cross of unhappiness, it isn't all bad in that daily experience. I suppose that for some of them, the one thing that can sustain them through a lifetime of that kind of work is that what they do, the actual work itself, is wonderful, elegant, exquisite; and secretly that is known. But, at its worst, the formula applies. The worker in that situation is deprived, is forced out of every possible pleasure or gratification that could come from the work itself, including the fantasia of what is to be seen there, which is, of course, extraordinary.

**BS: How do you like Sitney's word "sumptuous" as he applies it to your work?**

**HF:** It doesn't bother me at all.

**BS: I think it is a very good word. There are some of your films that seem to be deliberately sumptuous and are extraordinary and others that seem to deliberately work against any sense of being described that way.**

**HF:** There is room, I would hope, for the sumptuous and the spare, as well. To round the circle and go back to *Gloria!,* to burden that moment with sumptuousness, with embroidered trapping, would have lessened it, would have deprived it of its sense I would think.

**BS: Would you like to talk about the very early, the so-called "primitive" films that you use in *Gloria!* and at other points in *Magellan*?**

**HF:** I have gone through the Paper Print Collection at the Library of Congress like Lévi-Strauss went through the distant cultures of South America and the Pacific, desperately seeking primitive film. Of course, I haven't found one yet because all film assumes from the moment it comes into the world, as the child does, that it has a complete grasp of the universe. Later on it revises that, but it is not rejected. The experience of sitting there on a Steenbeck machine looking at those films is like the

experience of encountering the thirty-meter Lumière films. One is not impressed by their primitiveness but instead overawed by their subtlety, by their appalling depth of implication—to such an extent, of course, that one is left, to a certain extent, critically speechless. There is no such thing as that grand essay that sidles up to the Lumière films, for instance. I would love to imagine that in old age I could summon the wit to have a waltz with that stuff. It's incredible. A few years ago, when I first showed a couple of parts of *Mindfall* in New York, I showed it with primitive footage, ancient footage, from that same collection. I showed a medical documentary, or a series of them that were made from 1905 to 1911. Those have not at all been excluded. I have not taken them out, but they are subject to a further fragmentation and sandwiching procedure. I did not want to stick them in as an eighteen-minute block. They really schemed the sense of the thing very much. It's overpowering. When I showed that footage at Millennium that time, for once a very serious misapprehension of where I imagined it was going developed. But I have many, many more of those up my sleeve. I spent a lot of time, half a summer, looking at them in Washington, made a lot of notes, as they say. The material is in the public domain and I bought one each of what I wanted. There are a few things that I got simply because I wanted them; I have *The Life of an American Fireman*, which I think is an amazing, absolutely crazed film. But out of the one hundred and twenty-five I bought, probably a hundred will be used.

One of the most important sights within *Magellan* is on the occasion of Sadie Hawkins Day, February 29th, which of course in the calendric cycle is anomalous. There's a very large classification of soft-core Edwardian porn in the Paper Print Collection, peep-show stuff, which has a set of subclassifications. Among the things you saw, by the way, was another ancient film that is in the *Cadenza*, the film about the bride in which two gentlemen, who we may presume to be bachelors, strip more or less bare a putative bride of some kind. It's a very muddled situation that, given its context, I think someone might get a chuckle out of eventually. There are films in that collection that are interesting now and important now as their other posterities have modified them. In itself, the one man engaging the lady's attention while another one unravels her skirt is idiotic. Getting back to Sadie Hawkins Day, there is a redaction of a set of Edwardian pornography films or peep-show films that is a preface to a particular specification as a protocol which was made a very long time ago: that on February 29th, it is the request of the filmmaker that *Film About a Woman Who . . .* , or any other specified work of her own by Yvonne Rainer, shall be screened on that day. When I suggested it, slightly abashedly, to Yvonne, because I was concerned that she'd be worried about a misappropriation of her work, she understood immediately and saw a certain symmetry because she, of course, has incorporated entire works by other people into hers with no worry about how it should be understood. Now that's something that I would look forward to, some grand operatic screening of the whole thing—Yvonne Rainer as a readymade. Among all the films by all my peers, probably the ones that I most wish that I had made, because they are the ones farthest from my own capability, are Yvonne's. I can imagine states of one kind or another in which there are films I could have

made or approximated or done something like that, but Yvonne's, no. So I was amused at the idea of directly incorporating Yvonne as a true Other in that situation. I can't wait to see her new film.

**Notes**

1. Lindley Hanlon, "Arson: A Review of *Otherwise Unexplained Fires* by Hollis Frampton," *Millennium Film Journal*, nos. 4–5 (Summer–Fall 1979): 157–159.
2. Bill Simon, "Reading *Zorns Lemma*," *Millennium Film Journal* 1, no. 2 (Spring–Summer 1978): 38–49.
3. See Wanda Bershen, "*Zorns Lemma*," *Artforum* 10, no. 1 (September 1971): 41–45; and P. Adams Sitney, *Visionary Film: The American Avant-Garde* (New York: Oxford University Press, 1974), pp. 431–435. (B.J.)

*Millennium Film Journal*, nos. 7/8/9 (Fall–Winter 1980–81): 5–26.
The interview took place in New York City on January 19, 1980, during the course of a series of screenings of films from the *Magellan* cycle at the Whitney Museum of American Art. (B.J.)

# Text of Intertitles for *Gloria!*

These propositions are offered numerically, in the order in which they presented themselves to me; and also alphabetically, according to the present state of my belief.

1. That we belonged to the same kinship group, sharing a tie of blood. [A]

2. That others belonged to the same kinship group, and partook of that tie. [Y]

3. That she kept pigs in the house, but never more than one at a time. Each such pig wore a green baize tinker's cap. [A]

4. That she convinced me, gradually, that the first person singular pronoun was, after all, grammatically feasible. [E]

5. That she was obese. [C]

6. That she taught me to read. [A]

7. That she read to me, when I was three years old, and for purposes of her own, William Shakespeare's "The Tempest." She admonished me for liking Caliban best. [B]

8. That she gave me her teeth, when she had them pulled, to play with. [A]

9. That she was nine times brought to bed with child, and for the last time in her fifty-fifth year, bearing on that occasion stillborn twin sons. No male child was born alive, but four daughters survive. [B]

10. That my mother, her eldest daughter, was born in her sixteenth year. [D]

11. That she was married on Christmas Day, 1909, a few weeks after her thirteenth birthday. [A]

12. That her connoisseurship of the erotic in the vegetable world was unerring. [A]

13. That she was a native of Tyler County, West Virginia, who never knew the exact year of her own birth till she was past sixty. [A]

14. That I deliberately perpetuate her speech, but have only fragmentary recollection of her pronunciation. [H]

15. That she remembered, to the last, a tune played at her wedding party by two young Irish coalminers who had brought guitar and pipes. She said it sounded like quacking ducks; she thought it was called "Lady Bonaparte." [A]

16. That her last request was for a bushel basket full of empty quart measures. [C]

This work, in its entirety, is given in loving memory of Fanny Elizabeth Catlett Cross, my maternal grandmother, who was born on November 6, 1896, and died on November 24, 1973.

Screen version of intertitle text for the film *Gloria!* (1979).
    This text differs in minor detail from an undated draft version that exists as a computer printout. (B.J.)

# Mental Notes

1. I understand the word *autobiography* to mean: writing one's own life. But perhaps, as with so much of Greek, our text is corrupt. I would rather understand it to mean: life, writing itself; just as we who use the camera must understand *photography* to mean: light, writing itself. We are not so much agents as intermediaries when we introduce film to light, as we might bring together two good friends, hoping they will love one another as we love them both.

2. Near the end of his life, impersonating himself just this once more, Marcel Duchamp said that he did not like to work; that he preferred living, breathing, to working. But living is something we never stop doing, whether we work or not. For the autobiographer in words, though, it doesn't feel that way. As I write *these* words, locked in a room, far from home, I feel that my life is all outside the door, even as I know that I'm in here, alive, and nothing is outside the door. Nevertheless I can hardly wait to take my life back, out, into everything. So, I don't write. To feel that one is not alive is sufficient reason for not doing *anything*.

3. Brancusi said that creation should be as easy as breathing; and his beautiful and perfect works attest to the depth and ease of his breath. But sometimes the breath comes hard, in choking spasms, and sometimes it is reduced to the merest sibilance. Creation is just as uneasy as breathing. With inspiration, we draw in breath. In the end, we expire. While the breath runs, we feel moved, mysteriously, to conspire, to share breath. Of all the arts, none responds more fully and intricately to the flow of the breath of life than does film, nor does any other give itself so freely to the sharing of breath, unless we take inspiration from Ovid and look to an *Art of Love*, in which closest of all conspiracies we conceive, and were conceived.

4. Film is much spoken of as a way to teach, and not enough as a way to learn. Much of what I have learned—both what I value and what I have not yet learned to value—I have learned from film, which is to say, from its makers. What we try to learn, all our lives, is how to live. The last time I saw my grandmother, she said to me: we just barely learn how to live, and then we're ready to die. Then she cried a little. I wanted to cry too, but I couldn't. I hadn't learned how.

5. Please try to imagine this room in which I sit writing. Let me vanish from it, with my typewriter. You will be left with a cube. Now, if you like, draw that cube, in your mind, in one-point Renaissance perspective. The cube is transparent, so leave in all the hidden lines. Stare at it for a while, as I am staring, and in time it will suddenly transform itself into another cube, with a vanishing point outside your imagination. If you see what I see, then you will have experienced a voluptuous muscular shift of focus within the eye of the mind . . . that same eye that swam stubbornly upward through our flesh, seeking the light, surfacing our minds in our faces before we were born. Our imaginary cube partakes, rather humbly, of a metaphor for which I have no name. It is one of a family of astonishments that we call, curiously, optical illusions.

6. A few months ago, some students that I work with repeated Kuleshov's legendary experiment.[1] As we sat down to look at the footage, we all felt a little fearful. Eisenstein's montage, after all, rested on Kuleshov's foundation, and it is from that montage that we, all of us, measure our distances, in millimeters or in miles. We were bleeding, even, from a peculiar Heisenbergian trauma . . . for we were assaying our samples for the presence of something called the Kuleshov Effect, where Kuleshov himself was simply wondering what unimaginable thing had been given him. Starting the projector, we felt the walls of our minds shake. What if the whole thing were nothing but a Russian Revolutionary conspiracy? And then the cone of light mounted to radiance, inverted itself, thrust upon us, slid past lids and lenses, entered the mind, penetrated the eye of the mind. There was a prolonged gasp of delight in the room. For all of us, in the very midst of sifting our sight, ever so carefully, for signs of the Kuleshov Effect, had suddenly found ourselves overtaken by the rapture of *experiencing* it. Each of us had found his whole consciousness converging upon a point outside the boundaries of his imagination. After a time, when we felt more calm, we conspired to destroy our footage, or else lose it. Kuleshov had done one or the other: we would honor him by continuing a tradition of renewal he had founded. So, friends, if you need to see upon what foundations our art rests, I cannot show them to you. You must rebuild them for yourselves.

7. One way or another, everything in a filmmaker's life forces its way into his work, finally . . . everything, even, in that part of his life he spends in making films. Here is something from my life, and I'm not absolutely certain whether it has forced its way into my work or not. It's just a remembered fragment from the tango craze of the 1940s. It runs:

*When we're dancing, and you're*
*dangerously near me,*
*I get ideas, I get ideas ...*
*\* \* \* \* \**
*I kind of hope you get ideas too.*

HF
Buffalo, March 25, 1973

**Note**
1. In the early 1920s, the Soviet director Lev Kuleshov established a workshop to
train a new generation of filmmakers. In an editing exercise, he intercut a
close-up of an actor with a variety of shots, including images of a bowl of soup,
a woman standing next to a grave, and a child with a toy. The so-called Kuleshov
effect resides in the fact that the interpretation of the actor's expression (and
thus the meaning of the montage sequence) is transformed in relationship to the
shots that surround it. (B.J.)

Text delivered at the "Buffalo Conference on Autobiography in the Independent American Cinema," State
University of New York at Buffalo, March 1973. Participants included Jonas Mekas, Robert Frank,
Bruce Baillie, Stan Brakhage, Ken Jacobs, and others. Published in *CEPA Quarterly* 1, no. 4 (Summer 1986): 7.

*Protective Coloration*, 1984 (photographed 1981)
Detail from a series of thirty-six Ektacolor
photographs. © Estate of Hollis Frampton

# VIDEO AND THE DIGITAL ARTS

# The Withering Away of the State of the Art

A few years ago, Jonas Mekas closed a review of a show of videotapes with an aphorism to the effect that film is an art but video is a god. I coupled the remark, somehow, with another, of Ezra Pound's: that he understood religion to be "just one more unsuccessful attempt to popularize art." Recently, though, I have sensed a determination on the part of video artists to get down to the work of inventing their art, and corroborating their faith in good works.

A large part of that work of invention is, I take it, to understand what video *is*. It is a longstanding habit of artists (in the life of the race it might be our most valuable habit) to postulate a present that is more privileged than the past. Video art, which is by now virtually alone in having no past that's shady enough to worry about, joins in that relentless search for self-definition which has brought film art to its present threshold of intensity and ambition . . . and which, indeed, I understand to be the most notable trait of the whole text of modernism, throughout the arts, and in the sciences as well.

Moreover, it is doubly important that we try to say what video is at present, because we posit for it a privileged future. Since the birth of video art from the Jovian backside (I dare not say brow) of that Other Thing called television, I for one have felt, more and more, a pressing need for precise definition of what film art is, since I extend to film, as well, the hope of a privileged future.

But we know that what an art is, or what it is to be, is to be seen rather than said. I turn, then, to the mournful Aristotelian venture of trying to say, of film and video art, not what they are but what they severally are *not*, and how and what they are *like*.

First of all, then, what delights and miseries do film and video share? Both the film frame and the complementary paired fields of video are, of course, metaphorical descendants of the Newtonian infinitesimal, so that both are doomed, as from a kind of Original Sin, to the irony of mapping relativistic perceptions upon an atavistic fiction of classical mechanics long since repudiated, along with the simian paradoxes of Zeno that prefigure the calculus, by the sciences. Still more comically, film and video share similarly athletic pale-ontologies: that of film yielding racehorses, and that of video, wrestlers. But within the compressed moment that constitutes their mutual Historical Period, we may say that film and video art have in common:

1. A need. It belongs to the artists who make the art, this need, and it is the raw need to make images, illusions apparently moving, within what both

film and video understand to be a highly plastic temporality. Together they have virtually replaced painting as a technology of illusionism, throwing into high relief the painter's tactile needs to mark surfaces and make objects. (It cannot be entirely accidental that American painters seized, for good and all, upon the material of their art at a moment that coincides precisely with the "blossoming" of network television. Willem de Kooning's Women and the "bad" telecast quality of the period intersect upon a single iconic terrain . . . with the painter come to castigate the image, and purge it; and the anonymous video engineer, living, so to speak, in a different time, to indulge the wistful Occidental longing for a quick-and-easy universal surrogate for experience.)

2. A thermodynamic level. The procedures of most of the arts amount to heat engines; film and video first entrain energy higher up in the entropic scale. Photons impress upon the random delirium of silver halide crystals in the film emulsion an illusion of order; electrons warp the ordered video raster, determinate as a crystal lattice, into an illusion of delirium.

3. An ecstatic and wearisome trouble. I refer to the synesthetic problem of the place and use of sound in the visual arts. We may take the course of grand opera as a summary of the catastrophes awaiting fools and angels alike in this aesthetic quagmire. It is a commonplace that lip-sync sound sank film art for decades. A few film artists, at least in their doppelgänger roles as theoreticians, penetrated some way into the nature of the problem, both before and after Al Jolson uttered those famous last words: "You ain't heard nothin' yet!" But I freely admit that film has not, on the whole, advanced very far in that montage for two senses that seems to imply a dialectical mutuality between the dual inhabitants of the human cranium . . . granting, certainly, that we have abandoned the bourgeois assumption that purported surface verisimilitude is Art's Truest Note.

Ten years ago, filmmakers in New York used to say that you could tell a California film with your eyes shut, because there was invariably a sound track, and that sound track invariably consisted of sitar music. Times have changed, but the problem has not, and video artists seem still to be living in that moment. The unexamined assumption that there *must* be sound now yields, typically, the exotic whines and warbles of an audio synthesizer. Quite simply, most of the video sound I have heard bears, at best, a decorative or indexical relation to its coeval image, and at worst (and more often), obscures it.

At least one major filmmaker has, for twenty years, directed against the use of any sound a reasonable rhetoric that has increased in stridency as the muteness of his work has grown more eloquent; the same man (Stan Brakhage) has, of course, sinned often against his own doctrine, as we all must if we are to honor the good animal within us.

But again, and yet again, this chimerical problem of sound rises up to strike us down in our tracks, film and video artists alike, and we cannot forever solve it by annihilating it. Sooner or later, we must embrace the monster, and dance with it.

4. Finally, film and video share, it now seems, an ambition. I have heard it stated in various idioms, with varying degrees of urgency. It first appears whole, to my knowledge, in a text of Eisenstein's dating to 1932, at a time when a similarly utopian project, involving the dissolution of the boundaries between subject and object, *Finnegans Wake*, was actually in progress.[1] That ambition is nothing less than the mimesis, incarnation, bodying forth of the movement of consciousness itself.

Now that we have seen how film and video art are similar, how are they like things other than each other?

I think it is clear that the most obvious antecedents of the cinematic enterprise, at least in its beginnings, are to be found in painting, an art that, justly losing faith in itself as a technology of illusion, had gradually relinquished its hold on a three-dimensional space that cinema seized once more for itself, on its first try. The Lumière brothers' passenger train, sailing into the sensorium straight out of the vanishing point of perspective, punctures the frontal picture plane against which painting had gradually flattened itself during nearly a century. Early accounts of the situation tell us that the image had power to *move* the audience . . . clean out of the theater, and "instruction" be damned. The video image assumes the frontality that painting has since had continual difficulty in maintaining.

On the other hand, it would seem that video, like music, is not only articulated and expended in time (as film is), but indeed that its whole substance may be referred to in terms of temporality, rhythm, frequency. The video raster itself would seem a kind of metric stencil, ostinato, heartbeat. As such, like music, it is susceptible of being quantified, and thus expressed completely in a linear notation. In fact, it is quite commonly so expressed. I do not refer to anything like a musical "score," of course. The notation of video is called *tape*, and it is perfectly adequate. The filmstrip of cinema is not a notation, but a physical object that we are encouraged to misinterpret under special circumstances. Video has, and needs, no such artifact.

Finally: how do film and video art differ, in fundamental ways that define the qualities of both?

We might examine first the frame, that is, the dimensionless boundary that separates both sorts of image from the Everything Else in which that image is a hole.

The film frame is a rectangle, rather anonymous in its proportions, that has been fiddled with recently in the interest of publicizing, so far as I can see, nothing much more interesting than the notion of an unbroken and boundless horizon. The wide screen glorifies, it would seem, frontiers long gone: the landscapes of the American corn flats and the Soviet steppes; it is accommodating to the human body only when that body is lying in state. Eisenstein once proposed that the frame be condensed into a "dynamic" square, which is as close to a circle as a rectangle can get, but his arguments failed to prosper.

In any event, cinema inherits its rectangle from Renaissance easel paintings, which tend to behave like the windows in a post-and-lintel architecture . . . provided, of course, that one experiences architectural space from the fixed vantage point of paraplegia.

The video frame is not a rectangle. It is a degenerate amoeboid shape passing for a rectangle to accommodate the cheap programming of late-night movies. The first video image I ever saw, on a little cathode-ray tube at the top of a four-foot mastaba, was circular. At least I think I believe that's what I remember I saw.

Things find their true shapes most readily as they look at themselves. Film, looking at itself as the total machine that is cinema, rephotographs and reprojects its own image, simply reiterates to unmodified infinity its radiant rectangle, asserting with perfect redundancy its edge, or perimeter, which has become, for us inhabitants of film culture, an icon of the boundary between the known and the unknown, the seen and the unseen, what is present and possible to consciousness and what is absolutely elsewhere and . . . unimaginable.

But let video contemplate itself and it produces, under endless guises, not identical avatars of its two-dimensional "container" but rather exquisitely specific variations upon its own most typical content. I mean that, in the mandala of feedback, the graphically diagrammed illusion of alternating thrust and withdrawal, most often spiraling ambiguously like a Duchamp pun, video confirms, finally, a generic eroticism. That eroticism belongs to the photographic cinema as well, through the virtually tactile and kinesthetic illusion of surface and space afforded by an image whose structure seems as fine as that of "nature"; video, encoding the universe on 525 lines precisely, like George Washington's face reduced to a dot-and-dash semaphore on the dollar bill, resorts to other tactics.

And as the feedback mandala confirms the covert circularity, the centripetal nature of the video image, it offers also an obscure suggestion. If the spiral implies a copulative interaction between the image and the seeing mind, it also may become, when love is gone (through that systematic withdrawal of nourishment for the affections that is "television"), a navel—the mortal scar of eroticism

past—and thus an *omphalos*, a center, a sucking and spitting vortex into which the whole household is drawn, and within which it is consumed.

If I seem to be verging on superstition, please recall that the images we make are part of our minds; they are living organisms that carry on our mental lives for us, darkly, whether we pay them any mind or not.

Nonetheless, if video and film ultimately unite in an erotic impulse, a thrust away from *Thanatos* and toward life, they diverge in many particulars. For instance:

1. We filmmakers have heard that hysterical video artists say: "We will bury you." In one instance—and it is a very important one—I agree entirely. That instance is the mode we call animation. I have always felt animation, in its assertion of objecthood over illusion, to be an art separate from film, using the photographic cinema as a tool, as cinema uses the means of still photography (twenty-four times every second) as a tool. Film and video typically extend their making processes within a temporality that bears some discoverable likeness to real time; and that simply is not true of the animated film. But I suspect (and perhaps hope) that video will soon afford, if it does not already, the means of fulfilling, in something like real time, every serious ambition animation retains. And that, of course, would mean a wonderful saving of time, out of the only life we may reasonably expect to enjoy.

2. For the working artist, film is object as well as illusion. The ribbon of acetate is material in a way that is particularly susceptible of manipulations akin to those of sculpture. It may be cut and welded, and painted upon, and subjected to every kind of addition and attrition that doesn't too seriously impair its mechanical qualities. Upon that single fact of film's materiality an edifice has been erected, that of montage, from which all film art measures its aesthetic distances.

In short, film builds upon the straight cut, and the direct collision of images, of "shots," extending a perceptual domain whose most noticeable trait we might call *successiveness*. (In this respect, film resembles history.) But video does not seem to take kindly to the cut. Rather, those inconclusions of video art during which I have come closest to moments of real discovery and *peripeteia* seem oftenest to exhibit a tropism toward a kind (or many kinds) of metamorphic *simultaneity*. (In this respect, video resembles Ovidian myth.)

So that it strikes me that video art, which must find its own Muse or else struggle under the tyranny of film, as film did for so long under the tyrannies of drama and prose fiction, might best build its strategies of articulation upon an elasticized notion of what I might call—for serious lack of a better term— the dissolve.

Here the two arts of film and video separate most distinctly from one another. Film art, supremely at home in deep spaces both visual and aural, has need of intricate invention to depart from the "frontal plane" of temporality—an aspect purporting to be neither imperfective nor perfective but Absolute. Conversely, video, immanently graphic, polemically anti-illusionist, comes to spatiotemporal equilibrium through a dissolution, a fluidification, of all the segments of that temporal unity we call Eternity into an uncooked version of Once Upon a Time.

Hence the mythification of the seven-o'clock news and the grand suggestion that the denizens of the talk shows are about to be transformed into persons: one feels, almost, Daphne's thighs encased in laurel bark. Hence also—distantly—television's deadly charms. Is it a cobra, or is it a mongoose?

3. Sigmund Freud, in *Civilization and Its Discontents*, suggests that civilization depends upon the delay of gratification. I might caricature this to mean that by denying myself a hundred million lollipops, I'll end up with a steam yacht . . . and go on to envision a perfect civilization entirely devoid of gratification. But every filmmaker must perforce believe in part of this cartoon, since filmmaking involves long delays, during which the work more than once disappears into the dark night of the mind and the laboratory. I remember, on the other hand, the first time I ever used video. I made a piece, a half-hour long, in one continuous take. Then I rewound the notation and saw my work right away. That was three years ago, and to tell the truth, some part of my puritanical filmmaker's nature remains appalled to this day. The gratification was so intense and immediate that I felt confused. I thought I might be turning into a barbarian . . . or maybe even a musician.

4. The photographic cinema must be "driven," as synthesizer folk say, from the outside. But video can generate its own forms, internally, like DNA. It is the difference between lost-wax casting and making a baby. The most important consequence of this is that video (again, like music) is susceptible of two approaches: the deliberative and the improvisational. Certain video artists have rationalized the synthesis of their images into closed fields of elements and operations, *raga* and *tala*. It is mildly paradoxical that this work, which seems to me, with respect to the density of its making activity, to correspond to the work of Georges Méliès in film, need produce no record whatsoever, may suffer itself to remain ephemeral . . . while the Lumières of video, the improvisational purists of the Portapak, are bound absolutely to the making of tape notations. (I do not doubt that the exterior experience of work of either sort may be fully replete.)

5. There is something to be said about video color. One might speak of its disembodied character, its "spirituality," were one so inclined. That the spirituality in question is as vulgar as that of the painting from which (I conjecture) it took its bearings is not surprising. The decade of the sixties saw—or rather, mostly did not see—the early development of the video synthesizer contemporaneously with the hardening of a posture, within painting, that aspired to founding a chasm between color and substance. The photographic cinema, viewing its unstable dyestuffs as modulators of primal Light, mostly stayed at home and tended to its temporal knitting during a crucial period in chromatic thought.

For those who take note of such things, it will eventually become clear that video won out: were it not for the confusing matter of scale (video, after all, is "furniture" and has the protruding status of an object within living space, whereas public painting has gradually assimilated itself to the "heroic" scale of public cinema) video images should rightly have replaced a good deal of painting.

6. If the motion we attribute to the film image is an illusion, nevertheless the serial still frames of cinema are discretely apprehensible entities that may be held in the hand and examined at leisure. When these frames are projected, they are uniformly interleaved with equal intervals of total darkness, which afford us intermittent moments to think about what we have just seen.

Conversely, the video field is *continuous*, incessantly growing and decaying before our eyes. Strictly speaking, there is no instant of time during which the video image may properly be said to "exist." Rather, a little like Bishop Berkeley's imaginary tree—falling forever in a real forest—each video frame represents a brief summation within the eye of the beholder.

7. Since the New Stone Age, all the arts have tended, through accident or design, toward a certain fixity in their object. If Romanticism deferred stabilizing the artifact, it nonetheless placed its trust, finally, in a specialized dream of *stasis*: the "assembly line" of the Industrial Revolution was at first understood as responsive to copious imagination.

If the television assembly line has by now run riot (half a billion people can watch a wedding as consequential as mine or yours) it has also confuted itself in its own malleability. We're all familiar with the parameters of expression: Hue, Saturation, Brightness, Contrast. For the adventurous, there remain the twin deities Vertical Hold and Horizontal Hold . . . and, for those aspiring to the pinnacles, Fine Tuning. Imagine, if you will, the delicious parallel in painting: a canvas by Kenneth Noland, say, sold with a roll of masking tape and cans

of spray paint, just in case the perceiver should care to cool the painting off, or warm it up, or juice it up, or tone it down.

The point is obvious: Everyman has video to suit himself, even to turning it off or on, at minimal expense and effort. I am tempted to see, from one household to the next, an adequation of the broadcast image to the families' several notions of the universe. What a shame it is, we must often suppose, that other people persist in having their furniture so poorly adjusted.

Were we but intelligent enough, we might recognize here a window into the individual mind as unique and valuable as that afforded us by the twenty-one-centimeter radio band into the universe outside our atmosphere.

I would like to close out these conjectures of mine, as suddenly as I can, by embroidering upon an anecdote. It is about an encounter between two fertile artists: Nam June Paik and Stan Brakhage. Both of them have served their visions so long that they have cast aside, in their thought, the withered rubbish (read "hardware") that bears the bitterly ironic rubric: State of the Art. I can imagine Paik showing us video in a handful of dust, and Brakhage striking cinema from flint and steel. Well, anyhow, Paik was showing Brakhage his newest synthesizer, putting it through its paces. I can imagine Brakhage as he watched Paik elicit from the contraption, at the turn of a wrist, visions of his inner eye that he had labored for twenty years to put on film, feeling tempted by a new and luminous apple. "Now," said Brakhage to Paik, "can it make a tree?" I can imagine Paik's ready smile, which seems to come out of innocence, a little slyness, and the pleasure of feeling both ways at once. "Too young," Paik replied. "Still too young."

**Note**

1. The reference is to Eisenstein's "A Course in Treatment," in Sergei Eisenstein, *Film Form: Essays in Film Theory*, ed. Jay Leyda (Orlando, Fla.: Harcourt Brace, 1977), pp. 84–107. (B.J.)

Text delivered at the conference "Open Circuits: The Future of Television," Museum of Modern Art, New York, January 23–25, 1974. Published in *Artforum* 13, no. 4 (December 1974): 50–55.
Reprinted in *Circles of Confusion* (Rochester, N.Y.: Visual Studies Workshop Press, 1983), pp. 161–170.

# Proposal: Hardware and Software for Computer-Processed and -Generated Video

History of the Project:

During recent years, as costs for goods and services in many of the media-related technologies (e.g., film) have increased steadily, the cost of video has fallen dramatically, and the computer has become available at the personal level. It is literally true that more computational power is available today, for a few thousand dollars, than was imaginable on the multi-million-dollar mainframe computers of twenty years ago.

It has been true for some time that established video artists in mid-career may afford, with some sacrifice, to own the tools of their craft; younger artists have been able to share these means through a developing network of local non-profit facilities. This availability of tools has encouraged the growth of a new art form in a way comparable to the rapid development of independent film after the advent and acceptance of a relatively cheap 16mm film technology, which afforded wide distribution without seriously diminishing technical quality.

In the meantime, there has been great eagerness on the part of artists to explore the new possibilities for image generation and processing made available by the computer. In the past, this enthusiasm was thwarted by the scarcity and expense of computer time, by the problems that anyone has in communicating with others highly trained in a foreign discipline, and by a fundamental alienation from the extreme generality of computation. It has never before been possible for an artist to explore the uses of the computer in art with the intimacy and flexibility that the painter or writer takes for granted and finds the necessary condition of creative work.

However, most existing computer programming languages were designed, from economic necessity, to accommodate the scientific and business communities: the result has been a computing environment uncongenial to users in other fields. And the additional hardware required for video image generation, except for devices of very limited capability, is still too expensive for individuals to afford.

Since 1977 I have worked, both alone and with a small group of students in workshops at SUNY/Buffalo, to formulate the hardware and software requirements for a hospitable computing environment for the arts, emphasizing the notion of the computer as a personal creative tool. In practice, this experimentation has entailed the writing and testing of hundreds of programs, and the

design and building of dozens of hardware devices, during an estimated interval of twenty thousand hours. The conceptual portion of this work is now complete. It has produced two results.

The first is a design for a hardware device, called a frame buffer, that may be interfaced to virtually any minicomputer or microcomputer. The device treats a portion of computer memory as an image, and outputs as NTSC standard RGB color video a picture composed of 256 by 256 elements, each of which may be any 256 out of about 16.8 million possible colors. Up to four images are available within the device itself at any given time; further images may be stored on, and retrieved from, magnetic media such as tape or floppy disk. The contents of a frame may be generated directly by the host computer or loaded from a video camera. Embellishments within the buffer permit complex manipulations of picture information in real time, but the design, while versatile, is essentially conservative. This portion of the project exists, at the moment, as completed schematic and timing diagrams and parts specifications. I would emphasize that the prototype device can be completely constructed for less than $5,000 in materials, and that additional units should cost less than $3,000.[1]

The second result is the conceptual design of a software system for using the hardware to create and modify images. This design specifies a programming language containing more than 160 commands, and 19 additional software subsystems for performing special tasks such as building character type fonts, sequencing the output of images to a video monitor, redefining the set of colors in use, and so forth. The language is highly interactive, permitting a user to work with images after very brief instruction and without previous programming experience, but it is of sufficient richness to afford scope to experienced programmers as well as experienced artists. I have brought to bear, in the design of this software, twenty-five years of experience as a working visual artist and six years as a programmer and user of programs. I will write the programs as in-kind matching for funds. This will probably take about 2,000 hours and produce 15,000 lines of program code.

Work of the Project:
The work of the project will consist in (1) construction of the frame buffer by Robert Coggeshall, and (2) implementation of the software by myself.

Results of the Project:
1. Complete documentation for the frame buffer, including schematic and timing diagrams, bill of materials, theory of operation, construction and troubleshooting information, and specification of interface to software.

2. A high-level interpretive language and subsystems, in both human and computer readable form, together with its formal specification, user manual, implementation manual, and hardware test and alignment programs. The software will operate on the Zilog Z80 and/or the DEC LSI-11 microcomputer(s).

3. Demonstration and tutorial video cassettes of the system in operation.

4. A descriptive and critical report on the project.

All these materials will be placed in the public domain. Using them, any person with reasonable electronic skills should be able to build the hardware and bring up the software in about eighty hours.

Manner of Returning Results of the Project:

1. Copies of all documents, software media, and videotapes will be returned to the National Endowment for the Arts for archival purposes.

2. A copy of the report will be distributed to the field, insofar as it is known to me. This includes over one hundred individuals at upwards of twenty sites.

3. Human and computer readable copies of all programs and documents will be made available for the cost of duplication, estimated at $50.

4. Videotapes will be made available for the cost of duplication.

5. The project will be reported to relevant professional groups, e.g., the Association for Computing Machinery (ACM), its special interest group for graphics (SIGGRAPH), and the IEEE Computer Society.

**Note**

1. This hardware design was the work of Robert Coggeshall, a graduate student in the Center for Media Study, SUNY/Buffalo, with whom Frampton worked very closely, with a view to integrating hardware and software as thoroughly as possible. (B.J.)

Proposal submitted to the Media Arts Program of the National Endowment for the Arts, in the category of Services to the Field (Individual Application), undated (1982).

The Services to the Field grant for the construction of the frame buffer and design of the software was awarded in 1983. (B.J.)

## About the Digital Arts Lab

In September 1977, two new courses were approved and offered at the graduate level in the Center for Media Study: *Seminar in the Image: Theory* and *Workshop in the Image: Practice* (now called *Advanced Digital Arts Workshop*).[1] These courses were brought forward by Hollis Frampton and Bohuslav [Woody] Vasulka in response to a need, sensed by faculty and graduate students, for a re-integration, at both theoretical and practical levels, of contemporary thought surrounding the interfacial node of the several disciplines of film and video making and theory, film study, photography, and sound synthesis and processing as it interacted with and responded to pressures and suggestions from the fields of mass communications and the traditional fine arts.

Among the disciplines in question, there appeared to obtain an eclectic profusion of concept and terminology. It seemed reasonable to ask whether a virtual intellectual space exists, within which it might be possible not only to bring into congruence the apparent differences among them but to investigate a method and seek a terminology which could define a generalization that could describe their several states and historical predicaments in a satisfactory (and perhaps fertile) way, without losing sight of the scientific and humanistic discoveries that have always inseminated and complicated the development of the fine arts and the maturing media-related arts.

At the same time, both faculty experienced an increasingly urgent need to integrate into their teaching and research some accountability for the social presence of that supreme effort of technology, the digital computer. Coming from backgrounds in film and video, both were experienced in advanced image and sound technologies and accustomed to assimilating them into their own thought and teaching their use. At the same time, both were strongly oriented toward the use (and the consequences of that use) of existing media technologies as domesticated personal tools. By 1977, small computer systems were available for prices that made it feasible for small programs within institutions or committed individuals to undertake serious examination of the computer as a tool.

Computers had long occasioned massive revisions within the exact and social sciences. In some cases the reasons were socially important but intellectually trivial: the speed of operation and arithmetic power of computers is legendary everywhere. What is more important, however, is that the computer is a tool for manipulating symbols, and systems of symbols, in the most generalized sense. It seemed reasonable, since film or video or sound are symbolic

systems in precisely the same way that mathematics or the natural languages are, to pursue further the implications of a tool that must be perceived as totally generalized in fields where it had not been used or understood by experienced practitioners, teachers, and theoreticians.

What was most important, though, in attempting to use this new tool is that it rigorously enforces a precise understanding of the fundamental nature of the symbols and systems to be operated upon. To state very roughly a fundamental theorem in computer science, the generation of an algorithm that performs a process requires a rigorous and detailed understanding of that process. Thus if the operation of a symbolic system can be emulated by an algorithm expressed as a computer program, it is possible to establish a benchmark for a state of comprehension of the properties of that system and its constituent symbols. The attraction and power, then, of computers is that they afford means to test and exercise our understanding of what we are doing with any tool, what we mean when we say that we make something, what we mean when we say that we know what we are doing.

Teaching two graduate courses led to the growth of a very modest facility that has been called, by consensus, the Digital Arts Lab. At the practical level, our emphasis has been largely upon program (software) development, since it is labor-intensive rather than money-intensive. Since the state in which we at first found ourselves was relatively primitive, we concentrated on building tools that would help us to take on more complex tasks: programs to help write other programs. One of the first, which has been much modified and improved over the years, was called a text editor, which uses an electronic keyboard as a typewriter and a video screen as paper, emulating the cut-and-paste operations of the process of writing any text. The text you are reading was composed using this program. Another program emulated a print-shop typesetter, automatically performing such tasks as justification, centering, page numbering, paragraph indentation, footnote gathering, and so forth; the text you are reading was typed using a few of the commands in that program.

As the capabilities of the lab grew, a series of programs called languages were designed and developed. DAEMON, an acronym for DAta Editor and MONitor, facilitates recording and changing of sound information, and implements the operations of a sound recordist and editor using such simple instruments as a variable-speed tape recorder, microphone, razor blade, and tape splicer. MUSIC emulates a keyboard musician, who operates an instrument that can be made to resemble anything from a piano or organ to a string quartet, brass choir, or small party of New Year revelers using noisemakers.

OPOS, Optical Printer Operating System, emulates a film technician. A current project, IMAGO, is a computer language that includes functions to perform film or video animation, and implements many that are possible only to painting. The supporting hardware for IMAGO, an advanced device that executes more than one hundred keyboard commands, is being designed and built by students and faculty within the lab environment, as a cooperative project. Each of these projects, to name but a few, has been completed as part of the work of courses offered in the Center for Media Study, as a realization of a general problem stated and defined in lectures and discussions.

At present, students studying in the Digital Arts Lab come from Electrical Engineering, Computer Science, Mathematics, Psychology, English, Music, and Art as well as our own program. Increasing numbers appear from the undergraduate population, and we have applied for approval of new courses to meet this need.

Meanwhile, these courses and this research continue to offer valuable supplemental instruction to students within and without our program, and there seems to be appreciation of the "generalist" and synthesizing rubric under which we have functioned and whose definition we continue to pursue. It is reasonable to foresee considerable growth in student need in this area for the next several years, as the relevant technologies and their consequent problems grow ever more permeant. If these consequences are not responsibly examined at the level of university education, then the results must be socially catastrophic, so it is to be expected that support of course work and research associated with the Digital Arts Lab will achieve and maintain correspondence not only with momentary enrollment but also with the certainly privileged (and potentially bright) future we are obliged to expect for the impact of computer technology on our field.

**Note**

1. The Center for Media Study was established in 1972 at the State University of New York at Buffalo by Gerald O'Grady, offering undergraduate and graduate degrees in a range of media production (film, video, holography, digital arts), media history and theory, and the social impact of media. Early faculty included video artists Woody and Steina Vasulka; filmmakers Paul Sharits, Tony Conrad, James Blue, and Hollis Frampton; and theorist Brian Henderson. (B.J.)

Unpublished document, State University of New York at Buffalo, c. 1982.

Marion Faller, Hollis Frampton, *782. Apple advancing*
(*var. "Northern Spy"*) from *Sixteen Studies from*
*VEGETABLE LOCOMOTION,* 1975. Black-and-white photograph
© Marion Faller

# THE OTHER ARTS

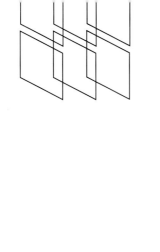

# Letter to Enno Develing

Dear Enno Develing,[1]

Some months ago I agreed to write you a letter about Carl Andre. The matter has been on my conscience ever since.

I am by temperament no biographer. I should do a friend a disservice by attempting to embalm him in prose at the age of thirty-three. Anyway, I secretly believe that Boswell faked the last of his book to cover the fact that he, Boswell, *cooked and ate* Doctor Johnson. That is the logical end of treating people as commodities.

So I write to you now rather in the role of archivist, not a very competent or thorough archivist, granted, but the only one available. How that state of affairs came about, and what is in the archive in question, I shall try to set down briefly. The events were boring enough at the time, certainly, but may by now be of some interest to strangers.

Carl Andre and I met as schoolboys.[2] We were interested in science and in art. It was customary at that time for young men with diffuse artistic intentions to fancy themselves poets: accordingly, we both were poets. But we took studio courses and painted. In the early fifties, action painting was showing muscle in New York. Our teacher was Patrick Morgan, who had studied with Hans Hofmann years before, in Munich, and knew what was going on.

Carl went to Kenyon College, in Ohio, briefly. He saw the great earthwork Indian mounds there before he was asked to leave. It would seem that he lacked what we call in America "school spirit." At any rate, he went back to his native Quincy, Massachusetts; saved a little money from a job at the Boston Gear Works; went to England for a time (visited Stonehenge and the Parliament), Paris briefly (visited the Eiffel Tower and the Louvre); returned to the States and spent two years in U.S. Army Intelligence in South Carolina; and then moved to New York City, where he worked for a while as a production editor for a publisher of textbooks.

I arrived in New York, to sleep on his floor, early in the spring of 1958. I found him living in one hotel room near Columbia University, forty pounds lighter than my memory, supporting himself by extracting an occasional book index (an activity he professed to enjoy)—and copiously making art. Chiefly he wrote lyric poems. There are still copies of some of them: literary objects are more portable than plastic, and at that time, as later, portability was paramount.

He made occasional drawings. Perhaps poverty first suggested that anything might be material for art. I recall a drawing of a predatory bird, made on a shirt cardboard with ballpoint pen and A–1 Steak Sauce.

That summer, an acquaintance gone off to the Army bequeathed him a cheap apartment. He dismantled the walls and made a series of paintings, somewhat on the principles of Kenneth Noland's

first work shown in New York but, I should say, not so tasteful. They were rejected by the old Tanager Gallery on East Tenth Street and became Carl's first group of lost works.

I had got a tiny slum apartment in "Little Italy," and the fall of that year found *him* sleeping on *my* floor. The painter Frank Stella, whom we knew from school days, had come up to the city from Princeton and was doing his first loose, expressionist stripe paintings in a tiny loft near Manhattan Bridge. The three of us began to spend a great deal of time together.

Carl brought downtown with him a beer box full of manuscripts and objects. He continually made more "objects," as it were by reflex. By the end of that year his object-making had taken a distinctly sculptural turn: he was systematically mutilating (I can use no other word) bits of wood in a variety of ways, none of which were traditionally sculptural: for example, charring, wire-brushing, and so forth. At about the same time, the still camera had turned my own attention from poetry, and I began systematically to photograph Carl's work. And that is how the "archive," such as it is, was begun.

I cannot now feel utterly certain of my motives in doing this. I have no impulse to "collect art," and can't remember ever wanting to record the work of any other artist. Surely this very first work was not especially "good" or "important" or "mature." Of course it was important to me personally. What struck me then, as it does now, was CA's utter concern for the root, the fundamental nature of art. His has always been an enterprise of *curiosity*, informed by the changing needs of his own mind rather than those of the market; hence his concomitant unconcern for the standard sorts of permanence (or read "posterity" *ad lib.*).

The other plastic artists I knew then were "studio artists," maintaining a workspace and taking a bustling bourgeois interest in preserving and disseminating their work. But CA worked wherever he happened to be, with what was at hand. His studio was his mind, so to speak. Anyone who admired a piece was welcome to shelter it, and a few did, but nothing encumbered him for long. When he moved, the work was left behind. If it became too copious, he discarded it. Since he has moved often, and produced much, a great deal is gone.

I guessed at the start that most of what I saw was ephemeral, so I began to make a record for myself—had I suspected that anyone else would be interested, I should have made a better job of it. As it is, much is missing entirely, and what there is often has the look of the photographs made in the pathology department of a hospital (they call them "gross specimens"). Ironically, some negatives of CA's lost work are, through the vicissitudes of my own life, themselves lost.

That winter (1958–59) was a time of considerable, if diffuse, activity. A long series of large india-ink drawings investigated with considerable wit the "distinct possibility of the draughtsman's page." (These were photographed: they are, with one exception, lost.) A short novel followed: *Billy Builder, or The Painful Machine*. Still unpublished (one copy exists),[3] it was turned down some years later by Grove Press, with the curious comment that it was "too long" (fifty-two pages). Carl described it at the time as "Tom Swift written by Dean Swift."

As the winter ended, he turned again, quite overtly now, to sculptural problems. Evidently, he had given thought to Brancusi's insistence on the superiority of direct cutting over modeling; at the same time, he insisted that the typical block of raw material, the ingot or timber, was already an object strong in its own sculptural immanence. The immediate result was a small group of objects made of acrylic plastic variously drilled and incised but with the given prismatic surfaces left intact, so that the sculptural work transpired within a rigidly defined transparent volume.

This led, in the spring of 1959, to "negative sculptures," man-sized for the first time, hand-cut from timbers pilfered from razed buildings in the neighborhood. He worked on them in Frank Stella's studio: I see Stella's aluminum *Union Pacific* in the background of the photographs of these pieces. I believe all are lost but one.

He spent the summer of 1959 with his family in Quincy, on the pretext of painting his father's house. July 4th seemed an appropriate time to visit him in the family seat of the Adamses. When I got there, I found that he had been up to more than housepainting. His father was an enthusiastic woodworker and kept a hobbyist's cellarful of power tools. Carl turned not to the lathe but to the more analytic capabilities of the radial arm saw, and had made forty or fifty small wood sculptures. He had modified the wood blocks in varying degrees, but the premise remained that the original block in itself implied a set of sculptures; he had, in each case, tried to end up with one of them.

I suppose they are all gone now, although he kept a few of the smaller ones with him for years. The photographs, taken later in New York, cannot suggest the vivid image they made standing by the dozens among the backyard flowers in Quincy, a little like a crowd of Japanese garden shrines. The radial arm saw, he said, had suggested itself because it "embodied thousands of years of human experience in cutting." His attention had shifted from Brancusi's carved pieces in bronze and stone to the hewn and stacked pedestals upon which they stand.

In the fall, he returned to New York and got married. A brief period of quiet followed. He lived in cramped quarters. That winter I took a very big apartment, mostly empty. CA moved his radial saw into it and in three months made eight or nine large "pyramids." They were built of ordinary 2 × 4 lumber, notched together stepwise in the manner of American wilderness log construction. Each could be assembled in two configurations, or taken down for storage and travel. Dozens of people saw them. They were, by any possible criterion, important work, generally admired by CA's peers—none of whom could "do something" for the artist—and equally ignored by dealers and curators. The single exception was the scholar and critic Eugene Goossen.

At the time, the grip of Abstract Expressionism was barely thawing. Of course Ellsworth Kelly and Ad Reinhardt had shown extensively, Stella was beginning to make headway—but, in the main, few persons besides very young artists (CA was then twenty-four) had grown sensibilities capable of "seeing" this new work.

So it simply stood there. In September of 1960, I gave up the apartment. The new tenant, the art dealer Richard Bellamy, agreed to store the pyramids, since Carl hadn't room. Curiously enough,

Bellamy, who was to show considerable prescience in the Pop Art area and its adjacent precincts, saw fit to burn the pyramids for firewood during that winter.

Carl had momentarily run out of money and sculptural opportunity. In the autumn of 1960 he again turned his attention to poetry. Earlier poems had been freely rhymed lyrics; now he began taking given texts and "cutting" directly from them as from a timber, mapping upon words what he had learned from sculpture. A prime text for some time (for years in fact) was an old history of King Philip's War, America's first, fought in the marshes of CA's native southeastern Massachusetts.

While emphasizing that Carl's verbal and plastic activities are in no way separable, I must beg off writing at any length about the poems. There is a very large body of work in words, and I believe it an estimable one. By virtue or compactness, most of it has survived, unnoticed—seminal work largely, as it were, gone to seed. I only hope someone will eventually put a good portion of it into print.[4] For the moment, the burden of proof rests mainly upon a file of carbon copies that parallels the file of photographic negatives.

In early 1961, financial necessity presented a new set of sculptural opportunities. CA went to work assembling freight trains as a yard brakeman for the Pennsylvania Railroad, a job he held for several years. The baldest guesswork would suggest that his earlier intimations of modular and iso-metric structures found abundant example among the boxcars and crossties of New Jersey. More concretely, he began bringing home fabricated scrap-iron bits picked up along the tracks: a hook, a spring, bearing balls. These were assembled loosely, held only by gravity or their own structural limits. A glazed ceramic insulator stood unmodified. Soon windowsills and floor margins were full of these little anecdotal pieces. They were underfoot.

I call them anecdotal, but they were not "literary" anecdotes, the iron cartoons of a Stankiewicz. Rather they were brief anecdotes about gravitation, friction, displacement, equilibrium, and like plain physical principles.

There was a concurrent effort that illuminates some of CA's thought at the time. He made per-haps a score of objects, less witty than funny (in an enigmatically vulgar way), which he called "Dada forgeries." I recall, for instance, a tin box for "Schwarze Weisheit" Brazilian cigars: inside it, a slice of desiccated toast, inked entirely black, the whole called *The Donation of Constantine*.

Clearly he was preoccupied with the possibilities of the readymade sculptural component, but wished to rid the readymade of the associative semblances of Dada and Surrealism. Rather abruptly, he found his way out of the quandary. The leavings of the railroad were abandoned as he began to shop for collections of identical modules, cheap at surplus houses, the tailings of industry in steel, glass, plastic, and aluminum. The endpoint of this series was reached in a group of small pieces made by combining identical bars of rolled steel measuring $1 \times 1 \times 3$ units into forms like capital letters I, T, U, L, post-and-lintel, and so forth. Wanting then to build these pieces again out of con-struction timbers, on a scale reckoned in feet rather than inches, CA wrote a detailed proposal for

a show to the dealer Leo Castelli. I can't recall whether that letter, with its attendant drawings, was simply ignored or waved aside with a vague "maybe next year."

In any case, late in 1961, with two bodies of work dismissed as pointless, CA went into a kind of seclusion. We saw little of one another until August of 1962. Then we arranged that I should come to see and photograph what he called his "indoor vacant lot." He would soon move to a tiny apartment in Brooklyn. There was no room there for storing old work; all was to be left behind.

The "vacant lot" was a complicated parlor-floor hole in a Lower East Side tenement. There were a bed and wardrobe somewhere, but no other furniture. A cabinetmaker's saw in the basement below rang like a carillon. A broken automatic toilet flushed Niagara. Children had stoned out the windows months before. There was finished work stacked on every horizontal surface and hanging on the walls . . . I think there must have been sculpture standing in the bathtub. I don't know how much was there: the film ran out before the job was done.

There were at least five classes of objects, ranging from prodigiously ugly through downright hideous. Collage "paintings" incorporating whole physical objects (gloves, umbrellas, lettuce), covered entirely in glossy enamel paint in primary colors, poured on so that viscosity and surface tension were exploited rather than hue or texture. "Polymorphous perverse carpentry" made by nailing up disheveled scrap wood from the streets, often "as though" they had been anonymous readymade modules. Polychrome stalagmites of pigmented concrete, sometimes embedding iron detritus or bricks. "Pizza pies," flat patties of Portland cement, bristling with glass marbles and dish and bottle shards. And a curiously memorable set of pieces made of "slices" of wet concrete, laid one upon another in collocations reminiscent of the excrement of dogs.

The landlord must have had difficulty in disposing of it all. CA has said often that he was pleased to be rid of the lot. Nonetheless, looking at the old photographs in the light of what has been done in American sculpture during the three or four years just past, I can't help noticing that those nine months were spent on work of unswervingly radical aspiration. There was more at issue than mere despair, or keeping his hand in.

For the next three years, in Brooklyn and Manhattan, CA's main activities were literary. The endless flow of lost sculpture never stopped, but poems, some of them extremely ambitious, were his concern. That words have spatial and plastic qualities, along with their sonorous and associative properties, was a discovery that exfoliated systematically in the space of pages divided by the typewriter into a uniform grid.

Finally, in 1964, E. C. Goossen, recalling the pyramids of years before, asked Carl to rebuild one for a group show at the Hudson River Museum. Inclusion in other group shows followed more or less immediately . . . but I'm sure you are quite familiar with Carl's career from that time to this. Of course, when his oeuvre became "public" my own task was finished. Others keep the records now, and there are no lost works anymore.

I hope this letter, melancholy as it is, has at least suggested that Carl Andre's work was not generated spontaneously upon the floors of the Tibor de Nagy Gallery. His work has already changed the plastic art of the West. I trust it will continue to do so, and in ways that are by no means subtle.

I think Carl, in a sense, is Brancusi's truest heir. The old Romanian peasant stressed direct cutting in metal, wood, and stone ... the young American makes direct cuts in gravity, mass, volume, density: the most fundamental properties of all sculpture, as of all matter.

I am sending you, along with this letter, a quantity of labeled photographs, and bits of writing, as documentation. They are merely my own choice among remnants. But they are surely of interest, as T. S. Eliot said of Dante's shorter poems, "because they are by Dante."

Very cordially yours,
Hollis Frampton
New York City, 24 May 1969

## Notes

1. Enno Develing was the curator of an important early exhibition of Carl Andre's work held at the Haags Gemeentemuseum, in the Netherlands, in 1969. Frampton's letter, together with his photographs of Andre's early, lost work, served as the introduction to the exhibition catalogue. (B.J.)
2. In the early 1950s, Frampton and Andre, together with Frank Stella, were students at Phillips Academy in Andover, Massachusetts. Frampton and Stella were in the same class, graduating in 1954; Andre graduated a year earlier. Other notable schoolmates included the composer Frederic Rzewski and filmmakers Standish Lawder and Les Blank. (B.J.)
3. "Mimeo proofs and offprints" of the manuscript are listed among the contents of the Hugh Kenner Papers, housed at the Harry Ransom Humanities Research Center at the University of Texas at Austin. (B.J.)
4. In its original publication, Enno Develing noted that "the whole body of poems is published in six volumes by Seth Siegelaub in cooperation with the Dwan Gallery." (B.J.)

Introduction to the exhibition catalogue *Carl Andre* (The Hague: Gemeentemuseum, 1969), pp. 7–13. Reprinted in *About Carl Andre: Critical Texts Since 1965* (London: Ridinghouse, 2006).

# Preface: *12 Dialogues 1962–1963*

Midnight, Central Standard Time, 11/6/79 Gregorian, −38 Celsius at 37,000 feet and northbound, over Arkansas: once again, in these pages, Carl Andre's trajectory intersects with mine; and again, as it has happened so often in the twenty-seven years since we first met (a conversation about physics, and a physicist) in a space that we have both traversed, but in our own times and ways, on errands of separate devising. Neither of us is there any longer.

Briefly, though, we were, both of us: in the arena of language, which is that of power. So, first, I would urge that these dialogues be read, if they are to be read, as anthropological evidence pertaining to a rite of passage and to the nature of friendship.

If our rhetoric is that of an aesthetic Cotton Mather downshouting himself in an imported mirror, there is still something to enjoy, a little: the text remains permeable to certain ragged discontents; it accepts, or admits, as I read it now, the paralyzing scarlet of oilcloth on a kitchen table in Brooklyn . . . diaereses, between paragraphs, of walks to the corner after Ringnes Beer . . . or a slip of the tongue upon which I shall always regret having acted too cautiously.

Making my way to a subway station, after what was to have been the last of these dialogues (and that one is not here, was lost) I saw and heard, in soft snow, a man improvising music in Fort Greene Park: fifteen years later I understood him to be Sonny Rollins, and that that audition may have been one convergence secretly prepared by the evenings Carl Andre and I spent at the typewriter.

This distant one, with an illusionist still (it appears) in flight, and of a different mind, is another.

H.F.
November 6, 1979

Carl Andre and Hollis Frampton, *12 Dialogues 1962–1963*, ed. and with annotations by Benjamin H. D. Buchloh (Halifax: Press of the Nova Scotia College of Art and Design; New York: New York University Press, 1980), p. xi.

The book reproduces dialogues that transpired between Frampton and Andre over the course of a year, beginning in the fall of 1962. These dialogues were conducted on a typewriter in Andre's Brooklyn apartment. According to Benjamin Buchloh, "while one participant was typing, the other was sitting on the bed, reading, waiting for his turn to reply." The dialogues cover a range of topics, from literature and music to painting, sculpture, and photography. (B.J.)

# On Plasticity and Consecutive Matters

**CARL ANDRE:** You have evaded the issue long enough. Now I propose to pin you wriggling to a definition of the plastic.

**HOLLIS FRAMPTON:** While it's still soft, you can push it around. When it gets hard, it pushes *you* around. Miss Miriam Webster says it means pliable, impressionable, capable of being molded or modeled. In art, characterized by being modeled, hence sculptural in form or effect.

I think sculpture in that sense is plastic by custom only.

**CA:** Are there not dimensional arts and durational arts? Cartography is dimensional and navigation is durational. Shape is the product of dimension, hence plastic. These categories are as false or useful as any others.

**HF:** Naturally you will say music is a durational art. Yet where is the "real" music? Is it not as much spelled out on the rectangular page as read out into the air? And does not my reading of a painting, or my revolution about a sculptural piece, explicate it in time?

**CA:** The real music is in the agitation of the molecules of air. Poetry and in fact almost all literary forms are durational in structure. Although a stop sign functions plastically. Perception is durational. You change and unfold if you truly perceive. Calder's mobiles are only apparently durational. Tinguely's self-destroying sculpture may possibly be durational.[1]

**HF:** There is no such thing as time. Time is a set of conventions for bracketing qualitative variation. E-flat does not exist "in time" relative to B-flat, before or after it: we hear them as they are sounded, which is always here and now. The adverbs *firstly* and *secondly* are pegs we use in our sentences when we wish to emphasize that those sentences imitate actions.

**CA:** Time as rate certainly is a thing. Given a certain amount of energy to discharge or a certain distance to cover, time as rate becomes time as duration. E-flat and B-flat do differ in terms of the rate of agitation of air molecules. Plasticity, once fixed in the painting or sculpture or building, has no rate of discharge or distance to cover. We do have rates of perception.

**HF:** Much better. I accept time as a directional stress obtaining among a set of palpable things or qualities. It is the notion of time as a tank of fluid in which everything floats, and which transmits only a displacement of any single particle without itself moving or changing, much like the old

fluid aether of wave mechanics, to which I object. Not so much as a bad model, but because it *is* a model, with attractive qualities of its own but none of the savor of the phenomena it is to account for. Dimension and duration appear to be two aspects of the same thing, if we consider cinema. *Potemkin* is a ribbon of cellulose acetate, cranked through a projector at a constant rate of sixteen frames per second (a speed which has to do with our average rate of failure to perceive separate images). Any one of the millions of frames might be considered as a separate event. But, coiled up in the can, no frame is more than a couple of handspans from any other.

**CA:** In place of time and plastic, or in place of duration and distance, substitute moving and still. Some art objects must be moved to be revealed.

**HF:** Your suggestion is confusing in the concrete. For the cinematographer who edits his own film, and sees a clear sensuous connection between the flickering moving image on his screen and his chopped and spliced and measured celluloid ribbon, the tangible coil of film is his "art object." Likewise the composer laboring over his score . . . and one need only look at scores of recent compositions to realize how much eye-attention modern composers give their work in notation.

You spoke in our last dialogue of poems organized "plastically." Now I was told as a boy that poems are organized "metrically." Perhaps we can come closer to a clear idea of plasticity via meter. I bracket the note divisions between the composer's bar lines, and the "shots" or short bits of film the cinematographer splices together to fill his measure, together with the iambus and trochaeus, when I mention meter.

**CA:** We read from left to right. Meter is a controlled rate of sounded reading from left to right. Stravinsky introduced the idea of meter as the articulation not of bars but of whole works. Scriabin had begun the process before him. Pound works in a meter whose single foot is a canto. Painting on the other hand does not read from left to right. A well-composed painting is not an interesting middle surrounded by deteriorating lefts and rights, tops and bottoms. The best Renaissance easel painting employed the edge of the painting as a framing device. The view was cut as if by a window frame. Only bad paintings can be read in a metrical way. They have an all-at-once appearance. We have a style of painting now, of which Jackson Pollock is still the exemplar, in which the edge of the painting is used like a political boundary: this much I painted, the rest is yours. A Pollock cannot be read; it can be *entered* right at the dead level.

**HF:** Any work of art is *something*, surrounded by *everything* else. We read it in whatever direction it leads us. The foot in verse is not the meter but the prime condition of our understanding the meter, that is, *measure*. The bar line in the neumic notation of plainsong was a breathing space, but not for

us: it marked the respiration of the extraordinarily sustained period of medieval chant. The habit of slugging the first note following it is perhaps three times as old as Picasso.

I am trying to define the splice, foot, bar line, and boundary as systole and diastole: the storage, release, and standing aside from a movement of energy.

**CA:** I have tried to indicate my idea of plasticity as having to do with the manipulation of dimensions. I introduced time, meter, etc. as a contrast. I am rather bugged by one aspect of plasticity: hard-edge as against thumb-imprinted. One can pour concrete into a form and let it set. Remove the form and one is no longer confronted by the mud but by hard, smooth stone. Then again, one can take the concrete mud and throw it about, cutting, wounding, bruising it. When it sets, it sets not as hard, smooth stone but as hard and clotted scab. I am disturbed because my bruised mud or paint always congeals in a peculiarly brutal and vulgar way. The form provides a great leveler. A precise cube is precise because of its dimensions, not because of the gift of its designer. Galena is a better Cubist than I am. My question, doctor, is this: is there a hierarchy of forms and scabs?

**HF:** The wooden form, then, restrains the sculptor and not his material? Certainly one of the major technical problems in plastic art is restraining the artist. But let me stay a moment with your wooden form. You are confused, perhaps, by the seeming indirection of making the wooden form first. You're not so sure you should not exhibit the wood form, rather than what comes out of it. Your main chance for control is in building the mold.

As for the brutality and ugliness in your work: I had heretofore thought of much of it as didactic.

**CA:** About my plastic clumsiness, I must admit, I am not interested in the disciplines that develop plastic tact. De Kooning's *Easter Monday* is an anthology of gestures derived from years of sign painting and figurative painting. My work is experimental. I believe all ideas are equal except in execution. My executions are tests of ideas rather than attempts at plastic virtuosity. Nevertheless, the problem of the thumbprint exists. Frank Stella insists that thumbprint expressionism is an inherently inferior style. The irony of his position is that Frank Stella's stripes are generated by his thumbprint brushing. He seeks plastic virtuosity, to match himself with Van Eyck. I, myself, formerly preferred the hard-edge style or crystal mode until I happened to read a text on crystal nurture in which the otherwise well-informed author insisted upon the moral superiority of crystalline patterns. I was caught short by the thought that the poor crystals could extend themselves only by accretion. Not a single fuck in a pound of chrome alum. Even the slippery paramecium enjoys the pleasures of conjugation. Crystals and straight lines suddenly seemed beside the point to me.

**HF:** Crystalline structure is a habit of matter arrested at the level of logic. Logic is an invention for winning arguments, and matter wins its argument with ionic dissolution by crystallizing. A logical

argument cannot change; it can only extend itself into a set of tautological consequences. But I don't think Frank Stella has pursued a train of logic to its end in his paintings. I think he has deliberately eliminated from his paintings every element a human being might find satisfying in the *act* of painting.

Experimentation means moving data from theoretical ground into the precincts of personal, tactile experience. That is not the same thing as testing or embodying *ideas*. I believe there *are* no ideas except in execution. An idea is a shape in my head.

**CA:** No. An idea is a pattern of electrical potentials in the cells of the human brain. These patterns obey the laws of electrical circuitry. The matters with which ideas concern themselves are phenomena that obey laws quite different from those of electrical circuitry. Hence an idea is at best an analogue or model. It must be tested in conditions that are consistent with the external phenomenon. To execute an idea is to recreate the intellectual model in terms of the external phenomenon. I also disagree with you about Frank's painting. His brush stroke is the housepainter's, and de Kooning's for that matter. Frank typically disguises his humanity with the appearances of a crystalline habit.

The chemical models of procreation have defied intellectual analogy to the present day, and with all our science we are only beginning to understand genetic semantics. This brings me to propose a new use or value for the arts. Astronomy and astrology were once one science. They divided out of a fatness of empirical observation, so that we have now a science and a hoax. The hoax of alchemy was split from the science of chemistry. Perhaps the hoax of art will some day be discarded and a system of detailed, accurate, and illuminating perception will become an anchor post for a civilization we have not yet achieved. That means tossing out the magic and the mystery, but I think it means introducing equally the full white light all around. Why is it only a poet seems to detect the fact that the science of economics is a delusive hoax?

I have no coherent thought, only a double image. There is the tree of cells, chemicals, atoms. To be human and humane is to want to know and understand that tree. But to be human and humane is to want to sit in its shade and to watch the bell leaves change the sky. Somehow it seems to me not a defect of science that trees cannot thrive in our cities, but a defect in our art.

**Note**

1. As Buchloh notes, the reference is to the Swiss artist Jean Tinguely's *Homage to New York* (1960), an assemblage of scrap metal and junk that, during the course of a twenty-seven-minute "performance" in the sculpture garden of the Museum of Modern Art, destroyed itself by means of circuits, resistors, gasoline, and chemicals. (B.J.)

Carl Andre and Hollis Frampton, *12 Dialogues 1962–1963*, ed. and with annotations by Benjamin H. D. Buchloh (Halifax: Press of the Nova Scotia School of Art and Design; New York: New York University Press, 1980), pp. 41–44.

The dialogue took place, in typewritten form, on November 11, 1962.

## A Note on Robert Huot's Diaries

Art is personal. It is personal in the making, and it is personal in the appreciation. Most personal, perhaps, of all is that continuing dialogue with other artists, living and dead, in which every mature artist finds himself engaged.

Seven or eight years ago, when I first began to know Robert Huot, his work was the most rigorously reductive of all that was being made in New York at that time. He took an acute personal interest in the question: How much may be discarded and a work of art still remain? He had carried this pursuit into theater and sculpture, and was soon to extend it into film; but the main thrust was always painterly. In one group of works, he discarded paint; and then, in another, discarded the painting itself as separable entity, making fugitive works of given spaces.

Logically, such an art risks refinement. It risks self-annihilation; or, more likely, becomes something that is by now intolerably familiar . . . an attenuated product, purged of all affection, that sustains interest only through incessant critical salivation.

But Robert Huot chose a harsher logic. He eliminated *himself* instead, withdrawing from the art milieu and all its concerns, removing to a farm in central New York State. With the adoption of an affirmative lifestyle, the art itself changed from exclusive to inclusive. Formerly, the impulse had been didactic—and that means dramatic, for the didactic situation implies *two* persons: one who teaches, and one who learns.

A new question supersedes the old: How much may be included and a work of art still remain? And Huot pursues the question more intensely, more personally, than ever before. The Diaries are lyrical: not always celebratory, but invariably *accepting* of life as experienced by his own very highly developed sensibility . . . and thereby genial, generous, *not* limited to the closed didactic interplay between the artist and his carefully imagined ideal spectator. As these Diaries, or rather, as Huot would prefer to have them called, this single continuing investigation, becomes more massive, it begins to move from the lyric to the epic. It includes so much of Robert Huot's history that it begins to include us all.

And that inclusion starts with the art of the past. The former exclusive work necessarily limited its concerns to what was most contemporaneous in painting; but the new work is open to intercourse with the personal necessities that artists have worked from over millennia, visible in the styles: Lascaux, Piero, Mondrian, Kline . . . and of course a younger Robert Huot . . . are among

the voices, the many voices, speaking these days. And all speak through a startlingly relaxed ingenuity and comprehension of the historic possibilities of painting, through the cunning (I use the word with affection) of Huot's master hand.

Now, however briefly, we are seeing these works publicly. In showing them, Huot affirms that art is a fundamentally sociable activity after all. As a friend of the man, and of his work, I am concerned that they be taken for what they are: gifts, freely given . . . and not as contenders in some sort of ghastly ongoing showdown. For these are bound to be "difficult" works. They are uncanonical; that is, they don't connect via a simple syllogism with any current "movement." (Presumably that means they are ahead of their time.)

But that is all a mirage, if Robert Huot's Diary paintings be but received as they were made: with love.

Hollis Frampton
Eaton, New York
January 1973

Text written to accompany an exhibition of Robert Huot's paintings at the Paula Cooper Gallery, New York, January 1973.

# Inconclusions for Patrick Clancy

Think always of the margins, of the cold walks, and the lines that lead nowhere.
—T. E. Hulme, 1917

Aesthetic modernism's characteristic strategies, during its entire growth, maturity, and decline, always encapsulated (and often managed to contain) latent contradictions that attracted energetic critical speculations within theory and practice alike.

But those speculations seldom prospered, seldom functioned as other than a "loyal opposition" within modernism, which had come into the world, as it were, fully armed and perfectly defended. The principal players of the first generation had, after all, learned much from the carnage of late Romanticism: Schoenberg from Mahler, Pound from Swinburne, Graham from Duncan, Brancusi from Rodin, and so on and on.

It was as difficult, at its onset, to say how modernism constituted itself as it is now to say the same of its struggling intellectual successor. Circumstantial paradoxes attend both cases: modernism, which eventually valorized the legible to an unprecedented degree, was judged to produce works whose supreme benchmark was illegibility; the postmodern inquiry in the arts, which finds the notion of legibility itself, in the most seminal sense, problematical, is as often hastily perceived as casually transparent, rather as language is understood in preliterate cultures.

If it remains a task of our culture to describe and anatomize entirely the extended moment of modernism, nonetheless it is clear that that task has become, by now, an academic one. If the largest poetic catastrophes of the period seem notably vulnerable to the explanations of premature consolidation during the times of social upheaval that enclosed the First World War, it is also true that those same events—social, economic, and political—are deeply implicated in the formation of some of intellectual modernism's triumphs. Of these there were very many, and some of them may fairly be placed among the finest achievements of the West.

I mean to include, in this assertion, the sciences along with the arts; and in this one, too: what was crucially at issue (and it still is) was an extreme crisis in representation.

It is possible to construct a compact "symptomatology" for modernism of any practical persuasion:

1. It is always possible to distinguish the work of art from the cultural ground upon which it is figured forth. We may be uncertain of our affection for it, but we distinguish it without difficulty, isolated as a scientific experiment from its control group.

2. The work thrives among the uncertainties of an ambiguity which it at once invokes and flees. That hallmark of modernism, ambiguity, is an artifact of determined misreading. What we find is not polyvalent perversity but a carefully restricted, mutually resonant subset of possible local meanings, strictly subordinated to global architectonics. Except in the most distinguished cases, the latter are not to be discussed.

3. The work, or body of work, challenges the authority of its embedding matrix without disturbing its established categories. For modernism, discernible activities (painting, biology, sculpture, physics, poetry, chemistry) are to be affirmed as the vestiges (one might say the sacred relics) of the notion of the possessible.

4. Typically, the modernist work in art is apodictically coercive of its pretext, whether it be the model in the studio or the topologist's cryptic page or its own ancestry, annexing wholesale, fragmenting, refictionalizing, in gestures oddly reminiscent of the abrupt rites of ownership.

5. The work is acutely assertive of its boundaries: in music, thematic enunciation and cadence; in painting, the edge and the center. What we might call the middle, which gave Aristotle the most trouble, is likely to be taken as a terrain upon which there is no difference between poetic license and a hunting license.

[ ]

There were always heresiarchs within modernism itself: I am thinking of the socially and psychologically utopian Joyce of *Finnegans Wake*; Marcel Duchamp, who abandoned painterly modernism as an infantile disorder; John Cage, who began with a severe testing of Western music's most intransigent parameter, timbre, and a systematic corruption of high capitalism's indispensable instruments, the piano and the orchestra; William Carlos Williams, who sustained for a lifetime an investigation into the unconsecrated poetics of language at large, of whom Gertrude Stein said, with perfect accuracy, that literature was not his métier.

If it was their work (and that of others) to challenge the categories of art, that part of the work is done. One sees growing, in contemporary artistic practice, an indifference to, and then a positive revulsion from, those categories: if their integrity is at stake, then the notion of art itself must be, to speak gently,

wholly compromised. At a time when the received visual arts of painting and sculpture are supine, the energies invested in them at ebb tide, that compound practice within the arts that identifies itself to our attention by its piercing concern for the integrity of all intellectual discourse (together with the perilous random seas that surround it) gathers itself around a constellation of proscribed activities: photography, film, video; unallied performance; something called "writing," cursive and vernacular; something else called "sound," which comes from the unidentified muse of psychoacoustics.

It is part of the work of theoretical criticism to generate lineages, affinities, realignments among the genetics of the mind. The outcome of this work is an apologia for the past, not the present: for we must regenerate the tender surface of a Catullus, Monteverdi, Turner, in each generation, if we are to recover the hope, and comprehend the hopelessness, of our own predicament— that we are, at once and always, the children and parents of imperfection. And for once, in the present, we may begin to see the founding of an entity that may aspire to supersede and confound the commoditized notion of "tradition" itself.

It has been called "postmodernism." For all the clumsiness of the hybrid term, one takes a small pleasure in the thought that it might cling for a while, become not too soon dignified with its own special cant. A generation of artists is giving its life to a modest, nameless enterprise that requires relentless dedication to the problematical, to the "middle," to the unimpeachable claims of pretextual integrity, to the perpetual and massive disarray of embattlement on every hand. If I have sketched an ancestry, I must point now to the special heritage it imparted: impossibly, in the midst of a double effort (repair modernism's defects, reassume the burden of its emblem), one is required to be efficacious and to sustain that thing, dogmatically abjured by visual modernism during its last days, that goes by the ancient name of *wit*.

This new sort of experience that we begin to have of works of art has come forward during two decades in a genuinely paradoxical arena that confronts acute practicality (how is work to be made at all that cannot command the bourgeois support accorded to the standard categories of art?) and an intellectual optimism and utopianism rendered daily more unlikely in the teeth of imminent social and economic collapse (how may we define an artistic theory and practice that shall at once serve and enforce the growth of a society, an intellectual and artistic climate, in which we imagine we should prefer to live?) that, properly entertained, takes on the dimensions of a serious dialogue.

[ ]

It is at the very center of that dialogue, or something more like it than I can describe, that the entire career and work of Patrick Clancy has transpired and

developed. What we witness as we experience his work is an evidence of the extreme effort required of maker and spectator alike at the pivotal point in space and time when a new tradition (one uses the phrase without hesitation) is sensed and known to be "under construction"; and, best of all, the extreme satisfaction consequent upon that effort in its most coherent moments.

This brief writing wants only to situate that effort, that satisfaction, this artist, these works. I have always felt a special privilege, as of being superbly and gropingly taught a grand new theorem, at a manifestation of Patrick Clancy's work: and only a part (but an important part) of that privilege has come from the certainty that I would never again have it present to my senses. The pleasures of Clancy's work are the pleasures of the mind, given that the mind finds its greatest pleasures when confronted by problems quite beyond its powers, whose solutions are instantaneously paramount to its survival.

Since Patrick Clancy and I are friends, it stands to reason that we read some of the same books. I don't know, though, whether he has found his way (few footprints lead out of the cave!) into Ralph Waldo Emerson, that stepgrandchild of the Enlightenment, who is responsible for an asyntactic text called "Brahma." A memorable line, in the midst of a memorably impossible figure, reads: "When me they fly, I am the wings."

It is from the midst of that figure that I would ask his spectators (myself, Emerson, yourselves even) to examine Patrick Clancy's radical, fugitive, courageous, delicious work. We shall not find ourselves disappointed.

Hollis Frampton
Eaton, New York
February 1980

Text of brochure for the exhibition *Marginal Works: Atopia—No Man's Land*, March 27—April 11, 1980, Utica College of Syracuse University, Utica, New York, curated by Scott MacDonald.

## Comic Relief

"COMIC RELIEF"

= THE WORD

*COMIC*, CARVED IN

LOW RELIEF

Unpublished handwritten text, undated (mid-1970s).

    This "script" for an unrealized sculptural piece, like that for *Two Left Feet*, recalls the visual wordplay of Frampton's 1961 *A Cast of Thousands*, the genesis of which was recounted in a section of the film *(nostalgia)*. (B.J.)

---

## Two Left Feet

"TWO LEFT FEET"

Imprint of left foot (like fingerprint)
+ (alongside) imprint of right foot *optically* reversed

or: plastercasts of 2 left (i.e., "discarded"
or "remaining") feet

6/11/76, Eaton

Unpublished typewritten text, June 11, 1976.

# Letter to Macalester College

December 31, 1980

Cherie Doyle
Curator
Department of Art
Macalester College
St. Paul, MN 55105

Dear Ms. Doyle,

I'm sending you the color Xerox series *By Any Other Name* today by Priority Mail. My form is enclosed, and I've written a characteristically opaque note on the back of it, which you may use or not as you see fit.

The images themselves, as you will see, take up a bit of space. Do not feel, if they seem boring or tenuous, under any special obligation to use all of them, or indeed any of them. I am aware that the group (there's a part two on the burner, by the way) rides roughshod over the notions of both subtlety and coherence: a mild triumph, in my book, but others may not find themselves tickled in the same spots I do.

In any case, I hope well for your show. It is about time that filmmakers be allowed outside the gilded ghetto of cinema: after all, the painting and sculpture gangs invade our turf without so much as a by your leave, and almost invariably there is hysterical applause for that. It reminds me of the Spanish "discovery" of gold in South America. The Incas had already dug it out of the ground.

Regards,
Hollis Frampton

Unpublished typewritten letter, December 31, 1980.

Frampton's series of electrostatic color prints (Xeroxes) were shown in a group exhibition, *Animated Images/Still Life*, January 8–30, 1981, Macalester Galleries, Macalester College, Saint Paul, Minnesota. (B.J.)

## Notes: *By Any Other Name*

Language and image, each trespassing in the other's house, secrete disquieting disjunctions, conundrums, circularities. We are accustomed to the poetic strategy, within language, of bracketing a noun within the genus of yet another noun which may come from an alien phylum, a foreign kingdom. Translation of that strategy into the economy of images yields artifacts—savagely grotesque, arch, silly—that seem to flee the rigors of self-reference; contradictory images, far from coalescing in a dialectical encounter, annihilate one another in a gesture that sweeps language clean of specification and seems on the point of suggesting a raw map of the preconscious work—the material *action*—of language. It is as though the formation of the meaningful had some ultimate chemical origin: "parts of speech" combine into propositional molecules through electrovalent attraction, or, where that attraction is lacking, remain in solution as free radicals.

If art has had a scientific mission, we find it in the exposure of such mechanisms, in a nonlinear display of the *occasions* of meaning. For meaning is not, for image or word, in things; it is in people. But there are other grounds on which to hunt those occasions besides the precincts of art. One such artless place is the supermarket: an ocean of modularized substance where everything in sight is meant only to be consumed, destroyed, wasted, returned as quickly as possible to the domains of amorphy or thermodynamic affinity. Where everything goes down the drain, anything goes. A certain appetite of mind can, then, find more nourishment in the label on the can than in its contents: a poetic, if wayward, feast.

That appetite began in photography and grew with film. It has not found its limit. Rather it seeks it, in a *metapraxis* of observation, analysis, production.

HF
Eaton, December 31, 1980

Typewritten text for the exhibition of the xerographic series *By Any Other Name: Series One* (1979).
     In Frampton's series, color Xeroxes were made of food-product labels that displayed the following general grammatical structure: adjective + noun [brand] noun + noun [contents] (for example, Blue Boy Chili Beans); the titles for each piece then reversed this structure (*Chili Bean Brand Blue Boys*). (B.J.)

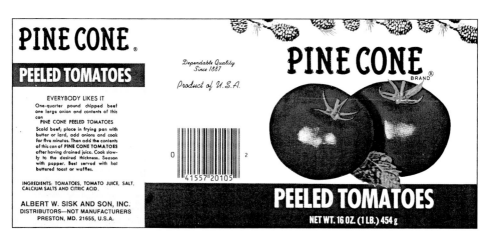

*Chili Bean Brand Blue Boys* from *By Any
Other Name*—Series 1, 1979. Color xerograph
© Estate of Hollis Frampton

*Peeled Tomato Brand Pine Cones* from *By Any
Other Name*—Series 1, 1979. Color xerograph
© Estate of Hollis Frampton

Texts

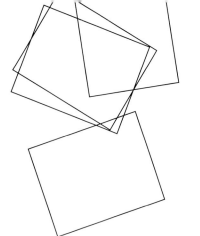

# A Stipulation of Terms from Maternal Hopi

Nearly a year has elapsed since the discovery, at Oaxaca and Tehuantepec, of three caches of proto-American artifacts of a wholly unprevisioned nature; so that some sort of provisional report on them is long overdue. I must apologize at the outset for what must seem, to colleagues unacquainted with the unprecedented difficulties posed by the material, an excess of scholarly caution. In fact, I have proceeded with all possible haste in dealing with a body of data that has proved, to date, resistant to study by canonical methods.

I am bound to acknowledge that whatever little understanding I have achieved has come largely through the perseverance and generosity of Dr. Raj Chatterjee, who heads the Project in Artificial Intelligence at Alleghany University; I owe him an insight that he first expressed with characteristic terseness: "We are obliged to assume that this stuff means *something!*"

My readers will recall that the archaeological finds in question were at once uncomplicated and singularly copious. All three sites included large silver mirrors, figured to remarkable flatness, and scores of transparent bottles, lenticular in shape and of varying curvature. But the bulk of the contents of those granite vaults (immediately dubbed "archives" by the sensational press) consisted of some 75,000 identical copper solar emblems, in the form of reels, each of which was wound with about 300 meters of a transparent substance, uniformly 32 millimeters wide, that proved, upon microscopic examination, to be made of dried and flattened dog intestine.

These strips are divided along their entire length into square cellular modules each 32 millimeters high. Each such square bears a hand-painted pictogram or glyph. The colors black (lampblack in a vehicle derived from the leaves of *Aloe vera*) and red (expressed from cochineal insects) predominate. There is seldom any obvious resemblance between consecutive pictograms. The draftsmanship is everywhere meticulous.

The dry climate has kept everything in a state of exquisite preservation; it is expected that lamination in polyester, nowadays a standard curatorial procedure, will offset a slight tendency to brittleness in the picture rolls. Oxygen dating places their fabrication during the eighth and ninth centuries of the present era, with a margin of error of only four per cent.

Complete cataloguing and analysis of this treasure will require many years; therefore, what follows is of necessity conjectural.

Of the culture of the artificers very little is apparent. They were men of the Cro-Magnon type of *Homo sapiens*, organized in a stable agrarian matriarchy

and calling themselves ]N[. Their food consisted of cultivars of maize and a variety of vegetables and fruits; dogs of medium size were bred as a source of edible protein and textile fiber, but were not used for work. The ]N[ worked stone and the native metals (copper, silver, and gold) and were particularly adept in the technology of glass. A partly subterranean dome about ten meters in diameter, similar to the *hogan* of the Navajo, was the uniform shelter.

What took place within these domes distinguishes the civilization of the ]N[ from all other known societies. They seem to have spent most of their time and energy in making and using the pictogram rolls, which were *optically projected* upon the walls. Sunlight, led indoors by an intricate system of mirrors, served as the illuminant. Images were brought to focus by lenses of water contained in glass bottles. At what rate the projected images succeeded one another is unknown.

What function this activity may have had is matter for speculation. The pictograms offer internal evidence that the projections served both educational and religious ends. Images of deities (if that is indeed what they are) occur with some frequency: they are depicted as human in scale, differing from the ]N[ themselves only in that their faces are without mouths, and their eyes, always open, are extremely large.

The pictograms clearly constitute a language. The semantic unit, however, is not the single glyph but a cluster of two or more pictures that denotes the *limit* of a significance; where there are three or more, the images serve as points defining a *curve* of meaning.

The connection between this visible language and speech is remote, and recalls the tenuous relationship between the ideograms of literary Chinese and their corresponding vernacular. Nevertheless, it has been my good fortune to decipher a few fragments, in privileged communication with a living female respondent in Hopi, and to establish clearly that the language of the ancient reels is ancestral to the secret languages, ritually forbidden to men and initiated male adolescents, that are to this very day spoken, *only by women among themselves*, throughout the remnant of the Mixto-Athapascan psycholinguistic community.

The parent tongue exhibits a number of unique traits. To begin with, it was a *speech-and-stance* language, with each component modifying the other. Since the picture rolls identify meaningful postures numbering in the thousands, it is doubtful that a one-to-one dictionary between English and ]N[ can ever be constructed.

Secondly, the language was made up entirely of *verbs*, all other "parts of speech" deriving from verbal states. A "noun" is seen merely as an instantaneous cross-section through an action or process.

The inflectional structure of the language was vast, exceeding in size that of Sanskrit by at least an order of magnitude, to which was added an array of proclitic and enclitic particles, of uncertain usage, seemingly derived by onomatopoeia from the sounds of the breath, as inspired and expired during different sorts of effort.

The verb stem consisted of one or more invariable consonants, or clusters of consonants. The grammar varied, according to intricate rules of euphony as well as meaning, the vowels and diphthongs in the initial, medial, and final positions that I have indicated with square brackets in the glossary that follows.

I append the few terms that I have thus far managed to decode. The reader is warned that multiple ambiguities of the sort found under ]K[ ]SK[, ]V[ ]TR[, ]Y[ ]X[, ]N[ ]T[, and ]L[ ]L[ ]X[ are the rule. Apparent exceptions are simply illustrative of defects in my own comprehension.

1. [ ] = The radiance.

2. ]D[ ]Y[ = Containers to be opened in total darkness.

3. ]PS[ ]L[ = A drug used by women to dilate the iris of the eye.

4. ]H[ ]H[ ]L[ = Epithet of the star ]S[ ]S[ ]N[,* used while succulents are in bloom.

5. ]PT[ ]Y[ = Last light seen by one dying in the fifth duodecad of life.

6. ]XN[ = Heliotrope.

7. ]TL[ ]D[ = Rotating phosphenes of six or eight arms.

8. ]BN[ ]T[ = Shadow cast by light of lesser density upon light of greater.

9. ]V[ ]TR[ = The pineal body; time.

10. ]XR[ = The sensation of sadness at having slept through a shower of meteors.

11. ]MR[ ][ = The luster of resin from the shrub ]R[ ]R[, which fascinates male babies.

12. ]NX[ ]KT[ = The light that congeals about vaguely imagined objects.

13. ]DR[ ]KL[ = Phosphorescence of one's father, exposed after death.

14. ]SM[ ]N[ = Fireworks in celebration of a firstborn daughter.

15. ]GN[ ]T[ ]N[ = Translucence of human flesh.

16. ]TM[ ]X[ ]T[ = Delight at sensing that one is about to awaken.

17. ]TS[ ]H[ = Shadow cast by the comet ]XT[ upon the surface of the sun.

18. ]R[ ]D[ = An afterimage.**

19. ]D[ ]DR[ = A white supernova reported by alien travelers.

20. ]K[ ]SK[ = A cloud; *mons Veneris*.

21. ][ ]Z[ ]S[ = Ceremonial lenses, made of ice brought down from the high mountains.

22. ]KD[ ]X[ = Winter moonlight, refracted by a glass vessel filled with the beverage ]NK[ ]T[.

23. ]P[ ]M[ ]R[ = Changes in daylight initiated by the arrival of a beloved person unrelated to one.

24. ]G[ ]S[ = Gridded lightning seen by those born blind.

25. ]W[ ]N[ ]T[ = An otherwise unexplained fire in a dwelling inhabited only by women.

26. ]G[ ]GN[ = The sensation of desiring to see the color of one's own urine.

27. ]M[ ]K[ = Snowblindness.

28. ]H[ ]R[ = Unexpected delight at seeing something formerly displeasing.

29. ]H[ ]ST[ = The arc of a rainbow defective in a single hue.

30. ]L[ ]L[ ]X[ = The fovea of the retina; amnesia.

31. ][ ]R[ = The sensation of satisfaction at having outstared a baby.

32. ]ST[ = Improvised couplets honoring St. Elmo's Fire.

33. ]V[ ]D[ = The sensation of indifference to transparency.

34. ]Z[ ]TS[ = Either of the colors brought to mind by the fragrance of plucked ]TR[ ferns.

35. ]X[ ]H[ = Royal expedition in search of a display of Aurora Borealis.

36. ]T[ ]K[ ]N[ = Changes in daylight that frighten dogs.

37. ]Y[ ]X[ = The optic chiasmus (*colloq.*); abysmal; testicles.

38. ]N[ ][ ]T[ = The twenty-four heartbeats before the first heartbeat of sunrise.

39. ]F[ ]X[ = A memory of the color violet, reported by those blinded in early infancy.

40. ]T[ ]Y[ ]Y[ = The sensation of being scrutinized by a reptile.

41. ]B[ ]NM[ = Mute.***

42. ]N[ ]T[ ]N[ = The sound of air in a cave; a reverie lasting less than a lunar month; long dark hair.

43. ]S[ ]TY[ = The light that moves against the wind.

44. ]B[ ][ = Changes in one's shadow, after one's lover has departed in anger.

45. ]N[ ]GR[ = The fish *Anableps*, which sees in two worlds.

46. ]RZ[ ]R[ = The sensation of longing for an eclipse of the moon.

47. ]H[ ]F[ = The fungus *Stropharia cubensis*.

48. ]S[ ]LR[ = Familiar objects within the aqueous humor.

49. ]W[ ]X[ ][ = A copper mirror that reflects only one's own face.

50. ]MN[ ]X[ = Temporary visions consequent upon trephining.

51. ]G[ ]KR[ = Cataract.

52. ]RN[ ]W[ = Hypnagogues incorporating unfamiliar birds.

53. ]M[ ]D[ = A dream of seeing through one eye only.

   * Probably Fomalhaut (*Alpha Piscis Australis*).
  ** Also used as a classifier of seeds.
*** Standing epithet of ancestral deities.

This text is for Stan and Jane Brakhage.

Eaton, New York, 1973/1975

*Options and Alternatives: Some Directions in Recent Art*, exhibition catalogue (New Haven, Conn.: Yale University Art Gallery, 1973). Reprinted in *Afterimage* (London), no. 8–9 (Spring 1981): 64–69; and in *Circles of Confusion* (Rochester, N.Y.: Visual Studies Workshop Press, 1983), pp. 171–176.

# Mind over Matter

*(...pour les six inconnus...)*

## 1. That Sometime Did Me Seek

PICTURE A SHAPE within a mass of living rock, as of one seated, facing forward, eyes peering, hands extended and cramped as if to grasp at two points (a third of its circumference apart) an imaginary wheel.

DO NOT FORGET the generous equation that rules certain lines of finite ambition:

$$X \uparrow N + A \downarrow \$1{*}X \uparrow (N{-}1) + A \downarrow \$2{*}X \uparrow (N{-}2) + \ldots + A \downarrow \$(N{-}1){*}X \uparrow \$PRI + A \downarrow \$N{*}X = F,$$

where F amounts to nothing. We shall calculate the first order only, and plot for small positive values of X.

HE BEGINS WITH A FEAR of tunnels. By degrees he revises this conviction, augments it, castigates it, until he is afraid to enter tunnels. As he matures, and the eventuation of every worst case seems progressively more and more likely, he achieves a further refinement: he is afraid to pass through tunnels. Finally, he finds elegant a regimen wholly organized around a need to avoid tunnels. Accordingly, in old age, he devotes himself to seeking out tunnels, but only in order to put them behind him as swiftly as possible, accelerating precipitously as he goes into the dark.

AT LAST, UNWITTINGLY, on a bright April afternoon in Clear Creek Canyon, he passes through a final tunnel. Moments later, entering yet another at terminal velocity, he sees a darkness unrelieved by any radiant vanishing point. Supposing this particular tunnel to be endless, or else that it must end abruptly on an invisible, flat, blind, solid face, he utters within his mind, for the first time, an unspecified desire to be, yes, absolutely elsewhere. Thus discharged in one indivisible instant, the accumulated force of six decades of evasion cascades, avalanches, cataracts, *simultaneously* destroys his body, and replicates it, at a more than sufficient lateral displacement.

PRODIGIOUSLY, EVERY VIBRATION that has cooperated in his physical person interlaces perfectly within a seam of basalt inside the buttress of an arrogant

young mountain. From this moment he perceives nothing . . . not even that he does not perceive. Alive, for a time, as he has ever been, he dies from a defect of the imagination in the end.

> [*Given certain foregoing rigors, it is asserted that they share among themselves, and with none other, a peculiar property, namely that each, unaided, may tessellate a plane of infinite extent, requiring for this task nothing more memorable than vigorous and perfect replication, indefinitely sustained. That every plane of the world is not, by now, fully populated by one or another suggests a failure of desire, or a dilapidation of opportunity, or that something eats them; or else, a nearly complete fracture, loss, dereliction of habitable (that is, conceivable) planes, such that most of them expired from loneliness before the sun coalesced. Mercilessly wanting any gift for[106] boredom,[107] they[108] may[109] simply[110] have[111] . . .]*

## 2. Stalking on Naked Foot

SUPPOSE A SHAPELESS gown of some soft, sheer fabric that covers a torso softer still. Suppose a further confusion: that the stuff half hides, along a smooth curve extending from the iliac crest to the spinal insertion of the lowermost rib, a stripe of coarse fur, alternately banded orange and black.

DO NOT FORGET the brief proud equation:

$$V = e^3,$$

which we shall solve for a pair of small positive values of e, each slightly larger than the other, plotting isometrically.

SHE THOUGHT SHE had finished her education in England. She came home to the plantation above Trincomalee. After the party she went for a tipsy stroll in the moonlight. In the warm evening, she removed her clothing, silently tossing away each garment along the garden path. The tiger, after due contemplation, devoured her, carefully, to the last scrap and the last drop. There was no pain at all, then. After a flushed, vertiginous period, she found herself reconstituted, entire, within the tiger's magnificent body, point upon point . . . except for a few points that caused her no particular embarrassment but occasioned, in her host, a certain brute puzzlement. She experienced superb pleasures, exquisite pleasures, glorious pleasures.

SHE WAYLAID A SIX year old boy by the village well and ate most of him, and then lapped up the unspilt water in his pail for good measure. She followed the musk of a tigress in heat, and mated with her two dozen times in one afternoon, savagely tasting the dry hair at her nape. She attacked a hunting rajah, clawing her way up the elephant's side toward his palanquin till a smart British captain opened her left flank with a rifle shot. Her host hid, moaned, licked, panted while she tried to retch from the agony of it. The wound healed to a pink, wide, voluptuous scar. She was captured.

IN HER CAGE in Regent's Park, she paced for long years the pattern of an hourglass; let out, during high summer, into a moated lawn, she patrolled a space no larger, inscribing her twisted sign of endlessness on the grass. She slept a great deal, and lived on horseflesh, tepid water, and a gruel that encouraged worms. One night, in a delusion, the tiger, bored and senescent, disintricated itself and crawled away. In the morning, their keeper found a dead tiger, its gaze rigidly averted, beside a sleeping woman curled in the damp immensity of her own mane. She was pale, and quite naked. There were uncertainties, to be sure, surrounding these three creatures. For one of them, all amazement had come to an end; and for another, astonishment had only begun.

> [. . . drifted into terminal exasperation when living matter first demonstrated its notorious tendency to imitate whatever it is not. Once in a while, the moist perennial breath of consciousness rehydrates a few shriveled specimens. (Some have argued that it is always the same one; but two or more of each have occasionally been seen sharing common boundaries, and even mentality cannot remain beside itself for long.) I, myself . . . by design, and at a perfectly appropriate age . . . resuscitated a good number of figures of the third kind, inscribed within circles. Now I am seven times as old, and the delight of that moment persists, undiminished: I sustain it by constructing[217] another,[218] from[219] time[220] to[221] time.[222]]

## 3. Within My Chamber

ASSUME AN INTERSECTION (hot wires raging behind cheap optics) of roughly collimated beams, refracted or rereflected by lacquered steel and specular nickel, diffracted in a fine rain, crossing and recrossing upon a corpse, supine on the drenched pavement, bloodless, hardly disarrayed. Two yards away, a driver still gapes through the accidental star in his windshield at a steaming knot of metal that was recently an automobile. A pair of bewildered ambulance attendants, along with twice as many sweating policemen, have tried, for nearly an hour . . . with no success at all . . . to lift the inert body to a stretcher.

DO NOT FORGET the inventory of powerful and delicate methods for performing a variety of operations upon such matrices as:

$$
A = \begin{vmatrix} N & N & N & N \\ N & N & N & N \\ N & N & N & N \\ N & N & N & N \\ N & N & N & N \\ N & N & N & N \end{vmatrix} \text{ and, } B = \begin{vmatrix} \alpha & \beta & \gamma & \delta \\ \varepsilon & \zeta & \eta & \theta \\ \iota & \kappa & \lambda & \mu \\ \upsilon & \xi & o & \pi \\ \rho & \sigma & \tau & \upsilon \\ \phi & \chi & \psi & \omega \end{vmatrix},
$$

where $N = 0$, and $\alpha, \beta, \gamma \ldots \omega > 0$, from which we shall select only two of the simplest, satisfying ourselves in the calculation of $(A + B)$ and $(A * B)$; we must hesitate (until a less sociable moment comes) to dwell on the graphic consequences of this act.

PRONOUNCED DEAD on arrival. Male, Caucasian or Eurasian, between thirty-five and fifty years of age. Clothing new, evidently worn less than a single day. The deceased affected no ornamentation, and carried no papers, money, or any other personal items whatever. Police report indicates nothing found within a radius of 100 yards. Length 1 meter 65 centimeters. Absolute mass, stripped, 720 kilograms exactly: about thirty-one times predicted value for physique. Very mild contusion of left thorax with partial fracture of three lowermost ribs, associated with collision impact. No identifying marks or scars of any sort, internal or external, either surgical or traumatic in origin. A rare instance of featureless skin, totally hairless (excepting the head, axillae, and pubis) and congenitally lacking friction ridges on hands and feet: this man left no fingerprints. Slight degenerative calcification in the minor bones of both ankles, but metatarsal arches surprisingly undeformed. All chemistries within normal limits, without sign of alcoholic or other toxemia. Gastrointestinal tract empty. The only perfect set of teeth I have ever seen during several decades as a practitioner in forensic medicine.

AN UNUSUAL CIRCUMSTANCE precludes customary documentation in this case: photographic staff has mislaid or misfiled gross external records, and reports inability to retrieve them after the most diligent search. I would note a subjective impression: this person was so remarkably nondescript that I have had trouble remembering the face even while examining it. And I can recollect thousands.

THE LIST COMPRISES SOME 5,040 items, and it is complete. Of these, one is jejune, and three more are also explicable. If my hypothesis is correct, acquisition dates may be approximated through microscopic assay of the fibrous connective tissue that progressively encysted each object. (In any case, the histological evidence is now obliterated.) By this reckoning, the oldest is a pair of souvenir cufflinks (paste set in brass) found, badly corroded, in the pleural space just beneath the Position of Carina. Thereafter, following a hiatus of years, the collection acquires immediate distinction. Each single thing is exquisite, beyond price, and crafted throughout in platinum, gold, palladium, iridium, or the most durable of precious stones. The largest is a *ting* of the early Chou, weighing 4,096 grams, long missing from the Östasiatiska Samlingarna in Stockholm, which enclosed the pericardium; the smallest, a Thracian tableau of the Graces carved in high relief from a single emerald the size of a bean, was lodged in the right sphenoid sinus. A ruby-encrusted Renaissance lady's dagger, lost from the Vatican, lay horizontally on the left side in the ninth intercostal space, while a Cellini bishop guarded the prostate. But not all are outright works of art. The frames of Jeremy Bentham's spectacles straddled a renal vein; and I found the tiny porcelain dish (soon to be returned to the Panthéon in Paris) into which the Curies distilled the first trace of radium nestled behind a tonsil. The reader is invited to consult the exhibits for further details. If this investigation has occasioned a most unusual collaboration between theoretical pathologists and art historians, I am nonetheless obliged to state that no one has offered a reasonable explanation for the physical presence of such a vast inventory at its implanted sites. The nameless deceased was, in a word, a walking museum.

WORTHLESS DIAGNOSTICS REMAIN to be accounted for. Rings of glass fragments embedded in either iris (radiographs are appended) have recently been recognized by S. Gobind, an assistant in this laboratory, from police photographs made at the scene, as reproductions *in miniature* of the shattered headlights of the vehicle involved; an aluminum ignition key, which the operator had been unable to produce, was discovered within the medulla oblongata, in a position indicating severe respiratory disruption at the highest level. Therefore, cause of death was certified to be ingestion, by unknown means, of a foreign substance. A determination of suicide was urged and returned. Legal counsel then brought an unprecedented motion: that the hospital be awarded salvage rights in the remains. Consequently, there is to be a spectacular series of auctions. Only today, armed guards conveyed those artifacts found within the cranium from the morgue to the gallery in a strongbox. Since it was very heavy, they took turns carrying it.

*[. . . Of the three kinds, the first (or least) displays the most numerous qualities; but all of these are trivial, possibly excepting one cunning resemblance or recollection. Several of them taken together, such that each lies adjacent to two others, with each contributing one vertex to a common indivisibility, make one of the third kind. Moreover, some of the first kind, arranged so that each is adjacent to three others, describe a volume, the number of whose faces is the same as the number of edges (or corners) belonging to a figure of the second kind; and two such volumes, placed precisely face to face, describe yet[328] another,[329] the[330] number[331] of[332] whose[333] . . .]*

## 4. Her Arms Long and Small

PROJECT, IMAGE FREE, in something more opaque than darkness, a human voice, a persuasive, modulated female alto speaking, to the inner ear alone, from some epicenter in the network of impenetrable determinacies out of eyeshot, breathing those very intimacies always left unsaid in the breathless moments of intimacy, patiently, with the prodigious craft of one who must do all with a single instrument, but most arousing in its annihilation of that same absence its presence wantonly invokes, announced by the ringing of a bell, nocturnally, for a year.

DO NOT FORGET that a determinant of order $n$ is a number D formed of $n^2$ numbers $a_{ij}$ (elements) set into a square table composed of $n$ rows and $n$ columns as follows:

$$D = \begin{vmatrix} a_{11} & a_{12} & a_{13} & \ldots & a_{1_n} \\ a_{21} & a_{22} & a_{23} & \ldots & a_{2_n} \\ a_{31} & a_{32} & a_{33} & \ldots & a_{3_n} \\ \ldots & \ldots & \ldots & \ldots \\ a_{n1} & a_{n2} & a_{n3} & \ldots & a_{nn} \end{vmatrix} = \sum (-1)^k \times a_{1_\alpha} a_{2_\beta} \ldots a_{n\upsilon},$$

where the sum is extended over all possible $n!$ permutations $\alpha, \beta, \ldots, \upsilon^{(2)}$ of the numbers $1, 2, \ldots, n$; the sign "+" or "−" before each summand is the same as that of $(-1)^k$, where $k$ is the number of inversions in the corresponding permutation. Setting calculation aside, we dare to expect (without knowing exactly why!) that this definition, or perhaps another growing from it, can comfort us in our present misery and grief; or, better yet, that we may get from it some warmth during such a calamity as we can only foresee.

HE LIVED INCONSPICUOUSLY then, his resources allowing him to do whatever he pleased, but very little else. The tireless daylight sustained his obscurity: after sixteen years, the author of *Reflections on Goldbach's Theorem* and *Concerning Inelegant Proofs*, still in retreat from the sorrow he had brought to his beloved science, recoiled again as he planned its reconstruction. Every afternoon he sat at a kitchen table he had hauled into the shade of a primitive lime tree and added a paragraph or so to *Principles of Simultaneity*, working with methodical discipline toward that moment when there should be nothing left for him to do. When the limes ripened, he revised his manuscript, annually mixing astringent juice with quinine and gin. Among themselves, his neighbors called him *el Chicharon*, and imagined that he dined on armadillo; alone in his workroom, he called his small digital computer *el Salvador*. On shelves alongside it, popular accounts of natural catastrophes inundated the accustomed Mallarmé and Babbage. Sleep beguiled him with dreams of diving in clear water. One night, fathoms down, his cool wet telephone rang and rang. On the anniversary of that moment, when it did not, he waited, grimaced, waited, and then uncorked the unmistakable champagne. Finally, in a spasm of irony, he uncradled the handset . . . and heard, for the first time, a question and a cry.

A CONTINENT AWAY, the superintendent accepted the bribe with a smirk. A dozen businesses had gone bankrupt here. The telephone depended from a cable as long as the room: she paced while she talked. The receiver dangled from its helical cord; listening, he heard his own dog bark, at home. Sandals, a thin cornflower jumpsuit, and a single light undergarment . . . clothing appropriate to this vile weather . . . were tossed on a chair; cigarettes and a lone key lay on the desk. In a canvas bag he found a pear, a scrap of quadrille-ruled paper bearing, on opposite sides in a large hand, the words "GET LOVELACE" and his own telephone number, another key, a copy (in blackletter) of David Hilbert's address to the Vienna Congress in 1900, overpowered by massive scholia in red ink, two pencils, and a sheaf of notes and equations. It was as she had said.

SPECIALIZING IN TIME, he had treated space as a contingent subset. She knew better; for better or worse, she had tested her knowledge. Now her thought and its sensations, conducted almost at the speed of light, shared with uncountable messages a space reconstituted from second to second; her body, no more than a trace impurity in the immense copper web, sustained its life in switch closures and fluctuating voltages. The cause of their present desperation lay in a bedevilment of novice algebraists: an error in the sign of a single quantity. To

extricate her, they must reverse all other signs, repolarizing sacred physical constants.

HE CORRUPTED ANATOMISTS, cartographers, and electricians, mapping her locations from Klickitat to the Outer Banks, from the Santa Ynez to Truro. For those tired and angry intervals when all was lost between them but affection, he risked indictment as a criminal nuisance, prattling sweet nothings to exchanges in Moline, Illinois, or Coeur d'Alene, Idaho, or Silver Plume, Colorado. The procedure strained his grasp of topology, and warmed the cockles of his heart.

HER FEARLESS EXPERIMENT transformed her: a creature of probability had become a child of algorithm. Nevertheless, one fine evening, after long calculation, he got her number. A voice in the dark, impossibly near at last, answered: "Hello?"

> [. . . *faces is the same as the number of sides (or angles) belonging to a figure of the third kind. Nevertheless, it is not true that the surfaces of this last volume, unfolded upon a plane in any manner that pleases you, will compose a figure of the third kind, even though both are made up of the same number of figures of the first kind; for this may only be done in one certain way. Several figures of the second kind, so arranged that each lies adjacent to four others, describe a volume, the number of whose faces is the same as the number of edges[439] (or[440] vertices[441]) belonging[442] to[443] a[444]. . .]*

## 5. How Like You This?

THINK OF A FRAME house in Saskatchewan, demolished as by a meteor. Think that there is something liquid, unspeakable, red within its wreckage.

DO NOT FORGET the tractrix, remote cousin of the catenary, governed by the equation:

$$X = A*(AR\ COSH(A/Y)) \pm SQRT(A \uparrow 2 - Y \uparrow 2); \text{ or by:}$$
$$X = A*LN(A \pm SQRT(A \uparrow 2 - Y \uparrow 2))/Y \pm SQRT(A \uparrow 2 - Y \uparrow 2),$$

which we shall calculate and plot only for positive values of X and Y, keeping a prudent distance as Y, decreasing in magnitude, nears zero.

WE WILL FIND him newly extrapolated through a momentary discontinuity in a sheet of aluminum of compound curvature. We will understand the metal to be the skin of an aircraft that will fly onward, bearing a cargo of strangers unseen through the glacial sky.

WE WILL DISCOVER the formal cause of his predicament in mutual desire uncomprehended. He will fall, a shriek erased from his mouth faster than he can propagate it by a gale outblowing its own whistle. Air more solid than ice will glaze his senses, will strip and freeze and flay him, will grind away his features, will erode him to a rough, tattered prism of clenched meat, will preserve him against a certain convergence.

WE WILL LEAVE him, interrupted in his insensible plunge, an infinitesimal distance from an asphalt-shingled roof. (He had been a young man whose orbit, vague or disintegrating, centered for an interval upon a young woman who, in most respects, might as well have been himself. He had become a courier, in something like the diplomatic service. On his incessant trajectories he came to presume, listlessly enough, that he might have lived differently. This midnight, bound for the West, he will recall, with distinct, gathering pressure, a woman, who, at that moment, lies asleep, six miles beneath him, lusting, in a dream, for satisfactions she is about to approach more closely than she will ever know, dismembering him in her remembrance.)

> [. . . *figure of the third kind. By raising the number two to a power of that same number of faces, and disposing just so many figures of the second kind in a grid whose ranks and files are of identical magnitudes, we shall compose a little terrain for playing games when we tire of reading. Furthermore, should we examine that volume, enclosed by figures of the second kind, from a vantage such that our line of sight traverses a pair of vertices as far removed from one another as the solid will allow, then the apparent boundary of that volume will amount to a single figure of*[550] *the*[551] *third*[552] *kind;*[553] *and*[554] *that*[555] . . .]

## 6. Newfangledness

RECONCILE THESE ANTAGONISMS: The oestrus of a dry season in Rangoon, and a dilation of old brandy in Vienna. Pungent chicken cooked with its own guts, and escargots with *vin gris*. Dried pyrethrum and rampant lilac. An inkblot on a knuckle, and a lapis cabochon. A repellent lotion, and a remnant of ambergris. The faint whisper of a kerosene lantern, and the subaudible drone of a carbon

filament. An insectile whine at twilight, and a streetcar rumbling at dawn. Susurrus of a racing pen, and a rustling of defended thighs. A forked, magenta tongue that hears, and a pierced, ivory ear that tastes. Diamond scales tiling a serpent's hood, and lozenges in a mullioned window. Its momentary posture, and a thesis of Hogarth's *Analysis of Beauty*. Its characteristic markings, and a keepsake lorgnette. A droplet of toxin, and a tear of distraction. Accidental stains in the margin of a page, and faint punctures near the ulnar nerve. Breath released in satisfaction at the anticipated expulsion of a precipitate, and breath indrawn in confusion at the unexpected miscarriage of a response. One who writes and one who reads.

DO NOT FORGET the canonical form of the equation:

$$((X \uparrow 2 / A \uparrow 2) - (Y \uparrow 2 / B \uparrow 2)) - 1 = 0,$$

whose sentiments, descriptive of the hyperbola, may also be stated in a more complex fashion where A, B, and T are real; thus:

$$X = (((E \uparrow T)^*((A + B^*\$IM)/2)) + (E \uparrow -T)^*((A - B^*\$IM)/2))) - Y^*\$IM; \text{ and:}$$
$$Y = ((((E \uparrow T)^*((A + B^*\$IM)/2)) + (E \uparrow -T)^*((A - B^*\$IM)/2))) - X)/\$IM.$$

We shall calculate for many values—exaggerated, typical, contemptible—in our accustomed effort to retrieve those boundaries within which we may hope to plot them upon an imaginable surface; neither shall we omit to feel a delicious agitation as we consider again those distant regions in the space of thought where asymptotes rejoin to embrace what once drew from Euclid a rare, wan smile.

THAT ONE WAS CELEBRATED, before gravure, for an interminable concatenation of falsehoods about ruined architecture, lethal geography, and ritual mutilation, but exotic or poisonous wildlife was privileged to decorate a prose hospitable to vivid circumstance. Sooner or later, she departed this life while passing through Customs. On the evening in question, confounded by citronella and enchanted by a description of its own choreography, the cobra, glands at the ready, dissolved into thin air: went transparent as a boiled onion, its venom formulated, and vanished on cue like a popping bubble.

THIS ONE IS SPARED her parent's defects and merits, except for a gullible synesthesia of the tactile. Unwilling to expend her remittance for the luxury of hysteria, she chooses laudanum . . . and finds it dull. Shortly before sunrise,

smarting from an ill-advised assignation, she takes to her library, and spitefully lapses into believing everything she reads. She is rescued by our bizarre (but unequivocal) diagnosis, confirmed, next winter, when the desiccated beast itself turns up behind a credenza. During her convalescence, despite chronic enervation and recurrent anoxia, she delivers herself of *Schlangendichtung*, a small visionary folio of drypoints and villanelles, and otherwise diverts her companions in the invention of encouraging new pastimes.

> [. . . *figure will seem to be made up of a triad of pairs of figures of the first kind, with each pair fused along its adjacency into a rhombus, which is nothing but a figure of the second kind gone weak in the knees from long standing. Figures of the third kind may never be persuaded to contain volumes. But when we take a number of them that is the same as the number of sides (or corners) of each, and arrange them so that each adjoins just two others, we find that we have enclosed yet another such figure: exactly, completely, congruently. It is my[661] favorite.[662] It[663] does[664] not[665] exist.[666]*]

## 7. I Wonder What She Hath Deserved

COMPARE THESE COLORS: a powdery azure, brushed with scorched fat, and a cyanotic custard, scummed with dichroic lemon. They are identical . . . but separated, at the alleged horizon, by a band of stale mist, within which, or beyond which, an escort of battle cruisers surrounds us on every side. The deck of our barge, big as a meadow, of the hue and texture of a baby, is punctuated by the prisoners' nondescript shelters. Somewhere beneath us, a thermonuclear device that may be armed and exploded by remote control is our only warden. Daily, at noon, our parcel of food descends by parachute; we rip and knot the tough cords and pastel silk into canopies, trapezes, parasols, and a burlesque of bridal finery. There has been no rain for thirty-six days. The stern rail is crusted with shit and vomit. Below the Plimsoll line, slowly, something pumps or throbs. We are becalmed.

DO NOT FORGET the corkscrew, which should always be used to open wine bottles, and from whose noblest import, as it were . . . suspended in the pure void, I might add . . . they derive the system of equations:

$$X = A*COS(S/SQRT(A \uparrow 2 + B \uparrow 2)); \text{ and:}$$
$$Y = A*SIN(S/SQRT(A \uparrow 2 + B \uparrow 2)); \text{ and:}$$
$$Z = B*S/SQRT(A \uparrow 2 + B \uparrow 2).$$

These purport to depict the thing ascending toward us, twisting counterclockwise as it comes, while we calculate (assuming that our stamina holds out) for conservative values of X and Y, and an appalling list of values for Z. All this, it would seem, is supposed to go on forever; or, at least, as long as their insouciant energy suffices to the production of real, finite quantities like A, B, S, and so forth, not to mention cosines, sines, and so forth.

THE COLONY SEEMS more distant, now, than the panopticon we were offered as an alternative. I have five friends, here; or, rather, there are that many personages with whom I have engaged in behavior that I, at least, do not consider hostile. None of them can talk. Two are confined, by a kind of stocks clamped around their strange heads, in barrels set flush with the deck. One has a skull shaped like a bowling pin, and drinks milk through a hose, and whistles; the other is a churning mouth, pointed at the zenith, crammed with hundreds of dirty molars, from which dangles a weak, achondroplastic frame. The eyes are like those of a calf; it groans happily when stew is poured into it. In order that they shall not drown, I siphon off their excreta. They do not object. Nearby, a pair of midget twins squats, sips tea, plays chess with men of chalk and jet, squeals and giggles. Brother and sister, they are otherwise identical; their immense, didactic genitals, and her breasts, tinted copies from Maillol, are the envy of us all. But their red umbrella, a careless display of the prerogatives of former wealth, has bred ineradicable distrust. Finally, a pudgy woman in middle life prowls incessantly, stumbling, cursing and slapping the cloud of greenbottles that follows her everywhere but dares not land. Her flesh and uniform look like varnished zinc; a soiled placard bears the legend: "The Filthy Nurse."

I HAVE NOT MENTIONED our cargo: a small box, or casket, bolted or welded amidships, made of quartz and bronze. By night it is lit, blindingly, from underneath. Inside, there is nothing more than a double handful of grayish pellets. They are all that is left of the brain of René Descartes, exhumed on the suspicion that it might still contain the germ of a truly complex thought. The outcome of this inquisition is still to be revealed; but the transportation of that relic is the secret motive of our voyage.

ASLEEP, I STOLE an unremarked helicopter and flew away. Spiraling upward, I saw that our great ocean was no more than Chesapeake Bay. I swooped along the Mall, from the Washington Monument to the Hill, swerved to the left over the Library of Congress, and headed for Maryland. Under a willow, on a hill, a girl waited for me, in a gown that left visible (against the sky) only her hands

and face. A picnic was spread of bread and chicken, quiche and radishes, wine and butter. At first, she administered a test, showing pictures for me to name. I failed in everything. Days later, I understood that what you have read was a play on the words of the name of a woman I hardly knew, for whom I felt nothing.

Paris/San Francisco/Ponce, 1976–78

*October* 6 (Fall 1978): 81–92.
A separate note, appended to the original manuscript, was not included in the publication of the text:

For those who take note of such things, it is necessary to resolve minor ambiguities in notation. I have used (not quite exclusively) the extended protocol of an antiquated but quite serviceable non-standard FORTRAN compiler on which I once learned the rudiments of that alleged "language." The <down-arrow> signals the onset of a subscript, and the idiosyncratic dollar sign <$> commences a string not natively recognized by the parser; it does not evaluate to an ASCII <escape> or the current address in the program counter. Both are understood to be in effect until the next operator or delimiting token is recognized. (Thus $IM is simply *i*.) I have taken this course in the interest of easing typographical problems. Refer to Bronshtein and Semendyayev, *Handbook of Mathematics*, for conventional etiquette.

HF
Eaton, New York
Labor Day, 1978

# Index

*Page numbers in italics indicate*
*illustrations.*

in film, 226
historic time, 39, 40–41, 42
plasticity of, 26, 226, 262
in video, 265, 266
Tinguely, Jean
*Homage to New York*, 286, 289n1
Tisse, Eduard, 77
Turner, J. M. W., 9, 17, 41

—

Valéry, Paul, 29, 71, 171–172, 176
"The Conquest of Ubiquity," 182n1
Van Dyke, Willard, 161
Vasulka, Woody (Bohuslav), 272
and Steina Vasulka, 274n1
Vertov, Dziga, 166, 240, 248, 249
*Man with a Movie Camera*, 168, 170n3
Vesalius, Andreas, 157
Video, 136, 176, 180, 227–228, 236, 238,
262, 264, 267
and image-processing, 269–270
relation to film, 261–263
relation to music, 263, 266
relation to painting, 263
and time, 265, 266
Vorticism, 12, 27, 184

—

Walker Art Center, 249
Warhol, Andy, 180
Webern, Anton, 20, 151
Weston, Edward, 6, 13, 16, 25, 45, 58, 59,
67–87, 88, 185, 186
and eroticism, 79, 97
and pictorial space, 83
previsualization of the image, 68–69,
84
and surfaces, 73, 74, 78
White, Clarence, 12
Whitehead, Alfred North, 79
White, Minor, x, 185
Whitney Museum of American Art,
173, 232
Wieland, Joyce, 186, 202n3

*Catfood*, 191
*La Raison avant la passion*, 191
Williams, William Carlos, 77, 184, 293
Wilson, Charis, 86
Windhausen, Federico, xvi, xviin9
Wordsworth, William, 39, 183

—

Xerography, xv, 174–175, 297, 298

—

Yeats, William Butler, 35, 41
Youngblood, Gene, 52

—

Zeno, 132, 262
*Zhizn Iskusstva*, 163, 170n1
Zorn's Lemma, 195, 196